PRAISE FOR

GEORGE HURRELL'S
HOLLYWOOD

"My grandmother Joan Crawford was the first star to credit Hurrell's contribution to her career. He boosted her ascent from ingenue to legendary superstar, and their work together created images that are still extraordinary for their clarity and power. Mark Vieira's updated book captures it all."

—CASEY LALONDE

"Hurrell's fantastic high-contrast black-and-white portraits of iconic Hollywood stars in seductive poses—including my mother Joan Bennett and my aunt Constance Bennett—are mesmerizing. And Mark Vieira knows everything there is to know about Hurrell's life, his technique, what was going on at the studios, and what was said during the sittings, which makes for a wildly informative and entertaining read."

—SHELLEY WANGER

"Hurrell's photographs of my father Gary Cooper are iconic. Everyone today is a photographer, and we capture moments memorable or fun, silly or serious, but an artist like Hurrell captured the magic in the moment, the mystery in the eye, in a tilt of the head. [Hurrell] used light and composition to create another level of reality and find the essence of his subjects, and in them, someone we thought we knew, but oh, so much more. We must be grateful to Mark Vieira for bringing Hurrell's work to new generations."

—MARIA COOPER JANIS

"Luminous. Sensuous. Incandescent. These words become almost clichéd when speaking of Hurrell photographs. Mark Vieira's updated tribute features his glorious prints of my grandmother, Norma Shearer, and so many others. For anyone interested in cinema, this breathtaking endeavor is a must-have."

—DEBORAH THALBERG

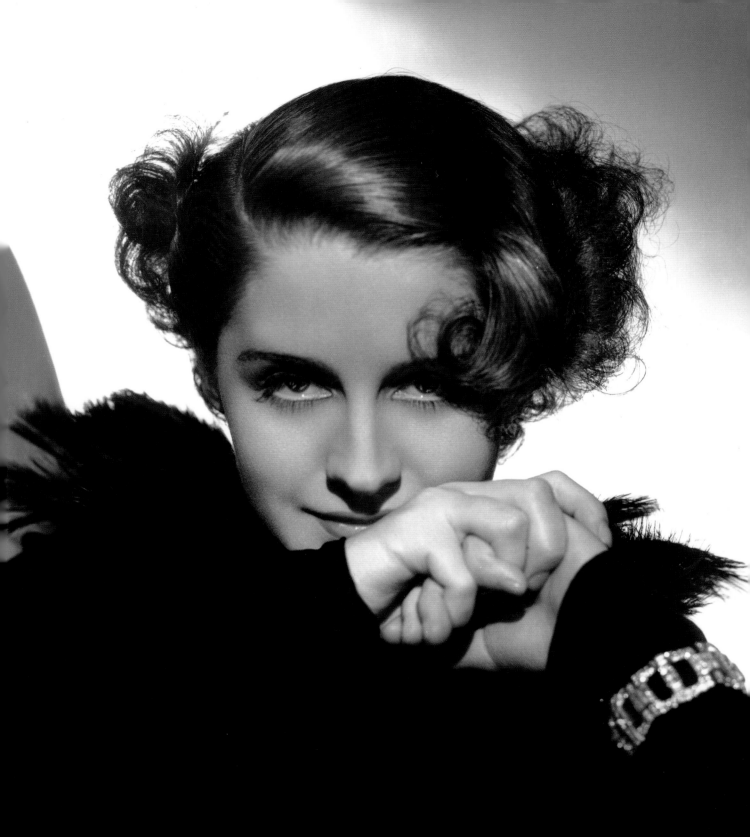

GEORGE HURRELL'S
HOLLYWOOD

GLAMOUR PORTRAITS 1925–1992

MARK A. VIEIRA
FOREWORD BY SHARON STONE

IMAGES FROM THE COLLECTIONS OF:
Michael H. Epstein & Scott E. Schwimer and Ben S. Carbonetto

RUNNING PRESS
PHILADELPHIA

To the memory of my parents, Alan and Eleanore Vieira.

And to the memory of my longtime assistant, Jonathan G. Quiej,
who helped me print many of the photographs in this book.

PAGE ii: Norma Shearer, a portrait for Edmund Goulding's *Riptide*, 1934.

OPPOSITE: Joan Crawford, a portrait for Clarence Brown's *Chained*, 1934.

OVERLEAF: Jean Harlow, a home session, 1934.

Running Press
Hachette Book Group
1290 Avenue of the Americas, New York, NY 10104
www.runningpress.com
@Running_Press

Printed in China

Originally published in hardcover and ebook by Running Press in November 2013
First Trade Paperback Edition: September 2023

Published by Running Press, an imprint of Perseus Books, LLC, a subsidiary of Hachette Book Group, Inc. The Running Press name and logo are trademarks of the Hachette Book Group.

The Hachette Speakers Bureau provides a wide range of authors for speaking events. To find out more, go to www.hachettespeakersbureau.com or email HachetteSpeakers@hbgusa.com.

Running Press books may be purchased in bulk for business, educational, or promotional use. For more information, please contact your local bookseller or the Hachette Book Group Special Markets Department at Special.Markets@hbgusa.com.

The publisher is not responsible for websites (or their content) that are not owned by the publisher.

Print book cover and interior design by Corinda Cook.

Library of Congress Control Number: 2013937706

ISBNs: 978-0-7624-8460-7 (paperback), 978-0-7624-5039-8 (hardcover), 978-0-7624-5069-5 (ebook)

1010

10 9 8 7 6 5 4 3 2 1

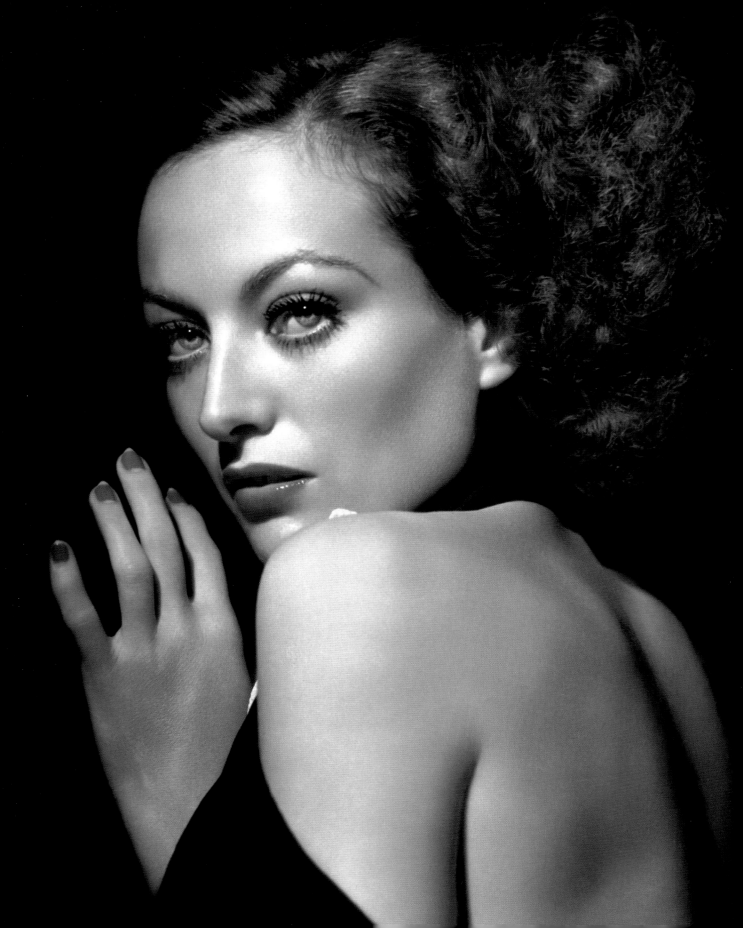

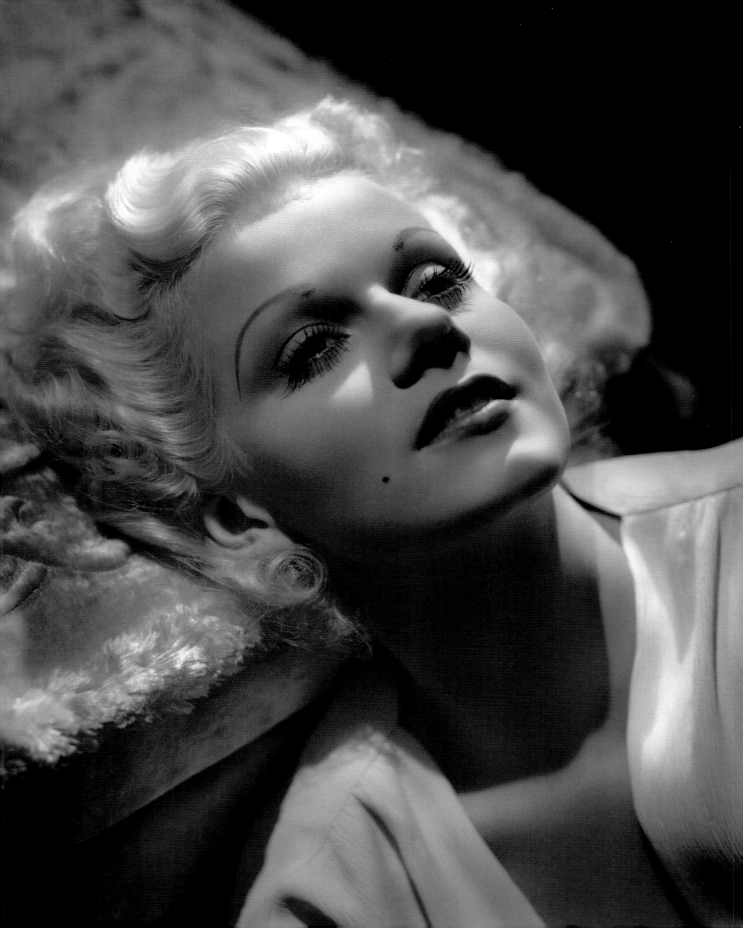

CONTENTS

FOREWORD BY SHARON STONE

George Hurrell was a master of light, elegance, and glamour. When I met him I had just arrived on the Hollywood scene. The legendary film-star manager Irving "Swifty" Lazar introduced me to the legendary photographer, Mr. George Hurrell, and they agreed that I had a kind of "lost type of glamour of bygone days." A photo session with George was set up immediately. He would shoot me in a satin gown on Mr. Lazar's giant satin bed, with a 1940s hairstyle and a smoldering look to match. I was amazed, when after some preparation of hair and makeup and a quick wardrobe change, George took a mere five or six shots.

Yes, he stepped in and lifted my chin just so, opened my pointer finger away from my others, turned my hand "the right way," asked me to part my lips, and in that rough voice said, "Okay, kid. Now look right here." And I did somehow—clear that I was with the greatest movie-star photographer of all time. Click, and he changed the giant 8x10 film slide from side to side. He asked me to hold still. He stepped in and adjusted my head. Click, and we were done. There was never any waste. No ego. No pretense. George was simple enough to appear blue collar and yet simple enough to be a king.

After that shoot we worked together a number of times. Each time I learned the mastery of the "clean photo"—

the elegance of the body, the hand, the foot, the "look." He knew it and he taught it to me.

I got to see almost all of his original prints from the beginning of his career onward, almost all of the real work, and I got to spend time with him right up until the end of his life. In fact, I was the last person George photographed before he died. And that shoot was as clean, clear, and simple as all the others. I was wearing leopard and lying on a saber-tooth tiger rug. Yes, a real saber-tooth tiger . . . rug. That was an era, he was a king, and yes, I learned how to be a movie star from the best of the best, Mr. George Hurrell.

Since then I have worked with many masterful cinematographers. I have found that somewhere during the film they always comment about George. There is a throwaway remark here or there, like "Move that key light; it should be more Hurrell," or "Hey, that really reminds me of a Hurrell photograph." Or "George Hurrell would have really loved you." That one brings a tear to my eye, as the feeling was mutual.

—Sharon Stone

OPPOSITE: Sharon Stone was an exemplary Hurrell subject. She exuded glamour—and she collected Hurrell prints.

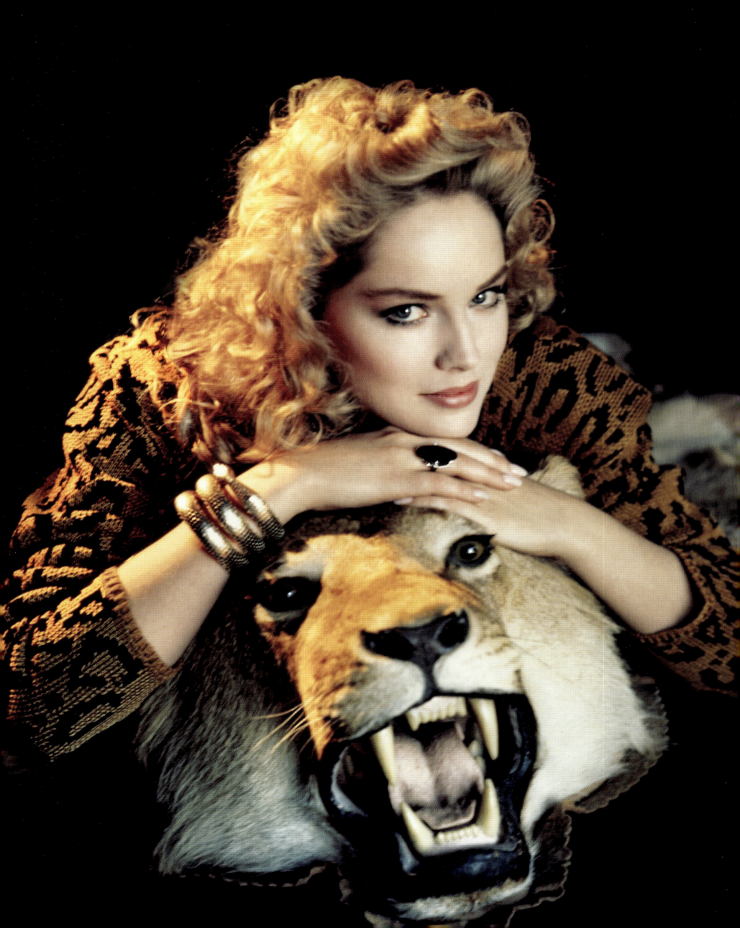

PREFACE

George Edward Hurrell was the creator of the Hollywood glamour portrait. When he came to Hollywood in 1930, a movie star photograph was soft and undistinguished, like a portrait from a Main Street salon. Hurrell introduced a bold new look: sharp focus, high contrast, and seductive poses. He told a story with each photo, blending the ethereal and the erotic. He created imagery that was unprecedented and unique. How did an unknown artist from the Midwest become the most influential photographer in Hollywood history?

In 1929 Hurrell was twenty-five, a full-time commercial photographer and sometime landscape painter. He was eking out a living in Los Angeles when the film star Ramon Novarro came to his Westlake atelier. A series of sessions produced a remarkable portfolio. Novarro was so pleased that he showed it to Norma Shearer, the highest-grossing star at the most prestigious studio in the world. Shearer commissioned Hurrell to make photographs she could submit for a new type of role. She got the role and Hurrell got a job—head portrait photographer at Metro-Goldwyn-Mayer.

The dreamlike world of silent pictures had created a star system based on personalities who were bigger than life. The naturalism of talking pictures diminished them. If the star system was to survive, the studios would have to enlarge them again. Along came Hurrell, who adapted his technique to this purpose. Using new lighting and retouching effects, he created spectacular, enticing images of Greta Garbo, Clark Gable, and Joan Crawford, and sold them to a worldwide audience. In the process, Hurrell perfected a photographic idiom: the Hollywood glamour portrait.

In a town where imitation is the sincerest form of survival, Hurrell was an original. Not only was his lighting unique; his personality was as much a tool as his famous "boom light." He was loved by his subjects and tolerated by moguls such as Louis B. Mayer, whose patience he tried with occasional bursts of temperament. For thirteen years, Hurrell was the highest paid, best-known photographer in Hollywood. Bette Davis and Joan Crawford gave him their fabulous faces, and he immortalized them. By 1943 he had worked with every studio in town, had a beautiful wife named Katherine, and was affluent. His sitting fee was $1,000, when the dollar bought thirty times what it does in 2013. The millionaire producer Howard Hughes paid him $4,000 to photograph an unknown girl in a haystack for *The Outlaw*. Censors suppressed the film, but Hurrell's photos made Jane Russell a household

OPPOSITE: George Hurrell's life was marked by dramatic, unexpected shifts of fortune. Here he is in 1980, on the verge of the most remarkable shift of all.

word—which Hurrell already was. "Hurrell is one of Hollywood's few genuine geniuses," said *Motion Picture* magazine. "He is Rembrandt with a camera." He was working at Columbia Pictures during the week and in his Beverly Hills studio on weekends, shooting foldouts for *Esquire* magazine. At thirty-nine, he had an enviable life and a secure future. The photographer of stars had become a star.

This is the story I told in *Hurrell's Hollywood Portraits*, which was published in 1997. It was the first book to show Hurrell's work in accurate chronology, to describe it in the context of the personalities he captured, and to analyze it in accessible photographic terms. I am a working photographer, using vintage camera equipment to make portraits in his style, so I can explain his technique and show why his art had five distinct periods. There were many craftsmen in the studio system, but only Hurrell's work had the periods that characterize a Picasso.

Hurrell's Hollywood Portraits was published just as the internet and digital photography were gaining currency. Before long, images from the book were all over the Web. Faces in magazine ads had a digital sheen that tried to copy Hurrell's retouching technique. Norma Shearer, known as the First Lady of M-G-M, became "Hurrell's patron." Joan Crawford, the most durable star in Hollywood history, was "Hurrell's muse." An authoritative book had honored the artist. I was no longer a Hurrell expert. I was a Hurrell scholar. I thought I had completed my life's work. It had only begun.

If you've ever written about a famous person, you can expect to answer questions for the rest of your life. "How long did you work with George Hurrell?" And "What happened to his career after Hollywood?" And "What was he like?" I am asked to identify his subjects, his sessions, and their dates; to demonstrate his technique; to give free appraisals; to weed out counterfeit prints; and, happily, to print his vintage negatives. In short, I function as a professor of arcana. This gives me the opportunity to share knowledge and to gain more. In the twenty-six years that have passed since I wrote *Hurrell's Hollywood Portraits*, I have learned that a few facts I wrote were incorrect. Hurrell never photographed Marilyn Monroe, even though

numerous people claim that he did. This is why I have written a second Hurrell book. The next time you see a Hurrell portrait, I want you to know when he shot it, how he shot it, and what makes it great.

I have also written this book because of the photographs. At one time, in order to see a Hurrell portrait, you had the choice of a museum, a gallery, a book, or a fortunate friend. Technology has changed that. In our democratized millennium, you can see Hurrell's work on the great god internet for free, any day, any time, anywhere. But what are you seeing? In the '70s I complained about books with poor reproductions of his work. I criticized copy prints that leached the subtle shades of gray from his black-and-white imagery. I have more to complain about now. Few of the Hurrell images on the internet retain the quality of his originals. I wrote this book to ensure that his photographs can be seen as he intended. I have secured prints made by Hurrell himself. I have included prints that I made in a photographic darkroom from his original negatives, sometimes under his tutelage, and sometimes under the supervision of his colleagues. I have scanned and restored each print myself. And I have entrusted these prints to Running Press, a publisher committed to fine lithography.

I have still another reason for writing this book. Hurrell died thirty years ago, yet he lives on. His personality vibrates in every image. People want to know more about him. There is more to tell. Like every Hollywood legend, Hurrell was bigger than life—brilliant, mysterious, mythic. I want to clear the apocrypha from the myth. Truth is more compelling than myth, *Hollywood Babylon* notwithstanding. I want to take the internet taint off Hurrell and put him in a worthy context. I also want to tell what has not been told.

In 1943, when Hurrell was at the height of his prominence, he suffered a vertiginous fall from grace. In 1975, when I met him, he was seventy-one but could not retire. He had lost his fortune to bad investments and alimony. Instead of shooting glamour portraits, he was working as "Unit Stills Photographer" on *Gable and Lombard*, a feeble tribute to the stars he had immortalized. After years of middle-aged struggle, the one-time Rembrandt of

LEFT: Hurrell's aptly named "boom light."

Hollywood was an anonymous studio employee. The artist was in eclipse, his portrait career in ashes.

Six years later, Hurrell was Hollywood's latest comeback story, a celebrated artist. Elderly but robust, he was charging $5,000 to photograph stars such as Diana Ross and Liza Minnelli. He was selling his 1930s work for twice that, in galleries that once had sneered at Hollywood photography. He was the subject of articles, books, and shows. He was enjoying a second career.

This is the story I add in this volume: Hurrell's return from the ashes. I was there, sometimes as a participant, sometimes as an observer. I watched him wend his way through the monolithic soundstages at moribund studios, through the lavender-scented living rooms of covetous collectors, through smoky dens of thieves, and into chic galleries. I saw him flirt with history and scandal, wooing this one and dismissing that one. I was there, like so many others, because I was entranced by the beauty of his work. Before long, I saw it tarnished by bootlegging, theft, and fraud.

The George Hurrell I knew was two people. Depending on what day you saw him, or what time of day, he was as bright as his spotlights or as dark as his famous shadows. When I knew him, I was too starstruck to anticipate his vagaries of mood. As a result, I was hurt and disillusioned. By writing the story of his life I have come to terms with that experience. I thank the individuals who have helped me write an objective account of Hurrell's second career. I have made every effort to convey the truth, both about the artist and about his images.

It is those images that motivate this book. They are luminous, powerful, and timeless. Most have not been published since they were made. As you will read, they have traveled a circuitous route from the studios to this book. With the help of the private collectors and the archives I thank in the Acknowledgments, I have worked to make *George Hurrell's Hollywood* the definitive work on this trailblazing artist, a shimmering montage of fact and anecdote, light and shadow.

—Mark A. Vieira, October 28, 2022

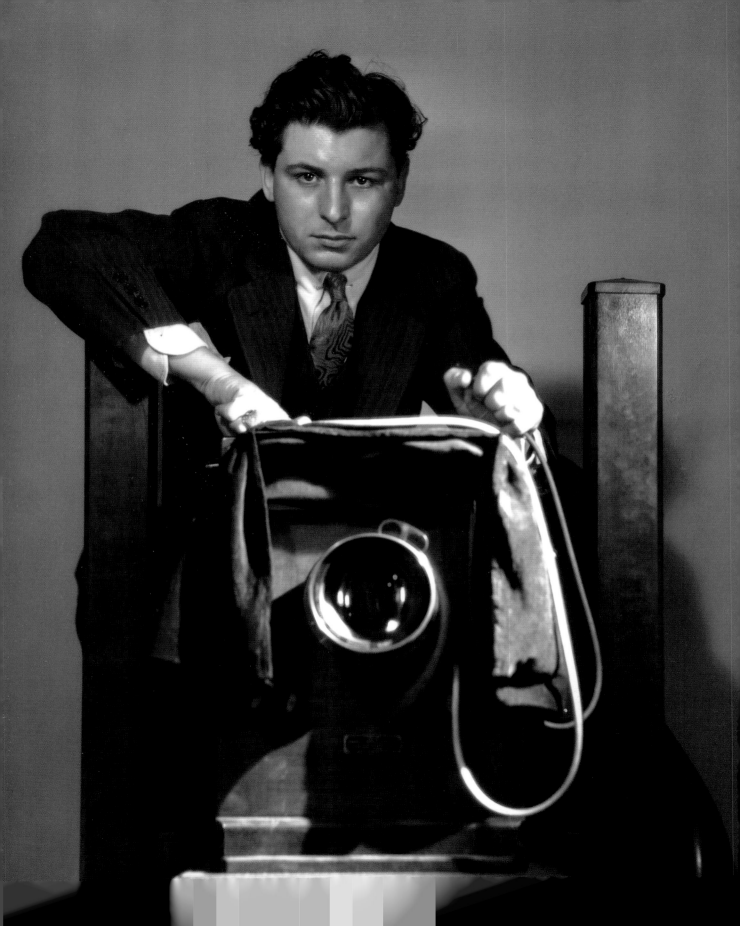

INTRODUCTION

The artist who would become famous for turning human beings into latter-day gods was born a Roman Catholic at the beginning of the twentieth century. George Edward Hurrell was born on June 1, 1904, in the Walnut Hills district of Cincinnati, Ohio. At one point his publicity would state that he had been born in Covington, Kentucky, a few miles across the Ohio River. Like so much of his life, the facts of his birth are blurred by myth. What is known is that his paternal grandfather came to America from Essex, England, where his forebears had been shoemakers for hundreds of years. George Hurrell's grandmother came from Dublin. His father, Edward Eugene Hurrell, was born in Cincinnati. His mother, Anna Mary Eble, was born in Baden-Baden, Germany, and came to Cincinnati as a child. Edward and Anna had five boys and one girl. George was the first born. He was followed by Edmond ("Ned") in 1907, Russell in 1910, Elizabeth in 1912, Robert in 1915, and Randolph in 1918. From all indications, the Hurrells were devoutly Catholic. Randolph studied for the priesthood for years but relented a month before his ordination. Likewise, Elizabeth was poised to enter a convent but instead chose the secular life.

OPPOSITE: George Hurrell was twenty-six when he made this self-portrait with an Eastman Century studio camera in the M-G-M portrait gallery.

In an *Esquire* magazine interview in the late 1930s, George Hurrell made a cryptic statement about his father, the only time he would ever mention his family in print. "I'm a somewhat screwy photographer—an artist gone wrong," he said. "And so wrong, I'm the shoemaker's favorite child." In 1909 Edward Hurrell moved his growing family to Chicago so that he could start a shoe factory. Chicago was the Catholic stronghold of the Midwest, and young George was undoubtedly influenced by twelve years of Catholic education. He served as an altar boy and eventually felt he was being called to the priesthood. In the spring of 1922, as he approached his high school graduation, he decided to acknowledge what was known in Catholic school as a "vocation." He applied for admission to the Archbishop Quigley Memorial Preparatory Seminary in Chicago. Yet he heard another calling. "As long as I can remember," he recalled fifty years later, "I wanted to be an artist. I was drawing all the time, in school and out. Art was my favorite class." George had always been putting his impressions of people on paper. By late high school, he was sufficiently skilled to consider a career in art. Hedging his bets, he applied to the renowned Art Institute of Chicago. He was accepted by both the seminary and the school. He chose the school, mostly because he could attend on a scholarship, and he began to study painting and graphics.

George did not find the Michigan Avenue campus entirely to his liking. The classes may not have been

sufficiently stimulating or it may have been that he was easily bored and given to impatience. After a short time at the Institute, he left and enrolled in the Chicago Academy of Fine Arts, which was located a block away, at 81 East Monroe Street. (Although this Academy had the same name as an earlier incarnation of the Art Institute, it was an entirely different school, founded in 1902 by the Pictorialist photographer Carl Werntz.) "I went to the Academy of Fine Arts at night for a while," recalled Hurrell in 1980, "and I worked part-time. I would just fit that in. Whenever I had to pay rent, I would go to work." His odd jobs did not include photography, although he did have a passing acquaintance with it. Students were encouraged to take snapshots during the warm months to use as the basis for the paintings that they would make in the winter. This was the first time George used a professional-gauge camera and entered a photographic darkroom, but he was more interested in surrealist painting, especially that of Giorgio de Chirico. After a year and a half, George dropped out of school, yielding to the inquietude that would inform the rest of his life.

In early 1924 George took a job as a hand-colorist in a commercial photography studio, but he soon wandered from the drafting table. "I got curious one day about life in the photography department," he recalled. His curiosity led to a transfer, and he was soon assisting catalog photographers, making photos of iceboxes, hats, and—appropriate to his family history—shoes. "One day," he recalled, "an emergency occurred in the studio. It was understaffed and a photo had to be taken right away— and there was no one else to take it." This was George's baptism by fire, his first professional photograph. It was a thrill, but it did not last. The elder staff members returned and George was back to assisting. After three weeks, he grew bored and quit. After taking a few more photography jobs, he found one that lasted. The portrait photographer Eugene Hutchinson had a splendid studio in the Fine Arts Building on Michigan Avenue, about a block south of the Art Institute. George was hired as a colorist but moved on to negative retouching, airbrushing, and darkroom work. He also learned how to shoot copy negatives of photographs and artwork. Although he continued to paint, it was his photographic work that made a fortuitous connection.

In early 1925 the California artist Edgar Alwin Payne was visiting Chicago with his wife, Elsie, and daughter, Evelyn. Payne was known for painting *en plein air*, particularly the Sierra Nevada mountain range. He had been traveling through Europe for two years and was exhibiting at the Art Institute, which contracted with Hutchinson to shoot negatives of the art. Because George was entrusted with this task, he had an entrée to a lecture that Payne was delivering at the Institute. Never one to stand on ceremony, the young photographer asked the esteemed artist for a critique of his paintings. Payne liked a landscape that George had recently completed. A number of visits followed.

At forty-two, Payne was an acclaimed artist, showing in numerous galleries simultaneously. He had helped found the Laguna Beach Art Association in 1918, and became its first president. He described Laguna's Mediterranean climate, lush landscape, and thriving art colony, and told George that if he was serious about an art career, he might do well in California. George was not averse to a move; besides the lure of Laguna's artistic offerings, the Chicago winter had made it difficult for him to get rid of what he would later call a "stubborn bacterial infection."

In May 1925, George climbed into a Hudson touring car with the Payne family and set off for California. Payne was a true artist. In 1912, when he and Elsie were about to be married, he had suddenly asked her to call their guests and tell them to come several hours later—when the light in the chapel would be right. Anecdotes like this enlivened the drive to California, but it was interrupted by a minor accident in Denver. The party of four escaped injury, possibly because they were insulated by a carload of canvases. George's first glimpse of the Pacific Ocean came on a balmy evening in late May. "No place like California," was Payne's breezy observation. For a young artist from the Midwest, this was an understatement. The image of Emerald Bay seen through a curtain of eucalyptus leaves would stay with Hurrell for the rest of his life.

OPPOSITE: The plein air painter Edgar Alwin Payne was responsible for George Hurrell's coming to California in 1925. Hurrell made this portrait in Laguna Beach in 1926.

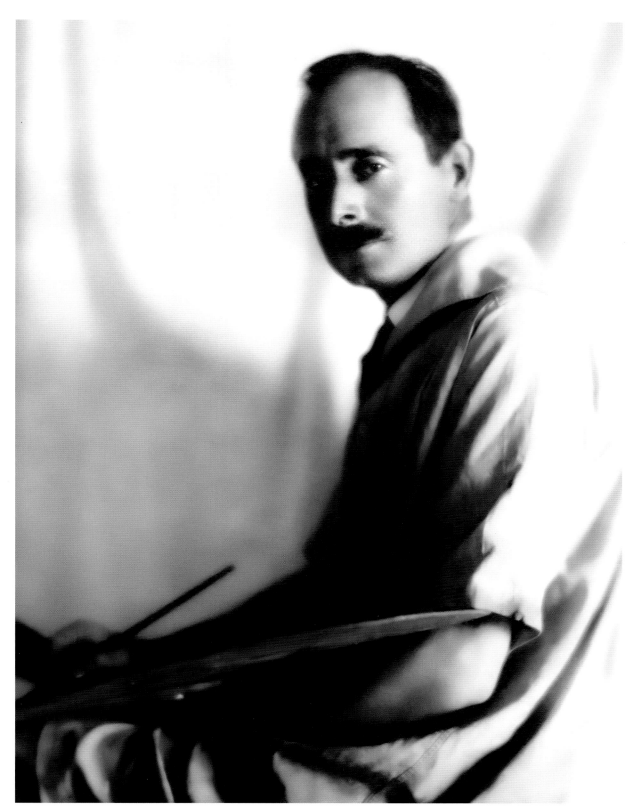

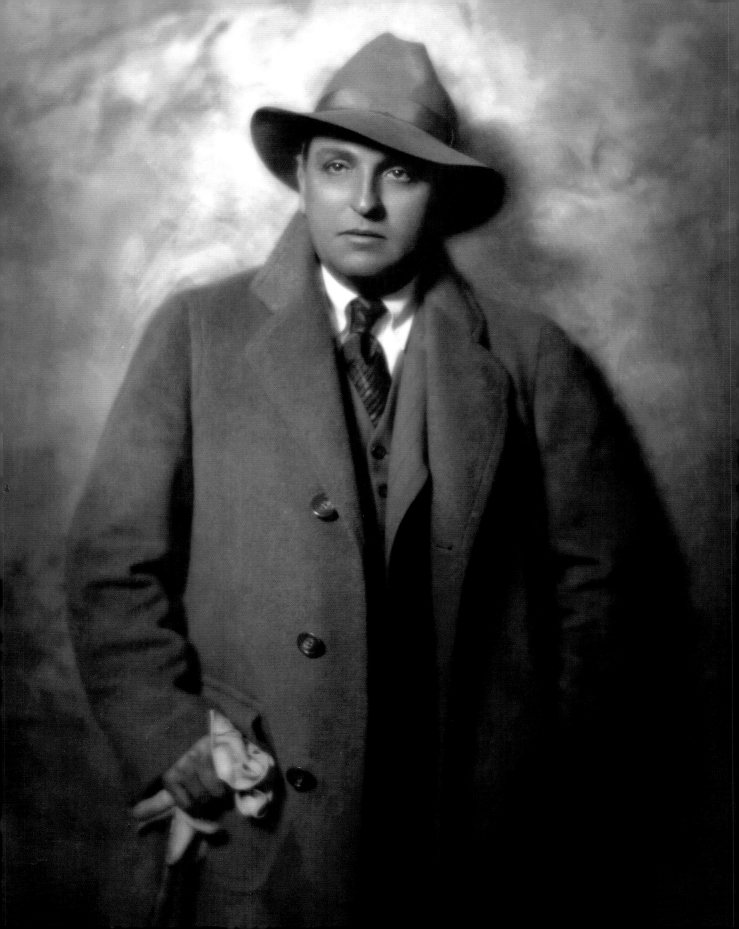

CHAPTER 1

SOUTHERN CALIFORNIA IN THE 1920s

LAGUNA BEACH

On June 1, 1925, George Hurrell celebrated his twenty-first birthday and began to live like an artist. Friends of Edgar Payne helped him find a place to live, a "picturesque cottage" that turned out to be a semifurnished shack called the Paint Box. It had been built in 1904 by J. N. ("Nick") Isch, who was the proprietor of Laguna Beach's general store and post office. The Paint Box was a place where an artist could pay for room and board with his or her work, so in a happy demonstration of quid pro quo, Isch accumulated an impressive art collection from tenants such as Emily White, James McBurney, and Donna Schuster. Hurrell's arrangement was equally liberal; he would more or less watch the cottage for an absentee tenant, Malcolm St. Clair, a film director whose father, watercolorist Norman St. Clair, was one of Laguna's first resident artists.

Hurrell soon found a sympathetic physician, but he prescribed pills that were both large and expensive. "I had to make a living," recalled Hurrell. "I'd brought a camera from Chicago, and these artists needed pictures of their paintings. I'd take them out in the sun and put a Wratten panchromatic K3 filter on the camera [because the film was black and white and the color values of the art had to be approximated], and I'd shoot these paintings. I was getting my bread and butter out of photography." And his health was improving.

Hurrell's photographic training did not consist solely of copy technique. He had learned how to make a portrait. Because the 8x10-inch sheet film he used was large and its exposure time lengthy, the rhythm of a portrait session was like that of a sketch session: the artist captured a pose, flipped to the next sheet of paper in the sketch pad, and told the model to assume a new pose.

Hurrell owned a portable 8x10 camera and an eighteen-inch Wollensak Verito portrait lens. This lens was manufactured with a chromatic aberration that created haloes around highlighted areas of the image, an effect called "soft focus." It gave the photograph a hazy, dreamy quality, not unlike the *sfumato* effect in Renaissance art, but only if the iris was used wide open, which was usually around f/4. Soft focus diffused facial detail, so the negative required less retouching, which saved both time and money. Moreover, the wide-open lens required less exposure time, which made poses more natural.

Before long, Hurrell was photographing Laguna artists. One of his first subjects was Edgar Payne. These dignified personages came to sit for him, even if he was young and his equipment primitive; he was using household bulbs with saucepans for reflectors. Sometimes he used nothing more than the north light coming through his studio's skylight. Hurrell knew enough about lighting to control

PREVIOUS: George Hurrell's portraits were first published by the Stendahl Galleries in Los Angeles, so it was inevitable that Hurrell should make a portrait of the influential Earl Stendahl.

OPPOSITE: William Wendt was known as the "Dean of Southern California landscape painters." He was one of Hurrell's first portrait subjects in Laguna. The lighting in this study of Wendt is subtle, considering the primitive implements Hurrell was using at the time.

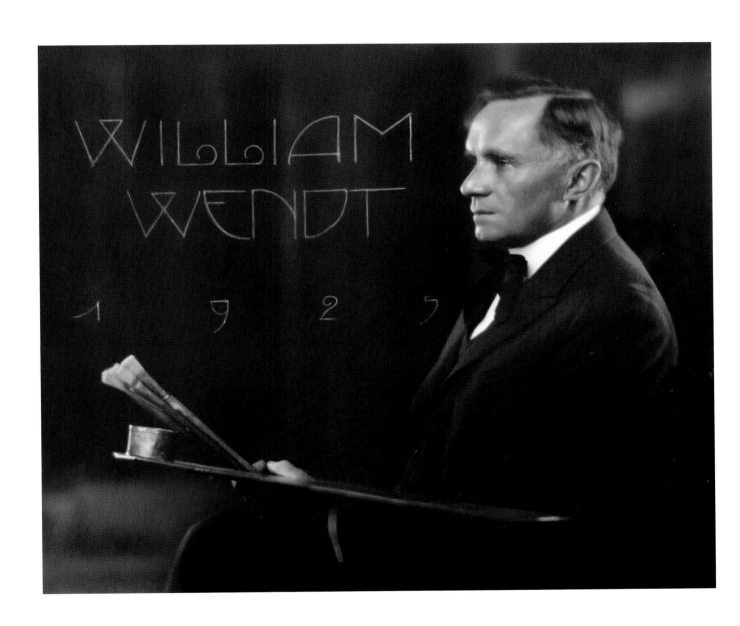

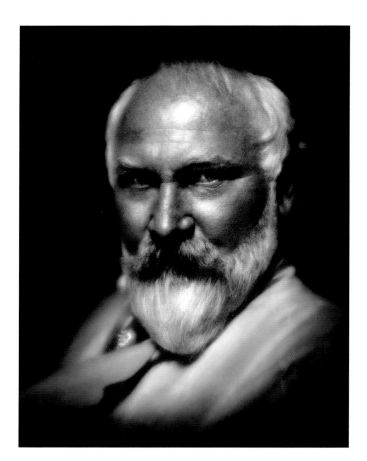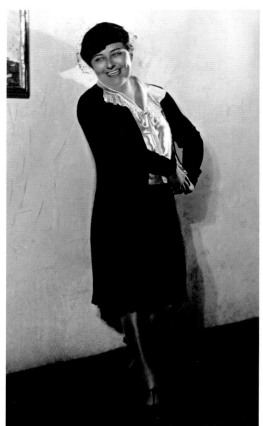

both intensity and direction. He had learned technique from Hutchinson, but he also had an innate understanding of what light and shadow could do. "Rembrandt was my ideal," he said later. "Rembrandt used one source of light, and that's what I did."

In 1925 the lighting scheme at the average commercial portrait studio consisted of: 1) the "key light," a large floodlight aimed from above to create modeling; 2) the "fill light," a floodlight set at eye level to lighten (or "fill" in) the shadows cast by the key light; 3) the "backlight" (or "hair light"), which was aimed at the subject from behind, in order to separate them from the background; and 4) the "background light," which illuminated the wall behind the subject. A photograph reduces a three-dimensional subject into two dimensions; lighting is supposed to persuade the viewer that there are once again three dimensions.

At twenty-one, Hurrell was an iconoclast. Having left a genteel salon environment for a Bohemian enclave, he was dispensing with studio technique. He made a portrait

of William Wendt, a sixty-year-old plein air painter, using a strong north light and a little edge lighting from the saucepans. Wendt was pleased with Hurrell's work; it was markedly different. When Hurrell used his Verito lens, he used it in a way that no one else had thought to. He did not shoot wide open; he chose to stop it down partway. The effect was akin to painting with a palette knife—not too soft and not too sharp. His Laguna subjects were quick to

ABOVE, LEFT TO RIGHT: Frank Cuprien was one of the plein air painters whom George Hurrell photographed in Laguna Beach in 1925 and '26. Cuprien was known as the "Dean of Laguna Beach artists." Hurrell's use of negative retouching to emphasize highlights is obvious, even in this seminal work. Hurrell was twenty-two when he made this portrait.

Florence Barnes was becoming fast friends with Hurrell when he made this portrait of the San Marino socialite.

note the new look. This young man who fished at Victoria Beach was talented.

Hurrell was tawny, muscular, energetic, and, although he was only five-foot-eight, a shock of dark, thick, unruly hair made him appear tall. His unconventional good looks were accented by dark brown eyes, long eyelashes, and expressive eyebrows. His native intensity was allied to a bombastic self-confidence. He was not shy about expressing his dislikes, which included stuffy behavior. He was soon creating a stir in Laguna, especially with the wealthy tourists from Riverside, San Bernardino, and Pasadena.

On Christmas Day 1925, Hurrell accepted an invitation to join the Paynes for dinner at the home of William A. Griffith, a plein air painter and president of the Laguna Beach Art Association. Hurrell was studying with Wendt and painting steadily but his photographic portraits were getting more attention; he wanted to talk to painters. As Hurrell would later recall, the evening was memorable, but not for the artists. "They were all very friendly, but they were very serious painters, not partygoers particularly. The society crowd that came down there from out of town were partygoers." Before the evening was over, Hurrell was introduced to a "Mrs. Barnes from San Marino."

Florence Lowe Barnes was born on July 29, 1901, to a wealthy Pasadena family. Her paternal grandfather, Thaddeus Lowe Sr., was the inventor and industrialist who built the Mount Lowe Railway in 1896. Her mother came from the social echelon known as the Philadelphia Main Line and owned extensive property, including the stately Broadwood Hotel. Florence was attending the party with her husband, C. Rankin Barnes, rector of St. James Episcopal Church in South Pasadena. They had been married for four years and had a three-year-old son named William. In a room full of artists, Florence stuck out, not because she was a young woman in the midst of a lot of bearded old men, but because she had a forthright quality. She was not particularly attractive. She was stocky, her face was round, and she had sloe eyes, but she sparkled with an earthy élan. She was also well-spoken, conversant in the arts, and quick with a pun. At first glance, she was an odd match for a staid minister. Hurrell

was drawn to her, if not romantically, then with fascination at an individuality as great as his. And she made him laugh. Like his sister Elizabeth, she was funny.

Florence Barnes was independently wealthy, having inherited a fortune at her mother's death the previous year, and she was beginning to live life apart from Rankin. She maintained a thirty-five-room mansion in San Marino but was spending more time at a rambling Laguna estate called Dos Rocas. This palatial home boasted the first fresh-water swimming pool in that community. It was even designed with portholes so that non-swimming guests could watch underwater horseplay. Hurrell visited her in January and was soon a regular guest at her pool parties. Most were colorful and some were raucous, even by Roaring Twenties standards, since Barnes's guests came from air circuses, art enclaves, and the fringes of show business. The eccentrics Hurrell met at these parties included Mary Frances Kennedy, before she became M. F. K. Fisher. There was also fifteen-year-old Katherine Gertrude ("Gigi") McElroy, who was madly in love with thirty-three-year-old Dillwyn Parrish. When neighbors complained about the noisy parties, Barnes's grandmother told her to stop them. Barnes ignored her. The headstrong young woman was beginning to incense both sides of her family with her unladylike pursuits. She loved to party, to fly, and to fish. "Whoever catches the smallest fish has to cook!" was her rule. After a few trips with Barnes, Hurrell's skill at casting was surpassed by his skill at gutting. Barnes was an entertaining companion, even if it was apparent that her bravado masked insecurity and a lack of direction. Like Hurrell, she was sensitive, talented, and dynamic, but she needed a goal.

In late 1925 and early 1926, Hurrell photographed Wendt's paintings to publicize an upcoming show at the Stendahl Art Galleries in Los Angeles. Earl Stendahl was printing a catalog to accompany the February show *William Wendt and His Work*. Hurrell made prints for it and shot a portrait of Wendt for the cover. Unfortunately, Wendt fell ill and the show had to be postponed. However, a solo show of Payne's work did open at Stendahl's in March. Payne was Stendahl's best-selling

artist, and the gallery published a lavish catalog, *Edgar Alwin Payne and His Work*; Hurrell shot both the art and the artist.

Hurrell divided his time between painting, shooting portraits, and exploring the coastline—Moss Point, Dana Point, and Main Beach. He was tanned, agile, and charming, so he got attention from the opposite sex. It may have been at this time that he evolved his aesthetic trademark. In a few years he would earn fame by positioning nubile young women with a shoulder toward the camera, chin tucked into it, the fabric of a blouse sliding downward, liquid eyes looking seductively into the lens. This image was enhanced by the unprecedented use of "bounce light." A bright light spilling onto the woman's head and in front of her would "bounce" upward into her eyes, making them glisten and shimmer. Perhaps Hurrell experienced an epiphany one day while seducing a woman in dappled sunlight next to a reflecting pool. Or perhaps it was during a camera experiment that the sun shone through his skylight and created a hitherto unnoticed effect. However it occurred, it confirmed his status as an artist and as a romantic. A fleeting image became an *idée fixe*, and Hurrell's first period of artistic development began.

Hurrell was flirting, even with the married women who visited Laguna. One flirtation led to a secret dalliance. He could not be seen bringing a married woman to his cottage, so she would meet him in a nearby eucalyptus grove. The all-clear signal was a toot from her auto horn. On Monday, March 1, 1926, Hurrell was told to expect such a cue, but first he had to drive his Model T Ford to Pasadena and photograph the guests at a California Art Club gala hosted by sculptor and president Julia Bracken Wendt. Hurrell had been busy all weekend, packing his belongings. Nick Isch was selling the property for a housing development, and the Paint Box was on blocks, soon to be moved. No matter; Hurrell had found another dwelling. The Paint Box's electricity had been turned off, so Hurrell lit candles when he returned from Pasadena to process his film. It was almost midnight when he heard the signal from the grove. He left the candles guttering in the shack and

ran down the hill. After a few minutes there, he heard the siren of a fire truck. The Paint Box was in flames. A volunteer fireman tried to stop Hurrell from going into the shack, but he was drunk and he put his fist through a window. He managed to save his Verito lens, a tripod, and his camera, but he saw his negatives and prints burn.

Hurrell soon recovered. Florence Barnes referred friends, and local shops put his work in their windows. "Laguna Beach was such a small town then," said Hurrell, "but it got so many people from out of town. They came from the inland cities such as Riverside, Santa Ana, Fullerton, and from Los Angeles, too. In the summer the society crowd were running up and down the streets and looking for interesting things, and my pictures of artists hanging in a place downtown would attract attention." The increased work bought him oil paint and even the time to use it.

In late March Hurrell attended the opening of the Wendt show at Stendahl's, and, while there, dined for the first time at the Musso and Frank Grill on Hollywood Boulevard. He liked both the fare and the ambience. In May 1927 Hollywood came to Laguna. Metro-Goldwyn-Mayer was filming the 1903 novel *Romance*, a pirate story written by Ford Madox Ford and Joseph Conrad. This silent film was the latest vehicle for the Mexican-born movie star Ramon Novarro. At twenty-eight, Novarro was basking in the stupendous success of M-G-M's *Ben-Hur: A Tale of the Christ*. During the day, he acted his scenes for *Romance* in sets built to look like a fishing village in 1820s Cuba. At night Florence Barnes showed him the best side of Laguna. The epicene actor and the moon-faced socialite became friends.

At one point while the Cuban sets were standing, Hurrell got permission to set up a camera on the beach and shoot a self-portrait. The arrangements were probably facilitated by his friendship with Florence Barnes, and by hers with Novarro. This was Hurrell's first connection with Hollywood, and it yielded a handsome, picturesque portrait.

In 1927 America was booming. Speculation and spending were running neck and neck, yet Laguna Beach was losing its tourist trade. Hurrell found himself in Los

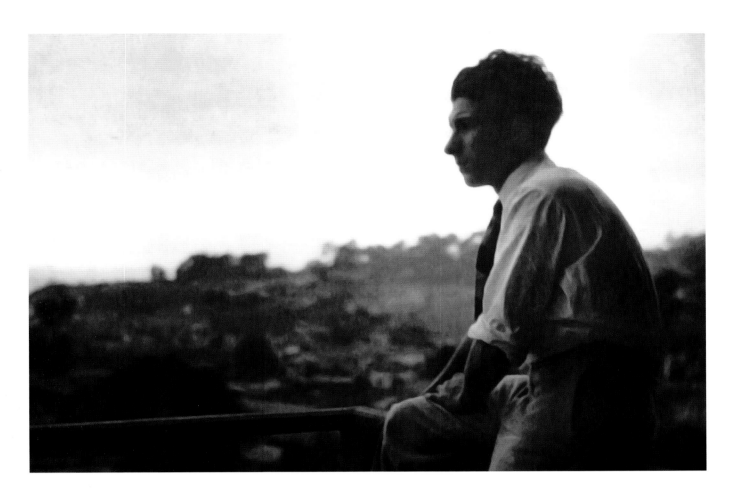

Angeles more often, photographing socialites. "Pretty soon I was shooting all kinds of social pictures," he recalled. "I was being asked if I would come to Redlands or Riverside or someplace, to shoot their family and that sort of thing." There was a growing art market in Los Angeles. Hurrell had met Earl Stendahl in his main gallery, which was located in the Ambassador Hotel on Wilshire Boulevard. A mile east, the Granada Shoppes and Studios, a complex of artists' lofts and galleries, was nearing completion. The prospect of selling art in a big city intrigued Hurrell. He had been living in a small community for two years. "I was bored with Laguna," he said. In December he decided to leave the art colony and enter the art world.

ABOVE: Hurrell at twenty-one had the intensity and resolve of an unknown artist.

THE GRANADA SHOPPES
AND STUDIOS

On January 1, 1928, George Hurrell took residence in the newly opened Granada Shoppes and Studios, which were located at 672 South La Fayette Park Place. What did the young artist expect to find in Los Angeles that was not in Chicago or Laguna Beach? There were certainly more people. The population had doubled since 1920, cresting at a million. There were also more automobiles. The city was a sprawling grid designed for the auto, and Hurrell was living half a block from the most-driven street on earth, Wilshire Boulevard. When he motored the six miles to Musso and Frank, he passed the manicured gardens of La Fayette Park, the Georgian-Revival Town House, the whimsical Brown Derby restaurant, and the elegant Ambassador Hotel. He had moved to an exciting place at an opportune time. Los Angeles was booming. Wherever one turned, there was something to beguile the eye, intrigue the mind, or provoke the senses.

Not everyone was impressed. New York playwrights and European literati thought Los Angeles a cultural wasteland, a cow town without cows. Hurrell knew otherwise. He had only to look at the event listings in the *Herald* or the *Examiner* to see what was available: exhibits, lectures, classes. Many of them were in the Westlake District, where he was living. Three blocks away, at the west end of Westlake Park, was the Otis Art Institute. Six blocks away was the Chouinard School of Art. Two miles east was the Biltmore Theatre, where stars such as Katharine Cornell brought their Broadway successes. Three miles south, in

Exposition Park, was the Los Angeles County Museum of History, Science, and Art, which featured a sculpture by Julia Bracken Wendt. Her California Art Club was headquartered in Aline Barnsdall's Hollyhock House on Hollywood Boulevard, and for women there were the Fine Arts Club, the West Coast Arts Group, and the Ebell Club.

There were thirty galleries in greater Los Angeles, including several on Wilshire. This path to the Pacific was known variously as the "Fabulous Boulevard," the "Champs-Élysées of the West," and the "Fifth Avenue of Los Angeles." It was a meeting place for oil millionaires and movie moguls, where Edwardian gentility met Jazz-Age inanity. At streetcar stops, men wearing hats removed them to greet women wearing gloves. A man was addressed as "sir," a woman as "madame." Inside apartments such as the Arcady and the Bryson, telephone conversations were limited to making plans; tying up the line with gossip was déclassé. In Westlake, the keynote

OPPOSITE: George Hurrell's first portrait of a Hollywood movie star took place in early 1929, when Ramon Novarro came to the Granada Shoppes and Studios.

OVERLEAF: The Granada Shoppes and Studios welcomed George Hurrell in early 1928. The complex was designed by former journalist Franklin Harper to suggest a street of storefronts in Spain. It was built in the arty Westlake District, home of numerous lofts, galleries, and art schools.

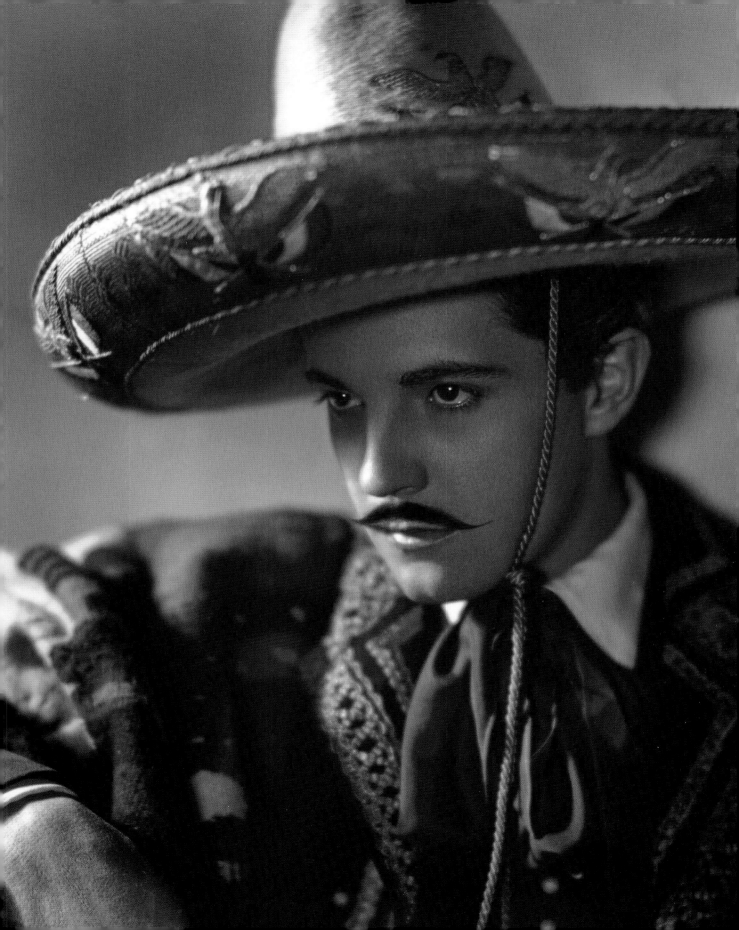

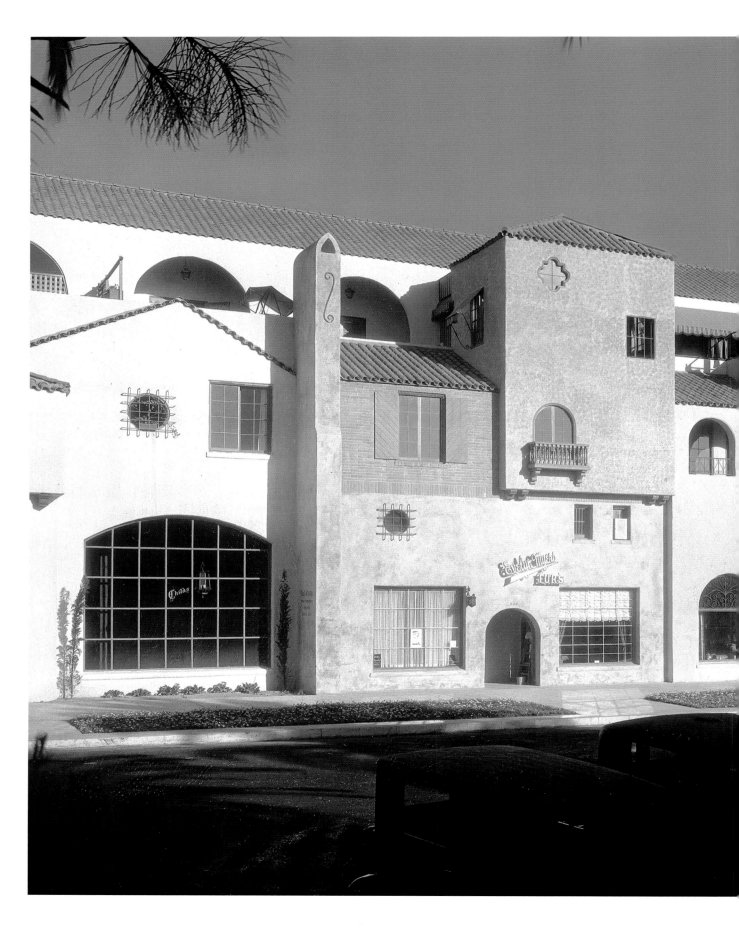

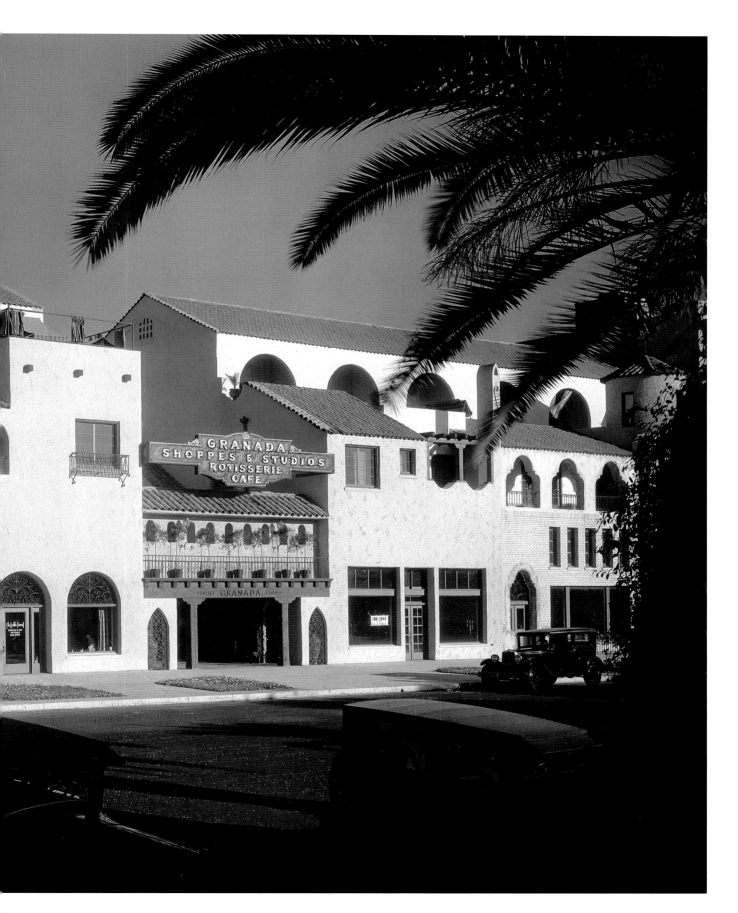

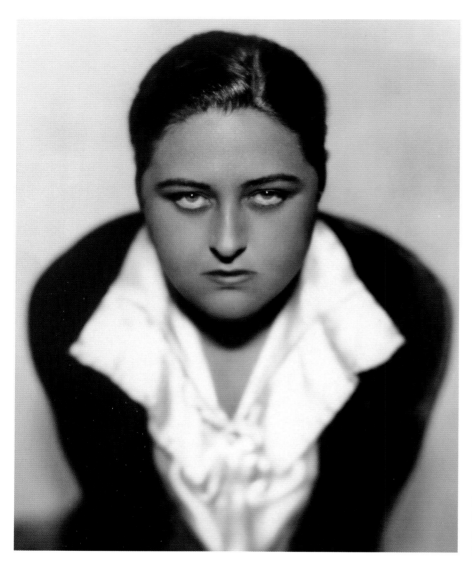

LEFT: Hurrell wanted Florence Barnes to have a pleasing portrait. No one was more pleased than she.

was graciousness. In the cafés that dotted Seventh Street, though, there was smoking, drinking, and racism. It was not uncommon to read of fisticuffs. But four-letter words were never used in public, even in the heat of anger. Los Angeles strove to be a decent place. The most decent, gracious, and artistic place of all was Hurrell's new residence.

The Granada Shoppes and Studios were designed by Franklin Harper to evoke a street in Spain. Four rectangular structures were linked by an open-air promenade, and twenty-four uniquely designed doorways fronted two-level lofts, some of which had Juliet balconies overlooking a salon. Harper told the *Los Angeles Times* that the design was "entirely new to Los Angeles, although incorporating apartments with shops and artists' studios is similar to the design of specialty shops in Europe." Hurrell was leasing Number Nine, which was located at the ground level. It had entrances from both a terra-cotta esplanade and a stained-glass-enclosed patio, which he shared with the Granada Café, where dinner could be purchased for $1.50 and enjoyed in the "colorful beauty of the court, its balconies, and arcaded wall, something different in the heart

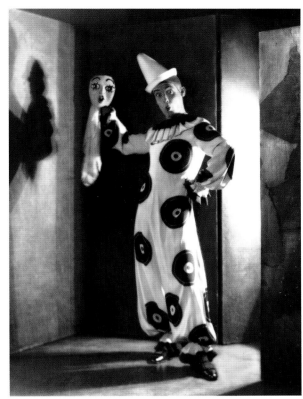

of the Wilshire District." This was not quite true, since Spanish Revival was all the rage in 1928.

On October 20, Hurrell participated in the grand opening festival of the Granada. Each suite had an open house with an "Old California Fiesta" theme. Neighboring tenants included Inga Petterson; Tiny Tots' Toggery; Madame Sylvia, Modiste; Oril Wing, book reviewer; Myra Ketcham, Sufi Movement Center; Mrs. Ella Pepworth, Vegetarian Tea Center; and Charles L. Shepard, pianist coach. The most prominent tenant was Mrs. Ida Koverman, who as secretary of the Republican Central Committee was working to get Herbert Hoover

ABOVE LEFT TO RIGHT: This was one of the characters Novarro essayed in a series of portrait sessions with Hurrell in 1929.

At Hurrell's studio Novarro posed in characters and costumes that his studio would never have approved.

elected to the presidency. She was also an unofficial adviser to Louis B. Mayer, president of M-G-M.

The fiesta, with its music, dancing, and fashion show, was intended to bring customers to the building. Hurrell had not been idle. Using two recently acquired arc lights, he had photographed a group of ballet students, an American stage actress named Irene Homer, a British actress named Mary Forbes (sister of the M-G-M actor Ralph Forbes), and prominent politicians. "The Dockweilers were a famous social family," said Hurrell. "I shot them, their weddings, their kids." Still, he needed more work, and Florence Barnes was not around to refer clients.

After coming to a crossroads in her personal life, Barnes had embarked on a series of adventures. It began when Barnes lost interest in helping her husband at the church. He was becoming pompous and sententious. Worse, she was unable to accommodate her maternal duties. In late 1927 she impulsively donned men's

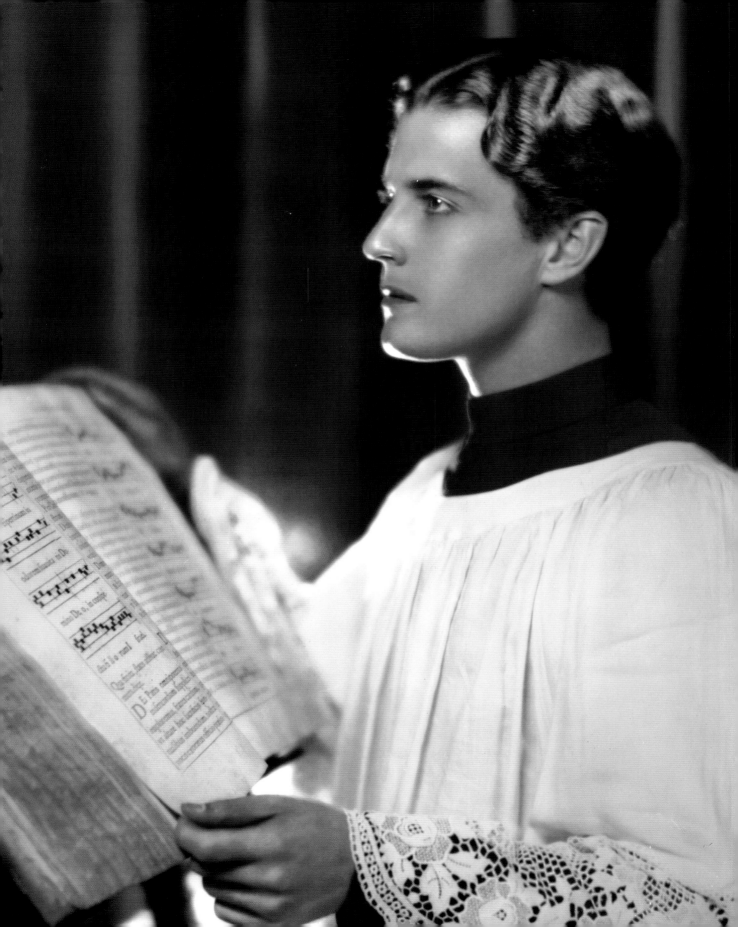

clothing, joined a few friends in San Pedro, and, pretending to be a man, signed up as crew on a banana boat bound for Peru. She wanted to go to the ruins at Machu Picchu, where she intended to think through her problems and decide what to do about her marriage. Before long, she and her friends discovered that the ship was running guns to revolutionaries. When it docked in San Blas, Mexico, it was taken over by townspeople who turned it into a floating fortress. While the town's money was guarded by soldiers, Barnes and her friends were sequestered as hostages. After two harrowing days, Barnes made a daring escape with the ship's helmsman, a Stanford-educated fisheries researcher named George Roger Chute. They traveled hundreds of miles to safety—on a horse, a burro, and on foot. When Barnes returned to California six months later, she looked like a native of Mexico. "Pancho" Barnes was born.

In July 1928 Hurrell heard from Barnes; this time it was she who needed help from him. She had taken flying lessons and wanted a license, but an official at the National Aeronautic Association would not process her application if it showed she was a woman. The inflexible official was named Orville Wright. Yes, *that* Orville Wright. Twenty-five years after his historic flight, he was handling applications and believed that aviation was too dangerous for the fair sex. If a damsel were to be injured while flying, why, the future of aviation could be imperiled! Could Hurrell make Pancho's application photo look like a man's? He could and he did, right down to the engine grease under her fingernails. Pancho got her application approved and she got her license. She then installed a landing strip at Dos Rocas and bought a Travel Air biplane. Hurrell insisted on doing another session so that she could have a more appealing portrait. The retakes were made at Dos Rocas. He got his way. Pancho looked gorgeous, like a purring *houri*. Once she got her wings, though, she was hard to find.

OPPOSITE: When Hurrell photographed Novarro in a cassock and surplice, he brought a reverence to his work that bespoke his own years as an altar boy. These distinctly un-Hollywood images were Hurrell's entrée to filmdom. The artist did not own a complete set of these photographs, so they remained unseen for many years.

While waiting for the next client to enter the Granada Shoppes, Hurrell picked up his palette and brush, and then something happened. "That slow pace got to me," he said. "I saw that I'd have to get into that routine again, of doing things so much slower, and I found that I didn't have the patience." His rat-a-tat temperament was better suited to photography, so he studied it harder than ever, analyzing the work published in *Vogue* and *Vanity Fair*. There were exemplary portraits by James Abbe, Nickolas Muray, and Cecil Beaton, but one artist surpassed them all. Edward Steichen was chief photographer at Condé Nast publications because *Vanity Fair*'s editor Frank Crowninshield thought he was the greatest portrait photographer in the world. "A scientist and a speculative philosopher stand back of Steichen's best pictures," said poet Carl Sandburg. "They will not yield their meaning and essence on the first look nor the thousandth." In August 1928 Steichen came to Los Angeles to photograph Greta Garbo and John Gilbert for *Vanity Fair*. On August 6 he took his gear to the M-G-M stage where Clarence Brown was directing them in *A Woman of Affairs*, a sanitized film version of Michael Arlen's scandalous novel *The Green Hat*. The scene being filmed was an inquest, so both Garbo and Gilbert were in black. Steichen made his shots of the famous duo and was then given a challenging six minutes to photograph Garbo. The two images he captured are among his most famous.

Hurrell was doing copy work for Leon Gordon, another Earl Stendahl painter, when he heard that Steichen needed film processed. He was shooting photos of cigarette lighters for the Douglass Lighter Company, and there was no darkroom in his suite at the Ambassador. "Steichen was sort of an ideal," said Hurrell. "To me he was *the* great commercial photographer. I used to subscribe to *Vogue* and devour every picture he shot." In short order, Steichen was standing behind Hurrell in his tiny, pitch-black darkroom as Hurrell gently agitated sheets of 4x5 film in a developing tray. "I apologized for the size of my darkroom," said Hurrell. "It had been a lavatory."

"Some of the best films I ever made I developed under a rug," responded Steichen.

Hurrell showed the master some of his recent work. "His attempt to admire some of my prints was indeed a

kindness," said Hurrell, who told Steichen that he some-
times had trouble during a sitting. His tripod tended to fly
out from under the camera.

"Never let your subject know when you are baffled,"
Steichen counseled him. "Shoot the film anyway. Then
make the change on your next shot. But be the master of
the situation at all costs."

When the film had dried and Steichen was leaving, he
told Hurrell that Douglass was paying $1,500 for a total of
three prints. [Roughly $45,000 in 2013.] After Steichen
left, Hurrell wondered how much money a photographer
could make if he worked for corporate clients—and had
a name.

By January 1929 Pancho Barnes had resolved her mar-
ital crisis, was living her own life, and was readying herself
for the first all-woman air race. She was also spending a
good deal of time with Ramon Novarro, acting as both
friend and adviser. He had been in Tahiti for two months
making what would be his last silent film, *The Pagan*. With
talking films overtaking the silents, he was anxious about
his Mexican accent. His next picture would be a talkie,
The Battle of the Ladies (later renamed *Devil-May-Care*).
If his fans decided that his voice did not match the image
he had created in silents, he could lose his career. For
someone making $75,000 per film, this was a frightening
thought. He did have a backup plan. His new contract
allowed him to take time off for concerts. He was planning
a tour of Europe in which he would sing excerpts from
operas. If his talkie debut was not a success, he could have
a singing career.

With this in mind, Novarro began rehearsing his
repertoire in El Teatro Intimo, the small theater he had
built in his mansion at 2265 West Twenty-Second Street in
Los Angeles. He had costumes and wigs made so he could
portray operatic characters such as Parsifal and Tonio, and
though he needed photos of himself in these costumes, it
would be impolitic to stroll into M-G-M's portrait gallery
with this ensemble. The publicity department would not
pay for the photographs, and he had not finalized concert
dates. He was pondering this when Pancho Barnes showed
him the portraits Hurrell had made of her. It was unusual
for a motion-picture star to patronize a photographer

outside his company, but Novarro's enthusiasm for
Hurrell's work overcame any qualms he might have had.
He would go to Hurrell's studio for a portrait but would
tell no one at Metro.

Once again Pancho Barnes was helping George Hurrell.
This time was different. Although Hurrell was unimpressed
by "important" people, this was an opportunity to make
money. And yet his excitement was giving way to doubt. The
night before the session he sat alone in his atelier, slightly
deflated. The world-famous Novarro had been photo-
graphed in richly appointed salons. What did this humble
studio have to offer? A beat-up view camera, a rickety tripod,
a used Verito lens, and two battered arc lights of the type
used to simulate sunlight shining through a window on a
movie set. His shooting area was less than 300 square feet,
so there was little room for props. For a background he
used the stippled plaster wall or a three-paneled screen. For
film he was using outdated Eastman Commercial Ortho.
Panchromatic film had become available a year earlier, but
he had gotten a deal on some old stock from a wholesaler.
Panchromatic film was the preferred stock for portraits
because it "saw" the entire spectrum; orthochromatic film
could not see red and saw too much blue. This made his
subjects look burnished and exotic, which was what he
wanted, and what they were learning to like. In many cases,
they liked it because they liked him.

Hurrell was something of a mystery to his family and
friends. He personified the duality of the Gemini twins,
bouncing between gregarious brightness and solitary angst.
His moodiness could be off-putting, but when he projected
good will, his eccentric appeal charmed male and female,
old and young alike. Hurrell would later describe himself
as "this hearty young man with too much energy, ready
for anything."

In the giddy 1920s, all the "bright young things"
had nicknames. One afternoon, "Pancho" left "Pete"
(Novarro) and his costumes with "Georgie." She then
headed for Clover Field in Santa Monica to prepare
for the air races that would be held in a month. Hurrell
directed Novarro to the upstairs area, which, like the
European atelier, was small and had a window overlook-
ing the studio. While the pleasant young man donned

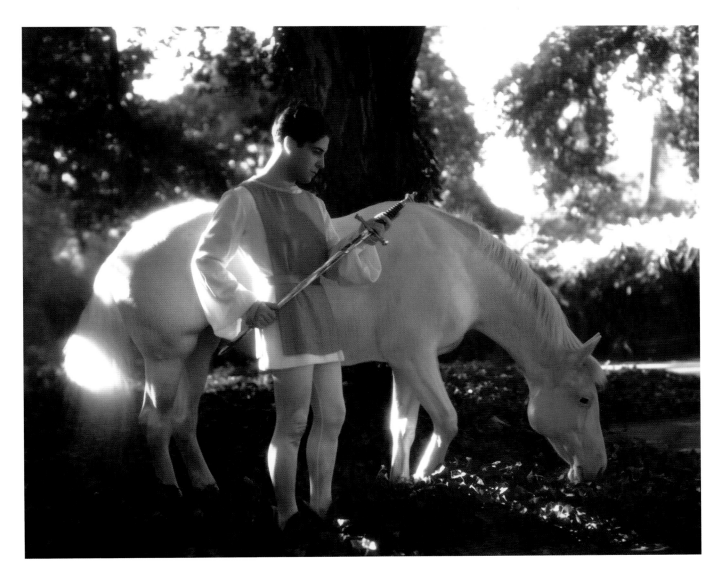

his first costume, Hurrell wound up his hand-cranked Victrola and played a record from his proliferating jazz collection. Novarro came downstairs in a black-and-silver *charro* costume. "Everyone takes me for a Spaniard," said Novarro, "but I was born in Durango, Mexico. My real name is José Ramón Gil Samaniego." He smiled and the mustache glued to his upper lip with spirit gum started to fall off. He thought it might look odd. Hurrell told him not to worry. He would fix it with retouching.

ABOVE: Hurrell made this study of Novarro as Parsifal in San Marino in the summer of 1929.

Novarro sat down and stared at the camera with a blank expression. Hurrell fired up the arc lights, and, as they flickered and buzzed, he stepped forward to analyze Novarro's face. "Pete had photographically perfect features," recalled Hurrell. "And he *could* face my camera with a blank expression." Novarro was an accomplished actor, able to convey nuances of emotion with slight changes in expression. Still, he was out of sympathy with Hurrell's music. "I'm old-fashioned in an age of jazz, gin, and jitters," Novarro said. Hurrell put a classical recording on the Victrola. "Pete became more responsive," said Hurrell. "After the fourth or fifth exposure, I knew I was catching something appealing." As Hurrell played

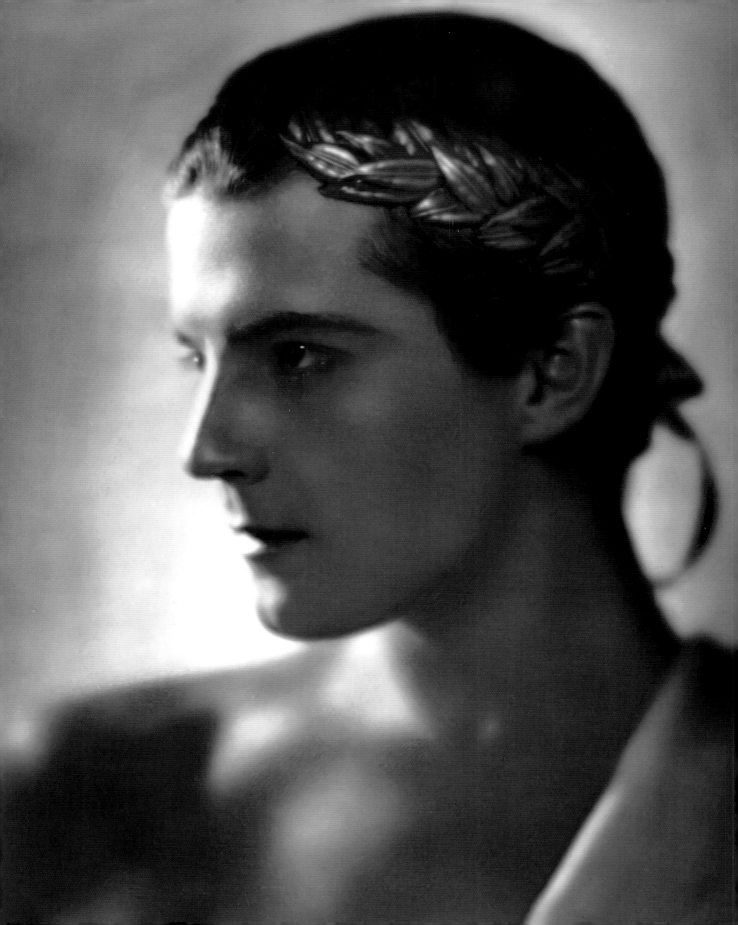

with light and shadow, he experienced the liberating pleasure of working with a gifted model. "I was really inspired," he said. He was so inspired that when Barnes came back for Novarro, she had to wait for the session to wind down.

Novarro returned to the studio two days later for the "proof pass," which can be an anxious moment for both subject and photographer. Even unretouched, the proofs were impressive. "You have caught my moods exactly," he told Hurrell. "You have revealed what I am inside." Novarro marked the proofs for retouching, an unusual skill for an actor at the time, and then scheduled a second sitting. And a third. "Every night we would take stills of one costume," recalled Novarro. "And we had some really stunning photographs." Hurrell shot him as characters from opera and from European history. Then the project was interrupted. On February 22, 1929, Novarro lost his brother to cancer. José Samaniego was twenty-four. Ironically, on the same day, at the dedication of the Grand Central Air Terminal in Glendale, Florence Barnes won the first all-woman air race, coming in twenty-four minutes ahead of her competitors. Because of Novarro's bereavement, there was no celebration.

Novarro promised to resume the sessions with Hurrell after he returned from his first concert tour. He sailed for Europe in March and got as far as Berlin before grief took its toll. He was unable to perform. When he returned home in June, he secluded himself in a religious retreat at Loyola College. Not coincidentally, when he resumed shooting with Hurrell, the photos had a religious theme. Hurrell shot one session at Novarro's home. While there, he noted the actor's devotion to his family and the religious statuary in his quarters. Although Novarro ran with a fast crowd, he had another side; at home he was devout and introspective. Their last session took place on the grounds of Barnes's San Marino estate. Novarro posed as Parsifal, and Barnes's

horse, Lightning, stood in for his mysterious steed. When Hurrell and Novarro showed Barnes the finished print, she exclaimed: "My God, George! Even the horse looks glamorous!"

Novarro was friendly with the German director F. W. Murnau, who had won acclaim for *The Last Laugh* and *Sunrise*. "So I went to Murnau," said Novarro. "I had, let's say, about fifty really first-class stills by George." Murnau went through them, making stacks.

"Fine, fine, fine, fine," said Murnau slowly. But when he finished, he had selected only five photographs for Novarro to use.

"Oh, Fred!" said Novarro. "I'm spending about a thousand dollars on this."

"Ramon, these are very fine photographic studies, but they are not *you*," said Murnau. "Your value at the box office is *you*. If you are going to act a Mexican drunk or something like that, and nobody knows it's you, then it's not worth anything."

Novarro was unconvinced. He took the photographs to M-G-M's publicity department. The reaction he got there was quite different. Instead of chiding him for using an outside photographer, the publicist got on the phone and arranged for a special spread in the rotogravure section of the *Los Angeles Times*. "Novarro with Impressions" ran on October 20, 1929, duly credited: "Photos by Hurrell." A caption stated that Novarro was "planning to desert the cinema for the operatic stage." In reality, a concert career was beginning to look redundant for Novarro. He had created a hit with his performance of "The Pagan Love Song" on the soundtrack of the otherwise silent film *The Pagan* and had sung numerous songs in the recently completed *Devil-May-Care*. His talkie debut was a great success. Novarro continued showing his portraits to other stars. For Hurrell, a satisfied customer would be the best advertising, and more.

OPPOSITE: Novarro asked Hurrell to name this portrait "The New Orpheus." Fifty-two years later, a sale of this image set an art-world record.

"WHEN MY BABY SMILES AT ME"

Ramon Novarro had a long-standing friendship with Norma Shearer. She was on the set of her latest film, *Their Own Desire*, when he showed her his Hurrell images. "Why, Ramon!" she exclaimed. "You've never been photographed like *this* before!"

When it came to image, Shearer was astute. She was known for her delicate beauty and patrician profile. It was not generally known that she had worked for years to match the rest of her appearance to those attributes. When she was starting out in New York, she suffered painful rejections because of her "odd looks." In 1920 the Broadway showman Florenz Ziegfeld gave her the once-over and then showed her the door. That same year the pioneer moviemaker David Wark Griffith told her that her eyes were too blue to register on ortho film. "She will never forget that horrible moment," said her husband, Irving Thalberg, "when D. W. Griffith told her to go home and forget about pictures."

Shearer persevered, made films, and eventually came to Los Angeles. She signed with Louis B. Mayer Productions on February 28, 1923. Within a week, the bugaboo of her "odd looks" returned. Her first screen test was judged a failure. Mayer was about to cancel Shearer's contract when a thoughtful cameraman took the time to light her properly. Ernest Palmer's expertise made all the difference. Shearer began to study lighting and angles, insisted on certain cameramen, and went on to compete with beauties such as Eleanor Boardman, Carmel Myers, and Aileen Pringle.

In 1924 Mayer's company merged with Metro Pictures and the Goldwyn Company to become Metro-Goldwyn-Mayer. By the end of 1925 Shearer was an M-G-M star, and one of the top five box-office draws every year thereafter. In 1927 she married Irving Grant Thalberg, M-G-M's vice president in charge of production. After a series of silent comedies, Shearer made her talkie debut in a drama, *The Trial of Mary Dugan*. Her voice recorded well, but she remained sensitive about her figure, her legs, and especially about her eyes. She suffered from a condition known as strabismus, which causes a misalignment of the eyes when focused at certain distances or in certain conditions, such as muscle fatigue. She exercised and practiced in a mirror to control the problem, but relied on cameramen such as William Daniels to make her look good on the screen. In the portrait gallery, she was not so fortunate.

Ruth Harriet Louise was M-G-M's head portrait photographer. She was twenty-five, beautiful, and inventive. Her studies of Greta Garbo were exceptional, but her work could also be prosaic and perfunctory. Her usual practice was better suited to a firing squad than to a portrait gallery.

OPPOSITE: Norma Shearer's portentous sitting began with images of her as a modern-day Madonna, even though she had no child of her own.

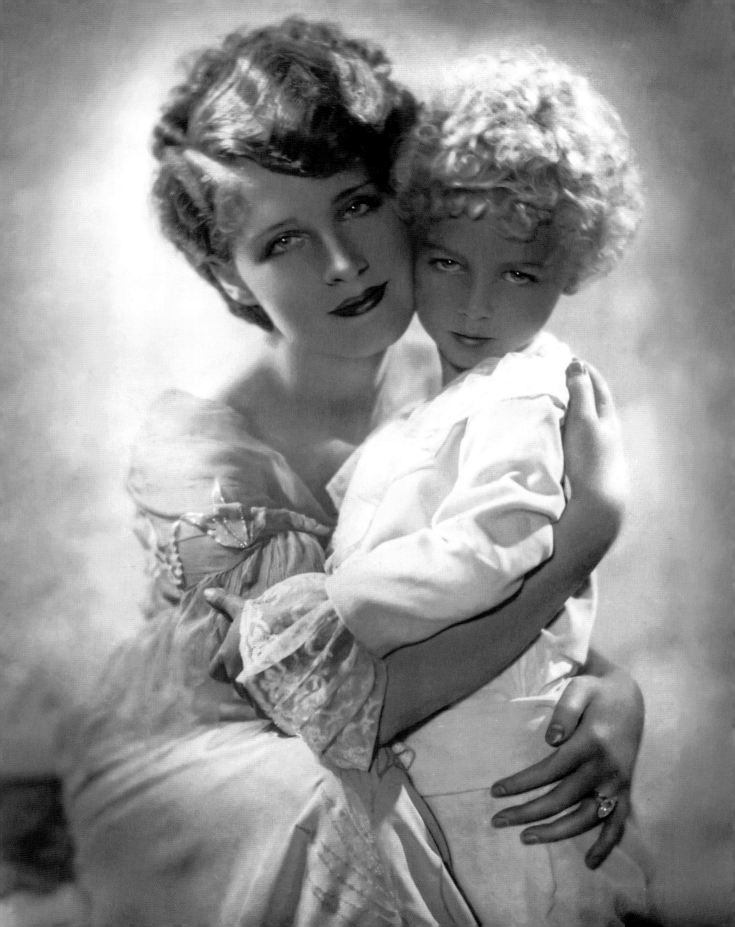

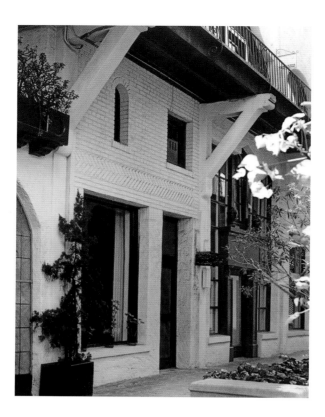

She put her subjects against a blank wall and shot them with flat lighting. She rarely moved the camera closer than mid-length. After processing the negative, she would have it retouched and printed—as was the custom—but would then deviate from accepted practice by shooting a copy negative of only the subject's head and shoulders. This copy negative became the official image. Predictably, the result was grainy, muddy, and marred by obvious retouching strokes. Far too many M-G-M stars had portraits that looked like this. Shearer suffered the worst because Louise did nothing to compensate for her eye problem. When Shearer complained to her powerful husband, he turned to her and said: "You wanted to be a motion-picture star?"

Fortunately, Shearer's popularity was not affected. She was strikingly beautiful and a polished actress. She excelled at portrayals of intelligent, honorable women caught in compromising circumstances. In her new film, *Their Own Desire*, she was playing a girl conflicted by her father's affair with her boyfriend's mother. Shearer had turned twenty-seven on August 10 and wanted something

stronger. "You can't really be interesting as a young girl," she said later, "or outstanding as an ingénue." Thalberg had purchased the novel *Ex-Wife* by Ursula Parrott, the story of a young career woman who fights the double standard after discovering her husband's infidelity. Shearer set her sights on the property. "I knew that M-G-M was considering borrowing someone from another lot to play it," she said. "I was there on the lot, under contract, and I felt in my heart I could do it. But Irving laughed at me when I told him. It was so utterly different from the type of thing with which I'd been associated. I was determined to prove to him that it wasn't ridiculous."

In a way, Shearer was a victim of her own publicity. She was constantly referred to as "gracious Norma Shearer" or the "First Lady of M-G-M." With that kind of press, she

ABOVE: George Hurrell would remember Suite Number Nine in the Granada Buildings as "tiny," but it was roomy and even had a side entrance with large double doors for loading furniture.

could hardly be expected to play a torch bearer of the single standard. One day her maid, Ursula, caught her reading *Ex-Wife*. "Oh, Miss Shearer," she said. "You don't want to play a part like that. She's almost a *bad woman*!" The next thing Shearer read was a listing in the Buyers Guide of the September 1929 telephone directory: "George E. Hurrell, 672 S La Fayette Pk. Pl.: DRexel-7663."

In late October 1929, after his Novarro photos had appeared in the *Los Angeles Times*, Hurrell received a call from Pete Smith, head of the publicity department at M-G-M. Hurrell could hardly believe what he was hearing. Norma Shearer wanted him to make portraits of her. "I was only too glad to do it," he recalled, "and it was important, except that I didn't care particularly. I wasn't ambitious in that way. I wanted to be a painter." Hurrell had recently shot Millard Sheets, who was barely out of Chouinard but was getting rave reviews for his first show of paintings, so Hurrell was once again thinking about his art. Smith pressed Hurrell about his schedule, and a date was set. Hurrell went out to buy new gramophone records.

A few days later, Hurrell looked out his front window and saw a canary-yellow Rolls-Royce parking in front of the Granada Shoppes and Studios. Shearer emerged, followed by Ursula, who was carrying an armload of outfits. Next came a hairdresser, a child model and his mother, and a publicist who was perplexed by this expedition; movie stars did not go to unknown photographers. "Norma came with a retinue," recalled Hurrell. "Even her chauffeur was carrying suitcases. And then I was surprised to see workmen carrying boudoir furniture. She'd brought a van full of it from the studio warehouse. All of these folks lined up outside."

"Welcome to my studio," said Hurrell. "Such as it is!" Shearer made a grand entrance into Number Nine, gave him a very firm handshake, and sat him down. "I loved your pictures of Mr. Novarro," she said. "Now there is a part in my husband's new picture that I must have. But he won't give me the part because he thinks I'm not 'glamorous' enough."

What Shearer did not say was that Thalberg's attitude was the latest in a series of hurts that had her wondering about the future of their marriage. He insisted that she live with him at his parents' home in Beverly Hills, even though he was wealthy and could afford to live anywhere. His domineering, overprotective mother made him and Shearer sleep in separate bedrooms. Shearer had put up with this for the sake of her marriage and to avoid any stress that might endanger Thalberg's fragile health, but she was beginning to feel slighted. When he sent a bouquet to former girlfriend Bessie Love, Shearer grew so angry that she spent the night at her mother's. Making these photos would send a message to Irving. Hurrell thought to himself that here was "a tough little gal, fighting in her own way to get the part."

"Can you turn me into a siren?" she asked.

"I'll try," Hurrell answered. He looked at the clothes Shearer had brought, consulted with the hairdresser, analyzed Shearer's face and hair, and then clarified what was expected of him. "The idea was to get her looking real wicked and siren-like," he said. "She wasn't really that type, you know. She didn't have any of it." At least that was his impression as he watched Shearer and her hairdresser climb the stairs to the dressing room.

"I was pretty nervous," he recalled. He had less at stake than Shearer did. "A great deal depended on that sitting, but if Norma was nervous, there was nothing to indicate it." She came downstairs with her hair slightly fuller, and he shot poses of her with the boy and then sent him and his mother off. Once again, Shearer climbed the stairs, and the hairdresser followed. Hurrell asked her to change Shearer's hair again. He thought her forehead made her look intellectual, so he suggested a down-over-the-forehead sweep, cascading over one eye. "It was my idea to get her hair bushy," recalled Hurrell. "She never wore it that way."

A half hour passed. Hurrell played record after record. He was just putting on Ted Lewis's "When My Baby Smiles at Me" when he looked up the stairway. Shearer was standing on the balcony, clad in a gold-brocaded dressing gown, her hair gelled to unruly perfection. She paused for a moment and descended the stairs. She walked over to the screen, and as the wraparound garment revealed a knee, she said, "I'm afraid my legs are not my best feature, Mr. Hurrell." As he assured her that he could find the right angle and pose, she skillfully found both. "And I realized

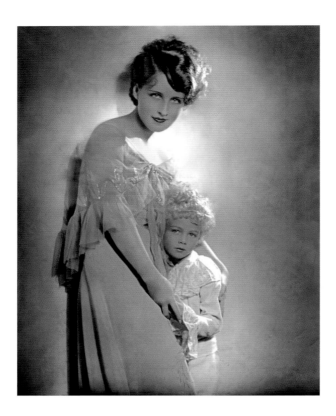

that she'd learned to handle all her faults brilliantly," he said. Shearer took a breath and concentrated on the Verito lens. Hurrell could see that her eyes did not quite line up, a symptom of the muscle problem. Then he saw her correct it. "She knew how to focus just beyond what she was supposed to be looking at," said Hurrell. "She looked through the lens, to something right past it."

A technical adjustment was needed. In order to get both Shearer's legs and face in focus, Hurrell had to close the Verito down to f/11. This necessitated more light, so he yanked the protective screens from the lights. Tiny particles of dust began to emanate from the bluish-white glare of the buzzing carbon arcs. Shearer squinted momentarily, but faced the camera uncomplaining. Hurrell got his f/32, and Shearer had to hold still for only two seconds, a trifle compared to what she had endured as a New York model in 1920.

Hurrell started to sing with the record: "And when my baby smiles at me / There's such a wonderful light in her eyes." Shearer stiffened and questioned Hurrell's choice

of music. "She didn't like it," said Hurrell. "She couldn't understand why I was playing it because it had no connection with getting a sexy mood particularly. I explained that *I* needed it." This was shrewd, since this regal young woman was slightly ill at ease. Before she could object further, Hurrell nervously danced right into the tripod and knocked over his camera. The lens didn't break, but the ground-glass viewing back did. He danced off, returned with a fresh one, and mentally thanked Edward Steichen for his counsel. "Always be the master of the situation," the master had said. Hurrell continued to sing. "The kind

ABOVE: This was not the kind of portrait for which Shearer had engaged Hurrell, but it was later distributed to magazines by the M-G-M publicity department.

OPPOSITE: At first Shearer was perplexed by the photographer who sang along with his Victrola and danced around his studio, but when his antics became silly, she began to enjoy the experience.

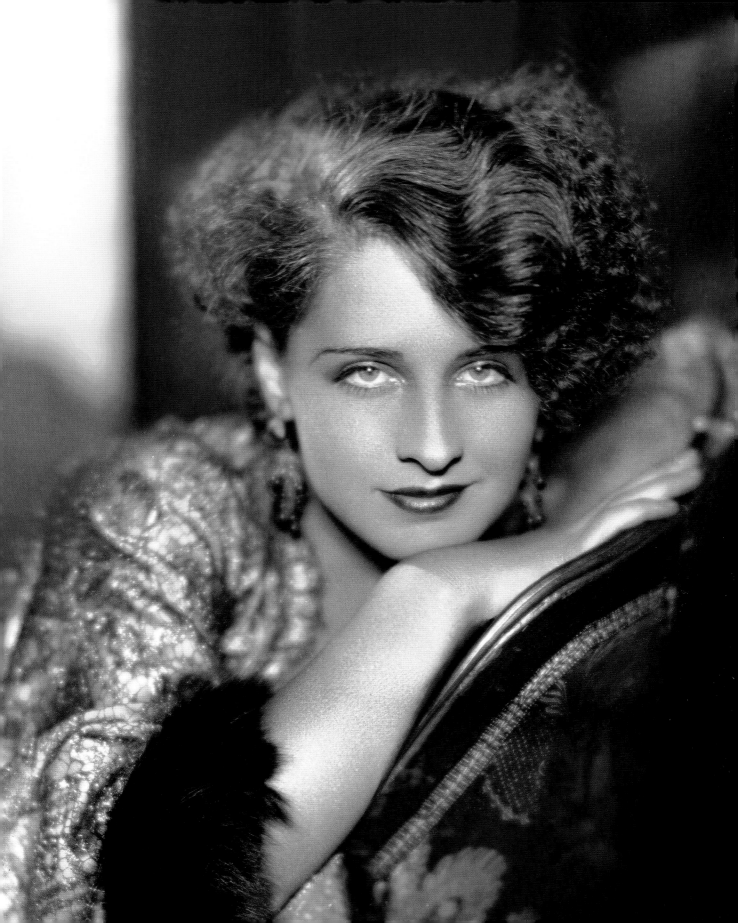

of light that means just love / The kind of love that brings sweet harmony."

The Victrola started to wind down, and instead of winding it again, Hurrell mimicked the bleary voice. Shearer stared, then shook her head, then grinned. "She laughed," said Hurrell. "I could see that she was starting to enjoy herself." He was master of the situation. Hurrell changed records, asked the musical question "Is Everbody Happy?" and continued shooting. By the time he finished, they had worked together for four hours.

The Rolls-Royce was barely onto Wilshire Boulevard when Hurrell locked himself in his darkroom and attacked the first sheets of film. "I'd used more than sixty plates," he recalled. "That impressed me considerably and seemed the height of lavishness." It was certainly a full day's work of processing; it took him until well into the evening to finish. As the negatives washed, his singing echoed in the empty atelier. "I hung the films around the studio—on tables, the wrought-iron staircase, anywhere I could shove a push pin—so the film could dangle and dry. When the last film was up, I went out to celebrate." Hurrell walked around the corner to the Silver Platter Grill on Seventh and Rampart Streets, and he got drunk.

"I didn't feel so good the next day," said Hurrell, "but I sent red proofs [impermanent contact prints] out to M-G-M, then sat by the telephone." Shearer did not feel well either. She was suffering from "klieg eyes," the common name for actinic conjunctivitis, which is an inflammation caused by prolonged exposure to ultraviolet rays. When Hurrell had impulsively pulled the screens off the Kliegl Bros. lights, he had given his subject an affliction that took her back to a painful experience in 1920s New York.

Shearer and her sister, Athole, woke up in the middle of the night, screaming with pain. They had worked the previous day as extras on a Marion Davies film, *The Restless Sex*, and had sat next to a bank of unscreened klieg lights. "We started stumbling around the room," recalled Shearer. "When we tried to open our eyes, tears would run from under stiff lids, and the slightest movement felt as if ground glass was scraping our eyeballs." Fortunately, their mother, Edith, got help from the night clerk at the hotel in which they were staying. "He reached a druggist who sent

Argyrol," said Shearer. "He knew this trouble well. It was caused by exposure to carbon lights." Shearer was in this kind of pain again, just as she and Thalberg were going on a yachting trip. Fortunately, Hurrell's lights were small, so this case of klieg eyes was not as severe, but this was no way to treat a movie star.

The star had reason to forgive the photographer. Even Thalberg sensed that something was up. "Norma was like an excited child as she waited for the proofs of her pictures," he said. When they arrived, she packed them away and brought them to Joseph Schenck's yacht *Invader*. When she looked at them in daylight, the sun faded them instantly. Thalberg, who was elsewhere on the yacht, did not see them. Shearer phoned the publicity department from Catalina Island. Hurrell got a call. He had to recover himself and rush out sixty more proofs, but on standard photo paper.

With some trepidation, Shearer finally showed the proofs to Thalberg. The thirty-year-old genius gasped. In seven years of looking at photos of his wife, he had never seen anything like this. Regaining his composure, he said, "Why, I believe you *can* play that role!" Shearer got the part of Jerry in *Ex-Wife*, which was released as *The Divorcee*. The film would become a major success, confirming both Shearer's popularity and the versatility she had shown in her silent film work. Her relationship with Thalberg

OPPOSITE: For her special session with Hurrell, Shearer posed on boudoir furniture lent by the M-G-M property department. Shearer was concerned that her legs would not photograph well. Before Hurrell could reassure her, she had skillfully angled them toward his camera. "Norma planned her campaign carefully," said Irving Thalberg. "She bought herself just about the goldest and most brocaded negligee she could find." Since Hurrell was shooting orthochromatic film and using arc lights, Shearer's coloring registered darker than it did with panchromatic film and incandescent lights, but a different look was what she wanted.

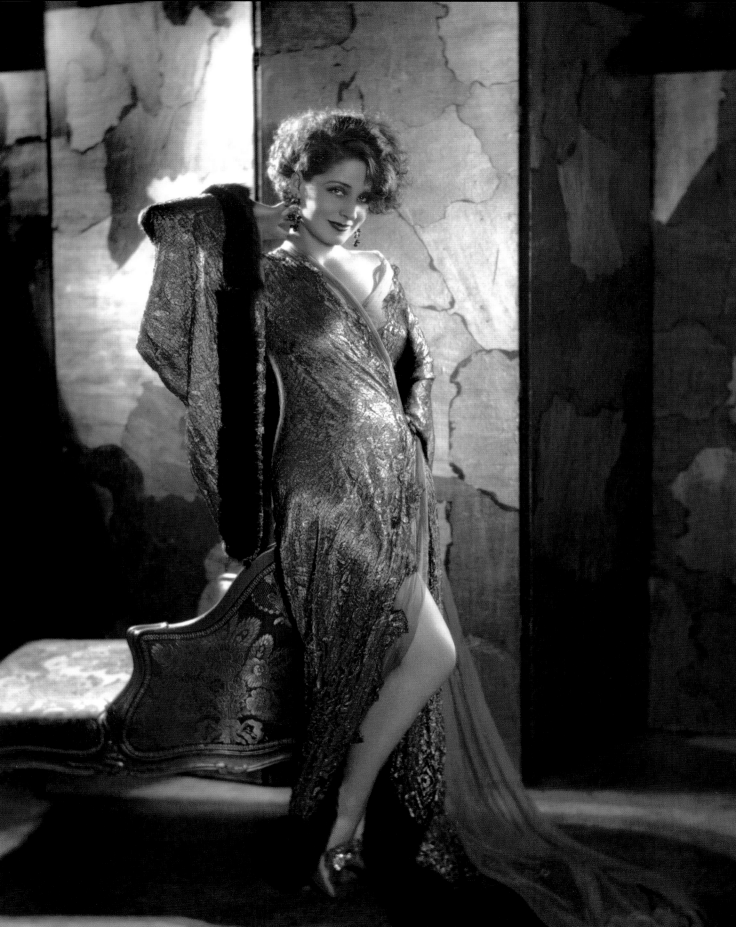

improved, too, and within a month she was expecting their first child. There would be another thrill when Shearer's performance in *The Divorcee* won her an Academy Award for Best Actress. All this good fortune came from a visit to a small Westlake studio. "It was a tremendous gamble," Shearer later admitted, "but a lucky one." It was lucky for Hurrell, too.

M-G-M was exercising its option not to renew Ruth Harriet Louise's contract. "The gal who had been there was giving them trouble," Hurrell recalled in 1980. "She suddenly decided to quit." This was hearsay. She had been married to director Leigh Jason for two years, but that was not a reason to quit a job she obviously enjoyed. Whether because of temperament or the need to raise a family, Louise was indeed leaving. She would work through part of December and then there would be a new head portrait photographer at the studio. The most likely candidate was Clarence Sinclair Bull, who had been with the company since the merger, and with the Goldwyn and Triangle companies before that. He was in charge of the larger gallery, the on-set photographers (the "stills men"), and the stills lab. He was also a highly talented portraitist. He had not gotten along with Louise, since she insisted on processing her film in her own lab. He was next in line. But Shearer wanted Hurrell to come to M-G-M—and the only job open was that of head portrait photographer.

Thalberg called Pete Smith, head of the publicity department, who then called Howard Strickling, the "publicity man" who oversaw the portrait department.

Strickling was ordered to offer Hurrell a job; five days a week, at $150 a week. Strickling expected Hurrell to jump at the offer, given recent events. On October 29, 1929, the so-called "Black Tuesday," the stock market had crashed. In one day, $14 billion had evaporated. The country was still trying to comprehend what had happened. This was of no import to Hurrell.

"I played hard to get," Hurrell remembered, "because that's the way I was in those days." Strickling was taken aback. He waited a day and then called again, still unprepared for Hurrell's indifference. He described the M-G-M portrait gallery. "Well, I've got a studio," countered Hurrell. "What do I want with another studio?" Strickling assumed that Hurrell was angling for more money. He was not. After this reception, Strickling decided that he would not offer Hurrell more money but kept the offer open.

Hurrell stalled for two weeks and then went to Laguna to visit Pancho Barnes. The visit included a flight to Mexico in her biplane. While they were fishing, Barnes told Hurrell to accept Strickling's offer. Hurrell decided to go to Culver City and meet with Strickling, but there was not enough time to drive there before the studio closed for the weekend, so Barnes flew him. While she waited at Clover Field, Hurrell signed a six-month contract. When she flew him back to Laguna, Hurrell triumphantly walked on the wing of her biplane. After a weekend of celebrating, he drove back to La Fayette Park. He had to complete his society portrait orders, buy a new car, find an apartment, and retouch the twenty-five poses ordered by Norma Shearer.

OPPOSITE: While Shearer assumed provocative poses, Hurrell kept cranking his Victrola and playing "When My Baby Smiles at Me." Said Hurrell: "She ribbed me for years about it."

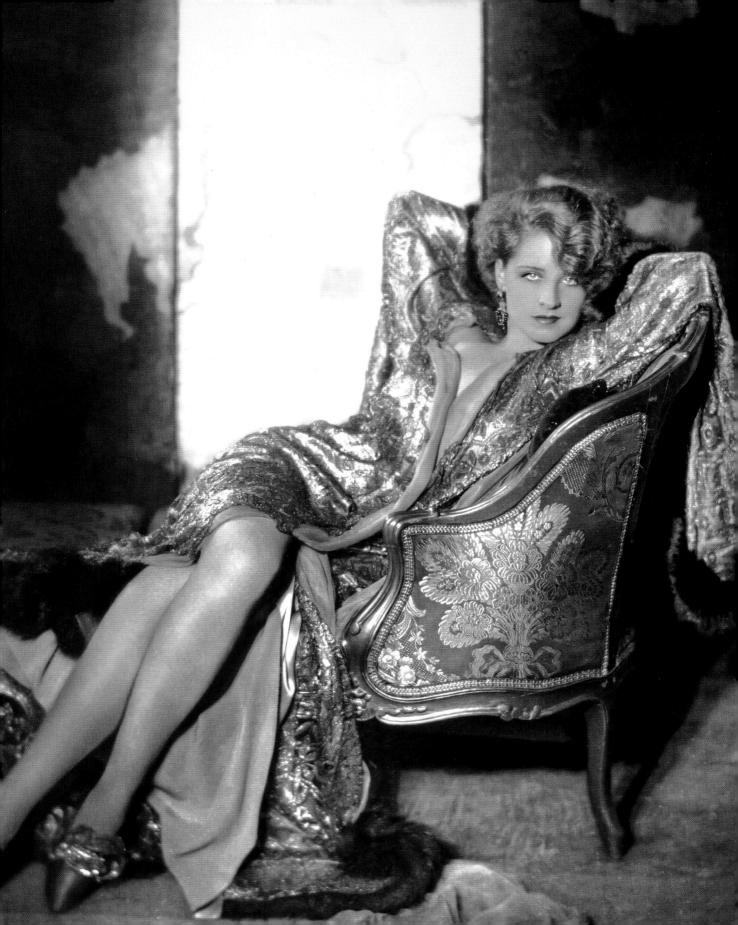

METRO-GOLDWYN-MAYER

MORE STARS THAN THERE ARE IN HEAVEN

Metro-Goldwyn-Mayer Studios has been likened to a city, a factory, or a fiefdom. In 1930, when it was roaring forward on a $12 million profit, it suggested a walled kingdom out of the *Arabian Nights*. It was rich, busy, and powerful. Three thousand employees worked to create fifty films a year. What sold those films, besides clever storytelling and sumptuous settings, were extraordinary performers—the stars in this studio's constellation. Irving Thalberg and Louis B. Mayer had risen to the top of the Hollywood heap in three years by creating stars. To quote the M-G-M publicity department, the studio had "more stars than there are in heaven." Universal had more acreage. Fox Film had more stages. Paramount had more prestigious directors: Ernst Lubitsch, Rouben Mamoulian, and Josef von Sternberg. M-G-M had more stars: John Gilbert, William Haines, Marion Davies, Ramon Novarro, Buster Keaton, Norma Shearer, Lon Chaney, Greta Garbo, and Joan Crawford. This was why Metro was the industry's most profitable company.

Having stars was only part of the formula. M-G-M also had a dynamic sales force. If people all over the world were to see the next Chaney film, they had to know about it. In 1930 the best way to alert them was in print. There were hundreds of newspapers and magazines in which to place articles and ads, but movie magazines targeted the filmgoer. There were dozens of fan mags, led by *Photoplay*, *Motion Picture*, and *Screenland*. Each had a rotogravure section featuring the latest "portrait art," fully credited. George Hurrell's job was to create art for that section.

Hurrell started work at M-G-M on Thursday, January 2, 1930. On that day he emerged from his new apartment at 1261 North Flores Street in West Hollywood, climbed into his new LaSalle roadster, and drove to his new workplace, 10202 Washington Boulevard in Culver City. His "office" was a studio on the roof of an editing building built in 1916 by the studio's original tenant, director Thomas Ince. To enter the "stills studio," Hurrell (and his subjects) had

PREVIOUS: This photograph, probably taken by George Hurrell's assistant, Al St. Hilaire, shows Anita Page posing for a Hurrell portrait. The light over her head is not a work light. It is a light that Hurrell used to define the contours of his subjects. He would eventually devise a way to make it fly, but at this point, the light was still immobile, fastened to an overhead beam.

OPPOSITE: When Hurrell began working at Metro-Goldwyn-Mayer in January 1930, one of the first players he photographed was Joan Crawford, who had just returned from the San Jacinto Mountains, where she was filming *Montana Moon*. This pose is from their first session.

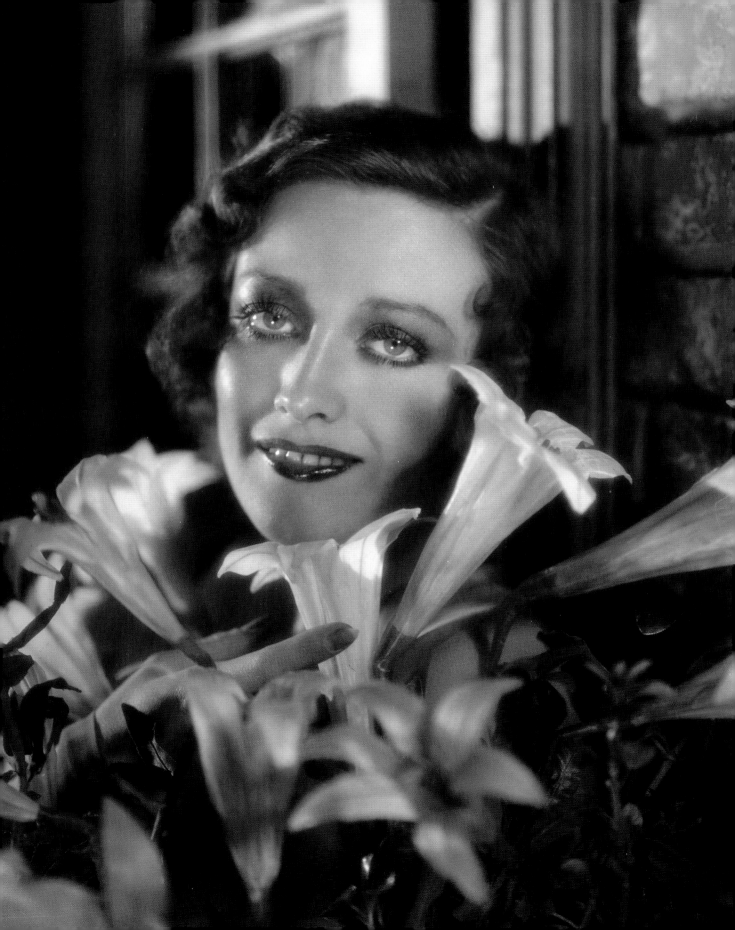

to climb three flights up an outside staircase. Facilities included two galleries, a film loading room, a retouching area, a small darkroom, and a rooftop patio. The film exposed in the galleries was developed and printed in another building, the M-G-M still lab, which churned out 25,000 negatives and 14,000 prints a week. The stills department offices, managed by Clarence Sinclair Bull, were in a third building.

Bull also shot portraits, but in another gallery. Hurrell would be getting the smaller gallery, the one used by Ruth Harriet Louise. He was also getting her twenty-two-year-old assistant, Al St. Hilaire, who had been with M-G-M since the 1924 merger. St. Hilaire would load 8x10 film into holders, move lights, help Hurrell with props and sets, and occasionally process film. Howard

ABOVE: On January 1, 1930, George Hurrell joined the Metro-Goldwyn-Mayer Studios. The production plant on Washington Boulevard in Culver City is now owned by the Sony Corporation.

OPPOSITE: Once Joan Crawford overcame her resistance, she was a frequent subject in the spring of 1930.

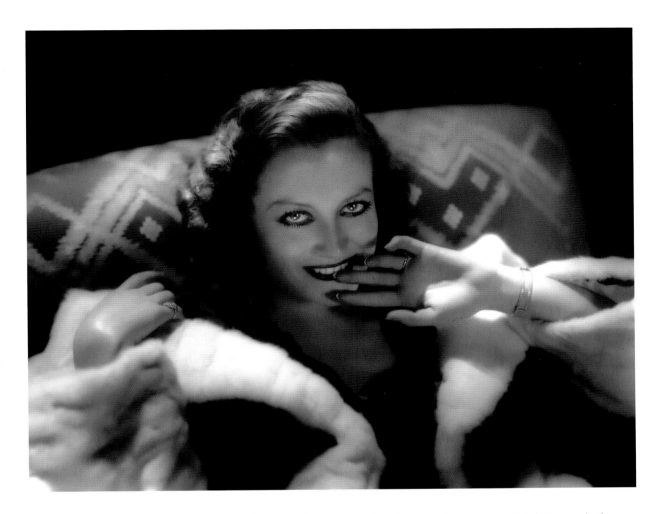

Strickling explained the job to Hurrell. Eight films were in production. When each one finished, Hurrell would shoot "in-character" portraits of its star. The session would take place the day after the film's completion, when hairstyling, wigs, makeup, and wardrobe could still be matched to what had been filmed.

On days when Hurrell was not shooting stars from a recently finished film, he would be shooting supporting players, as well as newly signed artists, directors, writers, and executives. Because of union regulations, he would not be shooting on movie sets. His first assignments would be starlets. In a week or so, he might be shooting one of Metro's stars. Was he excited about meeting one of these cinematic avatars? "I didn't care about movie stars," said Hurrell. "I didn't give a damn who they were." Was he

apprehensive about his new job? "I didn't care whether they liked what I did or not. I thought, Hell, this is only temporary. I'm just doing this to make a couple of bucks. Then I'm going back to my easel and paint."

If Hurrell's attitude irked his new employers, he tried them further by making demands. Bull had established guidelines for the stills department. He was meticulous and exacting, a company man, devoted to the studio and dedicated to his work. He expected the same of his employees. Hurrell did not care. He insisted that his workday end at five. No one at the studio, except for the exalted Garbo, dared leave at five. Hurrell would not budge on the issue. Strickling, mindful of the executive order that had brought Hurrell there, acceded. Bull was overruled.

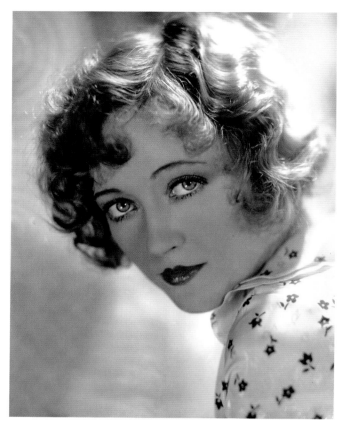

LEFT: A 1930 portrait of M-G-M star Marion Davies.

Hurrell also demanded that he be the only one to develop his negatives. Although Bull had engineered a peerless laboratory, Hurrell would not let it process his film. "I went in there with an attitude that nobody developed my stuff but me," recalled Hurrell. "So they set it up. They didn't care one way or another." Strickling may not have cared, but Bull did, especially when some of Hurrell's negatives were too contrasty to be printed by the machines that made hundreds of single-weight 8x10 glossies. The other reason why Bull wanted to process Hurrell's negatives was to conform them to a unique system.

Some years earlier, while working in the Goldwyn darkroom, Bull had invented a negative identifying device. A small box flashed a minute amount of light onto the edge of an exposed negative before it was processed, projecting a set of numbers and letters. When the negative was hung to dry, the lab technician could look at its edge and read the date on which it was shot and its photographer, as well

as the number of the production that was paying for it. Everything had to be charged to an account, so if the number "530" was on the edge of the negative, it meant that the job was charged to general publicity, but if the number was "469," for example, the negative belonged to the film *Madam Satan*. In this way, an M-G-M negative could never be misidentified. By refusing to cooperate, Hurrell was not only flouting Bull's system but also ensuring that among images shot at M-G-M, his negatives would be immediately recognizable as his own for their lack of identification. It was a decision that would come back to haunt him sixty years later.

Bull complained to Hurrell about his contrasty developer. Prior to this, Hurrell's negatives had never been printed by anyone else. They were not intended for large print runs. How many prints would a socialite need? Like it or not, he had to adapt to the corporate setting, so he made sure that his chemicals were fresh and not too aggressive.

On the other hand, when he made the 10x13 custom prints, he did not care if the chemicals were exhausted. As a result, these enlargements yellowed and faded within a few years, something that did not happen to Bull's prints.

Hurrell's indifference was in tune with industry policy. Publicity material was only as valuable as its role in selling the film, and that film was only being shown for a few months. After that, it had neither value nor meaning. So what if it was perishable? "Making pictures is not like writing literature or composing music or painting master-pieces," wrote Edwin Schallert in the *Los Angeles Times* in 1934. "The screen story is essentially a thing of today and once it has had its run, that day is finished. So far there has never been a classic film in the sense that there is a classic novel or poem or canvas or sonata. Last year's picture, however strong its appeal at the time, is a book that has gone out of circulation."

Ephemeral or not, Hurrell wanted control of his work. He next demanded that he alone would retouch his negatives. Bull had assembled a roomful of retouch artists, but Hurrell bristled at the idea of sharing his retouching secrets. Yet each portrait negative required at least two hours of retouching. There was no time for him to retouch negatives. He was needed in the gallery. He persisted, saying that his retouching effects made his work unique. This was true, so a compromise was reached. He was assigned his own retoucher, a willing pupil named Andrew Korf. In truth, Hurrell's retouching effects were innovative, but Korf's execution of them was smoother. Hurrell also wanted to shoot on sets. Strickling said he would see if the union stricture against outside photographers could be relaxed.

Hurrell had boxes and boxes of the Commercial Ortho he had gotten so cheaply. He demanded that M-G-M buy it from him for use in his gallery. Bull declined. Why use outdated, color-blind ortho when Eastman had just introduced Super Portrait film and a new edge-notching system to help film loaders and processors in the dark? But M-G-M bought Hurrell's film.

Hurrell stopped making demands when he started working. The gallery, though small, was appointed with the finest equipment. There was a new Eastman Century Studio camera and a Cooke Portrait Lens, which was a newer version of his trusty Verito. There were 1,000-watt spotlights, which he used to throw pools of yellow light. There were "Type 23" floodlights, nicknamed "double broads" by manufacturer Mole-Richardson because their rectangular shells contained two huge globes. When covered with silk scrims, they threw a soft, milky light. With these tools, there was no limit to what Hurrell could do.

From the first day, the work was nonstop. "The Culver City plant was a metropolis devoted to a single purpose," said Samuel Marx, who started working at M-G-M in May 1930 as Thalberg's story editor. "Any newcomer would have to be impressed by the efficiency of the studio's departments. Excellence began at ground level." Three stories up, Hurrell could look down and see hundreds of people hurrying between newly built soundstages. "M-G-M had pictures coming and going," said Hurrell. "God, they didn't know what they were doing half the time."

One of Hurrell's first subjects was Anita Page, a popular leading lady who had yet to become a star. They hit it off and he used his sessions with her to experiment with new lenses and lights. "Whenever we weren't busy," recalled Hurrell, "we'd call Nita in and say: 'Let's see. What haven't we done?' We used to shoot pictures of her all over the place. Up in the trees; out in the fields; splashing in streams; cuddling in silks." Page enjoyed working with the bubbly new photographer, but it required energy. "With George it was always a 'production,'" said Page in 1996. "It wasn't like that with the other photographers. With him, it was almost as though you were getting ready to make a picture." Hurrell's first M-G-M portrait to appear in print was a winsome study of Page. The photograph, made in early January, did not run until April. In 1930, the "lead time" for glossy publications such as *Photoplay* was six weeks.

By the time Hurrell's work was being seen in the fan magazines, he was already onto new effects. "I was always fighting myself to keep from being stereotyped," he recalled. "I would try to interpret each sitting as a new approach." He was able to do this because the equipment he was using was far superior to the two arc lights he had been managing with. Having spotlights with fresnel lenses gave him the ability to throw sharp shadows on the wall behind his subjects.

Suddenly he was mad for shadows, painting them behind nearly every subject. Sometimes he would take the silks off the double broad and throw beveled-edge shadows. He also had light stands that enabled him to put spotlights near the floor and shoot shadows higher and higher. He learned that lighting a person from below did not necessarily make him look like a monster; on the contrary, if he smiled, the effect was angelic.

Hurrell's first months at M-G-M were frenetic, productive, and happy, as he spent forty hours a week exposing sheets of Commercial Ortho and loudly playing a new Victrola. To the casual observer, he was a goofy young man having fun. Eighty-three years later, we can see that he had begun his second period of creative development. He was still using ortho film, still using the soft-focus lens stopped down for that singular effect, but his use of lighting implements gave his work a new vigor and impact. Georgie was on fire.

Bull steered clear of Hurrell. He was eight years older than the cheeky young man and had a slightly proprietary attitude toward the galleries. He had come to the plant in 1918, when it was Triangle Studios, and then stayed through its years as Goldwyn Pictures. The merger had improved both working conditions and his fortunes, so he was fiercely loyal to Mayer. "Clarence thought that when Ruth Harriet Louise left that at last he was going to have his chance," recalled Hurrell. Consequently, he was hurt when the publicity department chose to overlook his seniority and bring in Hurrell. "And he hated my guts all the time thereafter." Bull stayed in his office and let Hurrell learn about actors on his own. "I found that capturing glamour wasn't easy," he said. "Even veterans before cameras dreaded portrait sittings. They treated them as necessary evils. Stars showed a surprising inferiority complex about their appearance and the effect of their posing." His first star assignment was Joan Crawford, who had shot to stardom with a 1928 silent film, *Our Dancing Daughters*. She was used to working with either Louise, who accommodated her, or with Bull, who was sensitive, soft-spoken, and had a severe limp, the result of childhood illness. "Clarence Bull was a very quiet, serious man," said Crawford. "He might joke with you before you started the sitting, but once

you were in there, he was the most dedicated man imaginable." But Strickling assigned Crawford to Hurrell.

Crawford's first session with Hurrell went from an energetic exercise to a test of wills. Strickling had gotten him permission to shoot on a standing set. One of the reasons the studio discouraged this (in addition to cooperating with the union) was the expense of having a small lighting crew to aim lights from the catwalks above the set. Hurrell began shooting Crawford in fashion poses, which he had discovered was not his favorite type of photography. He began to find her poses coy and artificial. She found him overbearing. "I kept telling her how to pose," recalled Hurrell. "She didn't like it. She finally got so upset about it that she went into the dressing room and said, 'I'm not going to pose anymore.' So the publicity gal came out and said, 'You can't talk to her like that. She knows how to pose and she doesn't want you telling her how to pose.'"

"What the hell am I doing here then?" snapped Hurrell. "She doesn't want me to tell her how to pose? Pack it up, Al. Let's get out of here." St. Hilaire put the view camera into the carrying case. He was following Hurrell out the door when Crawford came running after them. They calmed down and agreed to complete the sitting. "I was the 'posy' type," recalled Crawford. "That was something I overcame by developing a sense of humor about myself." And once Hurrell had cooled down, he was able to see Crawford more clearly. "I felt a kind of emotional tug, an excitement," he recalled. "I knew I had a unique subject."

Two days later, Hurrell was having lunch in the studio commissary with Al St. Hilaire when a freckle-faced young woman rushed up, knelt before him, and kissed his hand. Once he recognized her, he was astonished. "Please forgive me, Mr. Hurrell," said Crawford. "I've just seen the proofs. They are so very, very lovely." When one of the images was published, the credit read: "Photograph by Hurrell." The caption described Crawford as the "darling of the great god Camera." The inspired quality of their work was already being noted.

In April Hurrell encountered two subjects whose talent was as deep and uncompromising as his, but, while he could be disarmingly matter of fact about his work, these artists took theirs very seriously. The first was M-G-M's

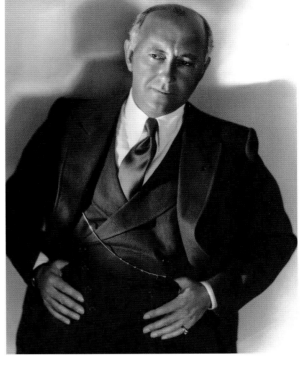

highest-grossing female star, Greta Garbo. She had been an instant sensation in her first American film, *The Torrent*, in 1926. Since then, the Swedish actress had crossed the line between movie star and cultural icon. At twenty-four she possessed the most famous face in the world. Her most recent film (and her first talking film) was *Anna Christie*. It was on its way to becoming the most-seen film of 1930. No public figure was known, followed, and indeed worshipped

ABOVE, LEFT TO RIGHT: Clark Gable had just signed an M-G-M contract when Hurrell made this December 1930 portrait. "The first time I ever photographed him," recalled Hurrell, "—and I was the first one who did photograph him—he walked into the Metro stills gallery as unselfconscious as if he'd known me for twenty years."

Cecil B. DeMille was the only producer-director working in his own production unit at M-G-M, a courtesy extended to the man who had helped make Hollywood the film capital of the world.

as was Garbo. Once again, Bull was passed over. Strickling assigned Hurrell to photograph the actress.

Hurrell knew that Garbo was wary of strangers. The sets on which she worked were populated only with employees from previous films, whether the employee was an extra or a cinematographer. She mandated that William H. Daniels photograph all of her films. Because of her special status, Garbo was able to isolate herself behind black screens while she created her magic. Sometimes even the director was excluded while Daniels and the camera operator filmed Garbo. "I was the one who insisted on the closed sets for her," said Daniels. "I did it to protect her. She was shy, *so* shy." She was also comfortable with Ruth Harriet Louise, so she specified her as her official portrait photographer. (Garbo would occasionally but infrequently work with photographers such as Russell Ball, a society photographer who sometimes did Hollywood portraits.) The previous August, when Louise had been unavailable, Garbo had grudgingly consented to work with Clarence Bull. A few days after the session, Garbo had insisted

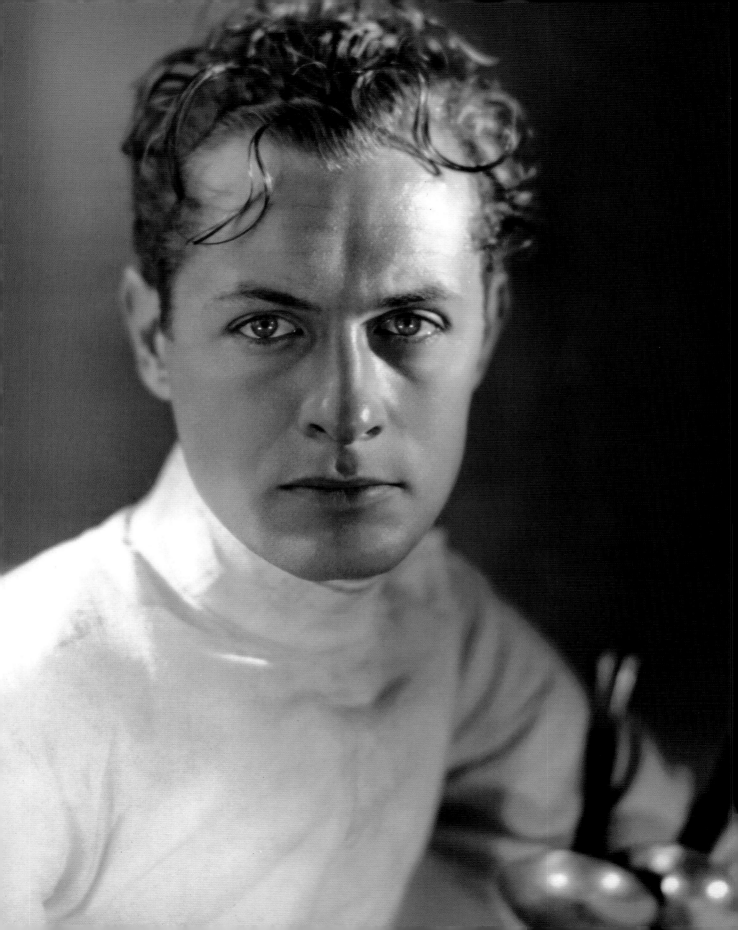

on seeing every proof and had realized that three were missing—out of three hundred. Bull was surprised when she approved every single pose and ordered one custom 10x13 print of each.

Strickling had pulled strings so that Hurrell could shoot the occasional session on a movie set, so Strickling sent him to the set of Garbo's latest film, *Romance*. Both her gown, which was designed by Gilbert Adrian, and the nineteenth-century mansion set, which was designed by Cedric Gibbons, were exquisitely detailed, but the draperies and decorations were too large and heavy to be taken to the portrait gallery, so it made sense to send Hurrell to the set. Garbo did not agree. She saw him as an intruder. She wore the expression of an angry child and froze up, barely cooperating with his good-natured suggestions. She complained to Pete Smith, who asked Strickling why he was sending Hurrell, who was not a member of Local 659, to work on a union set. Strickling promised Smith that Hurrell would not shoot on a set again. After his effective work on a number of sets (*Free and Easy*, *The Big House*, *Doughboys*), this was a disappointment.

Garbo's introduction to Hurrell had not been a happy one, but her contract required her to work with studio personnel, so Strickling scheduled a full session with Hurrell on the day after she finished work on *Romance*. At 8:50 AM, Hurrell heard a *clomp-clomp* on the outside staircase, and Garbo appeared at the door, loaded down with the heavy gowns. Because she wanted to be alone, she had chosen to carry her costumes and apply her makeup by herself. "I took a look at those costumes," said Hurrell, "and I thought I'd try something like one of those old daguerreotypes. There was a skylight there, so I first tried putting natural light on her, to get that feeling of an old portrait."

Garbo was accustomed to the incandescent lighting of Daniels and Bull. "She could 'feel' light," said Bull. She did not know what to make of the skylight. She was also used to looking at her reflection in the front element of the view camera lens. Like Norma Shearer, she understood the technical aspects of both filmmaking and photography. And she knew how she wanted to look. Hurrell found her face fascinating. "There wasn't any problem with photographing her," he said. "Her features were so photogenic. You could light her face in any manner possible; any angle; up, down. Her bone structure, proportions, her forehead, her nose were just right. The distance between here and here was just right. And her eyes were set in such a way that you couldn't go wrong." But something was going wrong.

Garbo was turning slightly this way and slightly that way, dispensing poses with a minimum of effort. Hurrell knew she was shy, but he had cleared the area. "She wouldn't allow anybody to be there," he said. "Just the assistant." She knew Al St. Hilaire from sessions with Louise, so he could not have been the problem. "I hummed and jumped up and down," said Hurrell. "The result was a slight smile, which I caught. Thereafter, she was pensive. She did not appear to respond very much to my popular recordings." He took a break while St. Hilaire unloaded and reloaded film holders. Garbo changed from black velvet to gray velvet. "I had to work with the bulky costumes as best I could," said Hurrell.

The costumes were not the problem. Garbo was the problem. "She was going to do what she was going to do," said Hurrell. "And that was that. There was never any give and take. She was pretty much self-styled." Desperate to get some kind of reaction, Hurrell resorted to antics. He crawled along the floor and then scaled a ladder. Garbo was unmoved. "She just sat there like a stone statue," said Hurrell. "I couldn't get her to do anything." He could not shoot the same thing over and over; he needed to vary the poses.

"On each sitting, they expected to have twenty-five okayed," recalled Hurrell. "You had to shoot fifty plates to get that. I'd shoot about a hundred. In those early days, they sent those publicity shots all over the world, and each editor would want an exclusive picture. So they would send out twenty-five shots and then two weeks later they'd have to send out another twenty-five shots, and those would have to be different."

Hurrell had St. Hilaire roll in a couple of spotlights so he could add some sharp edge light to the soft overhead

OPPOSITE: A 1930 Hurrell portrait of Robert Montgomery, who was fresh from a fencing lesson.

light. Garbo kept to herself. "She didn't respond to me," said Hurrell. "It may have been because we didn't meet on common ground, maybe because I was wild and yelling, hollering, and she wasn't particularly amused by it. It didn't do anything for her." He was determined to make her laugh. "But you didn't just tell a person to laugh," said Hurrell. "You made them laugh."

He had a trick up his sleeve. The camera was focused. St. Hilaire had readied the film by pulling the slide out of the film holder. Hurrell walked backward, holding a black rubber bulb in his hand. It was connected to the shutter release by a fifteen-foot hose. Peering at his impassive subject, he kept walking backward, pretending to be concentrating on her. "Finally, I almost fell over some cables—and she laughed out loud. In the split second while I regained balance, I instinctively squeezed the bulb."

Garbo had let her guard down, revealing a wry humor. And the sitting had come to an end. She wordlessly swept up her gowns and departed. On her way downstairs, she passed one of Bull's assistants. "There's a crazy man in there," she blurted. Garbo would never work with Hurrell again.

April 1930 ended with another memorable session. Lon Chaney was M-G-M's highest-grossing male star and, because of the economy with which his films were made, its most profitable, but he, along with Garbo, had delayed the transition to talking pictures. The "Man of a Thousand Faces" could transform himself into the Hunchback of Notre Dame, the Phantom of the Opera, or a wizened Chinese patriarch, using only the chemicals in his makeup kit and his uncanny acting talent. These characterizations had made him famous and the studio rich, but the makeup contorted his mouth, so he was happy making silent films. Actor Boris Karloff recalled, "Lon Chaney once told me that speech made impossible about fifty of his best makeup devices." Chaney had to be coaxed into making a sound film. "I don't want to talk and spoil any illusion," he told Thalberg.

"You've done all kinds of dialect and character stuff on the stage," said Thalberg. "Just use a couple of voices and let 'em guess." The vehicle they agreed on was a remake of his first M-G-M hit, *The Unholy Three*. Playing a sinister

ventriloquist, Chaney would use not two but five different voices—a major challenge. There was another reason for his reluctance to make sound films. A persistent illness had kept him from working the previous summer, and, although he felt better when he started *The Unholy Three* on April 1, by the end of filming he had missed two days of work and looked older than his forty-seven years.

On April 24, Chaney climbed the stairs to the gallery. As soon as he entered, Hurrell could see why he was so popular. Even without a fantastic disguise, he had a powerful presence. Chaney sat down in front of the camera and set a ventriloquist's dummy on his knee. Hurrell started moving lights around and then studied Chaney's face. "Don't worry about the wrinkles," Chaney smiled. "Just go ahead and shoot 'em. They're my trademark." What he was referring to was not a set of crow's feet but the contours of his face, which a good retoucher softens but never removes. Hurrell's goal was to capture the weirdness of Chaney's character, Professor Echo. Chaney began talking to the dummy, which made Hurrell a trifle uncomfortable. He felt as if he were eavesdropping on an odd relation, a con man berating a wooden homunculus. More than any subject Hurrell had yet photographed, Chaney was in character.

Hurrell found the experience slightly unsettling, but when the lamps were turned off and afternoon light came through the door, Chaney was the friendly fellow who had arrived an hour earlier. St. Hilaire had loaded more film, so Hurrell asked if he could capture this other person, too—the "real" Lon Chaney. "How about some straight stuff?" said Hurrell.

The actor's face darkened and he gave a regretful little smile. "Not today," he said. "I don't feel comfortable being photographed as myself."

OPPOSITE: Hurrell's job at M-G-M included making "fashion layouts" for movie magazines. Women constituted perhaps 75 percent of the movie market, so their interest in fashion had to be cultivated. Hurrell did not particularly enjoy shooting fashion, but he was respectful of Gilbert Adrian, M-G-M's costume designer. Here are two 1930 "Gowns by Adrian": Kay Johnson in *Madam Satan* and Kay Francis in *Passion Flower*.

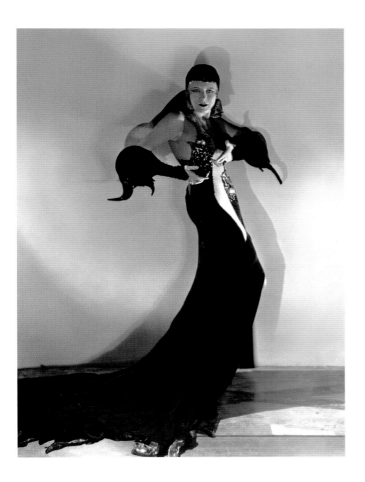

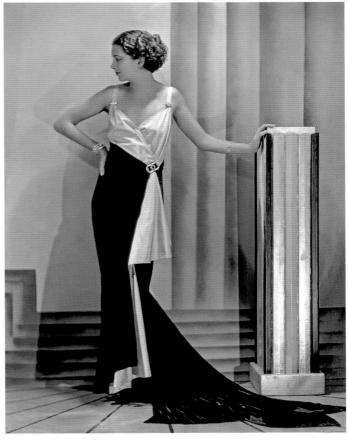

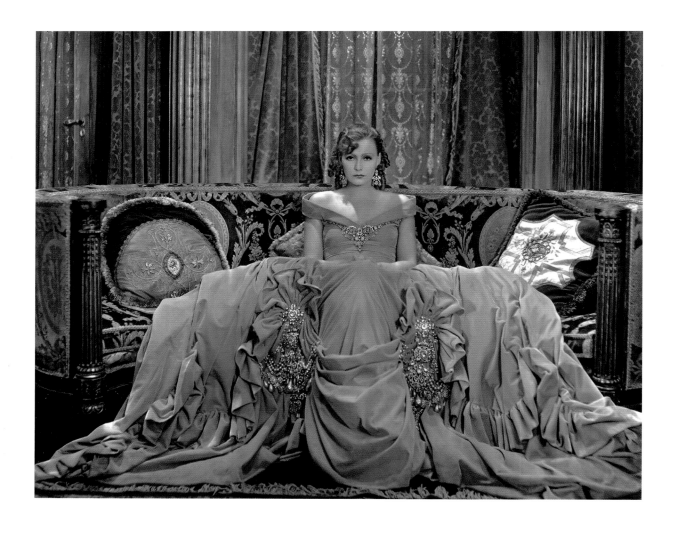

ABOVE: Hurrell went to the set of Clarence Brown's
Romance to make this portrait of Greta Garbo. Because
she was put off by his antics, she complained to the
publicity department.

ABOVE: When Hurrell next photographed Garbo, it was
in the portrait gallery, and she was no more forthcoming
than she had been with him before. To get even this faint
smile from her, he had to fall on the floor.

Hurrell later recalled that when Chaney went out the door, there was something poignant about the way he said good-bye, something that made the words linger. Hurrell tried to forget about it, and he did, until four months later. On August 26, Lon Chaney died of throat cancer. He was the first of Hurrell's celebrated subjects to die, a reminder that in spite of all the adulation, a movie star was a mortal human being.

LEFT: "The results [of the Garbo sitting] didn't turn out as dramatic as my usual work, but I think it served its purpose of promoting her and the film." As Hurrell would learn, Garbo thought otherwise.

OPPOSITE AND OVERLEAF: Hurrell found Garbo distant. "She just sat there like a stone statue," he recalled. "I couldn't get her to do anything."

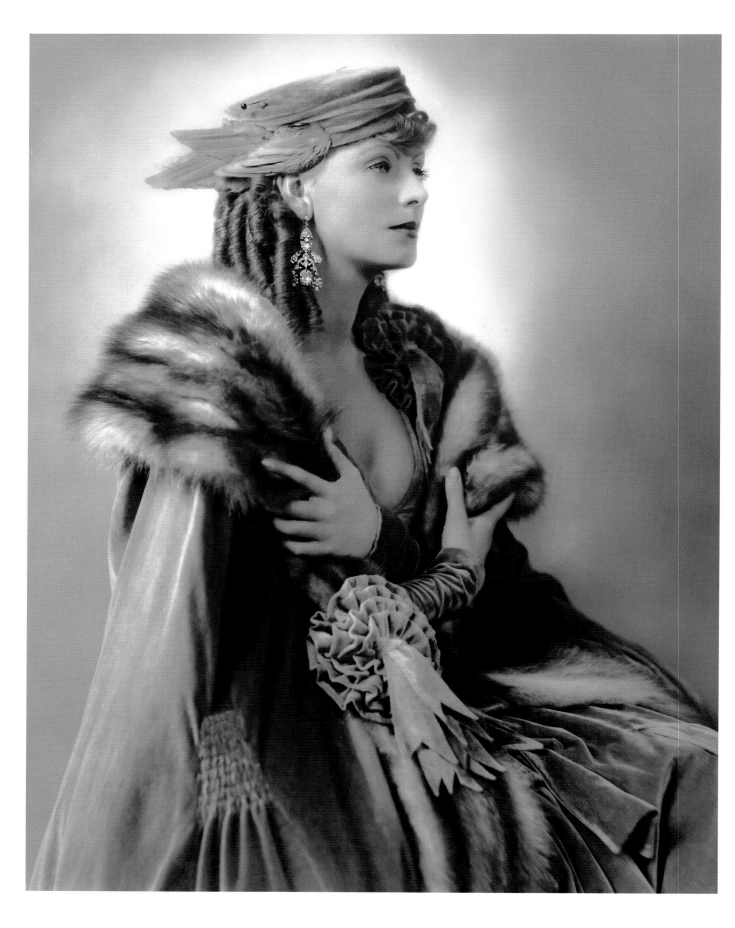

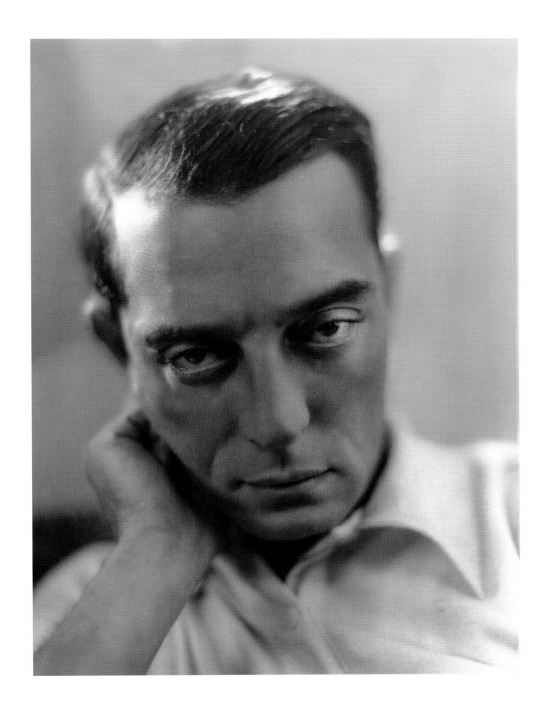

OPPOSITE: "I tried doing the kinds of things with natural lighting that artists like Vermeer did with paint," said Hurrell of his session with Garbo.

ABOVE: When Hurrell photographed Buster Keaton in 1930, he made an unusual, dreamy portrait of the world-famous filmmaker.

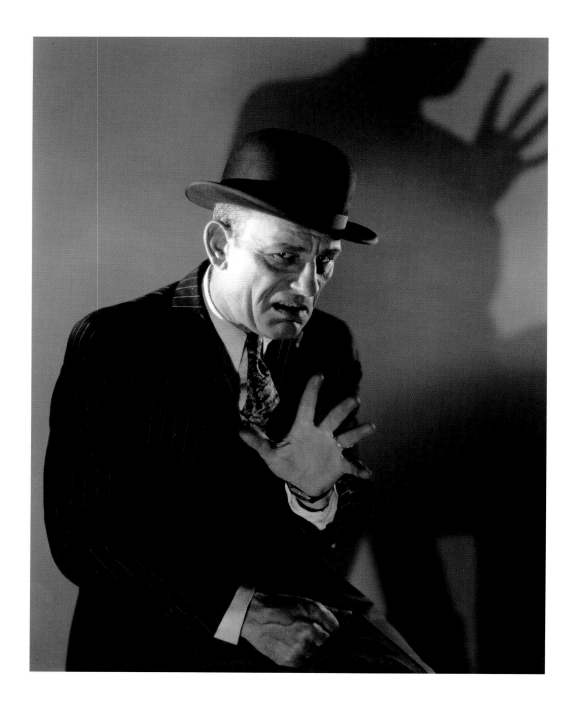

ABOVE: In April 1930, Hurrell photographed the mysterious Lon Chaney in order to publicize his first talking picture, *The Unholy Three*.

OPPOSITE: Joan Crawford was the M-G-M star whom Hurrell photographed most often in 1930. She would sometimes show up at the end of someone else's session and ask to be photographed. "I made more photographs of Crawford perhaps than of any other," said Hurrell. "She liked to pose. She was very pliable. She gave so much to the stills camera."

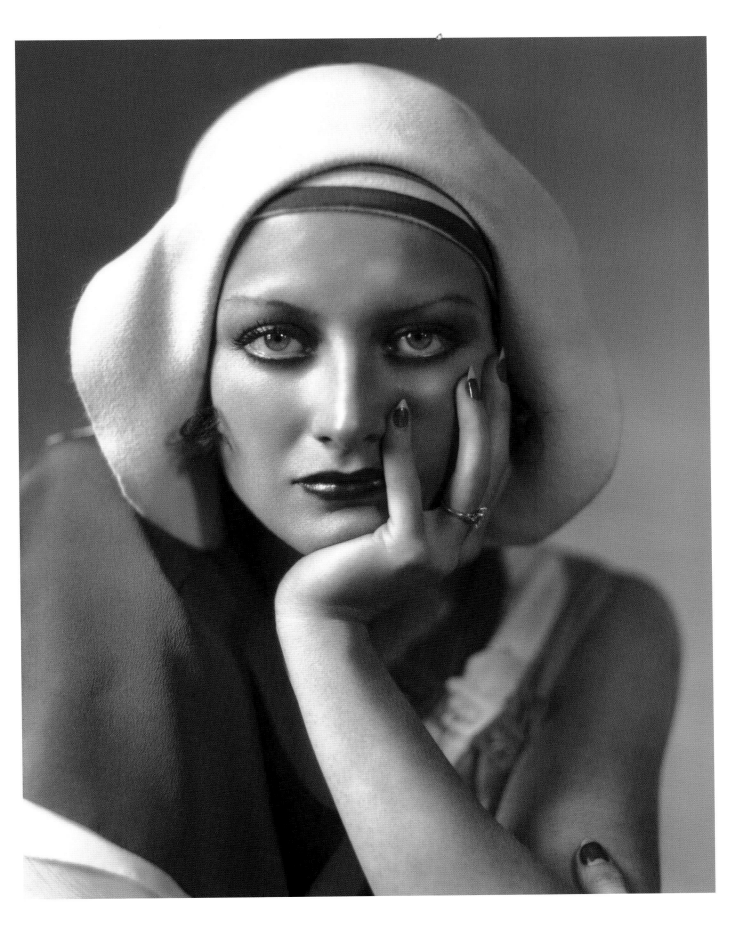

INVENTING THE GLAMOUR PORTRAIT

George Hurrell's third period of artistic development began in mid-1931. In a year and a half he had shot every M-G-M star and supporting player, and had helped two veteran performers achieve stardom. Marie Dressler was sixty-one and Wallace Beery was forty-five when their rough-and-tumble performances in George Hill's *Min and Bill* created a stir at sneak previews. "The best tunes are played on an old violin," said Dressler, confirming Irving Thalberg's hunch about the two character actors. Hurrell's portraits of "Min" and "Bill" were gentle, wry, and unretouched; he wanted them to look like the weather-beaten wharf rats that they were portraying. "Most of those portrait sittings were connected with a particular movie," said Hurrell. "You had to be familiar with the script. You didn't have to read it, but you had to have a general idea of what the picture was about. That enabled you to get closer to your subject." When he photographed Dressler and Beery as themselves, however, they were fully retouched. Veterans or not, they were M-G-M stars and had to look flawless.

There was an unspoken understanding that these performers were somehow set apart from other people, that they possessed something that qualified them to appear on a thirty-foot screen. The term "glamour" had not yet come into popular use in connection with the cinema. Popularized by Sir Walter Scott, it was an eighteenth-century word that denoted enchantment and magic—mysterious qualities that could emanate from a movie screen. To invent the glamour portrait, Hurrell had

OPPOSITE: This portrait was one of the most widely disseminated images of Joan Crawford in the 1930s. Made for Clarence Brown's *Possessed*, it was printed in magazines, and on posters, postal cards, and cigarette cards. Crawford had become a star three years earlier in *Our Dancing Daughters*. Playing a high-spirited flapper, she had personified the giddy hedonism of the Jazz Age. *Possessed* gave her the template for both a new era and the next phase of her career. She was the Great Depression's answer to Mary Magdalene, the working girl who acquires worldly wisdom from publicans and Pharisees, then redeems herself by virtue of her own willpower.

OVERLEAF, LEFT TO RIGHT: This is a print made from an unretouched Hurrell negative of Joan Crawford made in 1931 for Harry Beaumont's *Laughing Sinners*. As was customary with a Hurrell sitting, she was wearing eye makeup and lipstick but no base. The commercial lens that Hurrell had recently adopted was unsparing in its clarity; there was no softness to disguise sun damage or freckles.

This is a print made from the same negative after the retouch artist James Sharp spent six hours applying pencil lead to its emulsion. This is why Golden Era movie stars looked impossibly beautiful.

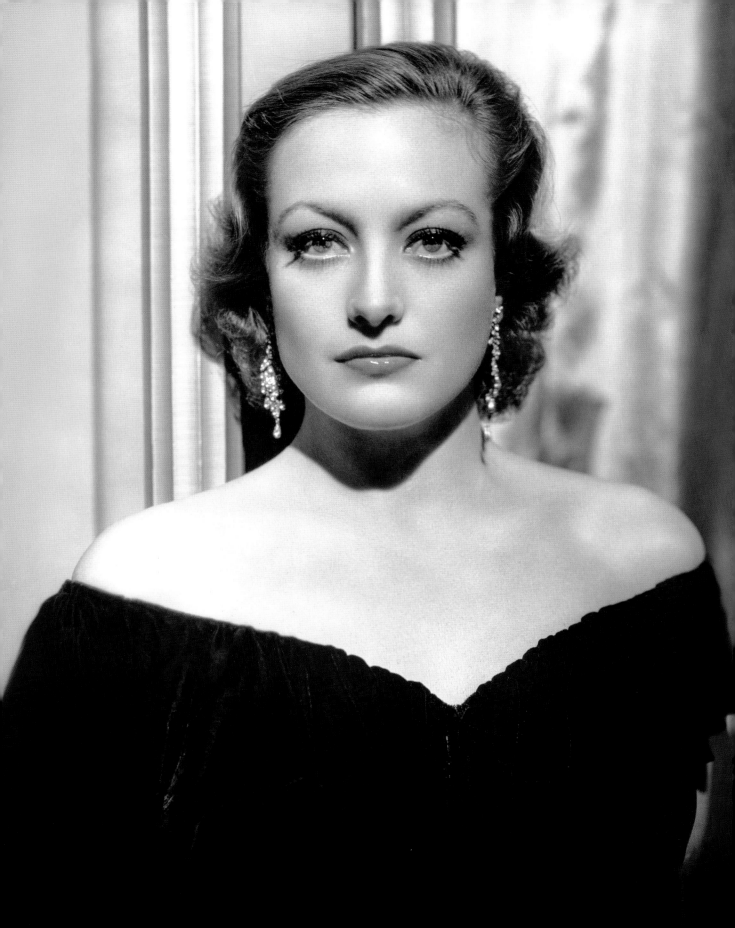

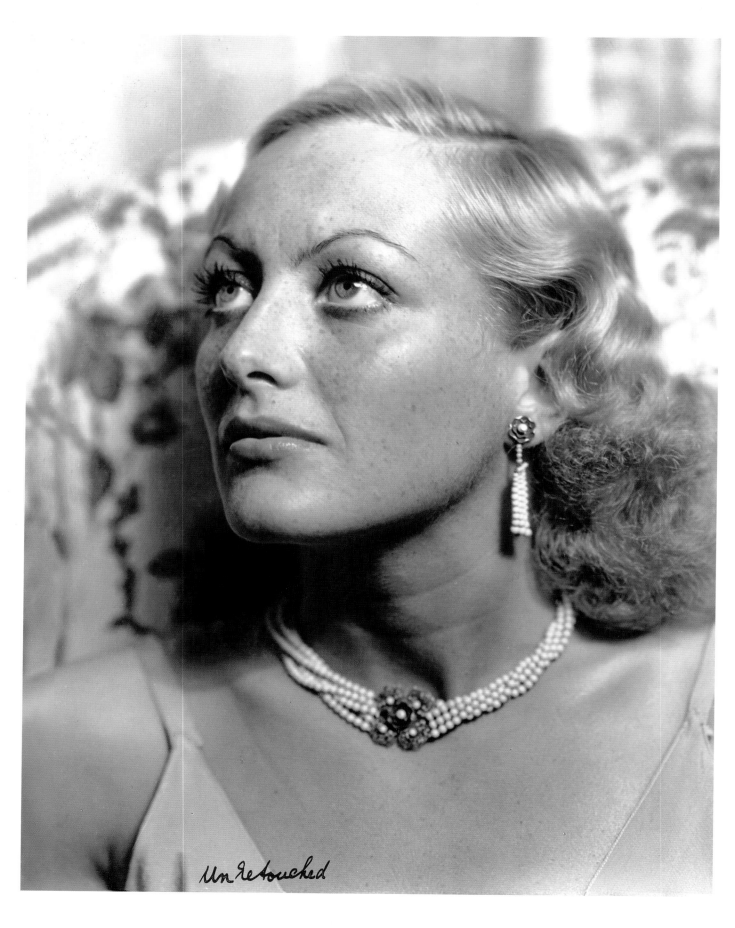

Un Retouched

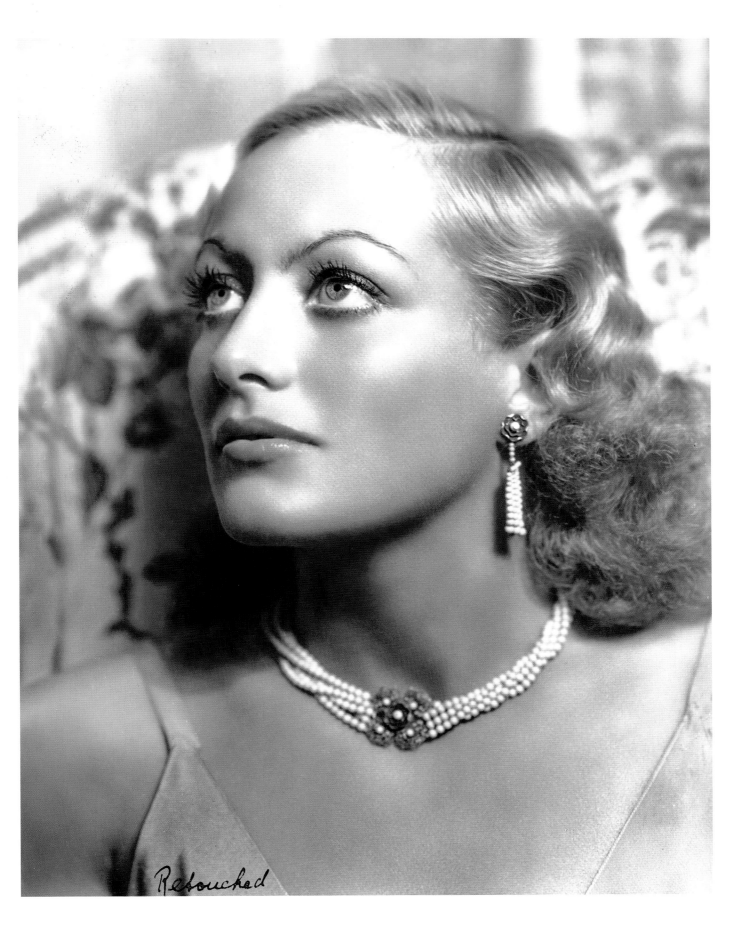

Retouched

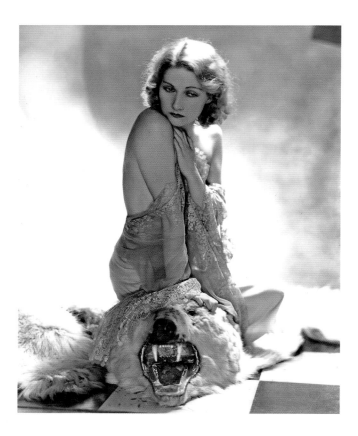

to transport that enchantment to the confines of a photographic image. For him, glamour began with personality.

"I did enjoy shooting film stars," Hurrell said later. "They had a wonderful feeling about being photographed." He understood their moodiness, their insecurity, their quicksilver flashes of brilliance. If at times it looked like he was trying to beat them at their own game by giving a zany performance, there was a reason. "When you get into an enclosed area with a star for four hours," he said, "it becomes monotonous as hell—if you don't do something to make it entertaining, or amusing, or at least interesting." Hurrell would do anything to get a rise. "I would stand on my head, fall on my face, even run up a ladder and fall over with the ladder. Whatever came to mind." Hurrell even managed to impress the irrepressible Jimmy Durante. "Ya got the best comedy shtick in town!" exclaimed the vaudevillian. Sometimes Hurrell would capture his act in a pose with his subject; he did this with Clark Gable one day. For

the most part, though, Hurrell was content to stay behind the camera. He would rather aim the spotlight than be in it.

The light he was aiming in 1931 was a significant element of his third period. The Mole-Richardson company had introduced a lightweight fresnel spot. It fascinated Hurrell. With it he could throw sharp shadows onto a white wall. He could project elliptical nimbuses.

ABOVE: In 1930 Edwina Booth returned from Africa, where she had played a "White Goddess" in W. S. Van Dyke's jungle epic *Trader Horn*. Hurrell's job was to present Booth as something other than the scary character, so he prettified her in a series of sessions. The first instance of Hurrell photographing a woman on a polar bear rug occurred in December 1930 during a session with Booth. This photograph shows most of the elements of his third period of artistic development. The lens is sharp; the retouching is smooth and undetectable; the boom light is outlining his subject with a hot white highlight; and the theme of the piece is sensuality.

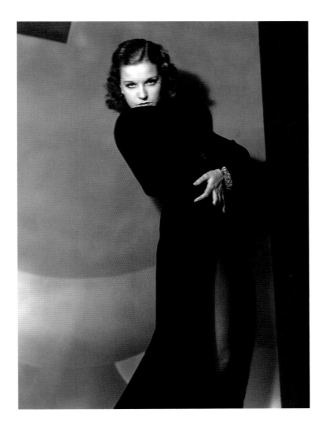
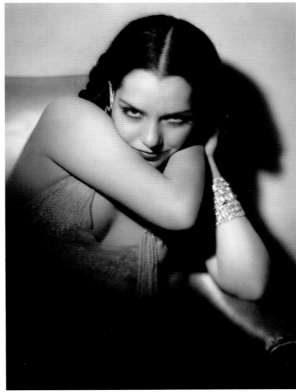

He could paint slashes of rectangular light. And when he threw this light across faces, his use of it was as playful or poetic as the moods of his subjects. Regular spotlights were so heavy that they were restricted to conventional light stands. One day Hurrell tried holding this new light over the head of a subject. The effect excited him. Before this, in order to get that hot light spilling over the shoulders, the effect he liked so well, he had had to use a stationary overhead spot—but it was immobile, nailed to a wooden beam stretched across the top of the gallery.

ABOVE, LEFT TO RIGHT: Lili Damita cooperated with Hurrell's campaign for more sexy photographs. The publicity department did not. This photograph was rejected. The image exists because Hurrell quietly removed the negative from studio premises.

This photograph of Lupe Velez shows the direction of Hurrell's work in 1931. Her pose is unabashedly seductive.

The subject had to be positioned under it to get the correct play of light and shadow. This frustrated Hurrell. He wanted his new light to fly over the heads of his subjects, as it would if he held it in his hand, but it was going nowhere; it was fastened tightly to a stand. Hurrell went to Howard Strickling. "Howard," he said, "I want that small lamp to be suspended from the end of a boom. You know, like a microphone. Is there such a thing?"

"No," replied Strickling. "It'd have to be built in the machine shop. Requisitioned. And there's no production I can charge it to. What's wrong with the ones you have?"

"They take too long to move," said Hurrell. "When I'm trying to get an expression out of a subject, I can't be worrying about the damned lamps. I could adjust this 'boom light' in a twinkling. Now: do I get it or not?" Strickling put in an order and Hurrell got his new toy. His intuition proved right. The boom light was an extension for his arm. The light could swing and sail and soar above his subjects, mimicking moonlight or sunlight. This light, more than

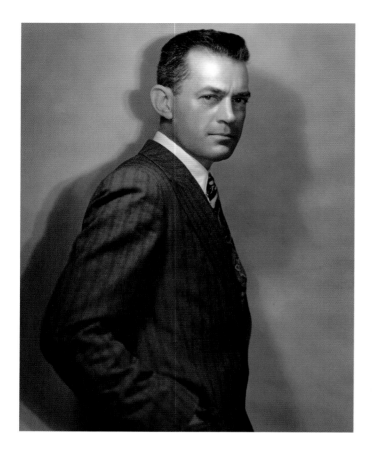

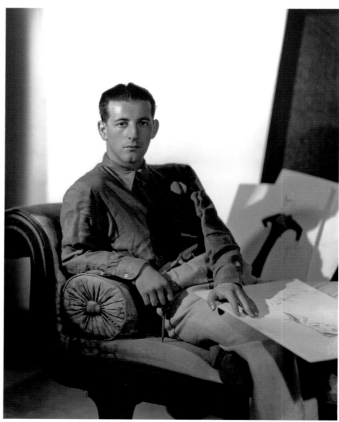

any other effect, became George Hurrell's signature. His use of it was totally unprecedented and completely his own.

Conventional lighting practice held that the key light should be set first, then the fill light, and only then, the hair light. Hurrell set this arrangement on its head, so to speak, by doing the exact opposite. He positioned the boom light first, molding a compositional pattern of light on the head and shoulders. Often he made a triangular pattern with the temple and cheekbone. Once he had created this white-hot design, he aimed the key light to fill in and mold facial features. His key light was usually set lower and dimmer than the brightness of the boom light—another unconventional touch. Then he skipped the fill light altogether; he filled in the shadows with the soft light that bounced upward from light-colored clothing or a tablecloth.

This lighting scheme was a startling innovation, and it attracted attention. No one dared to juxtapose glaring white highlights and somber shadows. No one dared

OPPOSITE, LEFT TO RIGHT: W. S. ("Woody") Van Dyke was known for films made in far-flung locations. As *Trader Horn* became the highest-grossing film of 1931, Thalberg assigned the versatile director a comedy-musical. *The Cuban Love Song* did poorly, which was ironic because Van Dyke's biggest hits would be the *Thin Man* mystery-comedy series and the Jeanette MacDonald–Nelson Eddy operettas.

When Hurrell photographed Gilbert Adrian, the designer's creations were becoming as influential as the latest from Paris, but he was loath to be photographed. "God, I deplore this sort of thing," he said to Hurrell. "What can you do with this face? I look exactly like a moose." Adrian was as moody as Hurrell. "Adrian was a loner," recalled his colleague John Scura. "Not a friendly sort of person, but a genius."

ABOVE: Irving Thalberg was often snapped by studio and press photographers but rarely posed for a portrait. When Hurrell photographed him on the back steps of his Santa Monica home, Thalberg brought his son, Irving Jr., to pose with him.

eschew a fill light. Why was he doing it? The answer was something that Hurrell may not have been able to verbalize. Looking at the images he lit in this way, one can see that his hot toplight and blazing white contrast make the subject stand out in bold relief from the background. There is a depth and dimension that the standard "three-point" lighting scheme cannot achieve.

To capture such shadings of light was impossible with Hurrell's old ortho film; this would exceed its latitude, its "contrast ratio." He had recently phased out ortho in favor of panchromatic film, which had been introduced in 1928. Panchromatic means "all colors," and this black-and-white film did "see" the entire spectrum. Panchromatic stocks included Par Speed Portrait, Portrait Pan, and Super Speed Portrait. Hurrell took a chance on Par Speed Portrait and found its tonal rendering an improvement; it gave skin tones a creamy rather than burnished look. It was also faster than ortho film. Its increased sensitivity to light allowed Hurrell to shoot at exposures as short as one second, and to stop down his lens. Seeing images this crisp made him think about trying a "commercial lens," one manufactured to be sharp at any f-stop. After a bit of deliberation, he raided his savings account and bought a very expensive lens, a 16-inch Goerz Celor. "I was trying to get character into my work," said Hurrell. "That's why I went sharp. There was no reason for that thing to be fuzzy. And that immediately gave the pictures more character."

There was one problem. This lens was a little *too* sharp. It made even youthful skin look bumpy, especially with the light from a thousand-watt spotlight raking across it. The Verito lens had allowed for relatively coarse retouching, and a darkroom technique called "diffusion" further disguised it. Diffusion was achieved by putting a glass or cloth diffusion filter between the enlarger lens and the photographic paper; when the negative was projected, the diffusion blended the dark areas into the light, and retouching strokes were smoothed out; unfortunately, so were detail and contrast. There was no point in shooting with a sharp lens if the picture then had to be softened to hide coarse retouching. The solution to this problem was achieved in two ways: one human, one mechanical. A new "retouch artist" was found, a man named James Sharp.

With him came an Adams Retouching Machine, a device that vibrated the negative, ensuring evenness of strokes. As Sharp did a number of Hurrell's negatives, Andrew Korf studied his technique, and was soon able to match it stroke for stroke. This retouching was so smooth that Hurrell's negatives could be printed without diffusion. They were startlingly sharp and yet the skin had an alabaster smoothness. This was another unprecedented effect.

While supervising Sharp and Korf, Hurrell continued to refine the retouching techniques he had used on the Novarro portraits two years earlier. He applied powdered graphite to the emulsion of the negative, then rubbed it in patterns with a rolled-up paper called a "blending stump." This technique embellished facial highlights, but Hurrell used it just as often to isolate the subject from the background; no one else in Hollywood was using this effect. In the darkroom, he used the printing technique known as "burning" to increase tonal range and to darken less important areas and make them recede. He was still making a master print for the darkroom technicians in the other building to match when they made the large custom prints that would go to selected movie magazines and to studio VIPs.

Another Hurrell innovation was his rendition of skin tones. He instructed his subjects to pose for him without the heavy makeup base they wore for the motion-picture camera. "I always tried to get them to leave the makeup off," recalled Hurrell. "In those days, it wasn't easy, because the makeup was so caked, and they used such heavy makeup, too. They would just iron out everything." Referring to the specular highlights created by a spotlight, he explained that "skin has a sheen to it and as soon as you put that heavy makeup on, it goes flat." In later years, writers would claim that stars showed great faith in Hurrell when they went before his camera without makeup. This was at best inaccurate and at worst disingenuous; no star portrait would be released to the press without retouching. Joan Crawford knew full well that her freckles would be retouched out

OPPOSITE: "The best male subject is Clark Gable," said Hurrell in the 1940s. "He's such a warm, he-mannish guy. He's interested in helping you out. He 'gives.'"

OPPOSITE: Lois Moran was on her way out of Hollywood when she posed for Hurrell in August 1931. She had just finished *West of Broadway* with John Gilbert, a film that brought no one credit. She achieved fame in Gershwin musicals on Broadway and notoriety as the inspiration for "Rosemary" in F. Scott Fitzgerald's novel *Tender Is the Night*.

ABOVE: A 1931 Hurrell portrait of newcomer Ray Milland.

of existence. "George Hurrell loved photographing me without makeup—except for my eyes and lips, of course," recalled Crawford, "and for him I never wore makeup. Just a scrubbed face." The result was a texture that was both transfigured and inviting.

Since coming to M-G-M, Hurrell had become reacquainted with both Ramon Novarro and Norma Shearer; they posed for no one else. The star he had photographed most frequently was Joan Crawford. Between January and August of 1930, he had shot her at least seven times and had been invited to her home to shoot her husband,

ABOVE: In mid-1930, George Hurrell photographed Marie Dressler in a style not dissimilar from a commercial salon's; she was a dignified older lady and not yet a star.

OPPOSITE: When Hurrell photographed Dressler in character for *Min and Bill*, his lighting showed a woman creeping through the dark to protect her loved ones.

Marie Dressler did not expect stardom at sixty-two, but she wore it well. Because she had struggled and waited for many years and had much to offer, she created a gallery of unforgettable characters.

Douglas Fairbanks Jr. Then—suddenly—Crawford was being photographed by Clarence Bull, and only by him. This unexplained estrangement persisted until the spring of 1931, when Crawford returned to Hurrell's gallery, just as he was orchestrating his new effects: "Pan" film, the boom light, the Goerz lens, and fine retouching. Crawford was making a film called *Girls Together* (later retitled *This Modern Age*) and had new effects of her own: cat's eye makeup and platinum blonde hair, bleached to compete with the increasingly popular Jean Harlow. The photos Crawford and Hurrell shot for *This Modern Age* were startling in their newness and gained precious space in *Photoplay*.

In April 1931 Hurrell was surprised to hear that for the first time in a year, he was going to shoot portraits on a movie set. This was not just any assignment. It was an executive command. It came about when he was making portraits of Norma Shearer for *Strangers May Kiss*. At one point during the session, she stopped posing and turned to him. "You know, George," she said, "it seems so strange to be up here, when we've got those magnificent sets down on the stage. I would feel much more at home being photographed there. I think my clothes would look better, too. Let me speak to Irving." The answer was a few months in coming, even though the request had come from the "First Lady of M-G-M." There had to be a reason to let Hurrell

shoot on a union set. William Randolph Hearst found a reason.

Louella Parsons was the gossip columnist for his daily, the *Los Angeles Examiner*. She was visiting the set of Shearer's latest film, *A Free Soul*, and Shearer wanted Hurrell to make flattering pictures of the event. Parsons's power was absolute and unchallenged, so it behooved Hurrell to flatter her. He did something unusual; he put a diffusion disk on his lens. After Parsons had finished her tea and left, Hurrell made poses of Shearer and her leading man, Clark Gable. "Shearer was right," said Hurrell. "The

ABOVE, LEFT TO RIGHT: Hurrell photographed Ramon Novarro in November 1931 for George Fitzmaurice's *Mata Hari*. It would become Greta Garbo's highest-grossing film but would not stop the steady decline of Novarro's stardom. One by one, the male stars of M-G-M's silent days were fading.

Buster Keaton could not wear a brave face for Hurrell's camera. Even though his films were doing better than those of Novarro, Haines, and Gilbert, he felt that his latest films had nothing of him in them, that he had sold out.

Hurrell's camera saw John Gilbert trying to hide despondency over a failed career. The vastly popular silent star had been jinxed since the talkies, trapped in a no-win contract with a studio that was forcing him to make inferior films like *West of Broadway*.

costumes did look better. Psychologically, it all worked. After that, I shot on the sets as often as permitted. No longer was I plagued with a plain backdrop or lack of props."

But when Hurrell saw the photos he had made with the diffusion disk, he did not like them. From then on, the quickest way to identify a Hurrell portrait was by its sharpness. The "Hurrell style" had crystallized. It would be refined in two more artistic periods, but it could never be mistaken for anyone else's work.

Hurrell was maturing. He was twenty-seven. He conducted sittings with confidence and aplomb, evoking honest poses and warm expressions. "I tried to create a theatricality, a mood for each shot," he recalled. "I jumped and hollered, fell down and carried on because I had to get reactions. Half the time I didn't know what I was doing, but it always worked. I'd get reactions."

Sometimes the reactions would linger, and he began to attract female admirers. The only romances to which he ever admitted were with Conchita Montenegro, a starlet from Spain, and Mary Carlisle, an M-G-M leading lady. His friendship with Pancho Barnes continued, even after she gained fame as the "Fastest Woman on Earth." On August 4, 1930, flying a Travel Air Type R Mystery Ship at 196.19 mph, she bested the record held by Amelia Earhart. Because Barnes had been flying to Mexico for Pickwick Airways (often with Mariano Samaniego, Ramon Novarro's brother), she knew more places to take Hurrell for fishing and landscape painting.

Back at the studio, Hurrell's work acquired a new sensuality. "I used to hate doing that fashion layout stuff," he said years later. So he found something more stimulating. He began a series of portraits that featured suggestive poses. When he told starlets to slide their blouses off their shoulders, some burst out laughing. Others, like Lili Damita, would willingly disrobe, but then the publicity department would "kill" the proofs. Hurrell was warned repeatedly not to shoot anything approaching nudity. "That was just the rule of operation," he said. "You understood that. Because, first of all, they couldn't publish it. You had to get those gals looking sexy without taking their clothes off."

The limits imposed by the studio did not apply to the expression on a woman's face, only to the degree of cleavage or inner thigh that could be shown. An undraped shoulder, when combined with a direct stare, could be more compelling than the full nudity that "art photographer" Edwin Bower Hesser was shooting in Griffith Park. Hurrell began testing his formula on every available subject. "The starlets knew the gallery sessions were important to them," he said. "Some of them had very decided ideas about it." Brainy Madge Evans, for example, would go just so far and then rebel against what she considered the absurdity of it; but Hurrell would already have gotten some stunning shots. Submitting this image to new film, a new light, a new lens, and a new retoucher, Hurrell trademarked a formula, something transgressive yet uncensorable—something that made fantasies tangible.

THE GILDED CAGE

On December 31, 1931, Marion Davies gave a party. It took place at 415 Palisades Beach Road, the Georgian mansion that William Randolph Hearst had built for her on the Santa Monica beachfront. Even though this was New Year's Eve, this was a "Kiddie Party." Clark Gable as a Boy Scout, Irving Thalberg in a sailor suit, and Norma Shearer as Pollyanna the Glad Girl were newsworthy, to say the least. Davies usually had James Manatt shoot for her, but to cover this party she chose George Hurrell. This made no sense. There was no artistry in snapping these flash-illuminated shots. Anyone could do them. Furthermore, Hurrell was present at the party, not as a guest, but as an employee, like a caterer, and could not mingle with studio people he knew. This was the price Hurrell paid for his enviable job. Like Howard Strickling and every other executive, he was on call. "When you got a phone call like that," said Laszlo Willinger, another M-G-M photographer, "they didn't *ask* you to show up. They *told* you."

If Hurrell was displeased with the treatment he was getting, no one knew. He was fortunate to have a job in 1931. He had come to M-G-M on the heels of the Crash. In the two years since, a thousand banks had failed, tens of thousands of businesses had folded, and more than six million Americans had lost their jobs. There were a hundred thousand unemployed in Los Angeles alone. The national lexicon included "apple sellers," "breadlines," and "flophouses." The American consciousness was permeated

by fear. At first the studios denied it. Movies were an escape, and the unemployed had quarters. By 1932, however, attendance had plummeted from 10 million to 6 million. Universal was shutting down for a month at a time, RKO was in receivership, and Paramount was dumping its theaters. Even theater-rich Fox Film was hemorrhaging money. Hollywood was staring into a vortex. The depression had hurt everyone—everyone but M-G-M. The studio was ending 1931 with a profit of $12 million. Louis B. Mayer and Irving Thalberg had bought surefire literary properties, adapted them to their stars, and cultivated new stars, all of whom Hurrell had photographed. With the depression worsening, Hollywood grew increasingly insecure.

Curiously enough, Hurrell had less trouble with Hollywood stars than he did with newly recruited Broadway stars. Helen Hayes had been on the boards since she was a child and a star for ten years, but at thirty-one she was frightened of having her picture taken. "I always have butterflies in my stomach before I go on stage," she told him. "I feel the same way now." As it transpired, she had recently seen herself on the screen and knew that she was

OPPOSITE: Alfred Lunt and Lynn Fontanne were the "First Couple of the American Theatre" when Irving Thalberg brought them to M-G-M to film their stage success *The Guardsman*.

far from camera-proof. Hurrell contrived to reassure her, playing "Vienna, City of My Dreams" on the Victrola. It worked. What also worked was lowering her face so as to minimize her chin, emphasize her eyes, and bring out the "whimsical something" he saw in her. The public saw it, too, and she became Metro's newest star.

Thalberg wanted more Broadway stars to join M-G-M, but he could not persuade Katharine Cornell to make a film, and Tallulah Bankhead kept him waiting; but in June 1931 he did convince Alfred Lunt and Lynn Fontanne, the "First Couple of the American Stage," to make a film of their 1924 hit, *The Guardsman*. Because framed portraits

of the Lunts would be used as props in their film, Hurrell had to reverse his usual procedure and photograph them before they started filming. Thalberg was concerned about how to sell the fortyish Lunts to the movie-going public. They had toured with their plays and were famous but were also thought of as "high-brow." In a way, they were. They were ill-at-ease in a city that had restaurants shaped like hats and hot dogs. They were used to posing for formal, almost professorial camera artists, so Hurrell's antics were a jolt. When he sang with a record of Gloria Swanson warbling "Love, Your Magic Spell Is Everywhere," Lunt blinked and said, "Nice touch." Hurrell saw the couple's attention flagging. He launched into a soft-shoe routine. The Lunts were reserved and unresponsive. Hurrell called it a day. Or so he thought.

"My God, George," said Strickling later that day. "What did you do to the Lunts?"

"What do you mean? Nothing. Why?"

OPPOSITE: George Hurrell made this portrait of starlet Lilian Bond in 1931.

ABOVE: A 1931 photograph shows Hurrell photographing Dorothy Jordan in the M-G-M portrait gallery.

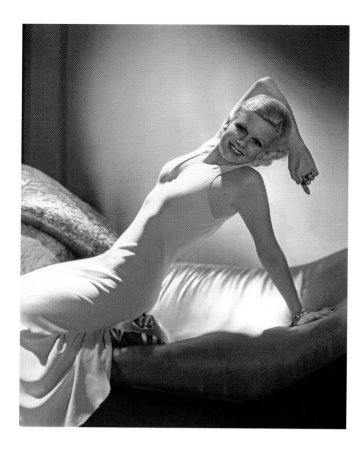

"They've been photographed a hell of a lot—by Abbe and Muray and Steichen—and they're sure these are going to be disastrous!"

For once, Hurrell bit his tongue. Strickling mailed the proofs to the San Francisco hotel where the Lunts were spending the weekend. A few days later, Hurrell was in the studio commissary when he saw Strickling approaching. "Alfred Lunt just called from up north," beamed Strickling. "And do you know what? He ordered all kinds of prints. Best photos they've ever had taken!" Alas, Hurrell's work could not persuade people in Waubeka, Wisconsin, to see *The Guardsman*. Midwesterners did not want to watch a man disguise himself as someone else to seduce his own wife. *The Guardsman* did well in the big cities, but not in the heartland.

What did well was *Trader Horn*, the first jungle movie actually shot in Africa. Its leading lady, Edwina Booth, was poised for stardom. Hurrell even innovated a stylistic element for her—he had her pose with a polar bear rug. The willowy Booth did not become a star, in part because

she was unable to work. She had contracted jungle fever during the very unpleasant ordeal of making *Trader Horn*. A lawsuit resulted, and M-G-M had to settle with the disabled woman. *Trader Horn* was too profitable not to have a sequel, but the next jungle film could not be filmed in a hazardous location. Southern California would pass for Africa. Since Thalberg had just purchased the rights to the *Tarzan* series from Edgar Rice Burroughs, the sequel's first script combined the characters of both *Trader Horn* and *Tarzan of the Apes*. As Thalberg developed the project, he saw that the Tarzan story needed no help. The only problem was casting. Who could play the atavistic hero?

In a curious echo of Shearer's visit to Hurrell, a candidate for the role created photos of himself as the character. Johnny Weissmuller, who had gained renown as a five-time Olympic Games gold medalist, stripped down to a leopard-skin loincloth and posed for the New York portraitist Hal Phyfe, who was working for the Fox Film Corporation. Weissmuller had already been interviewed by M-G-M, but Phyfe's photos convinced Thalberg to cast him in *Tarzan the Ape Man*. While the film was shooting in Culver City and Lake Sherwood, Weissmuller took a break and came to Hurrell's gallery. The session included the Irish actress Maureen O'Sullivan, who was playing Jane to his Tarzan. It was not a success, partly because O'Sullivan was unresponsive, but mostly because Weissmuller's makeup was too dark and his eyebrows too heavy. The studio decided to modify his look, and Hurrell had a second chance with the athlete. This session was a distinct improvement, and it introduced another Hurrell trademark, the use of baby oil to enhance specular highlights on skin. Weissmuller looked like a marble statue of a Greek god—and he became a star.

LEFT: Jean Harlow and George Hurrell hit it off at their first session together, which was in April 1932, shortly after she signed with M-G-M. It was his idea to dress her in white and surround her with white objects.

OPPOSITE: Hurrell's portraits of Johnny Weissmuller created excitement when they appeared in *Photoplay* to publicize W. S. Van Dyke's *Tarzan the Ape Man*. There had been previous screen Tarzans but none had received mythic treatment.

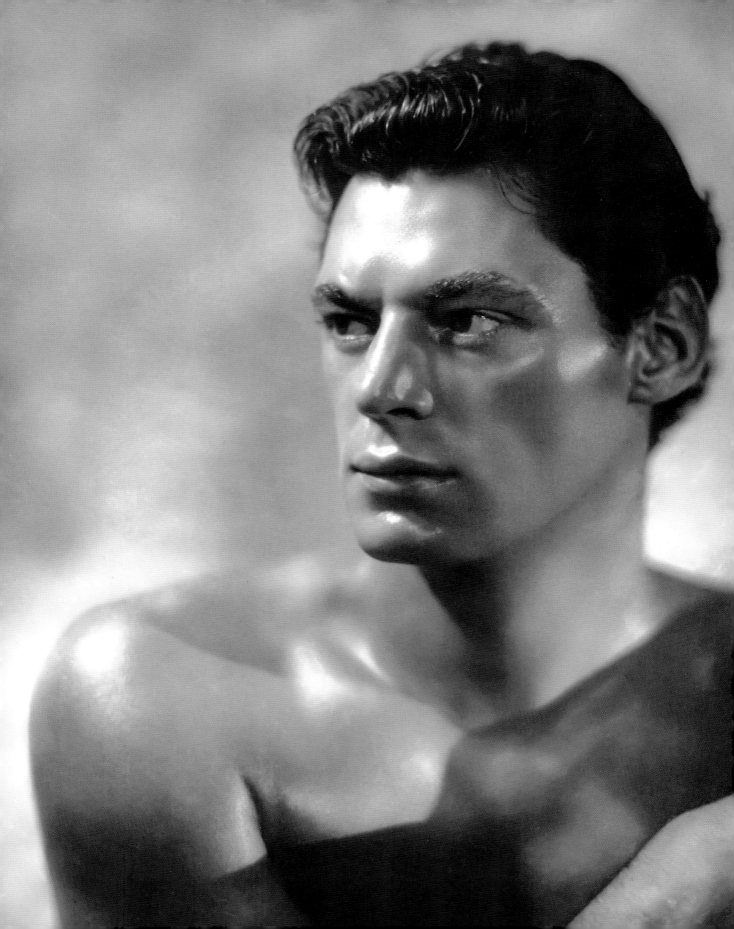

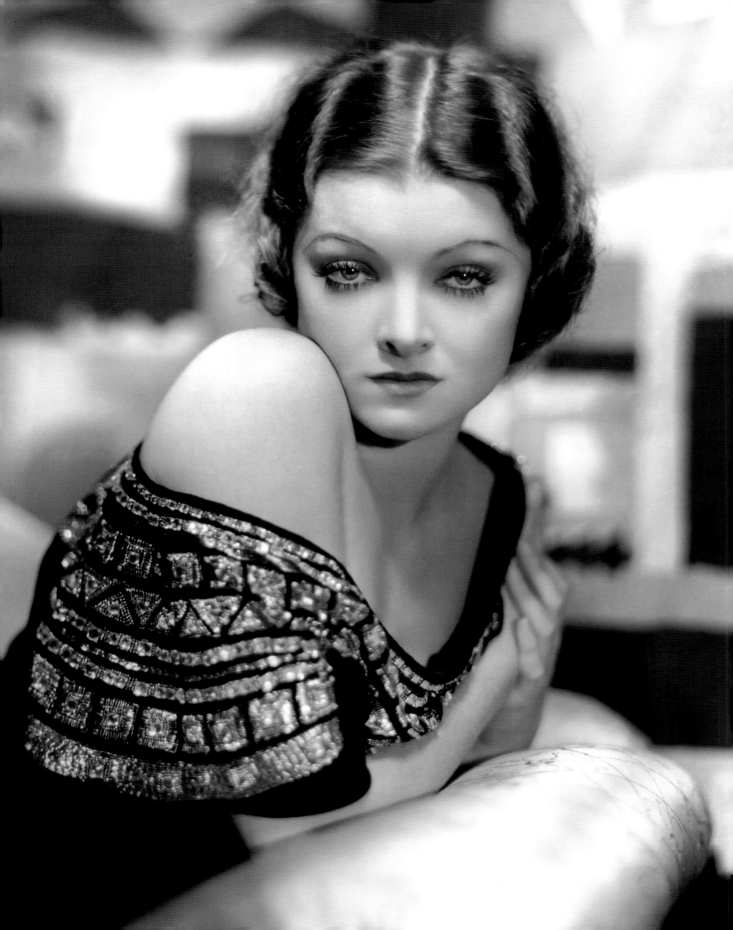

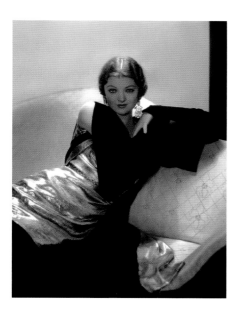 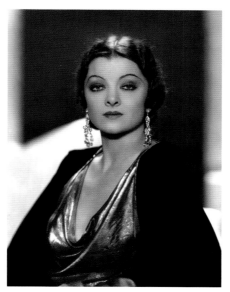 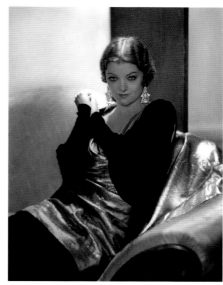

Hurrell helped launch a record number of careers in '31 and '32. He made charming photos of ten-year-old Jackie Cooper, whose performance in *The Champ* was the proverbial tearjerker. He shot Robert Montgomery in tuxedos and tails as he went from overworked leading man to sophisticated star. Hurrell worked with Strickling for a year to transform Clark Gable from a menacing lounge lizard to a sporty outdoorsman. "He was almost shy in those early days," recalled Hurrell. "He didn't know how long his career would last." In October 1931 Hurrell shot Gable as the ambitious attorney for his third film with Joan Crawford. "The era of the sophisticated lady got under way when I was cast with Clark Gable in *Possessed*," said Crawford. The frankly adult film crystallized Thalberg's formula for Crawford—the working girl who claws her way into high society. It also confirmed Gable's

status as the hottest leading man in Hollywood. And it created a situation: Crawford and Gable were more than coworkers. "It was a love bounded by the flats on the set," wrote Crawford. "When we went into a scene, everything else ceased to exist. When stills photographer George Hurrell took pictures of us, he'd simply have the lights set up. Sometimes we were oblivious of the fact that he'd finished shooting." The extramarital affair was squelched, and by no less a personage than Louis B. Mayer. Gable had starved in stock companies for ten years and felt that security was more important than romance.

In April 1932 Hurrell photographed Jean Harlow for the first time. The studio had just purchased her contract from Howard Hughes and was in the process of refining her image, which had grown a little tawdry. The "Platinum Blonde" was really an uncomplicated twenty-year-old,

OPPOSITE: When Myrna Loy signed with M-G-M in late 1931, she was immediately booked for a session with Hurrell. Never mind that she had been working in films for years and been photographed by the best. M-G-M's policy was to use the gallery as a proving ground. "It started with the stills—the buildup, the exploitation, feeling out the public," said Hurrell. "I'm not saying this just to make myself more important: they would start with my stills. No matter who it was, she would have a stills session when she arrived, and I would make large prints, and these would go to the top man, whether it was Jack Warner or L. B. Mayer."

ABOVE: Prior to her arrival at M-G-M, Myrna Loy (who was born Myrna Williams in Radersburg, Montana) had been playing either "Oriental" characters or unpleasant vamps. Thalberg felt that this straightforward young woman had more to offer. (He knew her outside the studio because he was a booster of the Los Angeles Opera and she was a regular.) But she did look exotic. "A top light on Myrna Loy tends to bring out her exoticism," said Hurrell at the time. "Her face flattens slightly, and her slant eyes are emphasized. Lowering the light will make her lose that Eurasian appearance."

but Hughes and her mother, Mrs. Jean Bello, were selling her services to any studio (and any film) that would pay their price. Harlow would just as soon read a good book but spent hours posing in revealing gowns and suggestive poses for photographers who were ordered to "get some sex into it." There was Ray Jones at Universal, Hal Phyfe at Fox Film, and Elmer Fryer at Warner Bros. They all encountered difficulties when photographing her hair. Her natural color was ash-blonde, but a scary mixture of peroxide, ammonia, and Lux soap flakes gave it a platinum tone. When lit from behind it tended to "blow out" the film's contrast.

Clarence Bull was the first M-G-M photographer to shoot her. He first did in November 1930, when she visited M-G-M to make *The Secret Six*; next in April 1931 for a special sitting; and again in November 1931 to promote *The Beast of the City*. In addition to developing a rapport with the easy-going girl, Bull solved the problem of her hair. He noticed that a surgical lamp on a hospital set had a "hot spot" in the center of its beam. By aiming the hot spot at the crown of Harlow's head, and letting the penumbra light the outer edges, he avoided the blown-out effect and created gorgeous, glowing images of her. When she signed with Metro full-time, Strickling assigned her to Hurrell.

Hurrell was fascinated by Harlow's porcelain-doll appearance and began by shooting her in white. "A white dress is always more arresting, in the camera and in life," said Hurrell. "Men turn to look at a white-gowned woman." He, too, found her hair hard to light. His solution was to turn the knob on the back of the spotlight so that the beam had a hot spot, but instead of aiming it at the crown of her head, he aimed it to shoot past her head, letting the penumbra of the beam fall on her hair. The effect was spectacular. She looked like one of the Art Deco statues that were being sculpted for M-G-M by David Williams, brother of Myrna Loy.

"We were on the same wavelength from the beginning," Hurrell recalled. "I had a job to do and she had a job to do." Hurrell's job was to balance the sweet, good-natured girl with the saucy siren. Given his propensity for sizzling images, it was surprising that his shots of Harlow captured as much sweetness as they did sauciness. Their next sitting

was to publicize her first M-G-M film, *Red-Headed Woman*. "When Jean wore that cinnamon-colored wig for her picture," said Hurrell, "I found her slightly less interesting to photograph." Hurrell's pictures of Harlow hit the magazines two months later, and readers saw platinum polished to the M-G-Mth degree.

Meanwhile, Metro executives had lost interest in the stars who brought their company to prominence. By 1932, William Haines, Buster Keaton, John Gilbert, and Ramon Novarro were fading. Each actor had his own problem, but they all shared a complaint: Mayer and Thalberg were not giving them good films. These were stars of the first magnitude, and though they were still adapting to sound films—and aging—their skills were greater than ever. What neither they nor their bosses could control was the public. It was fickle. There were loyal fans, to be sure, but there were just as many who were turning from Gilbert to Gable. When Hurrell was assigned to create new art of these still-young veterans, he found them dispirited.

Haines was too busy preparing his exit from M-G-M to cooperate with Hurrell. His exit line was: "I'm not nervous about posing, but I *am* nervous about this man!" Keaton was hung over and sometimes drunk. Novarro was preoccupied during the sitting and then critical of the proofs afterward. He marked them heavily, hoping the retoucher could remove evidence of heavy drinking. Gilbert was the worst, a sad shadow of his former self. He had been the brightest light of the silent era, M-G-M's biggest money-maker, yet Mayer, angered by the fat contract that his New York partners had brokered for Gilbert, wanted to get rid of the highly strung actor. "The poor guy was fidgeting and shaking and sweating," recalled Hurrell. "He knew they'd put the skids under him. He was about ready to collapse. I shot some plates and was getting warmed up when he

OPPOSITE: In 1932 Hedda Hopper was not yet a powerful gossip columnist. At forty-two, she was a show-biz veteran and was appearing in Edgar Selwyn's *Skyscraper Souls*. This image was an unretouched proof of a "killed" pose. Given to the author by Hurrell in 1976, it was recently retouched in Photoshop to look like a finished 1932 print.

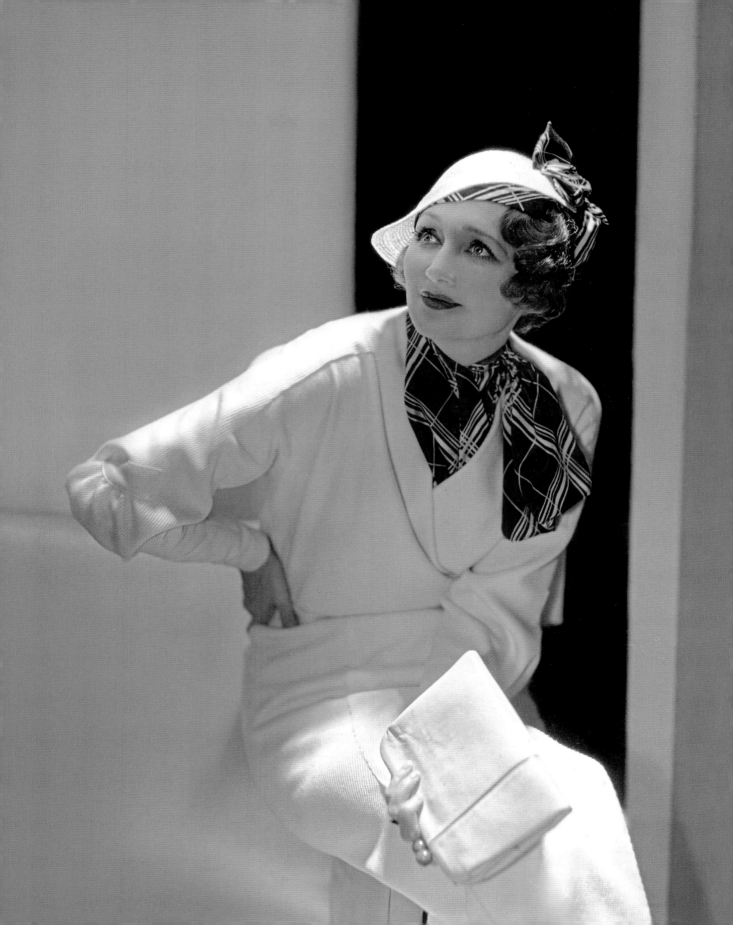

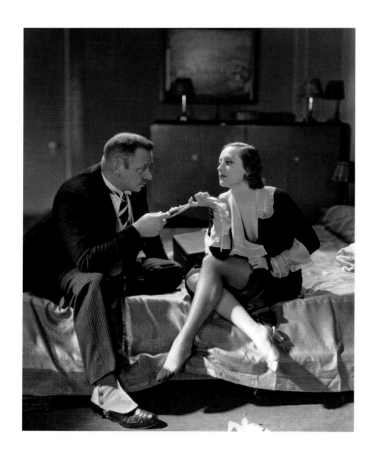

jumped out of his seat and snapped at me, 'That's enough! I've got to go now.'"

Curiously enough, these stars, all of whom were in their thirties, were being eclipsed, not exclusively by fresh young talent but by much older actors. Marie Dressler was sixty-three. Wallace Beery was forty-seven. Lionel Barrymore was fifty-four. His brother John, who was brought to M-G-M with much fanfare, was fifty. To Hurrell these were oldsters; they were also vital and powerful. Dressler, the most popular woman in America, was a delight. "She'd come the long, hard way," recalled actor Robert Young, "and she was very, very grateful." Beery was difficult, disliked by many. After years of enduring slights and oversights as a supporting player, he was taking full advantage of his new status, stealing studio furniture, intimidating other actors, and using soundstage perimeters for bodily functions. At one point Strickling lost patience and went to Mayer. "Yes, Howard," sighed Mayer, "Beery's a son of a bitch. But he's *our* son of a bitch." Hurrell had his share of Beery stories. It took months for Beery to show up. "He'd rather go to the dentist," said Hurrell. When he did show up, he would rush through a session. Still, Hurrell did get honest, unaffected expressions from Beery.

Beery had no choice but to show up when Hurrell shot him with three other stars on the set of Edmund Goulding's *Grand Hotel*. This was unusual, as unusual as the film itself. Conventional wisdom dictated one star per movie. Thalberg challenged this notion with the first "all-star production." Instead of one star, *Grand Hotel* had five: Beery, John and Lionel Barrymore, Joan Crawford, and Greta Garbo. In the ingenuity of its conception, the economy of its production, and the quality of its showmanship, *Grand Hotel* was M-G-M at its most effective. The all-star ensemble was not only in front of the camera. Behind it were Hurrell, director-writer Goulding, art director Cedric Gibbons, and cinematographer William Daniels. Only two men worked on *Grand Hotel* without credit. The first was Thalberg. His name never appeared in the credits. "If you can put it there," he said, "you don't need it." The other uncredited artist was a freelance photographer named Fred Archer. Garbo had not forgotten her discomfort at working with the "crazy man" Hurrell two years earlier. She

OPPOSITE, CLOCKWISE FROM LEFT: A Hurrell portrait of Wallace Beery and Joan Crawford made on the set of *Grand Hotel*.

Hurrell expected to photograph John Barrymore with Greta Garbo for *Grand Hotel* publicity, but Garbo had other ideas.

Hurrell shot Lionel Barrymore for *Grand Hotel*. "He was a serious dramatic actor," recalled Hurrell. "I don't remember ever trying to make him laugh. It was pretty much a straightforward kind of thing, looking over his shoulder, looking straight at the camera, leering at the camera. If he would get too serious, I'd just make some sly remark about going too far in one direction or another."

ABOVE: Jackie Cooper was M-G-M's youngest star in 1932, carrying films like *Divorce in the Family* with his prodigious talent.

even after Bull returned from sick leave. Hurrell began to feel that the room was hot and claustrophobic, and that his schedule of sittings was not so much an artistic opportunity as a contractual obligation. From the age of eighteen, he had come and gone as he pleased. At twenty-eight he was either coming from work or going to work. No matter that the work was exciting and fulfilling. He was required to do it.

Hurrell tried taking weekend trips to Mexico with Pancho Barnes. He found the trips less and less enjoyable because he would inevitably have to return. He liked working with actors, but when they had problems, even artistic crises such as his own, he was unable to muster sympathy. All he could see was his own vexing immobility. He tried a change of residence, renting a house at 1346 North Harper Avenue, half a block from the Sunset Strip. The house resembled a little Mexican hacienda, and for a time it quieted him.

At the gallery, the air was still stuffy, and Hurrell vented his frustration on anyone who represented the management. Strickling heard complaints and cautioned him about the way he spoke to people. "If I couldn't work alone," said Hurrell, "if somebody was sitting around, like even the publicity, if they didn't keep their mouths shut, they had to leave—or else I left."

Hurrell also guarded his aesthetic territory. Strickling told him that the magazine editors wanted the majority of portraits to have white backgrounds. Clarence Bull complied. Hurrell said, "To hell with the editors." Strickling would shake his head over Hurrell's latest batch of low-key pictures. "Black backgrounds were taboo," Hurrell recalled. "So I shot black backgrounds. If they didn't like the black backgrounds, they could throw them in the trash can. They had to wait 'til I was in the mood for a white background. That's the way it worked, because I was just

mandated that someone else take her on-the-set portraits. Because Bull was ill, Fred Archer—not Hurrell—took the famous profile-to-profile portrait of Greta Garbo and John Barrymore.

Hurrell shot the rest of the cast on an Art Deco set that faithfully represented a Berlin luxury hotel. His portraits of Crawford with John Barrymore showed that she was in awe of America's Hamlet; she later called him "beauteous and fiery." Of the Great Profile, Hurrell later said, "His 'presence' was similar to Chaney's, so strong that all he had to do was lean against a doorway." Even if Hurrell did not shoot Garbo, his *Grand Hotel* portraits convey the richness of the film and the pride of its performers. When it premiered, on April 12, 1932, it put Metro-Goldwyn-Mayer at the top of the heap.

Hurrell had no time to bask in reflected glory. He was busy shooting Shearer on *Strange Interlude* sets and Crawford on the *Grand Hotel* set again; it had been dressed as a ship's ballroom for her next film, *Letty Lynton*. The pace of work in the rooftop gallery continued to accelerate,

ABOVE: In July 1932 Hurrell made this portrait of Joan Bennett. Because she was under contract to Fox Film, not M-G-M, the session was conducted outside Hurrell's place of employment—a risky enterprise in a company town.

OPPOSITE: Madge Evans was being groomed for stardom when Hurrell put her through the glamour paces.

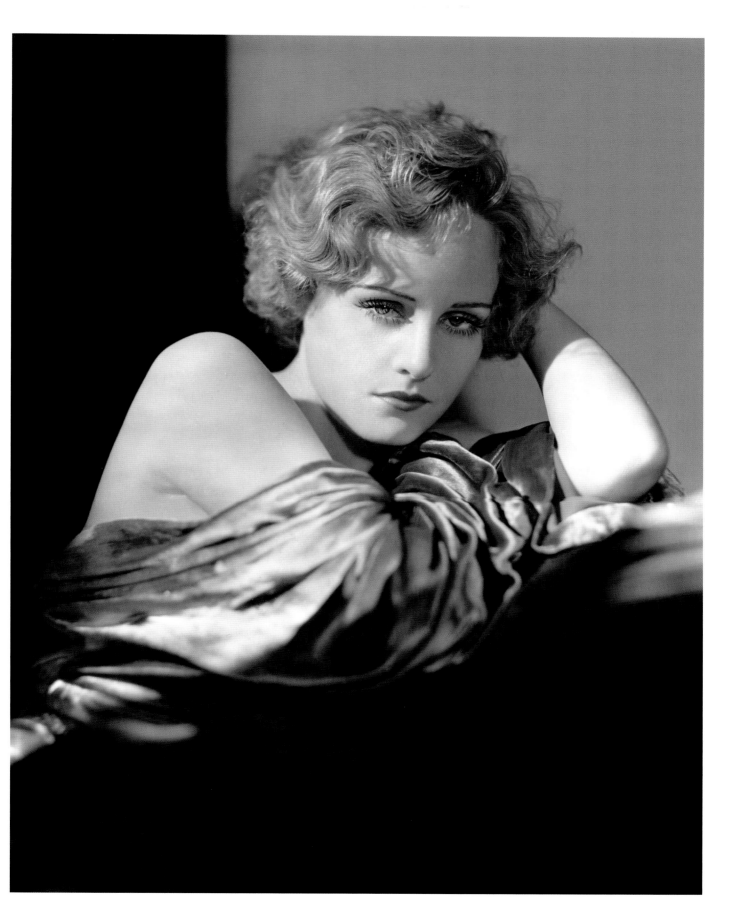

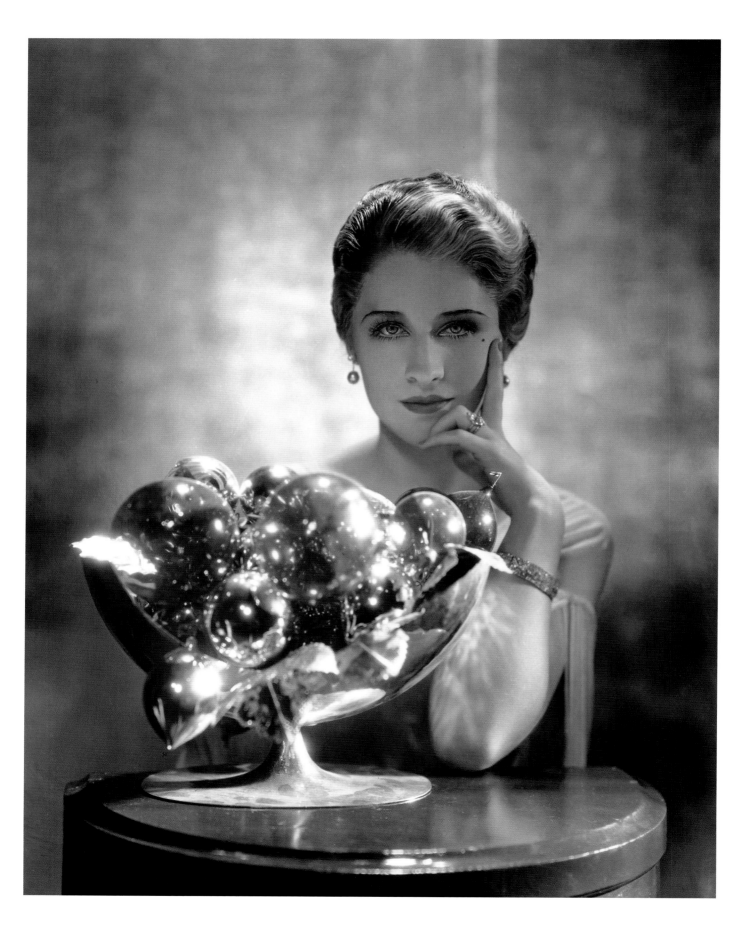

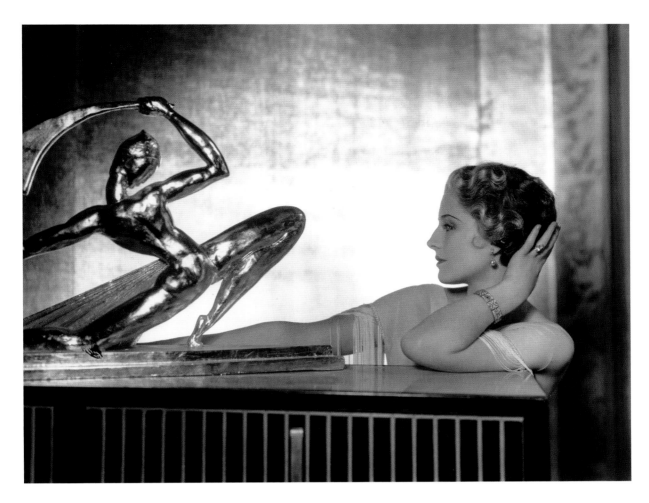

an arrogant, egotistical bastard." Strickling diplomatically asked Hurrell if he could leave some lightness in one of the corners of each portrait, or at least in some of the portraits. Hurrell refused.

Per the initial agreement, Hurrell had a privilege. He was the only employee allowed to make the first prints of the freshly retouched negatives from each sitting. These "artist's proofs" would then be given to darkroom technicians, who would make prints to match Hurrell's. Their custom-printed 10x13 enlargements would then be

OPPOSITE AND ABOVE: Playing Nina Leeds in Eugene O'Neill's *Strange Interlude* had been a challenge even for Lynn Fontanne, but Shearer met it head on, giving a performance as strange as the film's title. The plot required her to age, and in this pose she is wearing her middle-aged look.

sent as exclusives to specific fan magazines. For Hurrell, hand-printing his negatives was more than the culmination of his work on a sitting. It was an aesthetic transport. Working alone in the quiet and the dark, he did not have to deal with egos or politics. He was free to create.

Even though the little darkroom was situated in Hurrell's gallery, it was under Bull's jurisdiction; he supervised all stills studio and stills laboratory functions. For years, M-G-M had been purchasing film and photo paper from Eastman Kodak. This was reflected in the order blanks imprinted on in-house negative sleeves. The film supplied to Hurrell by Clarence Bull was Eastman Super Sensitive Pan. The paper was E.K. AZO Double-Weight Gloss (although it was never dried glossy, but rather to a semigloss luster), or E.K. AZO Double-Weight Matte. If prints were being made for stars or producers, the paper was "buff," E.K. AZO "E"; its deeply grained surface made

half-tone screening impossible, thus preventing unauthorized reproduction. Studios lived in fear of "leaks."

Hurrell's fondness for low key led him to experiment with various photographic papers. He liked them all until M-G-M got a ferrotype dryer. It dried the AZO as it was meant to dry—totally glossy. His coveted black backgrounds suddenly had the glistening opacity of obsidian. He removed the borders of the prints and came up with something really exceptional—a new look, an artistic breakthrough. He decided that from now on, this would be his signature paper. AZO was it.

There was only one problem. Company man Bull had just signed a deal with the DuPont Corporation. Throwing the huge M-G-M stills account to DuPont would earn him kudos from Mayer and new respect in the photographic world. Hurrell had tried these papers that Bull was espousing, in particular DuPont Varigam, but he was not impressed with semigloss prints. He would stick with AZO, dried to a high gloss. But Bull's deal with DuPont

specified exclusive use of DuPont products by M-G-M, and for once, Hurrell was no exception. A fight was brewing.

To add to his vexation, Hurrell received a call from Publicity that "Mr. Mayer" wanted him to work later than five o'clock on a certain day because a visiting dignitary wanted a "photo by Hurrell." How did he respond to this executive "request"?

"I told him to go to hell."

It is impossible to know if this injudicious response made its way back to Mayer, one of America's most powerful men, but before a skirmish could erupt on this front, Hurrell moved to another. Realizing the value of

ABOVE: Hurrell caught the chemistry between Clark Gable and Norma Shearer in this portrait for *Strange Interlude*

OPPOSITE: Erich von Stroheim was an actor, not a director, when Hurrell photographed him for George Fitzmaurice's *As You Desire Me.*

OPPOSITE: Hurrell professed to be disappointed when M-G-M put a wig on Jean Harlow for Jack Conway's *Red-Headed Woman*, but his images are no less arresting.

ABOVE: If Shearer did snatch *Strange Interlude* from Crawford (at least in Crawford's mind), Crawford got a nifty film herself, *Letty Lynton*. Both stars were exceedingly fortunate to have Hurrell creating images of them, for he was inspired in the spring of 1932.

OVERLEAF, LEFT TO RIGHT: Robert Montgomery was brought to M-G-M to be a leading man to its stars, and he served this function admirably; but he was too talented, versatile, and intelligent to be a perennial consort. By the end of 1932, he was a star in his own right.

Crawford gave a heartfelt performance during her *Letty Lynton* portrait session, as she had before the movie camera. "The serious moments would always be a reflection on her movie," said Hurrell. "You'd suddenly drop everything and turn off the music and think serious. Both of you would have to get into a serious mood."

his services, he had begun to shoot an occasional portrait outside the studio walls. One such portrait was made at RKO Radio Pictures. The British actor Laurence Olivier had seen Hurrell's work and wanted a portrait. Perhaps Hurrell just wanted to create art outside the gallery, to use fresh settings. Perhaps he wanted to lay the groundwork for his eventual departure. "On a weekend I felt that I was free to go down and shoot what I wanted," recalled Hurrell. "So I did. It was my Sunday operation, let's say."

The Sunday operation was facilitated by a wily publicist named Maggie Ettinger (who was born Margaret Oettinger to the brother of Louella Oettinger Parsons). Ettinger knew that players outside M-G-M, especially freelancers, would be eager to have a portrait made by Hurrell. Capitalizing on Hurrell's discontent, she lined up a number of sittings in early July. First there was freelancer Lilyan Tashman, wife of the Fox Film star Edmund Lowe. Hurrell photographed her at their Malibu beach house. Then he photographed Joan Bennett, who had been on

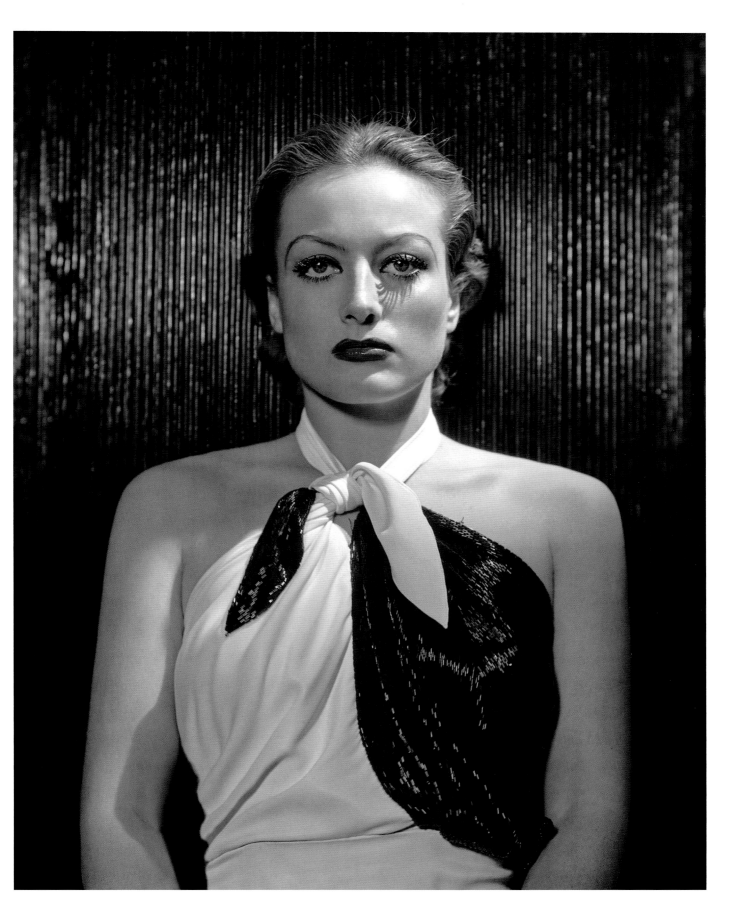

location for a backwoods role, *Wild Girl*, and who needed glamour portraits. She was not a freelancer; she was a Fox Film player. Hurrell was treading on dangerous ground. "And while I had no contract with M-G-M," said Hurrell, "they considered me under contract and I was not allowed to shoot anyone outside the studio." He was working without a contract, but "industry practice," then as now, required an implicit loyalty. Hurrell either did not know about industry practice or did not care.

"I saw no reason why I shouldn't do it," he maintained, years later. He also saw no reason why he should not use M-G-M film, paper, or processing facilities. He surely must have known that someone would see the unfamiliar face of Joan Bennett floating in a tank of fixer or falling out of a drum dryer. Inevitably, someone did. That person knew that Joan Bennett was not a Metro star and, in short order, notified Strickling. He grabbed an assistant, went looking for Hurrell, and ambushed him. For once Hurrell could not appeal to Shearer or Thalberg. This was Friday, July 15. They were preparing for a big night. Grauman's Chinese Theatre was hosting the elaborate premiere of their latest opus, *Strange Interlude*. Hurrell was at the mercy of two agitated publicists. "What do you mean using the studio facility for outside work?" Strickling asked him. "Doing the job on our time!"

"My God, you'd think I had robbed the bank or something," recalled Hurrell. "They walked me around the lot, talking to me and telling me what a dirty rat I was and how horrible and how could I even think of doing such a thing and how could I go and shoot a movie star from any other studio."

"Look!" Hurrell said through his teeth. "I've had this job up to here. I can leave right now!"

"Where will you go?" sneered Strickling. "If you leave Metro, you'll be unemployable. No studio will touch you."

"That's all right," said Hurrell. "That'd be better than taking this crap." Strickling was aghast that Hurrell could be so unthinking—and so ungrateful. Then Hurrell really hit him. "I'm going to open my own gallery." Strickling just stared for a moment.

"Your what?" he gasped. Then he laughed. "You're a fool. Whom would you photograph? People off the street? What would they make of your crazy behavior? Look at Hal Phyfe. Russell Ball. Independent shops don't make a living in this town. Calm down. Be grateful and go back to work. You've got a good job."

"A good job?" shouted Hurrell. "Well, you know what you can do with it!" In front of a lot of executives, extras, and grips, Hurrell turned on his heel and stomped off to the old editing building. He ran all the way up the outside staircase, and disappeared into the stills studio. A few minutes later, he emerged, followed by Andrew Korf and Al St. Hilaire. The three men silently walked past Stage Twenty, Stage Seventeen, the commissary, the administration building, the guard post, and then out the side gate and into the parking lot. Within minutes, Clarence Bull got a phone call. "George has quit!" Strickling shouted into the receiver.

OPPOSITE: Hurrell's photographs of the gowns created by Adrian for Clarence Brown's *Letty Lynton* helped Macy's Cinema Shop sell 50,000 copies of this garment. No less an authority than Edith Head called this film the single most important fashion influence in film history. "He was a really great artist, that Adrian," said Hurrell. "I had great admiration for him—a creative genius."

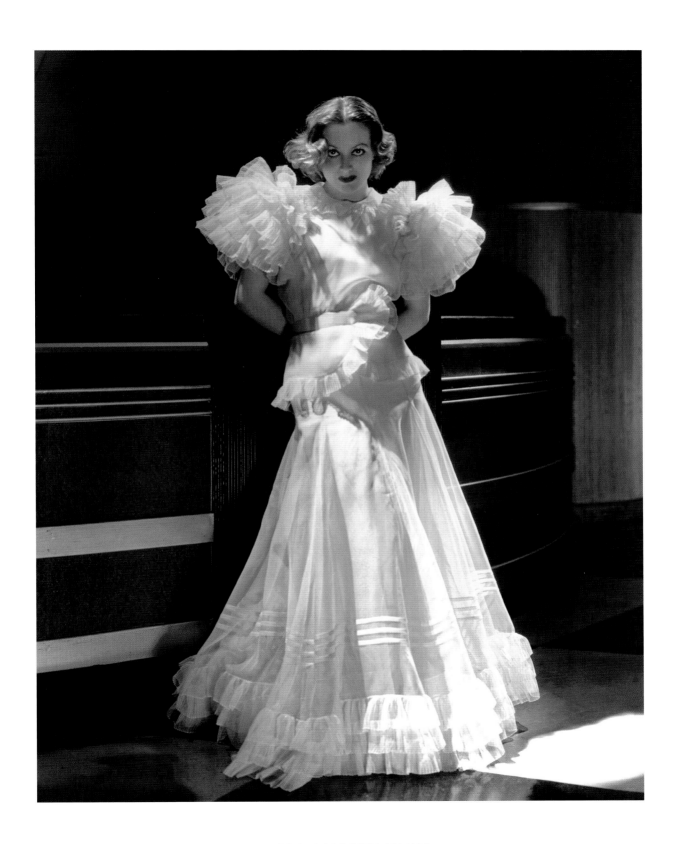

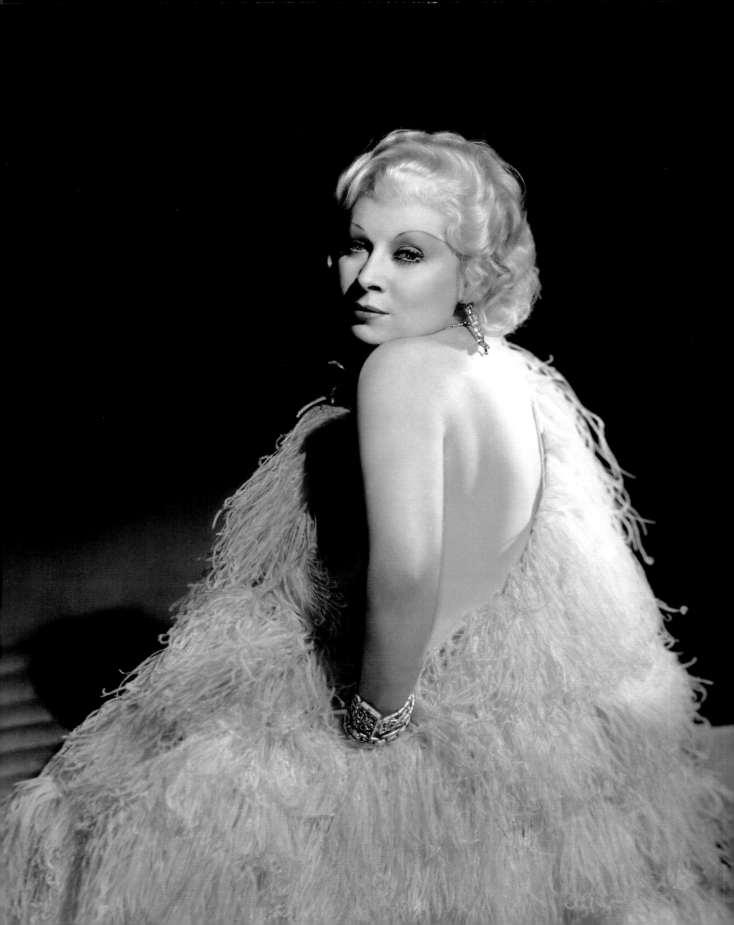

HURRELL PHOTOGRAPHY

"I WISH I LOOKED LIKE THAT"

The Pacific Ocean was a hushed rumble outside the half-timbered mansion on Palisades Beach Road on Saturday, July 16, 1932. Norma Shearer opened a telegram and read it. "Allow me to pay tribute to the most glamorous woman of the screen," wrote George Hurrell. " 'Strange Interlude' shows you as the finest actress of all. I have left M-G-M to open my own studio again. I feel that I cannot do justice to my subjects or to myself when sittings are made under the pressure of mass production. You as an artist must understand this. To me you will always be the loveliest and greatest. I hope I may still regard you as a friend and patron."

The previous night Shearer had been the main attraction at a major Hollywood event. The premiere of *Strange Interlude* had been a success, even if a stampede of fans had broken a girl's leg, but then the film was not the usual M-G-M fare. "There was nothing exactly normal about *Strange Interlude*," Shearer wrote years later. "How could there be, with people walking around, talking to themselves?" O'Neill's controversial asides did nothing to detract from her performance. Shearer had tackled Eugene O'Neill, inviting comparisons with Lynn Fontanne, and looked like a million dollars. "I can't do the Garbo or Dietrich thing," she told the *Los Angeles Times*, but she did commandeer their cameramen—William Daniels and Lee Garmes—to glamorize her in *Strange Interlude*. It was her night of triumph, something she had worked toward for

years. In this she was no different than Garbo or Dietrich. "They would build that personality," said George Hurrell, "so that it became a strong, personal, willful projection." At that moment, Shearer was indeed the First Lady of M-G-M.

A week later, Hurrell was in his house on Harper Avenue, working in a new medium, when the telephone rang. It was Howard Strickling, and his voice sounded friendly. "What are you doing, George?"

"A charcoal sketch," replied Hurrell. "And I'm resting. Why?" He listened closely as Strickling cleared his throat and continued. When the publicity man was nervous, he stammered.

"We'd like to . . . to have you come back. What do you say? Are you interested?"

"Nope."

Strickling said that Hurrell could work as an outside contractor, without hidden restrictions. Hurrell feigned indifference. Strickling was being conciliatory. Hurrell

PREVIOUS: Mae West sat for George Hurrell in early 1933, just after she had completed her first starring film, Lowell Sherman's *She Done Him Wrong*.

OPPOSITE: A magazine feature was Norma Shearer's opportunity to save Hurrell's Hollywood career. "Norma's New Wardrobe" was written by Virginia T. Lane for *Modern Screen* and included this photograph of Shearer.

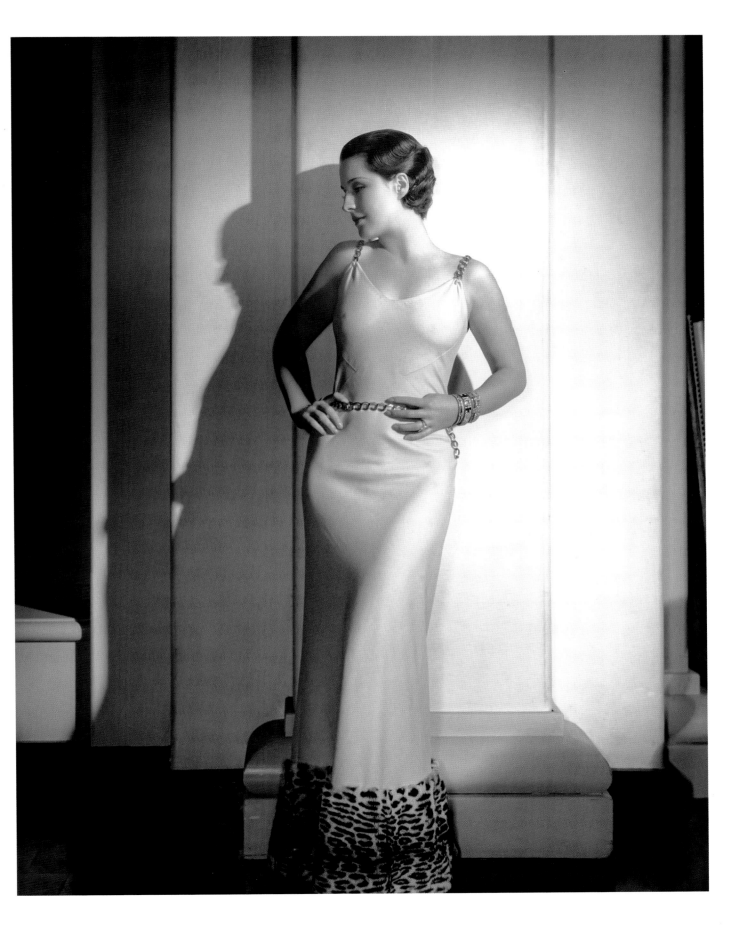

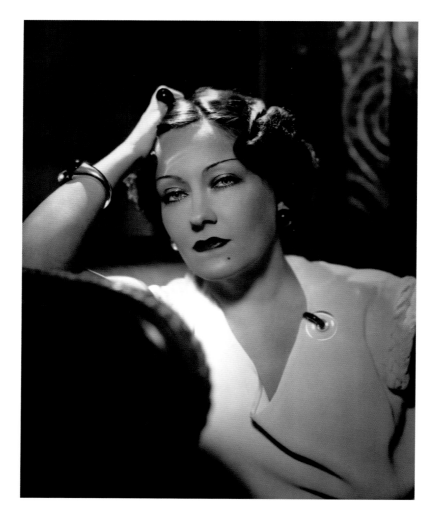

was being peevish, which was uncalled for, given the many concessions Strickling had gotten him. Strickling got tough. He proceeded to tell Hurrell his right name. He had quit the biggest photo job at the biggest company in America's sixth-biggest industry. The country was in a depression. Folks could not afford basics, let alone portraits. There was no such thing as a blacklist, but Hurrell might have difficulty finding work. Studio

ABOVE: Gloria Swanson had produced a film in England, only to see it flop. She was hoping to sign with Fox Film or M-G-M, so she came to Hurrell. New portraits were the best way to remind the industry (and her fans) that she was still a great star.

contractees could be prevented from using him. He had tailored his style of photography to movie publicity, so he might want to stay in Hollywood. Then again, he might not.

Hurrell had a history of impatience and restlessness. He might very well pull up stakes and go to New York. Furthermore, his work had become so influential that every photographer in Hollywood was imitating his use of hard lens, boom light, and single spotlight. The imitators would eventually run out of steam, and there would be a demand for the original. Then, too, there were two hundred people for whom Hurrell had done portraits. They might just remember him. But if M-G-M did decide to freeze him out, he would not be too cold; for the last eighteen months, he

HURRELL
PHOTOGRAPHS
TELEPHONE OXFORD 7701
8706 SUNSET BLVD. HOLLYWOOD

ABOVE: Joan Crawford lent her face to Hurrell's calling card in early 1933.

RIGHT: Hurrell made this portrait of Ethel Barrymore in the garden of the Laurel Canyon home she was renting while she worked on Richard Boleslavsky's *Rasputin and the Empress*. "Her cello-like voice gave me goose bumps," he recalled.

had earned $350 a week and had not had time to spend it. He stood his ground.

"Say, listen, George. There's one more thing. Norma called. She heard about, about you leaving Metro. Well, she needs some new shots. She has some new outfits and *Modern Screen* is planning a feature around them. It's a grand opportunity."

"Yes?" Hurrell perked up.

"Well, why don't you come out, and, well, shoot the stuff? On an independent basis, of course."

"Oh, all right," said Hurrell.

"How much will you want?"

"Let's see. A fashion layout should be about twenty poses. All right. Twenty negs for two hundred dollars."

"My God!" blurted Strick. "That's highway robbery!"

"That's only ten bucks each. [$300 each in 2013.] If that's going to break the studio, then I suggest you get someone else."

Strickling said he had to get approval and hung up. Hurrell later learned what that meant. "Strick called Norma and tried to talk her out of it. Said it was too much. She didn't care what the hell it was. She just wanted me."

To make the transition from corporate employee to independent contractor, George Hurrell accepted the help of several well-connected women. Actress Hedda Hopper talked him up to important writers such as Frances Marion, who had Mary Pickford's ear. Maggie Ettinger introduced him to publicist Helen Ferguson. In 1930, after struggling for years as an underpublicized freelance actress, Ferguson had begun representing players who were not under contract to the majors. She

RIGHT: Hurrell Photography opened in the fall of 1932 at 8706 Sunset Boulevard. This photo was taken later by Dick Whittington Photography.

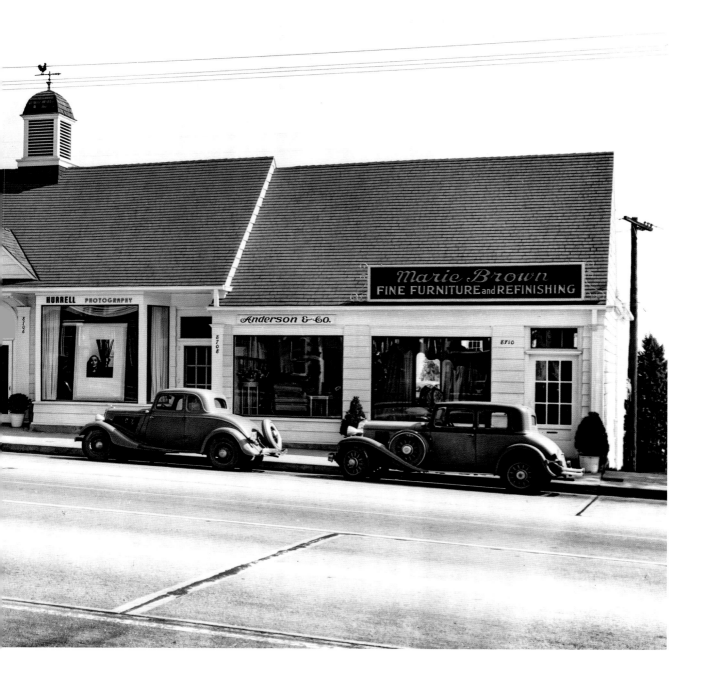

and her clientele booked sittings and helped Hurrell achieve independence. But no one could have helped him if the First Lady of M-G-M had not saved him first.

Shearer wanted Hurrell to shoot her session on one of the sets from *Smilin' Through*, where she had recently been working. When she arrived and greeted Hurrell, she saw carpenters working on the set and set dressers moving furniture. "We're sorry, Miss Shearer, but it won't be ready for an hour," said a workman. Then she realized that the set had been struck but was being reassembled and dressed just for her. She hurried to a telephone on the wall of the soundstage and called Strickling. "Oh, Howard! You should have told me! I had no idea! Oh, don't do that." She and Hurrell found another set, where he hung his favorite Marie Laurencin print on the wall, and a crew of electricians began setting lights from the catwalks overhead so that Hurrell could have his favorite effect. Shearer was happy. "She was the Queen," recalled Hurrell. "What she wanted, she usually got. No expense was spared."

Hurrell next photographed another Queen—or, to be more precise, an Empress. Irving Thalberg had brought Ethel Barrymore from Broadway to costar with her brothers John and Lionel in *Rasputin* (later renamed *Rasputin and the Empress*). For the first time, all three members of the "Royal Family of the Theatre" would be in one film. On August 8 there was a gathering of the clan at the Laurel Canyon home Ethel was subletting from author P. G. Wodehouse. Clarence Bull shot John and his family indoors while Hurrell shot "Miss Barrymore" and her sons outdoors. Hurrell found the great lady as intimidating as the Romanoff she was portraying. When he arrived at her home early in the morning, Ethel snapped at him: "I have to have my breakfast before I sit for you." He blinked when he saw her breakfast. It was a double Scotch.

"I want a few snaps for my family album," said Ethel. "My sons are here with me, and we haven't had decent pictures taken together since they were mites." Hurrell posed her with her boys, Sammy and Jackie Colt, in

the garden. Ethel observed the care that Hurrell and Al St. Hilaire were taking to aim a silver reflector at her, and she told Hurrell not to over-retouch her face. "I've spent a lifetime getting these character lines," she smiled, "and I wouldn't be Ethel Barrymore without them." She was turning fifty-three, and as this was M-G-M, her negatives were heavily retouched. When she left Hollywood a few months later, she criticized its artificiality, calling it a "glaring, gaudy, nightmarish set built up in the desert."

Hurrell got a call from the Fox Film Corporation, Joan Bennett's studio. He went there to shoot starlet Irene Ware and star Warner Baxter, using the gallery where Hal Phyfe usually worked. If Hurrell had stayed, he could have made spectacular images of the fiery Clara Bow for her comeback picture, *Call Her Savage*, but Fox did not invite him. He later admitted that he was disappointed, but he was not really interested in working for someone else. He needed a place of his own.

On September 1, 1932, Hurrell moved into 8706 Sunset Boulevard. His new studio was just a few blocks from his home, on the increasingly popular stretch known as the Sunset Strip, which was located in West Hollywood, an unincorporated part of Los Angeles County. His studio was the deepest of six storefronts in a white, Colonial-style commercial building owned by Montgomery Properties, Limited. The studio was only twelve feet wide but had a depth of sixty feet. Its back wall was white "sprayed stucco," ideal for portraits, and the tall picture window looking onto the Strip was perfect for displaying portraits. The rent was $50 a month. Before "Hurrell Photography" could open, however, Hurrell had to buy a camera, lens, tripod, and lights; commission the construction of a new boom light; hire a receptionist; and rehire Al St. Hilaire and Andrew Korf. Hurrell's savings account was quickly depleted. He turned to Maggie Ettinger for help; her husband, the painter Ross Shattuck, lent him $800.

Hurrell placed a listing in the Buyer's Guide; it read: "Hurrell / Photographer / 8706 Sunset Blvd. / Oxford 7701." His friends gasped at his fees. A $250 portrait package would yield one print each of only twelve poses. This was portrait art for the carriage trade. How would he get it?

He invited Norma Shearer to his new studio for a complimentary sitting. After she chose her favorite pose from the proofs, he would enlarge it and hang it in the shop window. Shearer liked the pictures but suggested that he use a pose he had taken in June for *Smilin' Through*. This was the one she had hung over her son Irving's bed. She arranged for Hurrell to get the negative from Bull, and Hurrell paid a lab to enlarge it to 48x60. He then framed it and installed it in the window.

A few nights later, he went to dinner with Pancho Barnes at the Brown Derby on Vine Street. He was slightly apprehensive. He had not been there since quitting Metro. Would he be turned away at the door? He was greeted by every star and publicist in the restaurant. Word of Shearer's visit to his studio had spread through the film community. If she had not set herself against M-G-M's boycott, Hurrell might not have been seated that night. But she had. And now, with her stamp of approval, he was in.

In early 1933, the Great Depression worsened. Hurrell's business fell off. So did M-G-M's. By February the country was in near chaos, with banks shipping gold overseas in expectation of a complete economic collapse. "At the end of February, the United States was a congeries of disorderly, panic-stricken mobs and factions," wrote Walter Lippmann. On March 8, Louis B. Mayer called all employees to a soundstage for an emergency meeting and tearfully asked them to take a 50 percent salary cut. Wallace Beery made an obscene noise and walked out, but the rest of the employees agreed. If things were that bad, could Hurrell hope for more assignments from Strickling?

As Hurrell walked into his studio one day, his receptionist handed him two phone messages from Joan Crawford. Perhaps she was tired of Bull's gentility. Perhaps she needed the Hurrell "sheen." Perhaps she was tired of seeing Shearer's face in Hurrell's window. "I admire and like Joan," Shearer said later that year. "I think both of us have been hurt and embarrassed by the persistent rumors of our rivalry and hatred." Crawford had been the second star Hurrell had photographed at M-G-M in 1930. She would be the second M-G-M star to visit 8706 Sunset. In both instances, she followed Shearer.

Crawford had started 1933 in her own personal depression, after an unprecedented two flops in a row, *Rain* and *Today We Live*. She needed Hurrell's ebullience, and she needed his photos to remind her fans that she was still perfecting her image—for them. The image Hurrell created for her in 1933 was a sparkling new one. Ferguson used it for publicity and the phone began to ring. One of the first to call was Crawford's newly divorced husband, Douglas Fairbanks Jr. Hurrell found Doug Jr. "erudite, urbane, and amusing." His well-known stepmother was riding west on Sunset when she saw the huge enlargement of Crawford's

ABOVE: Mary Pickford, the original Queen of Hollywood, saw Crawford's picture in the window of Hurrell Photography. "I wish I looked like that," said Pickford, who had also seen the portraits Hurrell had made of her husband, Douglas Fairbanks, and his son.

OPPOSITE: In 1933, Clark Gable was in his second full year of stardom, and he was trying to enjoy it, even if he wasn't sure it would last.

portrait in Hurrell's window. "I wish I looked like that," said Mary Pickford.

At thirty-nine, Pickford was no longer "America's Sweetheart" but still internationally famous. She was making a new film, *Secrets*, the story of a pioneer woman who triumphs over a lifetime of hardship and tragedy. Pickford wanted to show her fans that she was an adult, not "Little Mary, the Girl with the Curls." Playing characters such as Pollyanna had made her one of the richest, most powerful women in Hollywood, but she yearned for a mature image. Hurrell could create it. He took his gear to Pickfair, the estate that Pickford and Douglas Fairbanks Sr. had occupied at the height of their phenomenal fame. Their marriage was strained, which was another reason

Pickford wanted alluring portraits by Hurrell. The images he created of her were both wistful and vaguely sensuous. She was pleased and became a repeat client.

Soon after this, Hurrell photographed another thirty-nine-year-old star. Mae West had just burst onto the scene in the racy, funny *She Done Him Wrong*. This slightly

ABOVE: Mae West sat for Hurrell in the portrait gallery at Paramount Pictures, a company that owed her a great deal in 1933. Her films saved it from bankruptcy.

OPPOSITE: Carole Lombard schooled herself in photographic technique so she could get better portraits. In the spring of 1933 her studies led her to Hurrell Photography.

cleaned-up version of her stage play *Diamond Lil* was breaking attendance records everywhere and bringing desperately needed cash into Paramount's coffers. In fact, the film saved the company from receivership. Everyone was seeing it. Even Mary Pickford had a comment: "I passed the door of my young niece's room," said Pickford. "She's been raised, oh, so carefully. And I heard her singing bits from that song in *She Done Him Wrong*. I say 'that song' because I'd blush to quote the title." The song was "A Guy What Takes His Time."

Mae West was on her way to becoming a cultural phenomenon. The only problem was that no one knew what she looked like out of her 1890s costumes, not even Hurrell. "The first time I saw her," he said, "I was standing in the reception room at Paramount, there by the Marathon Street gate, and she came walking in. Well, I thought, 'Who is this?' But she came in like she was Mae West. So it couldn't have been anybody else!" Hurrell knew immediately that West was bound for stardom. "You could feel an atmosphere to it," said Hurrell. "You felt inspired when someone like Mae West or Marlene Dietrich or Joan Crawford walked into the room." In case he did not feel inspired, West was willing to help.

Hurrell was shooting West in the Paramount Pictures portrait gallery when she asked him to dismiss Al St. Hilaire. "George," she said, "I want you to take some nude shots of me."

"I'd been around Hollywood for quite a spell," recalled Hurrell, "but this was the first such request I'd had from a major celebrity. She removed her clothing and I discovered she had a beautiful body. I made the shots, she dressed and, just before she left, she held out her hand."

"Now give me the plates, please."

Hurrell complied, and the nude portraits of Mae West disappeared into her collection, never to be seen again.

By the late spring of 1933, America's fiscal crisis had passed, thanks to President Franklin Delano Roosevelt and the first of his New Deal policies. The country had a leader who could both unify and galvanize. He was a real-life hero to many. First Lady Eleanor Roosevelt was equally respected. In June she flew across-country, and, while she was in Arizona, one of Hurrell's society clients phoned.

Mrs. Franklin K. Lane Jr. explained that Mrs. Roosevelt had been the victim of a series of unflattering pictures. After refusing to be photographed for two years, Mrs. Roosevelt had agreed to sit for *Junior League* magazine—but only if Hurrell made her portrait. He was flabbergasted.

On June 6, Hurrell carried his camera and lights into 701 South Ardmore, the Wilshire District mansion of Franklin K. Lane Jr. Hurrell would have seven—count 'em—seven minutes to make a portrait of the First Lady of the United States. After setting up, Hurrell waited for an hour. There was a hubbub, and Mrs. Roosevelt entered the palatial living room exactly on time, and wearing a blue floral-print dress. "So nice to meet you, Mr. Hurrell," she said, and he thought to himself that she sounded like Ethel Barrymore. Hurrell was struck by her poise and by the way she put him at ease, asking about his work with film stars. She was good-humored about her misadventures in photography. "For a lady who was through with photographs," she smiled, "I seem to be doing pretty well." Hurrell quickly exposed the plates, and Mrs. Roosevelt took her leave. "A few weeks later," recalled Hurrell, "I received a note saying that she thought the photographs were some of the best ever taken of her."

Hurrell shot more freelance actors for Helen Ferguson but only an occasional M-G-M actor. The studio was ignoring him. Bull was shooting more sittings, and Strickling had brought in a New York photographer named Harvey White, who was shooting Jean Harlow for *Dinner at Eight*. White's work was excellent, and as sexy as Hurrell's, but the artist was troubled. "Harvey came to M-G-M after I left," said Hurrell. "He was damn good. He did his best work on Harlow, but he had a problem. He was an alcoholic. He'd get stewed and sit on the steps of Howard Strickling's office, singing and shouting. Finally, L. B. Mayer passed by and saw this, and that was the end of Harvey White. They wouldn't even credit him."

OPPOSITE: Jeanette MacDonald came to M-G-M in the hopes of reviving a stalled career. Her first M-G-M portraits, shot by Clarence Bull, did not quite come off, so Howard Strickling assigned her to Hurrell, who found her best angles.

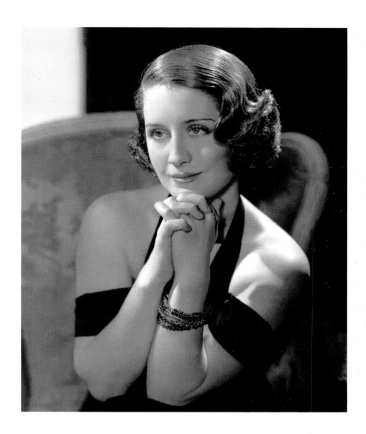

Producer David O. Selznick decided that he needed more images of Harlow to sell *Dinner at Eight*, so Strickling called Hurrell to M-G-M in June. Hurrell saw that Harlow had acquired a suntan in her garden. The tanned girl who carried her navy blouse and white satin gown to the standing set from *Dinner at Eight* was not the wisecracking doll she had portrayed three months earlier. "When you got her alone, she became sweet and shy," said Hurrell. "It was like she didn't have to be 'Jean Harlow' anymore."

Jean Harlow was her mother's maiden name. It had replaced her own, Harlean Carpenter, when she started acting. Even the most disinterested onlooker could see symbiosis in Harlow's relationship with her mother, Jean Bello. The mother was a frustrated actress who lived through—and off—her overly dependent daughter. Hurrell was acquainted with Jean Bello. "She had will," he said. "She had willpower, and the Baby didn't." The only resistance Harlow put up was when her mother's husband, an oily con man named Marino Bello, became obstreperous. Then Harlow would seek refuge in gambling, drinking,

or sexual adventures. Her mother tried to monitor the drinking. Harlow was resourceful. "I'm not going to drink around her," she said, "but I *am* going to drink." One place where she could drink was at Hurrell's studio. Knowing that he did not countenance interference, she went to the studio alone.

The session commenced with her navy blouse. It continued with gin, which Hurrell shared. Inspired by

OPPOSITE: Hurrell was justifiably proud of the portrait he made of First Lady Eleanor Roosevelt on June 6, 1933. "She was warm, outgoing, and bright," remembered Hurrell. "She had a genuine interest in other people."

ABOVE: Hurrell's patron, Norma Shearer, was absent for almost a year. "When illness rendered me useless," said Irving Thalberg, "Norma unhesitatingly risked everything for me. The bugaboo of a star—being off the screen for any length of time—she flouted for my sake. She left her work to go abroad with me, helping me in my pursuit of health." Hurrell made this portrait in the fall of 1933, shortly after Thalberg and Shearer had returned to Culver City.

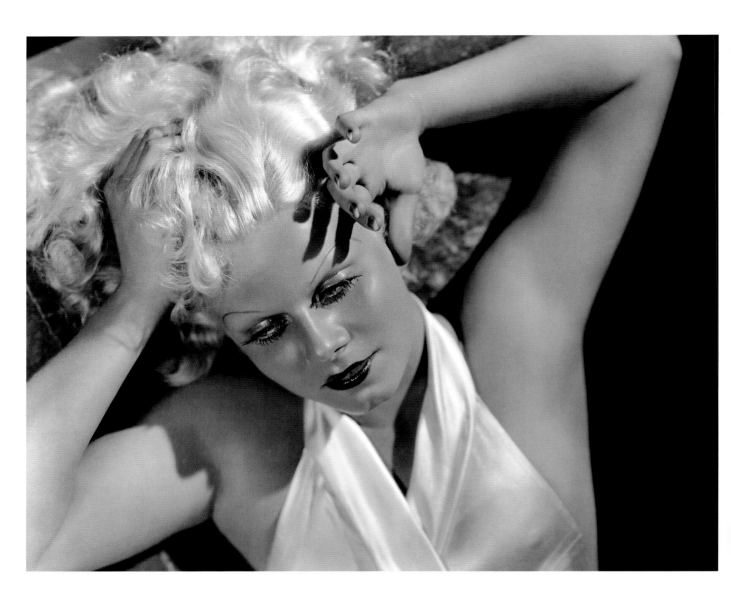

ABOVE: Jean Harlow had a backyard tan when she reported to the standing sets from *Dinner at Eight* to work with Hurrell. This was the gown that Harlow wore to the eponymous dinner party, but this was not the mood of that scene. "I was trying to get something with a sexy quality to it," said Hurrell, "so the first thing I would do was put the girl on her back. But she couldn't have her hair under her head. They had to brush it back, with the hair flying out. That's where that thing came from."

OPPOSITE: Hurrell and Harlow dreamed up poses to ignite the pages of *Photoplay*.

OVERLEAF, LEFT TO RIGHT: Harlow's sailor suit came from her own wardrobe, not from Adrian's salon.

Joan Crawford had a career breakthrough in late 1933 with David O. Selznick's production of *Dancing Lady*.

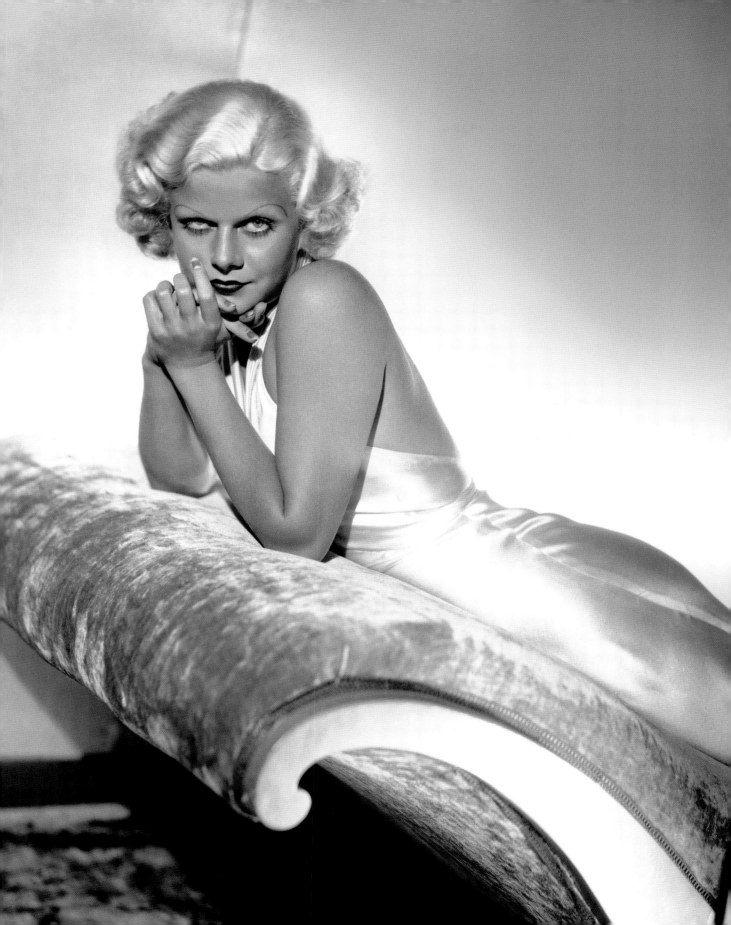

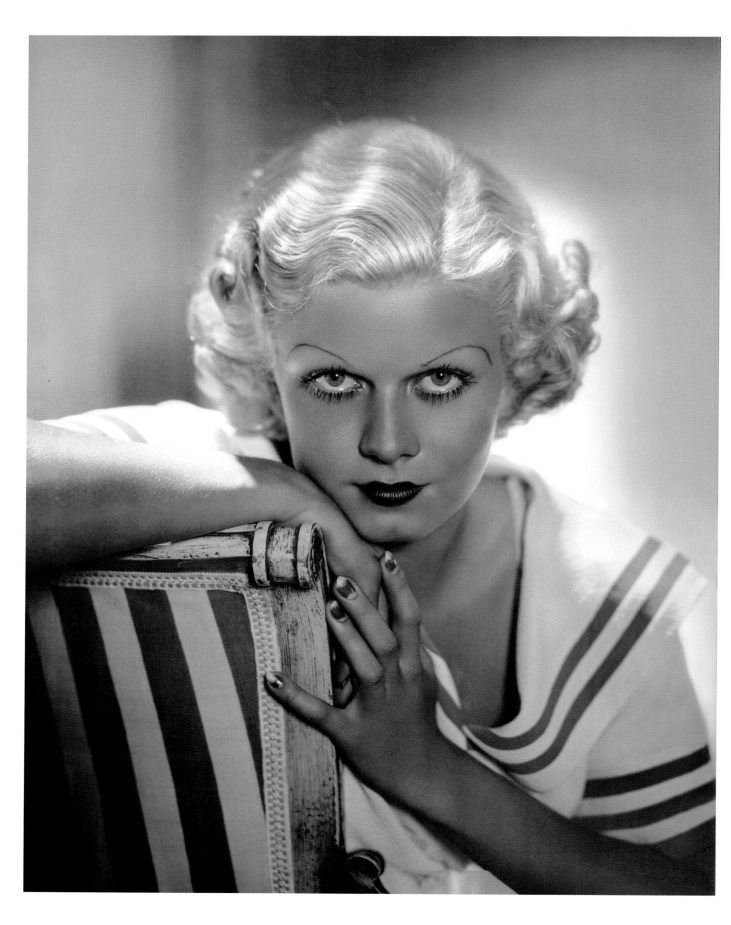

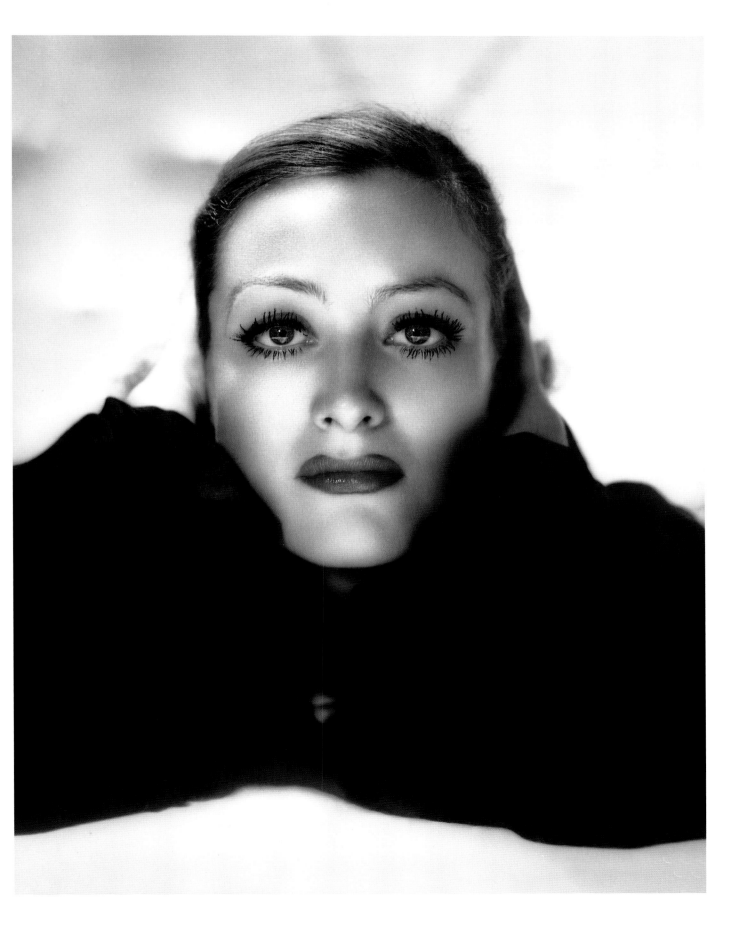

the Muse and fueled by the gin, he shot the most erotic sitting of his career. He accomplished it with a line of talk that would have shocked Sigmund Freud. There was no M-G-M stenographer there to transcribe it, but second-hand reports say that he painted word-pictures of Harlow's sexual fantasies.

The photos created a sensation. Hurrell's client load increased dramatically. Mary Pickford introduced Hurrell to her studio, United Artists, and to her director, Frank Borzage. When Hurrell attended a party at Borzage's house, he met a beautiful brunette who had once been chosen "Miss Seattle" by Rudolph Valentino. Her name was Katherine Cuddy. By the end of the summer, she and Hurrell had eloped to Santa Barbara. Before the newly-weds could enjoy a real honeymoon, Hurrell was swamped with work. Joan Crawford was making a comeback with a new musical, and Norma Shearer had come back from Europe with a new wardrobe. The studios were enjoying a resurgence in ticket sales and could afford Hurrell's fees. He had just enough time to find a home for himself and Katherine at 8254 Fountain Avenue. Maggie Ettinger and Helen Ferguson continued to push him. A *Movie Mirror* article, "The Camera Does Lie," called him "Hollywood's youthful wizard." By December, he had shot fifteen more Metro stars. Every week he put a new enlargement in the window of Hurrell Photography, and Hollywood watched 8706 Sunset with growing interest.

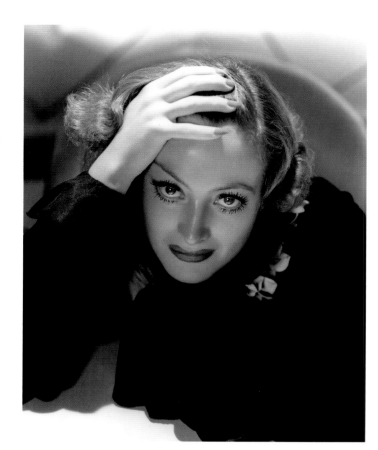

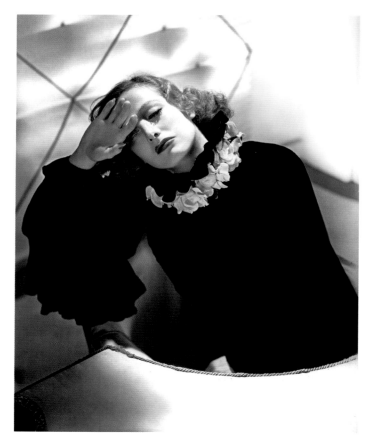

TOP AND BOTTOM: This backstage musical became known as M-G-M's "100 percent commercial picture." Hurrell's *Dancing Lady* portraits are among his best.

OPPOSITE TOP AND BOTTOM: Shooting Crawford in black velvet against white satin flew in the face of traditional portrait technique, but Hurrell used bounce lighting from the white surfaces to make it work.

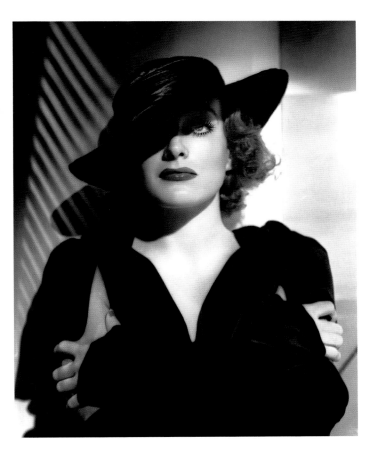

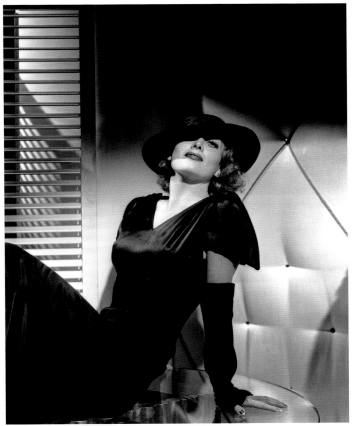

OVERLEAF, LEFT TO RIGHT: Hurrell and Crawford did several sessions at the time of *Dancing Lady*. "Crawford had that kind of photographically perfect face," said Hurrell. "You could light her from almost any angle and it would work."

In September 1933, Crawford was living a real-life romance on the set of a movie. She was in love with her *Dancing Lady* costar, Franchot Tone. Hurrell made this study of them in her living room.

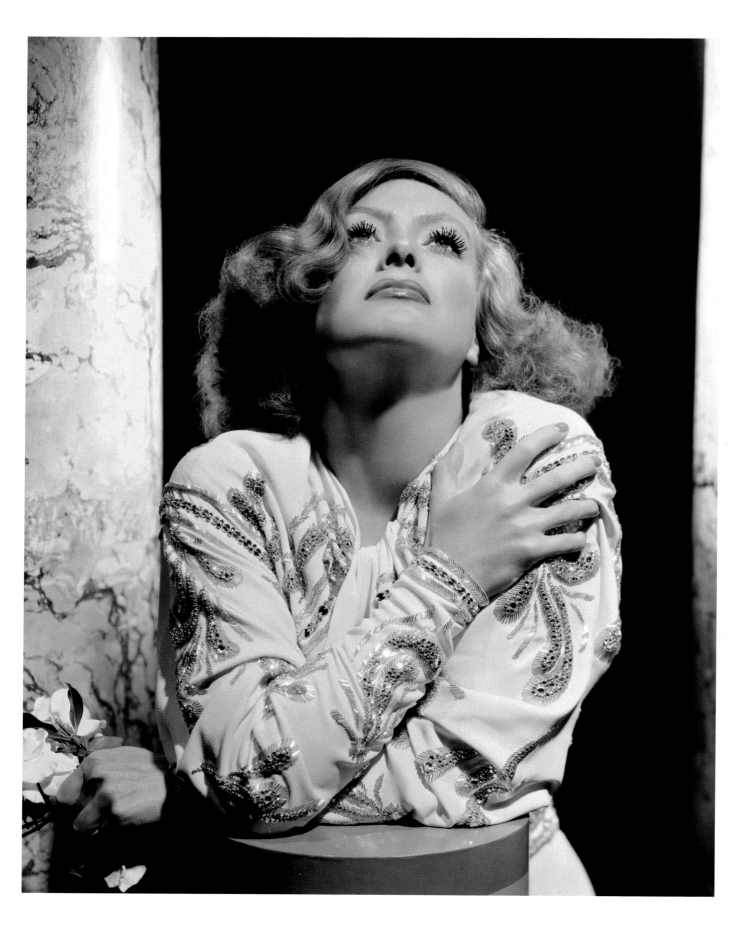

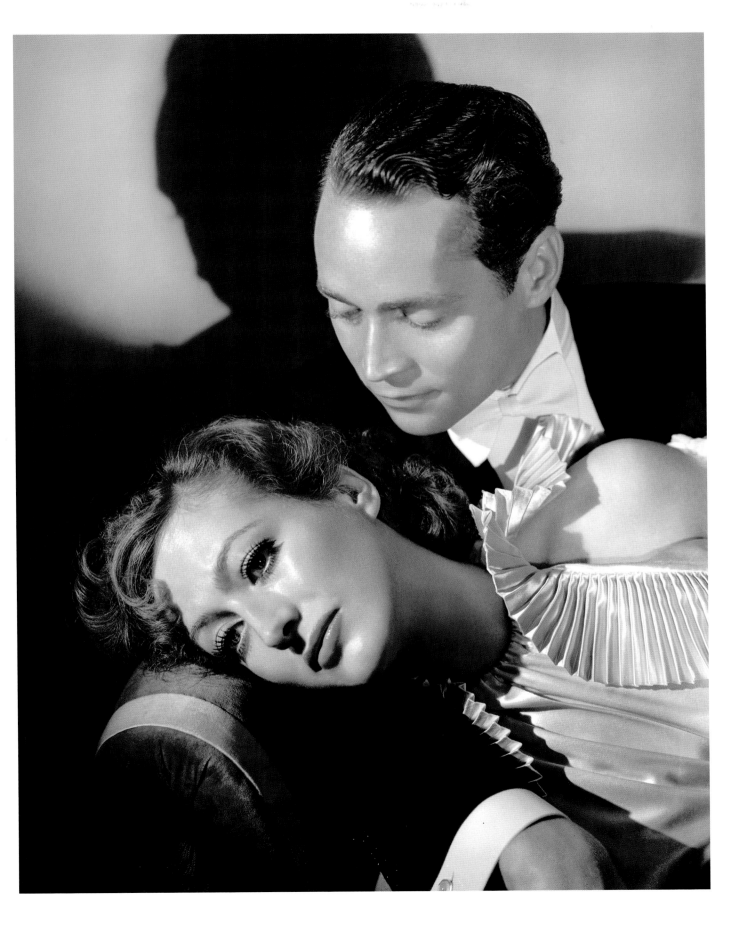

THE HURRELL STYLE

In late 1933 George Hurrell gained a generous new client. Samuel Goldwyn was known as the prince of independent producers. He released finely crafted films like *Arrowsmith* and *Street Scene* through United Artists, yet he envied M-G-M for Garbo and Paramount for Dietrich. He was determined to create his own exotic star. In April 1932 he imported Anna Sten, a Ukrainian Swedish actress who had renounced her Soviet citizenship to work for the Ufa Studios in Berlin. Goldwyn coaxed Ruth Harriet Louise out of retirement to make Sten's first American portraits. The actress was subjected to English lessons, drama coaching, screen tests, and halting interviews, but no project eventuated until August 1933, when she finally began filming a bowdlerized version of Émile Zola's *Nana*. Then Goldwyn brought in Hurrell. "We make Ann a star," Goldwyn said proudly.

Hurrell found "Anoushka" Sten easy to work with and remarkably photogenic. "Anoushka's face could be entirely changed by lighting," he said. "Lights from different directions painted different pictures on her features. Her face was like a canvas." After Crawford and Shearer, Sten was his most-photographed subject of 1933. "I took hundreds of exposures of her," said Hurrell. "And Sam was a funny guy. He had a great big office, and he'd spread her pictures out on the floor. Sixty or seventy big prints. And then he'd walk around, trying to think of how to make her a star." After two years of hyperbole, Sten's debut in *Nana*

was a cruel disappointment. She was an accomplished actress but lacked that intangible something that makes a star. "Sam spent millions," said Hurrell. "But nobody went to see Anna Sten." They did see his photos of Sten, which were stylish.

What Hurrell was accomplishing was not merely stylish; it was a new style. Moving to 8706 Sunset had initiated another period of artistic expression. Hurrell's fourth period of work was distinguished by the effortless look of his images and the seamless integration of unique effects. Gone were the urgency and experimentation of his Verito days. His boisterous self-confidence had mellowed into an unspoken self-assurance. Each sitting followed a graceful

OPPOSITE: Samuel Goldwyn was determined to make the Ukrainian Swedish actress Anna Sten the next Garbo. One man's obsession became another man's income, and Hurrell finished 1933 in fine shape. This portrait was made to publicize her debut film, Dorothy Arzner's *Nana*, which was released in 1934.

OVERLEAF, LEFT TO RIGHT: Paulette Goddard was a "Goldwyn Girl," one of the chorines who both decorated and enlivened his films. When Hurrell put her against this cellophane background, she had been signed by Charles Chaplin.

Hurrell painted indirect light on calla lilies for this portrait of Mary Pickford.

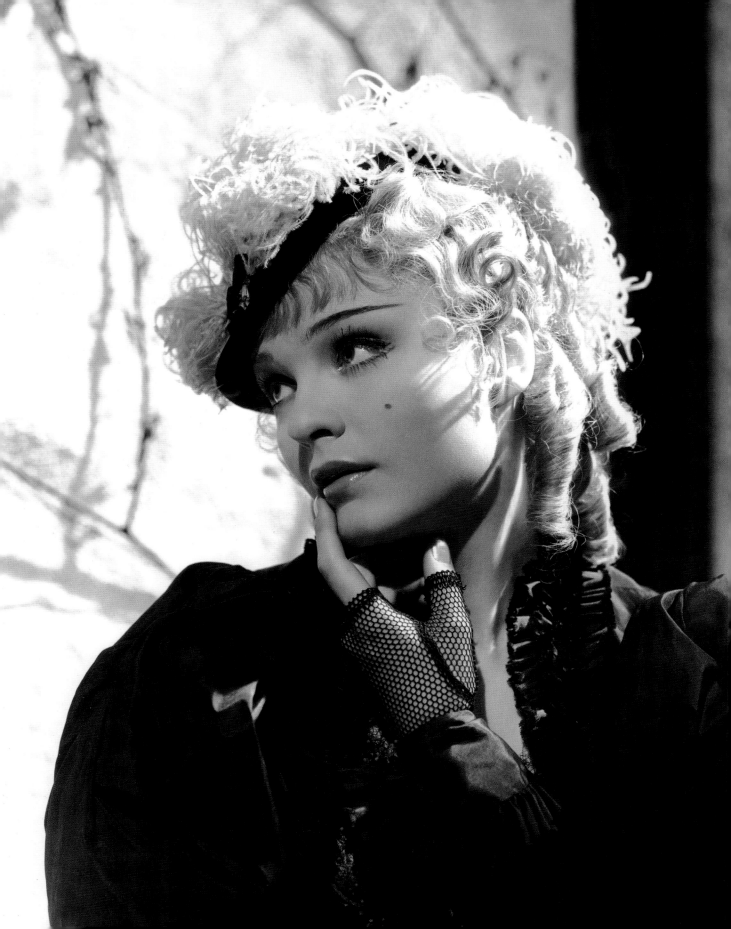

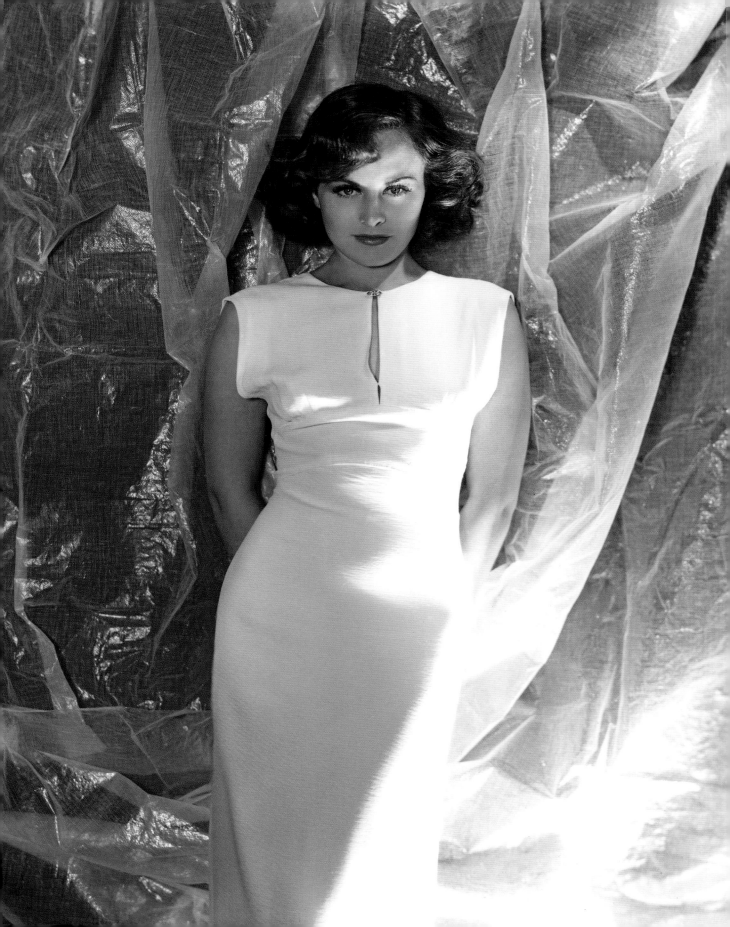

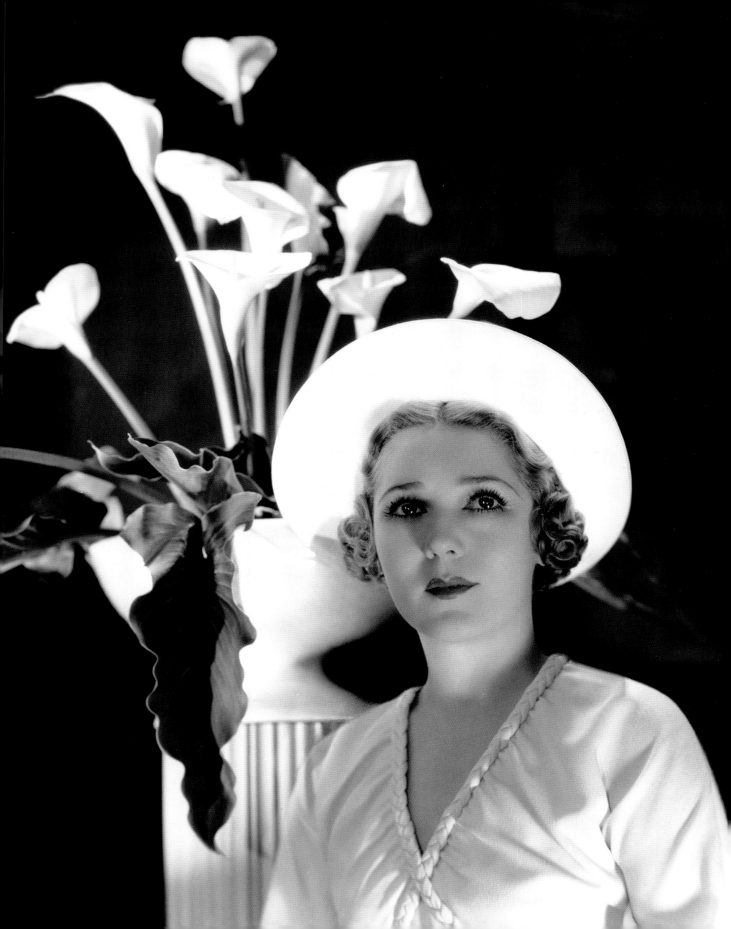

arc. Each was tailored to the subject, yet had a consistent polish. Because Hurrell had his own studio he could evolve his art without interference or interruption. Hurrell's trademark effects included: shooting a subject upside down on the floor so that her cascading tresses seemed to fly up; an occasional "Dutch tilt" to throw vertical lines zanily out of plumb; using only one light, a spotlight, to shoot a subject against a white wall; elongated eyelash shadows; the placement of the boom light so that it shone down from behind, or down the part in the subject's hair, or onto the cheekbones; a spotlight shining up from the floor; lead retouching to lighten the iris of the eye; a tiny dot of retouching "opaque" to enlarge the specular highlight in each eye; and using a spotlight instead of a soft light as the fill.

Except for manufacturing film, Hurrell controlled every aspect of his work. He was known, for example, for his attention to the subject's wardrobe. Prior to every sitting he conducted a consultation and recommended specific clothing. "Personally I like blue and white, or a black and white contrast in gowns," he said. "Printed materials detract from the face." Once the correct garment was chosen, he carefully arranged the folds in its fabric and the fingers on each hand. Some models could do it themselves. "If I posed Jean Harlow in a certain attitude that did not look quite right in my camera," recalled Hurrell, "I would say, for instance, 'Change the position of your left hand,' and she would deftly move her palm or her fingers a fraction of an inch without altering the whole effect." Inside 8706 Sunset, clients surrendered to Hurrell's taste and abided by his judgment.

ABOVE, LEFT TO RIGHT: "Wallace Beery projected so much," recalled Hurrell in 1969. "He was the kind of guy who would be ideal today for the motor-drive [camera] because he kept up this action. He never stopped. He couldn't hold still. He liked me 'cause I was so fast!"

This sheet music for the theme song from the David O. Selznick production of Jack Conway's epic *Viva Villa!* shows one of the many ways in which Hurrell's images were used.

ABOVE, LEFT TO RIGHT: Eddie Cantor was a big moneymaker for Samuel Goldwyn Pictures, but the independent studio had no portrait gallery, as such. It only had a stills department, which was headed by the unit photographer Kenneth Alexander. Goldwyn grabbed Hurrell and got him to shoot Cantor.

Stuart Erwin was one of many freelance actors who visited Hurrell Photography in 1934.

OVERLEAF, LEFT TO RIGHT: Mae Clarke posed for Hurrell when she was making a comeback after the nervous breakdown that followed her successes in *Frankenstein* and *Waterloo Bridge*.

William Powell's home featured a handsome display of Hurrell portraits given to him by his stellar friends.

Hurrell was a one-man band but he was not solipsistic. He studied the work of other artists, especially the elegant George Hoyningen-Huene and Cecil Beaton, who frequently visited Hollywood, photographing stars for *Vanity Fair* and *Vogue*. Hurrell shot them both. Beaton had done a noteworthy portrait of Shearer in 1930, using spotlights and cellophane. Hurrell liked the effect, so he ordered rolls of the stuff and posed numerous subjects in front of it: Jean Parker, Carole Lombard, Paulette Goddard, and Ethel Merman. When asked about the cellophane years later, he laughed, "We had a run on it." It was typical of him to transform a design element into a signature effect.

OPPOSITE: In 1935 Hurrell was experimenting with multiple exposures, as in this portrait of Merle Oberon.

ABOVE: The East Indian classical dancer Ram Gopal was photographed by Hurrell in February 1938 to publicize a concert series at the Wilshire Ebell Theatre.

Hurrell was also fond of his sprayed stucco wall. When Wallace Beery came directly from the dusty sets of *Viva Villa!* he was still in costume and, as always, anxious to leave. "I put him up against the wall," said Hurrell, "and shot seventy-two poses in forty-five minutes!" Many of these poses were out of focus, but M-G-M used them anyway. Just as many, though, were excellent. Hurrell liked that sprayed stucco so well that his next apartment, 1332 ¼ North Miller Drive, had the same look.

In 1934 the Great Depression lightened. Americans began returning to the movies. Hollywood was flush again, and Hurrell doubled his fee from $250 to $500 a sitting. Howard Strickling gulped and continued to book sessions, sometimes more than two a day. "One day I made fifteen hundred dollars!" Hurrell recalled. Strickling would call when the studio had a new actress who needed a different look.

Rosalind Russell was considered "horsey." When she finished J. Walter Ruben's *Trouble for Two*, she was driven

to Hurrell's studio by a publicist, "along with a load of evening dresses, turbans, veils, and earrings." Years later she could still remember that the session lasted until seven in the evening and that after she changed back into her tweed suit, the publicist had the bright idea of walking down the street to the Trocadero nightclub—where every other woman was wearing satin. Louis B. Mayer accosted her and said, "You're a wonderful girl but you represent yourself as a cold New England woman." This was why she was getting the Hurrell treatment.

Jeanette MacDonald had been the "lingerie queen" in a series of sophisticated Paramount films made by the masterly Ernst Lubitsch, but after signing her, M-G-M could not find the right look for her; she had a prognathous jaw. It was left to Hurrell to find her best angles. He elicited a combination of operetta grandness and sultry seductiveness. MacDonald's spark of stardom was ignited. So was Russell's. This was the oft-invoked "star quality." Hurrell knew that it existed. When he photographed socialites, he could make them look attractive, but he could not make them glow from within. That was the intangible thing that made a star. That was glamour. MacDonald and Russell had it. "Those gals were products of that period," said

RIGHT, TOP AND BOTTOM: Clifton Webb came to Hollywood in May 1935 with eighteen trunks, twenty-two handbags, and his mother, Maybelle, expecting to appear in a Joan Crawford film tentatively titled *Elegance*. After waiting eight months to rehearse with Crawford, Webb was disappointed to see the project canceled.

Hurrell photographed Edward Weston and his wife, Charis, in Carmel, California, in 1936. "I admired his work," said Hurrell in 1980. "I still think that he's the only great artist in the history of photography. He was a purist. He was a technician. You name it and he was it."

OPPOSITE, TOP AND BOTTOM: Not content with double exposures, Hurrell used triple exposures on, respectively, Nelson Eddy and Joan Crawford.

OVERLEAF, LEFT TO RIGHT: From 1935, double exposures of Jean Harlow and Norma Shearer; Hurrell drew on his camera's ground glass with grease pencil to indicate the size and placement of each face.

Hurrell. "After somebody coined the word glamour, they thought that way and they felt that way. They developed that thing. They projected that quality. You'd see them at parties, for instance, cocktail parties, just idle things, but when they'd come through the door, they wouldn't just walk through it. They'd *arrive*. I never saw anything like it. It was as if they had internal trumpets that blew just as the door opened."

By 1935 Hurrell was getting regular referrals from every studio but Fox Film and Warner Bros. Fox was in a state of turmoil and Jack Warner was too cheap to pay for portraits outside his own gallery. Warner's attitude was one reason why his head of production, Darryl F. Zanuck, had left in April 1933. Zanuck, who was second only to Irving Thalberg as a brilliant production chief, started his own company, Twentieth Century Pictures. The legendary Harry Brand was its head of publicity and threw a great deal of work to Hurrell. In May 1935, Zanuck merged Twentieth Century with the Fox Film Corporation. Soon Hurrell was getting even more calls from Brand. Twentieth Century-Fox had the temperamental Simone Simon, the precocious Shirley Temple, the sunny Alice Faye, the sinuous Dolores Del Rio, and, last but not least, Loretta Young.

"Loretta Young was one of the most inventive subjects that I ever shot," said Hurrell. "She always had exciting ideas about the way she should be shot. She had radiance." Young was barely twenty-three but a veteran of more than sixty films, so she knew a few things about being photographed. "I saw some pictures of his when he had his gallery on Sunset," recalled Young, "and I thought they were gorgeous." At the time, Young was being photographed by the in-house portraitist Eugene Kornmann. She went to Harry Brand and told him: "The next sitting I have, I want to go to George Hurrell." She did and they hit it off. "She was a disciplined pro," said Hurrell. "I don't think we ever repeated a pose."

Pancho Barnes had brought Ramon Novarro to Hurrell, and Joan Crawford had brought the younger actress Gail Patrick to watch a Hurrell session, but Loretta Young went them one better. The unit still photographer on her films at Twentieth was named Frank Powolny. He kept asking Young if he could do portraits of her. Finally

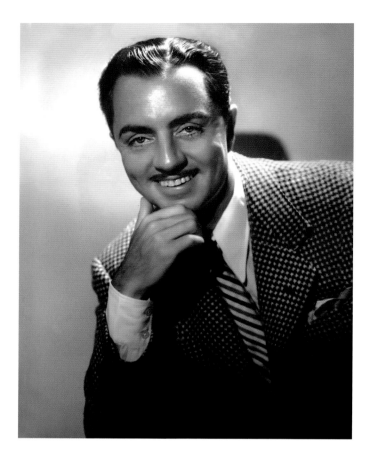

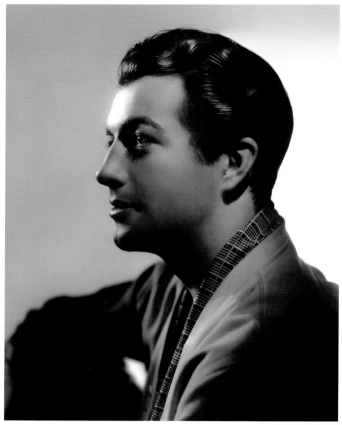

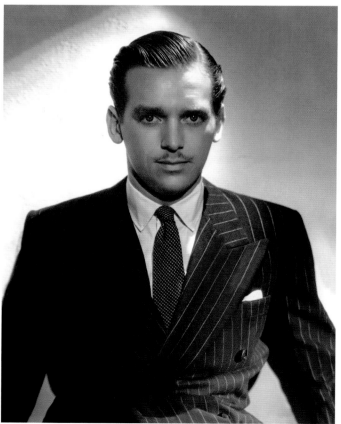

CLOCKWISE FROM TOP LEFT: When William Powell was cut loose by Warner Bros., M-G-M picked him up and created a breezy new character, the one he played in *The Thin Man*. "Bill hated stiff poses," said Hurrell. "He'd been photographed soberly too often, especially when playing 'heavies' early in his career. So I put on hot swing music and hollered and danced and tore my hair, breaking him up time after time."

Robert Taylor was photographed with unconventional lighting because some photographers had made him look too "pretty."

Douglas Fairbanks Jr. came to Hurrell because he was making a costume film, *The Amateur Gentleman*, for his own company, Criterion Pictures, and needed a contemporary-style portrait.

OPPOSITE: "Bob Taylor wasn't the ambitious type," said Hurrell. "He was never up there at the front office, fighting for roles. And he was very casual about his good looks. He just liked being at his ranch. He was a delightful guy."

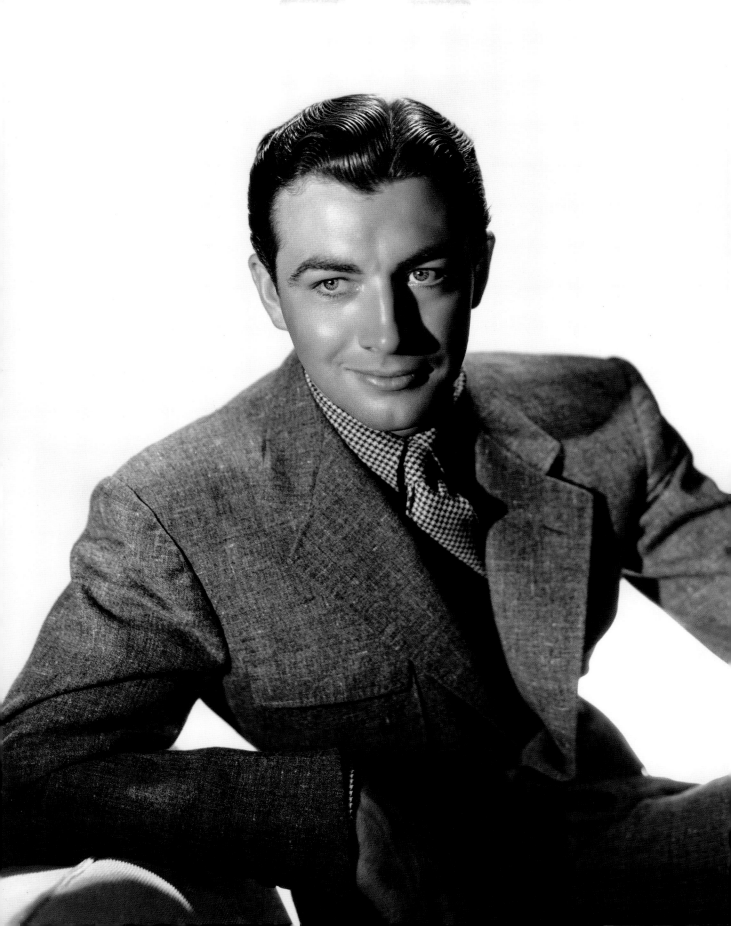

she agreed, but only if he could do a certain kind of photography. "Just take a look at those Hurrell things," she told Powolny. "That's how I want to look." It was a tall order, to be sure, but Powolny was able to satisfy her. He had to. She could not always get Twentieth to pay Hurrell's fees. And yet there was no one like him. "What I liked about the way he photographed was the way he made you look so glamorous," she recalled years later. "And your skin looked

so shiny. I know the secret. He was the first man who said that he didn't want any makeup. You used to put a little oil on your face and that was all. You could wear eye makeup if you wanted to, but no greasepaint. Your skin in the photo looked like you could touch it. It didn't look like chalk. It looked like skin."

Less than three years after opening his own studio, Hurrell was the most sought-after photographer in Hollywood. He was averaging fifty sittings a year. But if his energy was inexhaustible, his patience was not. The old restlessness was back. "Familiarity breeds contempt" was admittedly one of his pet theories. He had to calm himself, though, because this was one job he could not quit. It helped his moodiness if he got out of town, so in August 1935 he took Katherine to New York for a short vacation. The cream of Gotham society demanded portraits, and he rented a studio on the mezzanine of the Sherry-Netherland

OPPOSITE: When Rosalind Russell came to Hollywood in 1934, she was not interested in glamour. "I wasn't a sex symbol and never could be," she wrote years later. "I was always a character actress." This portrait was made to publicize Frank Lloyd's *Under Two Flags*, a 1936 film from the newly merged Twentieth Century-Fox.

ABOVE: Sylvia Sidney was another freelance player who benefited from Hurrell's elegant portraits.

Hotel. He also shot fashion for Bergdorf-Goodman and advertising for Elizabeth Arden. The vacation lasted two months, and, when he grew vague about a return date, Strickling began interviewing photographers. "Howard looked at one fellow's portfolio," said M-G-M photographer Ted Allan. "His name was Stephen McNulty. They didn't know when—or if—George was coming back. So they hired this McNulty. Come to find out he was a male model and this portfolio was something he'd got together from all his pals' portfolios. He gave himself away by putting oil in a lens to make it 'shoot faster.' Metro lost a lens and he lost his job."

Meanwhile, Hurrell was in Ensenada, shooting the locals with Ted Cook, a *Los Angeles Examiner* columnist. Hurrell had gone there to paint landscapes, but he met Cook, stopped painting, and started shooting. When Joan Crawford started clamoring for portraits, the vacation

ABOVE: This 1937 portrait of Dolores Del Rio was made in the Art Deco home designed by her husband, Cedric Gibbons, who was head art director at M-G-M.

OPPOSITE: An artificial tree was placed in front of a white backdrop for Hurrell's portraits of Johnny Weissmuller, whose next film would be *Tarzan Escapes*. Needless to say, this actor's vibrance overcame the artificiality of the setting, and the image became a prized pinup in 1935.

OVERLEAF, LEFT TO RIGHT: Charles Boyer was making films for Walter Wanger Productions, which had no portrait gallery, so he came to Hurrell for a series of stunning portraits.

Simone Simon was a sexy actress imported from France by Darryl Zanuck and Twentieth, so Hurrell was enlisted for a massive publicity push.

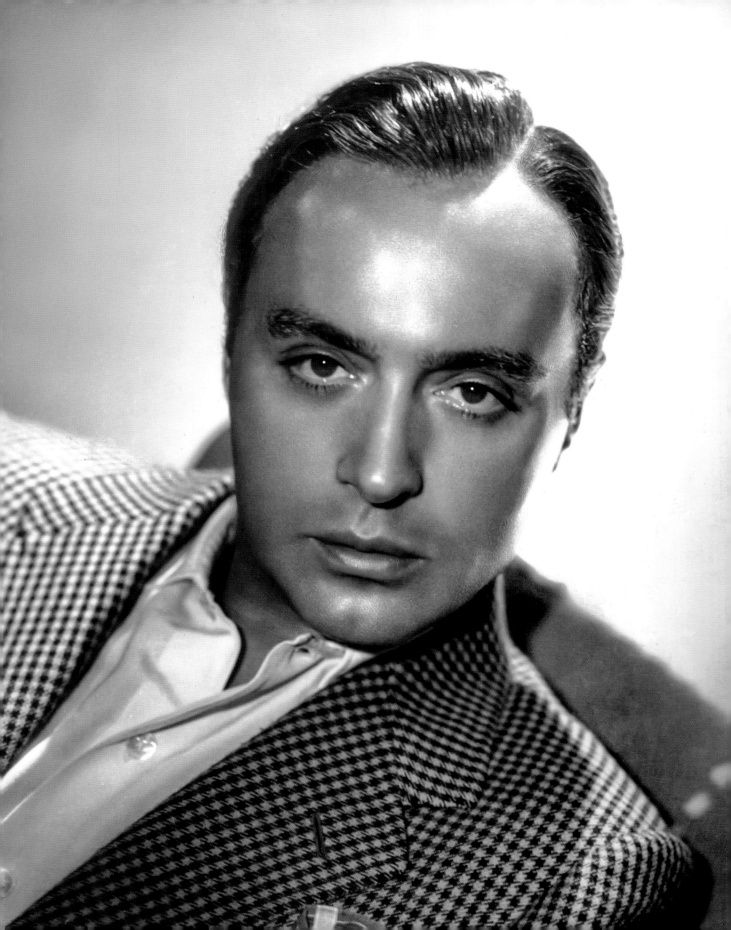

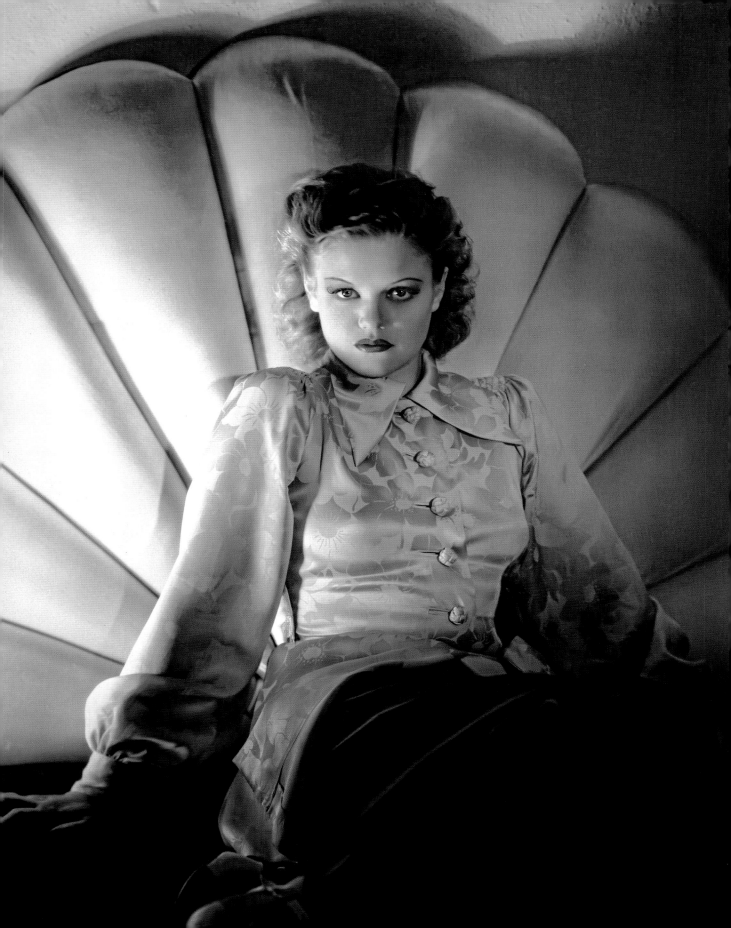

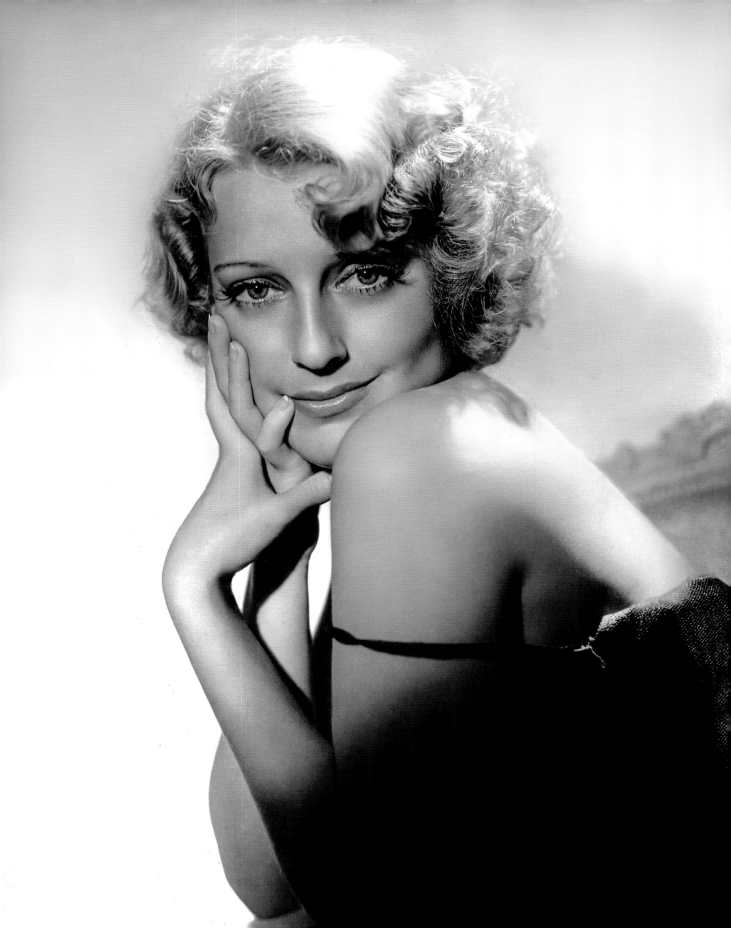

ended. In January 1936 Hurrell took time off and drove to Carmel to visit a new friend, the photographer Edward Weston. "He was an artist," said Hurrell in 1980. "He knew composition. He had an innate quality. I can't think of any other photographer who had it, including the great Steichen. Now Steichen had a semblance of greatness about him, in a different vein, but he didn't have that simple quality that Ed had. I think of Weston as just so great, instinctively. No matter what he did, no matter how he approached it, nobody could match him. Everything that he did had an original quality to it."

In May Hurrell went back to Mexico. In July he returned to New York, where he signed a contract to supply *Esquire* with one Hollywood glamour portrait per month. Back in Los Angeles, he spent weekends shooting abstracts with Ted Cook. This work was exhibited in April 1937 at the Chouinard Art Institute. On the day after the opening, the two artists headed for Ixcatepec.

If Hurrell could not escape the pressures of work with travel, painting, or fine-art photography, he partied. "All you had to do was go to some friend's house," he said, "and boom, there was a big gathering. But I didn't like standing around. I preferred, if I had to get drunk, to sit down with a friend or two and get drunk. I'd just play at it and keep chattering away, being *non compos mentis* about things you didn't even want to talk about." Interestingly enough, the few stars with whom Hurrell socialized liked fishing, not drinking. There was Johnny Weissmuller, with whom Hurrell would go to Mexico, and Robert Taylor, who enjoyed fishing more than acting. "We would gab, not about the studio, but about where the salmon were running," recalled Hurrell.

When Hurrell came back to earth, there was much to be grateful for. By 1937 he had been accepted into International Photographers, Local 659. Its house organ, *International Photographer* magazine, voiced the sentiments of the film capital when it described Hurrell as "one of the ace portrait photographers of the day."

OPPOSITE: Jeanette MacDonald had a session with Hurrell in early 1935. She had just completed W. S. Van Dyke's *Naughty Marietta* with her new costar, Nelson Eddy. Hurrell revisited the sexiness of MacDonald's earlier films and avoided the coyness of her later work.

THE ICONS

By the late 1930s, the word *glamour* had gained currency in connection with motion-picture stars. In years to come, journalists, essayists, and historians would refer to movie stars as "screen queens," "love goddesses," and "super-stars." It was not until the 1970s, however, when journalist John Kobal was writing about Hollywood portrait photography, that the word *icon* was used to describe a movie star. "The people in these photographs are not real people," Kobal said in a 1974 interview. "They are icons. In those Depression days, stars had to be removed from reality, from anything that had to do with mundane everyday life. It was as if the gods were stepping down from Mount Olympus to momentarily deal with mortal problems."

In the course of his research, Kobal interviewed George Hurrell numerous times and, as we shall see, passed many hours with him. Yet Kobal never learned that the artist had for years been exposed to religious icons. Hurrell had spent his childhood as an altar boy, looking up at life-size, lifelike plaster saints. The statues situated around the sanctuary were typically illuminated by candles from below and by spotlights from above. Thus, the glistening bounce light in Norma Shearer's eyes is reminiscent of the sparkle on the glass eyes in a statue of the Blessed Virgin. And, just as the most memorable representations of the Virgin are both universal and particular, Hurrell's greatest work in his fourth

period was accomplished with subjects whose appeal transcended individual characterizations; in other words, stars who were immensely popular—and who, defying the passage of time, have remained so. By the 1990s, the American actresses Katharine Hepburn, Carole Lombard, and Jean Harlow had been inducted into the pantheon. These Hurrell subjects are bona fide icons. Hurrell would later claim that he gave an equal amount of effort to every subject, yet there were some who simply made better photographs.

"There were only a few who possessed that indefinable quality," wrote Norma Shearer years later. "They had an aura, something that set them apart. They were special. They glittered. We have no new Hepburn or Harlow or Crawford. After them, they broke the mold. They were young, but they were not afraid to portray women who had lived and loved. They were not afraid to be different. Each star was beautiful and glamorous in her own individual way."

Hurrell had been commissioned to shoot Katharine Hepburn for a magazine feature on Paul Flato jewels. "I had never seen anyone quite like Katharine Hepburn before," recalled Hurrell. He was accustomed to stars

OPPOSITE: George Hurrell made portraits of Tallulah Bankhead in 1936 to publicize the West Coast opening of the George Kelly play *Reflected Glory*.

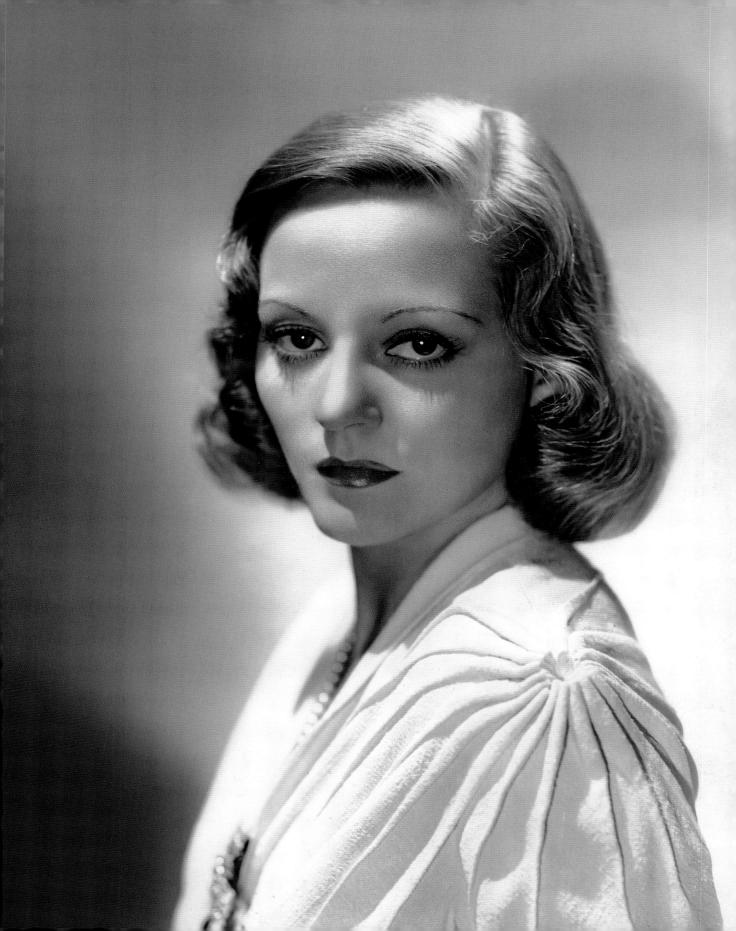

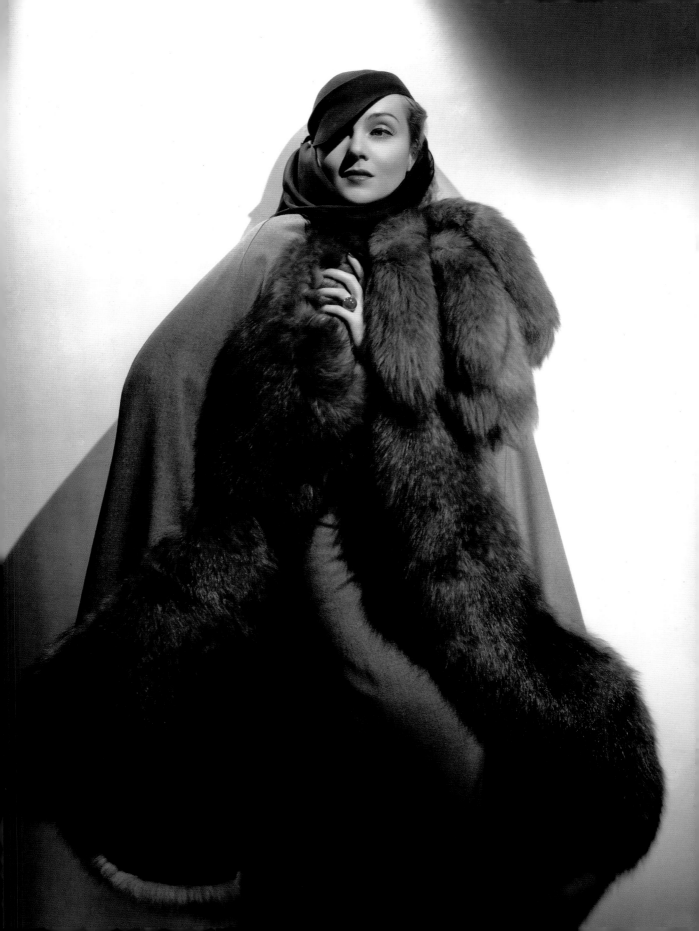

who arrived with an entourage or at least with a stylist, but Hepburn showed up alone. "She came striding into my studio in slacks and a corduroy coat, carrying a black velvet evening dress over one arm."

"It will take me only a moment to change," said Hepburn as she ducked into the dressing room. Hurrell was just setting his lights when she bounded into the shooting area. "I'm ready," she said. "Where do you want me? I think maybe if I sat in a chair where I would be comfortable, it might be better. I don't like being photographed, so it helps if I can have some support to my back."

Hurrell was still using music to draw out his subject. Hepburn talked over his records. Hurrell played a 1935 song, "Lulu's Back in Town." Hepburn listened for a moment and then said, "Don't you have anything more

up to date?" Hurrell tried "Slumming on Park Avenue." It amused Hepburn. Hurrell got a few shots, and then, before he knew it, Hepburn was at the front door, waving good-bye. Hurrell looked at Al St. Hilaire, and they both said, "Whew!"

Hurrell worked numerous times with Carole Lombard. Like Norma Shearer, she was conversant in lenses, filters,

OPPOSITE: There was no word for glamorous images of Carole Lombard until the 1970s, when John Kobal popularized the term *icon*.

ABOVE: "Katharine Hepburn is such a spontaneous personality, a glib extrovert," said Hurrell. "She talks and talks. She's amusing when she's chattering away."

PAGES 146 AND 147: Portraits of Carole Lombard for Wesley Ruggles's *True Confession*.

and lighting. Unlike that star, Lombard was content to let the artist direct the session; but she was a superb model, endlessly inventive and enthusiastic. "She never gave me any trouble," said Hurrell. "She was a real professional. Whatever you asked her to do, it was always fine with her." Lombard was often compared to Garbo because of her classical beauty and her ability to turn mannered poses into sincere expressions of emotion. "Carole Lombard has a knack for striking poses that are stately and graceful without being artificial," Hurrell said in 1939. "Ordinarily I don't like the poses of actresses, but I like Carole's." Lombard understood lighting. No star was 100 percent camera-proof and each had learned what angle to avoid. Lombard had a slight scar on her left cheek, the result of an automobile accident. She also had a strong jaw, which she trusted Hurrell to minimize. "I have to use a top light with her," he said, "because a flat light would emphasize her jaw, and that's one thing she is particular about. But she's a lot of fun to work with."

The fun was not only in the artistry. Sometimes Lombard would bring her fiancé, Clark Gable, with her, and then she'd tease him. "She could swear so fast a truck driver couldn't keep up with her," recalled Hurrell. "Gable got so embarrassed that he'd turn red in the face. The more he tried to get her to quit, the more she'd swear, just to aggravate him. She had him wrapped around her little finger." Lombard had learned in her adolescence to use profanity to ward off mashers. With colleagues like Hurrell, it was in fun and it never interfered with the work.

If any star was an icon, it was the instantly recognizable Jean Harlow. By 1934, she was a veteran of fifteen features, two divorces, and one husband's death. To Hurrell, she was "just a big, healthy, happy girl." Behind this carefree facade was a conflicted child-woman. "Jean used to come into my dressing room," recalled Jeanette MacDonald. "She had the one next to mine. She was a very unhappy young girl. She always played such sluts

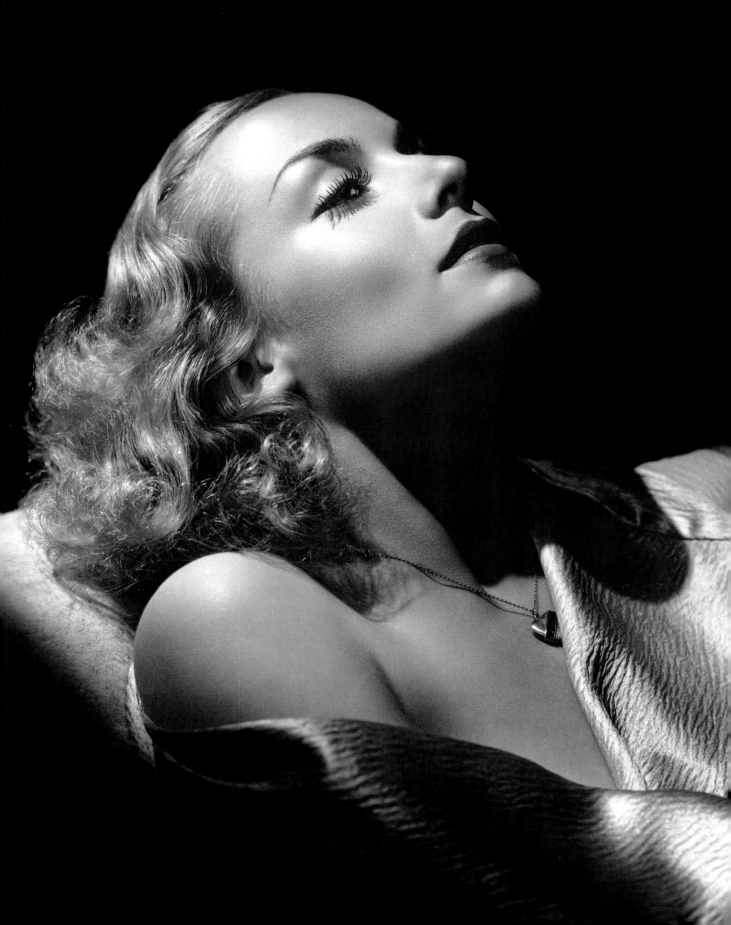

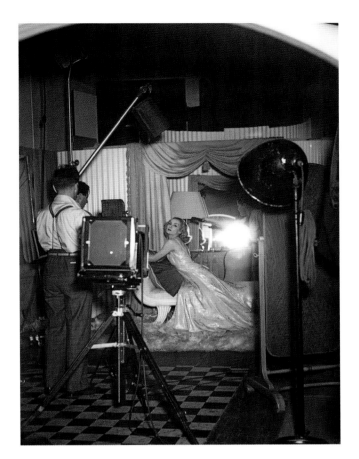

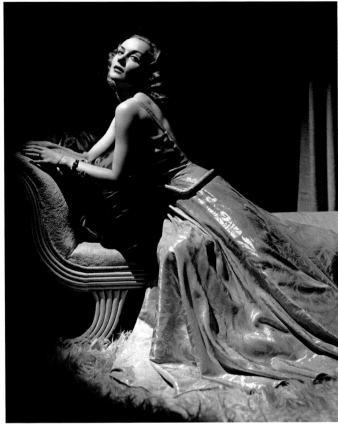

on the screen. Really, she was one of the first so-called 'immoral creatures.' At heart she was a young, naïve, nice girl who was being exploited by the studio and really wanted to be just somebody's wife. That's what she told me." This conflict could be seen in Harlow's portraits. When she turned off the sex allure and became soulful, her expressions were a little too sad. Still, she enjoyed the sexy poses.

OPPOSITE: A 1937 portrait of Carole Lombard.

ABOVE LEFT: The cramped portrait gallery at Paramount Pictures in 1937.

ABOVE RIGHT: Here is the finished product of the setup at left, a 1937 portrait of Carole Lombard.

OVERLEAF, LEFT TO RIGHT: Carole Lombard worked with Hurrell and other photographers to plan her sessions in terms of costumes and setting, but the best images from these sessions were simple close-ups.

In the spring of 1934, Harlow was filming *Born to Be Kissed*, and Hurrell was engaged to shoot poster art. This time, he convinced her to go as far as partial nudity. She did not require much convincing. In fact, she would sometimes disrobe without warning. "She'd come in with something just wrapped around her," said Hurrell, "and then 'accidentally' drop it. That was her entrance. That was her way of saying, 'Let's do some pictures here, man.'" This was different from Mae West's nudity, which was planned for one part of the session. "Harlow would just drop her dress and be nude underneath," recalled Hurrell. "Not in a seductive way; she just had no shame or inhibition about her body." If Hurrell did shoot nude photos (or seminude, which Harvey White had done), they were never used by Howard Strickling and the publicity department; they were not even seen by them. Shooting this kind of material was part of the ritual established by Harlow and Hurrell. "Harlow was not frightened of the camera," said Hurrell. "She reacted to it,

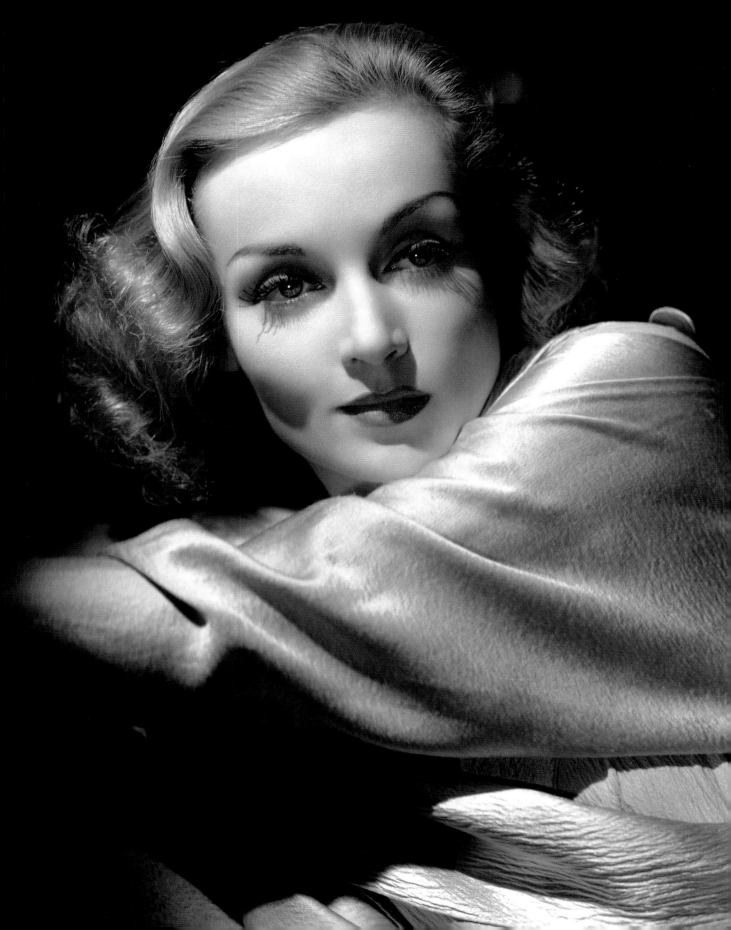

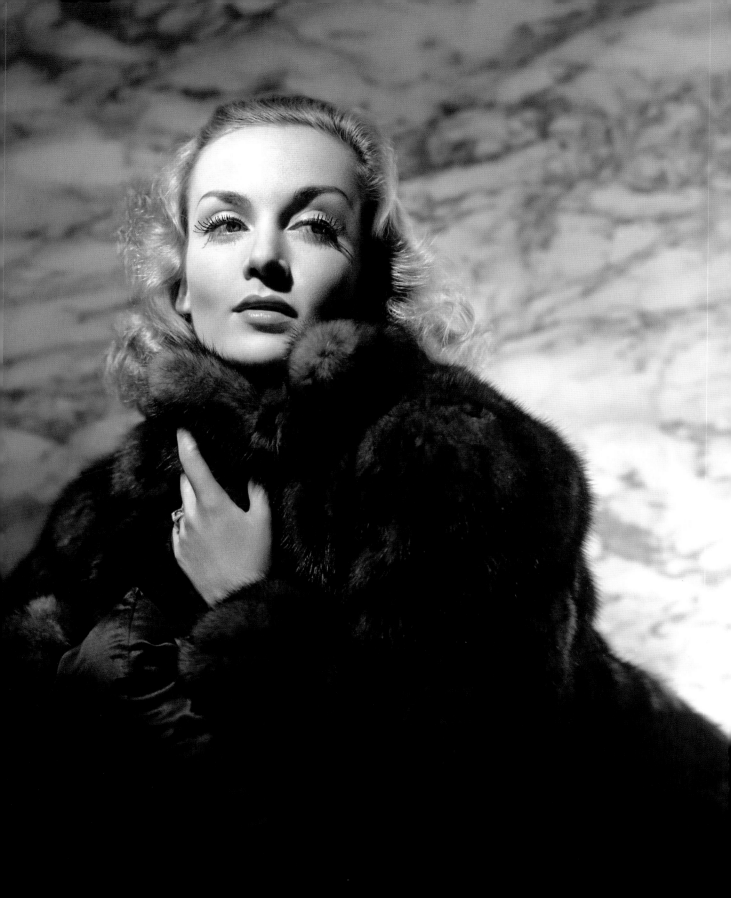

and in some strange way, I was the third party. They were the conspirators."

Born to Be Kissed ran into trouble with Joseph I. Breen. The new head of the Studio Relations Committee (SRC) was orchestrating a grassroots campaign against "immoral movies," and his ally, the Legion of Decency, had singled out West, Shearer, and Harlow. "The heat is *really* turned on the industry," Harlow wrote her friend Stanley Brown. "But it isn't turned on where it *should* be turned on." Breen soon took care of that. A national boycott forced the studios to accept a reconstituted Production Code and appoint him head of an enforcement office, the Production Code Administration (PCA). This was in July. By August, when Harlow's film was released, it had gone through four titles, been rewritten and partially reshot, and was called *The Girl from Missouri*. Hurrell would also be affected, since suggestive advertising art was also forbidden. The white-hot Harlow that Hurrell had created would soon be a fading memory.

In keeping with Hollywood's newfound propriety, M-G-M decided to modify Harlow's image. Hurrell had done a dignified sitting with Harlow in July, but her scoop-necked white dress was still too revealing. A series of sittings was scheduled for late September and early October. The first to photograph her, on September 24, was Russell Ball. His home layout was intended to publicize Jean Bello's latest decorating spree. In control again, Mrs. Bello managed three more home sittings. The next was by a woman photographer from Seattle named Gene Hanner, who shot Christmas art on the morning of October 18. In the afternoon, Hurrell showed up to shoot Harlow with the same hairdo but different gowns.

There was a reason for this piggyback shoot. Strickling had finally managed to get a full page for Harlow in *Vanity Fair*. After this superb photograph was published, everyone wanted a portrait with a polar bear rug. Hurrell had to buy one. "I actually began to hate the popularity of that rug," said Hurrell. "I thought it was artificial." Still, he was proud of having his work appear in *Vanity Fair* and pleased with the image of Jean it presented. "My inspiration for the lighting of that shot came when I posed her in front of the fireplace."

More photos were needed. Hurrell returned to 214 South Beverly Glen Boulevard a few days later, for Harlow's fourth shoot in less than a month. No one complained, then or later. "It was always a joy to have a sitting with her," he said, "because you never stopped laughing. I didn't have to fall on my face for her." The concept of this shoot was to make Harlow look contemplative, almost austere, so three classic-looking gowns were chosen. The first was of white ribbed crepe. Hurrell set up portable flats in the kitchen and then pulled a hassock from the living room and put a lime-green sofa cushion on it. Then he posed Harlow in a series of meditative attitudes. Harlow next donned a velour gown of forest green, and Hurrell began to shoot more moody images. He swung his boom light over her head, creating precise shadows. She changed to black velvet, and the images became more abstract. "She was very sensitive to suggestions," recalled Hurrell. When Hurrell worked with her in May 1935, it was the last time he shot her as the Platinum Blonde. Hurrell shot her at his studio in a wig from *Reckless* and a gown from *China Seas* and then as he preferred her— supine. A month later, M-G-M softened Harlow's look still further. When Hurrell next photographed her, for Irving Thalberg's production of *Riffraff*, she was wearing a lackluster "brownette" wig.

In 1936 no one in Hollywood believed in death. "We were talented," said Hurrell. "We were working. We were making money and assumed it would always be so. We didn't fret and worry about it. We were too busy being alive. We were the children of the gods." On September 14, 1936, Irving G. Thalberg, age thirty-seven, succumbed to pneumonia. The "Boy Wonder" had spent the last three years of his life as an independent producer, making some of the most profitable and acclaimed films of his career, many of which starred his wife.

In March 1937, Harlow turned twenty-six. To the world, her life looked blithe and privileged, but it was

OPPOSITE: Hurrell coaxed a mysterious look from Jean Harlow in this portrait. "At her age, Harlow wanted fun and youthful excitement," said Hurrell. "Being the great actress didn't make much difference."

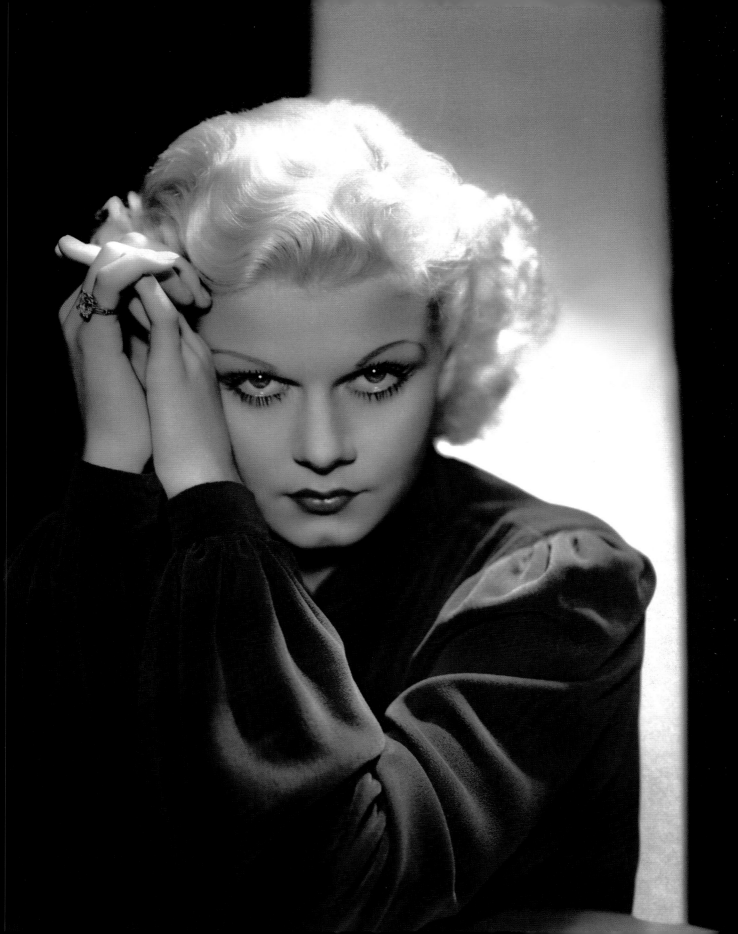

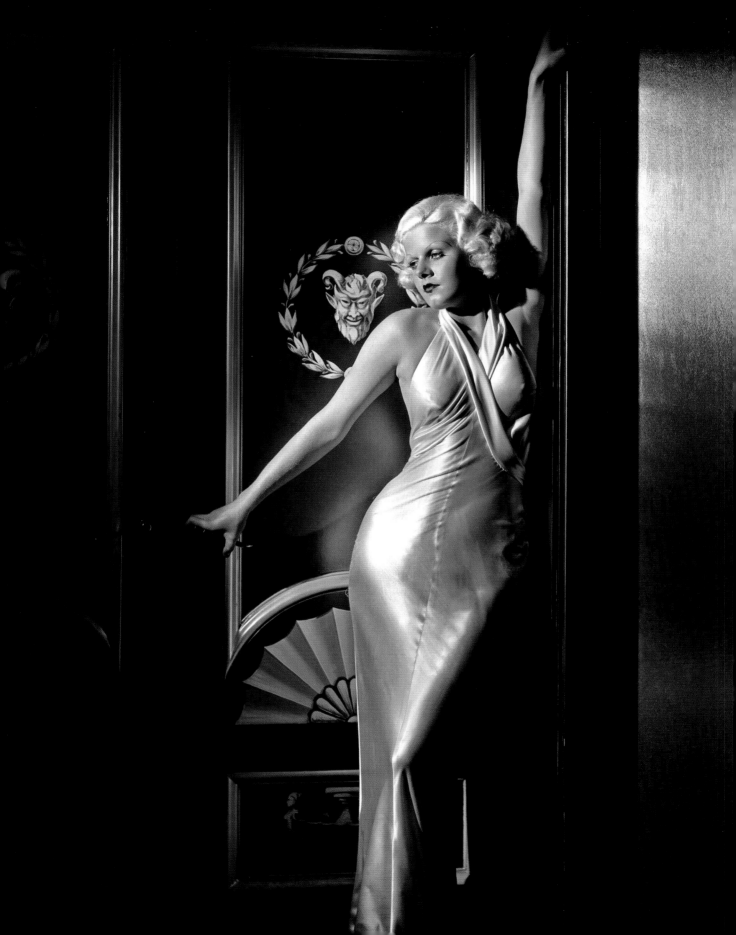

OPPOSITE: This portrait was made in a bedroom set from *Dinner at Eight*. "My style is designing," said Hurrell. "If a portrait doesn't have a design or a composition, it doesn't have strength in the face. That's why I use spotlights."

ABOVE: "Harlow was spirited and loved having a good time," said Hurrell. "She held the unofficial dice record at the Agua Caliente Casino in Mexico, with thirty-four straight passes."

OVERLEAF, LEFT TO RIGHT: Hurrell photographed Harlow in the kitchen of her Beverly Drive home in October 1934, disguising it with hinged backdrop panels.

laced with frustration and resentment. One evening Rosalind Russell began to admire Harlow's famous polar bear rug, then noticed that the bear's fangs had been damaged. "What happened to his teeth?" asked Russell.

"I kicked 'em in," Harlow answered, in a sad comment on her home life.

Harlow came to Hurrell's studio for a sitting that would combine wardrobe from the already completed *Personal Property* with wardrobe from the upcoming *Saratoga*. As soon as Hurrell saw her, he knew something was wrong. "I could tell she wasn't well," he recalled. "She looked heavier, and she faded fast." The added weight was the result of bloating. Hurrell dealt with it by shining a bright light on the background behind her waist, then opaquing the negative to approximate her

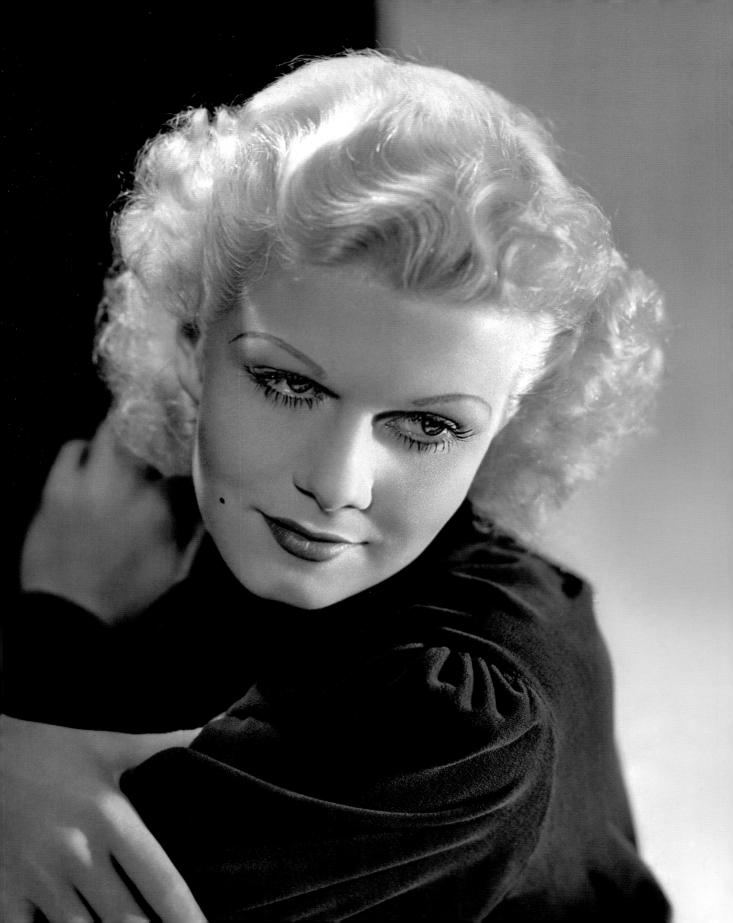

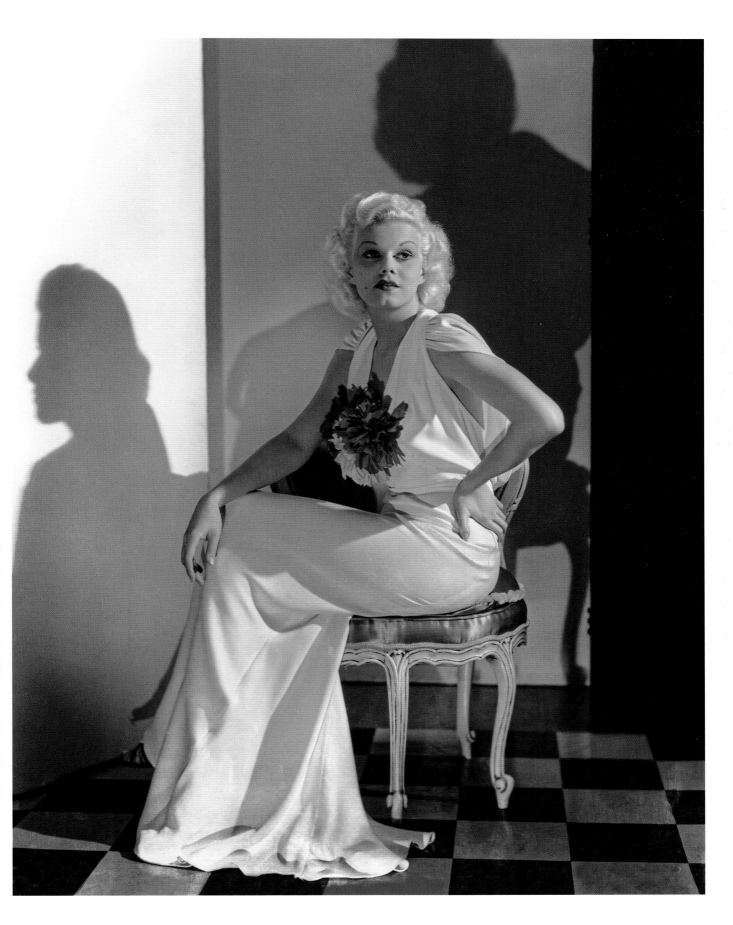

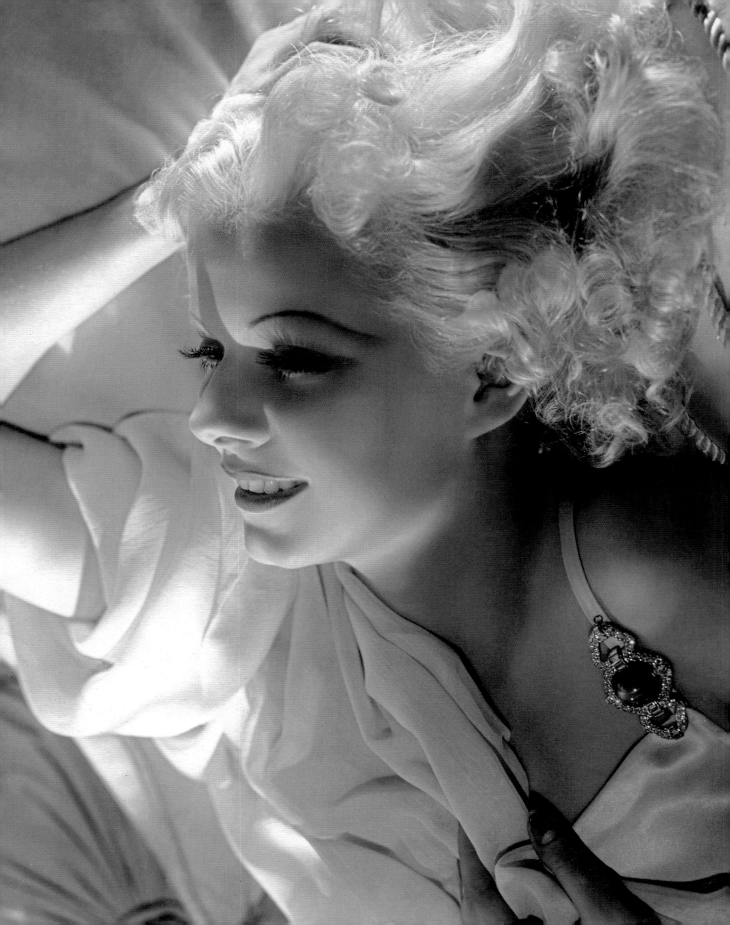

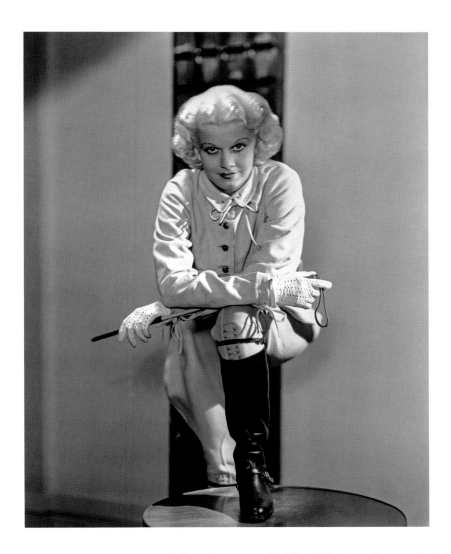

former slimness. He could not disguise her wan, defeated mood. Less than three months later, Harlow died of degenerative kidney disease. A sad postscript occurred when William Powell called Hurrell. "I hardly recognized his voice," recalled Hurrell. "The underlying, mocking tone was gone. He sounded strained and wounded." Powell asked for a set of prints from the last sitting.

OPPOSITE: In many Hurrell portraits, his subjects appear to be airborne.

ABOVE: This fashion portrait was made in 1935 at the fur salon in the Bullocks Wilshire department store.

Hurrell obliged him. Powell was well-nigh devastated by the passing of the woman whom many assumed he would marry. A few months later, Powell had to be photographed in connection with his latest film, *Double Wedding*. When he arrived for his appointment, Hurrell was shocked at his appearance. He had lost weight and his eyes were still red from weeping. "I genuinely liked Jean," recalled Hurrell. "Even after she became big box office, she never changed personally. She was one star who never, ever believed her publicity. But the girl was driven like you'd drive a team of horses. They just worked her to death."

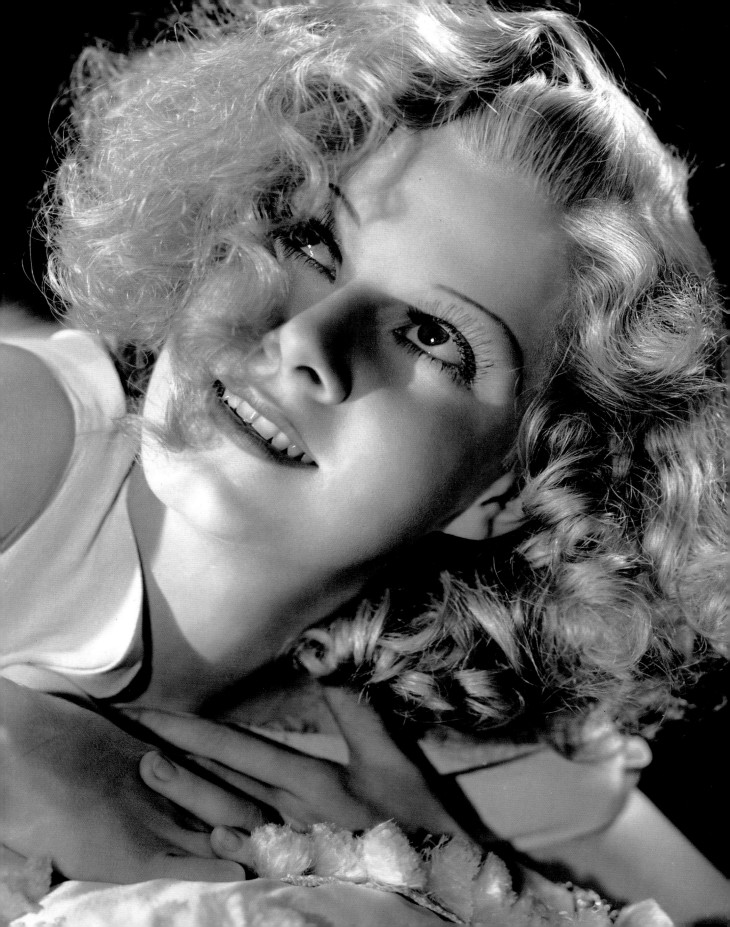

OPPOSITE: Jean Harlow was wearing a "brownette" wig from her film *Riffraff* when she posed for Hurrell in 1935.

ABOVE: William Powell did not want to be photographed while he was mourning Jean Harlow in 1937, but the studio held him to his contract. Hurrell was not able to cheer him.

THE PATRON

In 1934, after all his success, George Hurrell was still beholden to Norma Shearer. She had taken him from a downtown salon to the loftiest photo job in Hollywood, and when he had impulsively chucked it, she had single-handedly kept him from being blackballed. She was his patron. She was also a world-famous figure, an artist who used the acclaim she had won and the power she had earned to advance the status of women in film. To historian Lewis Jacobs, Shearer was a prototype, "the ultra-civilized, sleek and slender, knowing and disillusioned, restless, oversexed and neurotic woman who leads her own life." To *San Francisco Chronicle* film critic Mick LaSalle, Shearer was "something new, a nice young woman who wants sex as much as a man does, and goes after it." To coworkers and fans, Shearer was "The First Lady of M-G-M." In the liberal atmosphere of pre-Breen Hollywood, she had brought her patrician beauty to a series of slightly scandalous and highly profitable films: *A Free Soul*, *Strangers May Kiss*, *Riptide*. "If I just stayed sweet and appealing," said Shearer, "I fear the roles I played would be very dull." When her films began to earn more than Garbo's, Shearer became a prestige artist, required to make only one a year.

With so much time off, Shearer needed to occupy herself, so she reared two children, shopped for film properties, and worked with Hurrell to refine her image. Of the sixteen sittings they did between 1929 and 1936, only half were done in connection with a specific film. The other half were done to experiment. "Each time, she seemed a different personality or presented me with a different side of her personality," said Hurrell. "She was never static. Never let herself stagnate. She was always thinking ahead."

Shearer routinely auditioned photographers and cinematographers, grading them on their ability to flatter her. In the portrait gallery, she preferred Hurrell, because she knew what he could accomplish. Because of him, she was considered one of the great beauties of the 1930s. And she performed for his camera as she did for the movie camera. Hurrell told *Movie Mirror* that he never lit Shearer from below, even though generally this was an effect he liked. "Strangely enough," wrote Marquis Busby, "it will appear that Norma's chin is too full, and that her cheeks are chubby, of all things." She continued to monitor the strabismus in her left eye. Corrective surgery was not a possibility, so she used exercise to keep it from wandering. "She knew how to handle the eye thing," said Hurrell, "because she would always focus just out there. She could never look at anything close." The result was a knowing, seductive stare, as much a Shearer trademark as her sculpted profile.

OPPOSITE: From 1929 to 1936, Norma Shearer and George Hurrell collaborated on a series of extraordinary images.

With the enforcement of the Production Code, Shearer's vehicles assumed a more conservative tone, but her portraits continued to personify the modern woman—intelligent, sexually aware, and in control. The control extended to Hurrell. He had to accede to her use of a whiter-than-white makeup known as Silver Stone Number One. He also had to allow the use of a full-length mirror in the gallery, as well as the questions it occasioned. "She worked in front of that mirror so much," said Hurrell. "I don't think she was ever in the dark about how she looked in front of the camera."

"My experience in silent pictures served me well," wrote Shearer. "I had learned that you can't fool the camera. It creeps up and peeks inside. It sees through you like an X-ray. It discovers your innermost thoughts, so your expressions must be intimate. The trace of a smile, the flicker of an eyelash can transmit a chain of thoughts. Irving taught me that no matter what bags of tricks you've accumulated, what comes out of you must be real. It must come from the heart."

In pursuit of this artistic verity, Shearer was demanding, both of herself and others. "Norma is a very *strong-minded* girl," Thalberg once said. "I have a fierce power of concentration," concurred Shearer. She could be deadly serious, but she could also be funny. If the mood in the gallery grew tense, she would break into a rendition of "When My Baby Smiles at Me." As Hurrell remembered, "She ribbed me for years about it."

In 1935 Shearer's work with Hurrell grew increasingly dramatic. She chose hairstyles and wardrobe that would give her a timeless look, favoring draped velour or black velvet to set off her bone-white face. Hurrell responded to these challenges with a series of images that were unprecedented in their boldness and sophistication. Indeed, they approached abstraction and transcended the purpose for which they were created. Intended to prepare Shearer fans for a new film, they assumed their own importance. Each image was a film in itself, telling its own story. In these transporting photographs, Hurrell created a firmament for the star pictured there.

OPPOSITE: Like Joan Crawford, Shearer understood the value of portrait photography to the star image, so she scheduled sessions that were not connected to a particular film.

OVERLEAF, LEFT TO RIGHT: A Fall 1933 portrait of Norma Shearer that told her fans she was back from Europe.

This 1932 portrait was made on the Santa Monica beach, behind the home Shearer shared with Irving Thalberg.

PAGE 168: This 1933 portrait of Shearer was made with unusually soft lighting. "I was always fighting myself to keep from being stereotyped," said Hurrell. "I was always trying to think, 'Let's see, this time you gotta do it differently. Eliminate that top light, or just put cross-lights. Keep things lively, keep them alive.'"

PAGE 169: "You can't fool the camera," said Shearer. "It creeps up and peeks inside. The trace of a smile, the flicker of an eyelash can transmit a chain of thoughts."

PAGE 170: When Shearer bought clothes at Bullocks Wilshire, she would arrange for a Hurrell session; this is from 1935.

PAGE 171: Shearer was preparing for her role in George Cukor's *Romeo and Juliet* when she posed for this widely reproduced portrait. A magazine copy was pasted by Anne Frank on a wall of the annex where she and her family hid from the Nazis in Amsterdam during World War II.

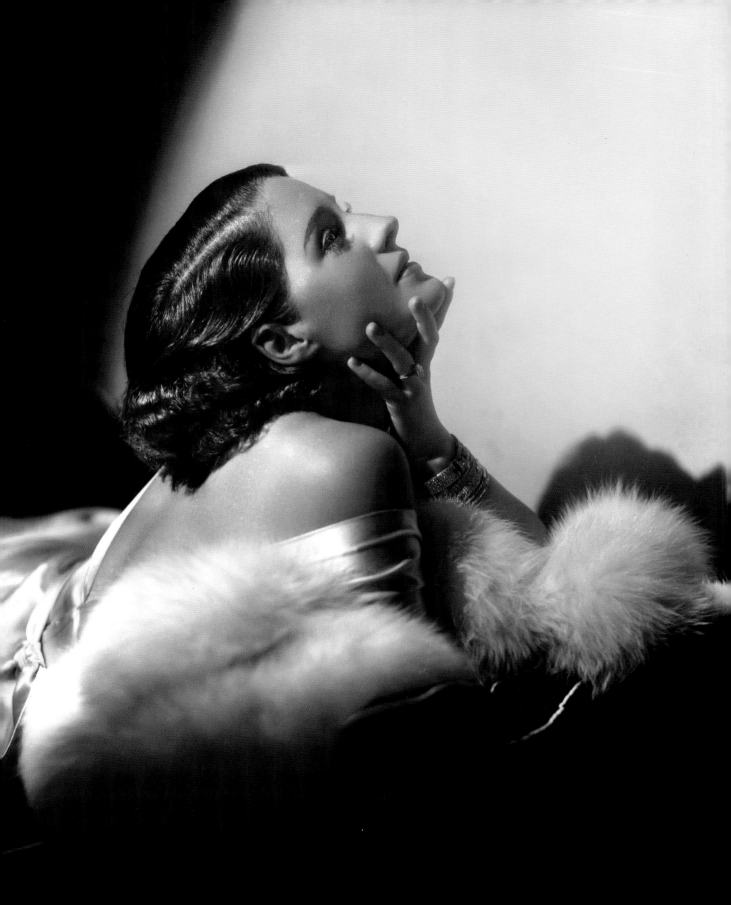

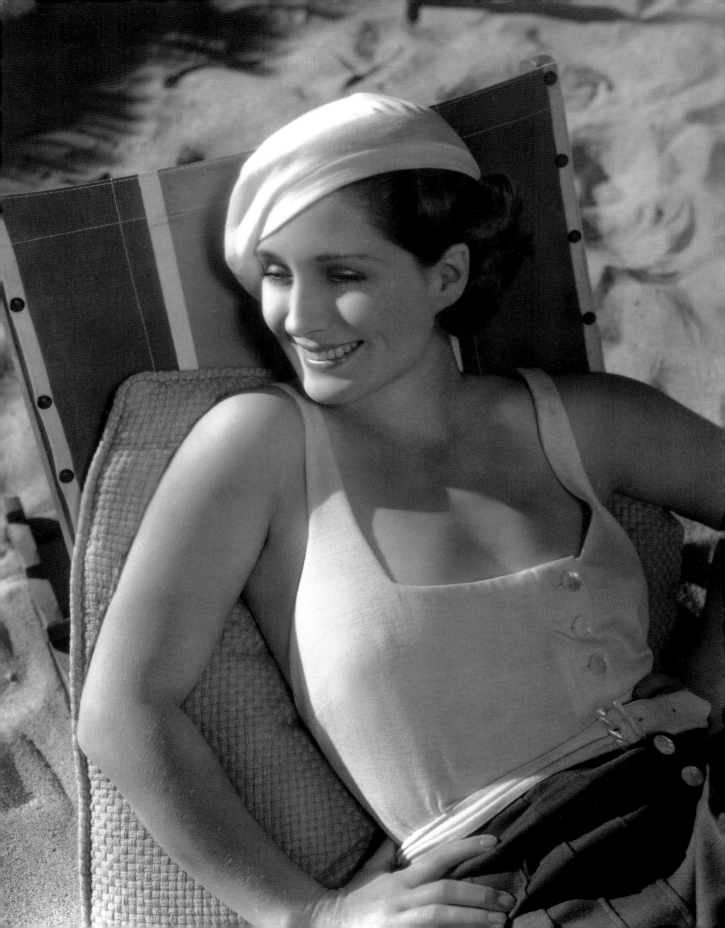

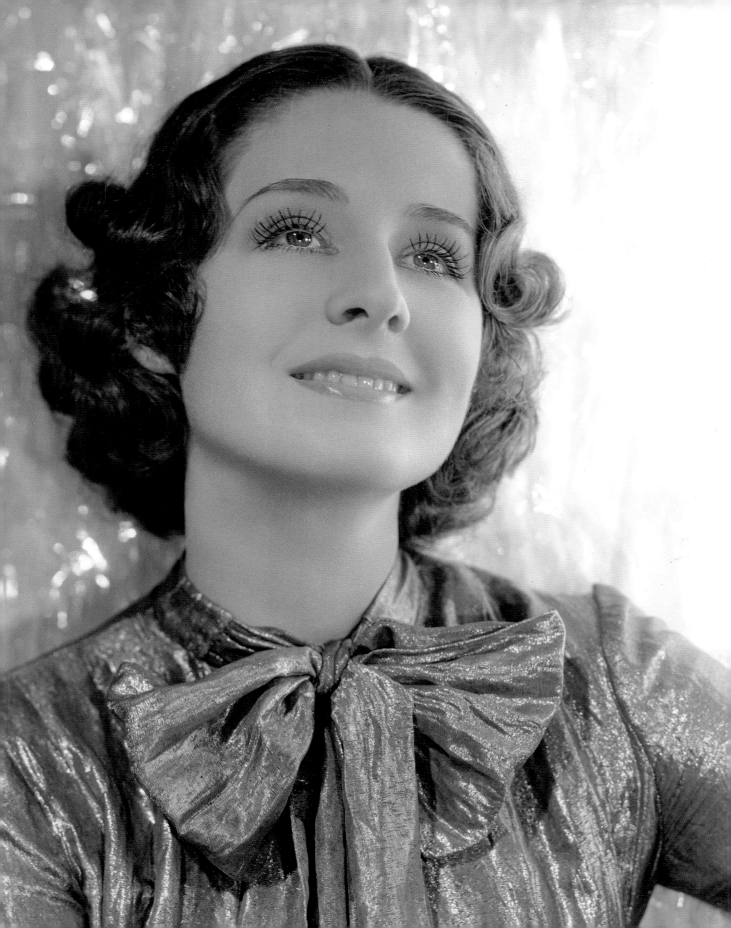

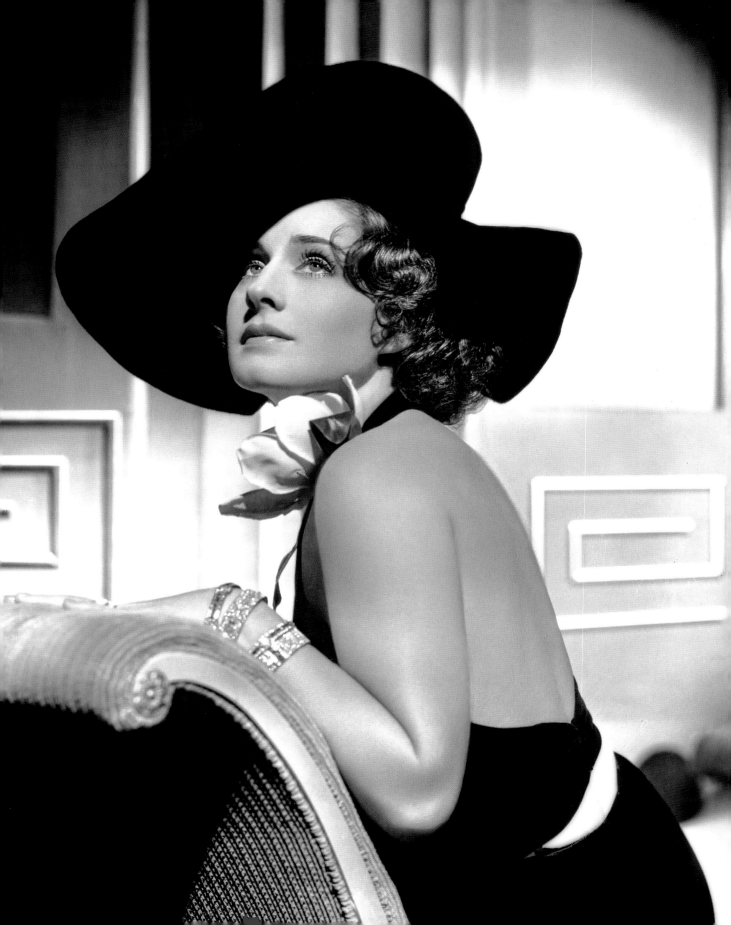

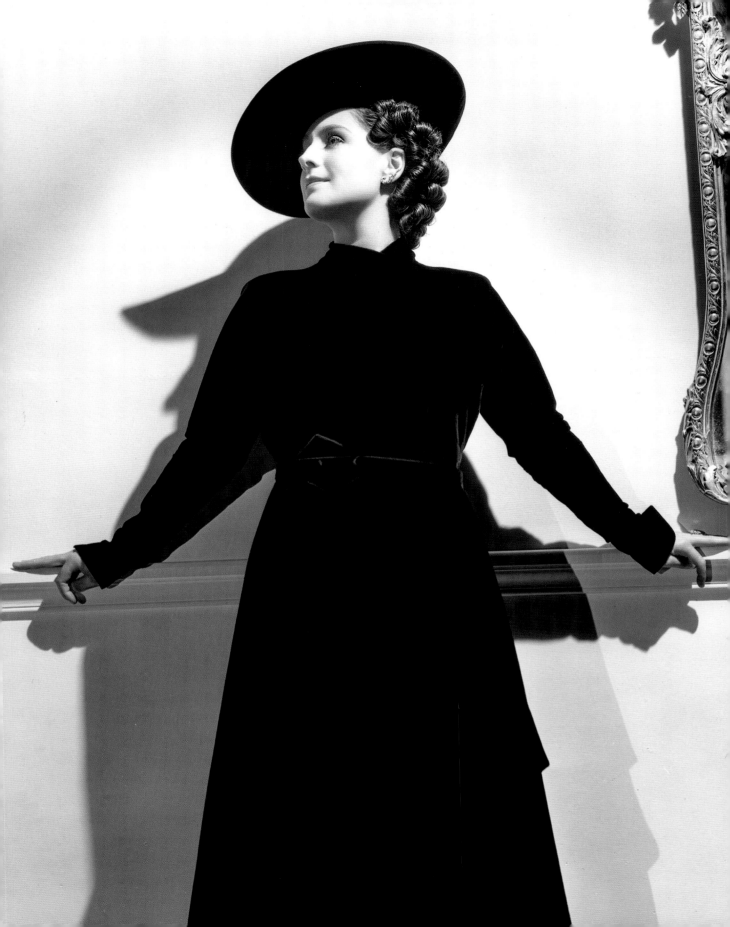

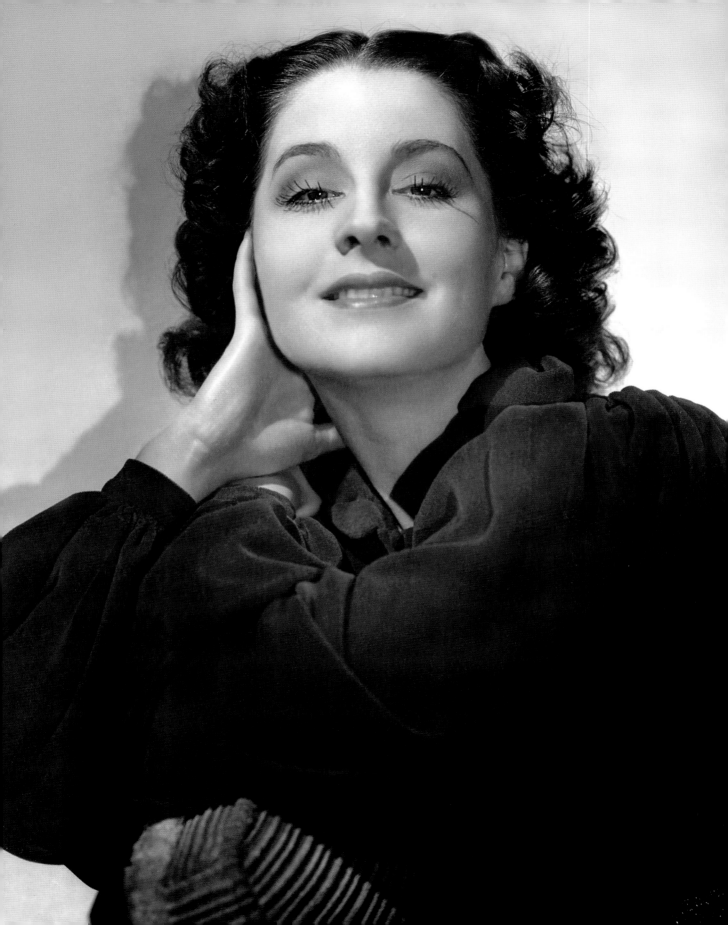

THE MUSE

While George Hurrell was working on the Sunset Strip, virtually every star of the Golden Era came to him for portraits. It was easier to make a list of who did not. Charles Chaplin, Cary Grant, Lana Turner, and John Wayne never came to Hurrell Photography, in most cases because of contractual restrictions. There were very few stars Hurrell did not photograph. Yet as busy as he was with his cast of thousands, he sometimes appeared to have only two clients—Norma Shearer and Joan Crawford. Given his creativity and his need for change, Hurrell should have grown tired of working with the same people. He did not. These actresses approached their sessions with as much enthusiasm as he did. "They made themselves available," he said. "They liked doing it. They had fun."

Joan Crawford liked being an actress. She liked making glamorous movies. "To walk onto a set at nine in the morning in a beautiful evening dress," said Crawford, "perfectly coiffed, made up to perfection, with men in dinner jackets, and then start playing a love scene, that's pretty exciting." To walk into Hurrell's gallery was exciting, too. Why else would she have done thirty-three sittings with him in sixteen years? Most of these were scheduled to publicize a specific film, but many were not. "Sometimes Crawford would show up at the M-G-M gallery at the end of the day," said Joan Rose, a photo archivist who knew Hurrell in his later years. "George had finished shooting somebody who didn't like having his picture taken and was out of there

by three. And Crawford would know that George had a couple of hours left. Lo and behold, there she was, waiting to have her picture taken. 'Don't you like this dress?' Or 'Isn't this the most adorable hat?' (She'd been down in wardrobe, carrying on.) And she came to him because she had this instinct that these photographs were important to her career."

In 1935 Crawford had been at M-G-M for ten years and had seen stars come and go: John Gilbert; Lillian Gish; William Haines, her close friend. She knew the inconstancy of fame. If there was a way to hold on to stardom, she was going to find it. "The studio didn't make me a star," said Crawford. "The public did. On *Our Dancing Daughters* the exhibitors discovered that I was box office."

OPPOSITE: Joan Crawford inspired George Hurrell over a period of sixteen years and thirty-three portrait sessions. She was his muse. "I photographed Crawford literally thousands of times," recalled Hurrell. "Each sitting was a new experience for both of us. For one thing, she constantly altered her appearance, the color of her hair, eye makeup, eyebrows, mouth. Yet with all the changes, there was a classic beauty, a weird kind of spirituality."

OVERLEAF, LEFT TO RIGHT: Because the 1932 *Letty Lynton* redressed part of the *Grand Hotel* lobby as a ship's restaurant, Hurrell shot all the *Letty Lynton* portraits there. "Crawford was a natural at posing," said Hurrell. "She had an instinctive sense of design and of herself."

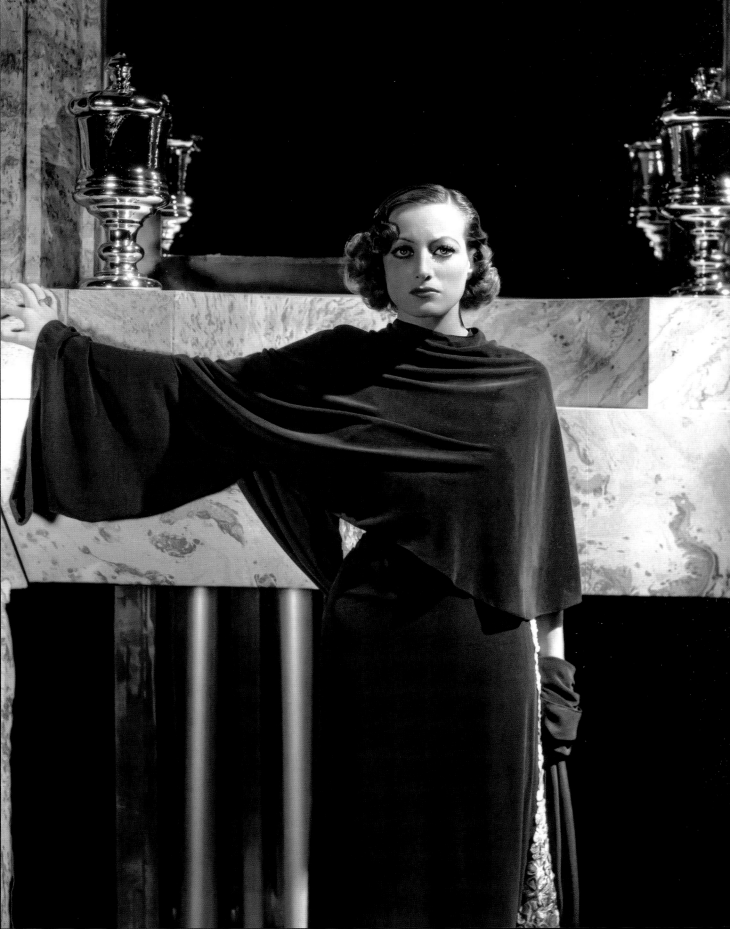

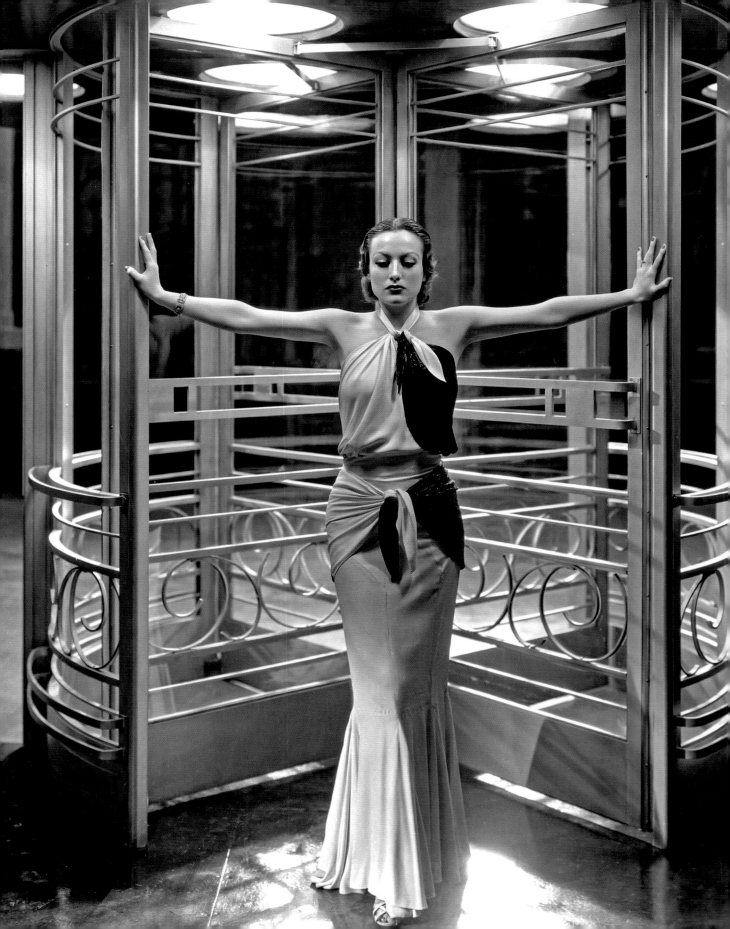

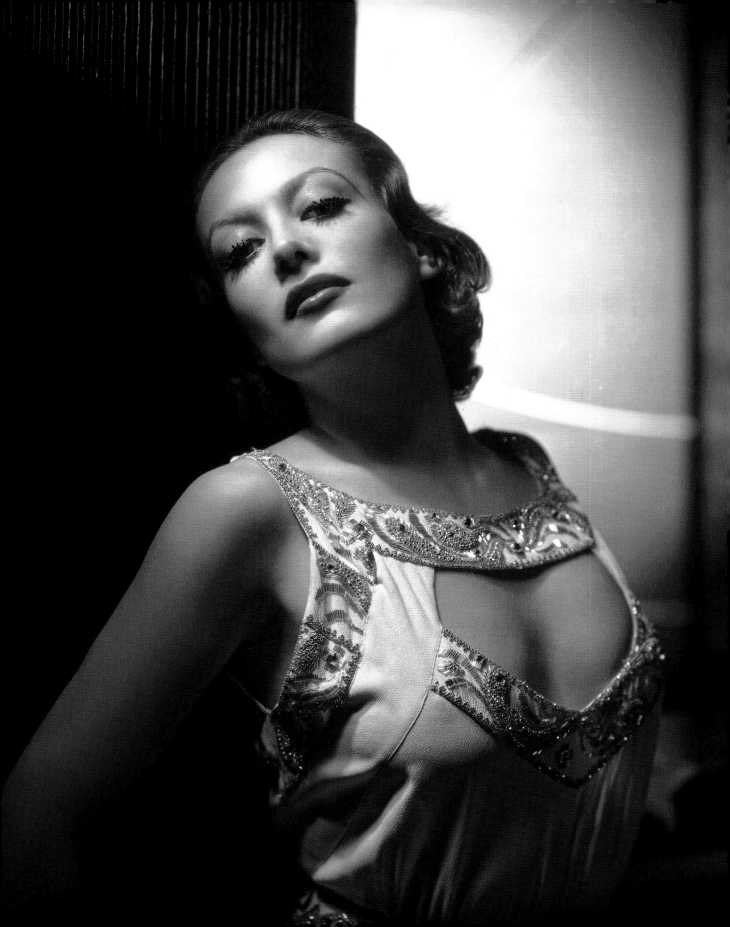

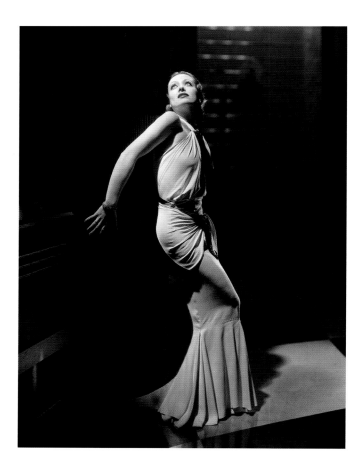

LEFT: A 1932 portrait of Crawford made for Clarence Brown's *Letty Lynton*. "Joan Crawford has the clearest conception of what it takes to make a photograph interesting," said Hurrell at the time. "She knows what to do and when to do it."

OPPOSITE: A portrait of Crawford made for *Letty Lynton*.

OVERLEAF, LEFT TO RIGHT: "A lot of the things of Joan were done with one spotlight," said Hurrell. "But you had to be careful you didn't get a photograph of a face hidden in the shadows."

Hurrell photographed Crawford with her favorite costar, Clark Gable, for *Dancing Lady* poster art. "Clark Gable is as natural before the still camera as on the motion picture set," said Hurrell at the time. Crawford was delighted to work with Gable, too. "We always worked well together," wrote Crawford. "Harmoniously."

They put my name on the marquee. They gave me star billing. The studio didn't." This was true, because the film was about a trio of girls, but she was the only one of the three who became a star. "Joan had begun to show that she was an actress," recalled Norma Shearer. "Audiences weren't watching just those dancing feet. They were watching that fabulous face." Once Crawford discovered what Hurrell could do for that face, she became his most loyal client, surpassing even his patron.

"I admired her spirit," said Shearer. "She cared how she looked and was willing to fight for what she wanted. She wanted a lot and I'm happy to say she got it. It didn't take her long to catch up to me." Crawford had envied Shearer's position at M-G-M from the beginning. "I tried to watch everything Norma did," said Crawford. "She was that wonderful being, a star." In time, Crawford's attitude hardened. "She made no bones about her jealousy of Norma Shearer," recalled her then-husband Douglas Fairbanks Jr. "But Norma was unquestionably given most of the plums."

It was said with less-than-total accuracy that Garbo got the art, Shearer got the production values, and Crawford paid for them. The M-G-M ledgers would show that the big money really came from the Marie Dressler, Tarzan, and Jeanette MacDonald–Nelson Eddy films. But Crawford believed that her films were underwriting "those mammoth Thalberg productions that Miss Shearer used to do." No matter that Shearer's *Marie Antoinette* came out the year that Crawford's films were losing money and she was labeled "box-office poison." Crawford was competing with Shearer and her unlimited access to Hurrell. Crawford insisted that Shearer had not really discovered him. "Ramon Novarro discovered George Hurrell in Laguna Beach," said Crawford, who then tried to get more time with him than Shearer.

"Joan and I ran neck and neck," recalled Shearer, "even though we weren't running the same course. There should

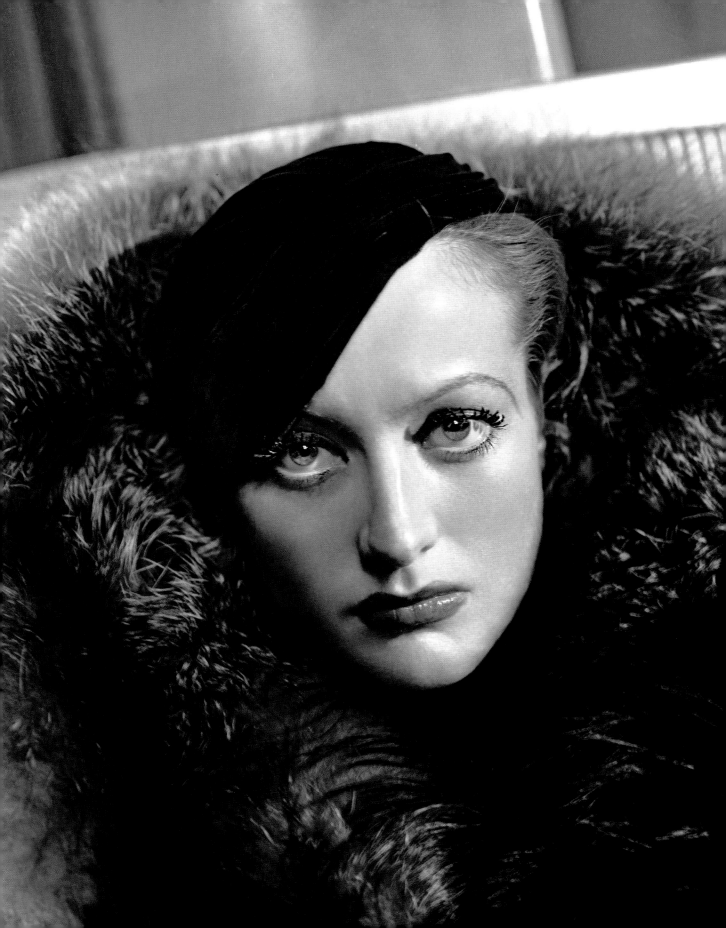

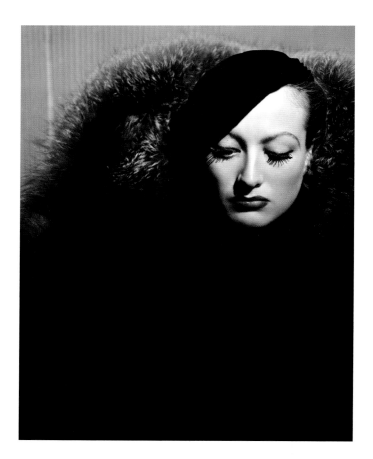
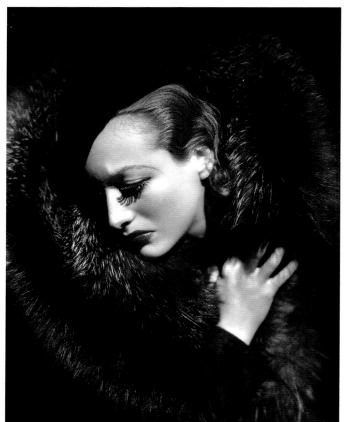
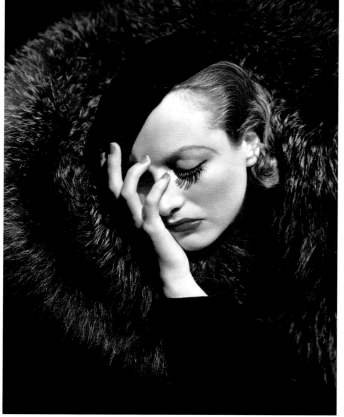

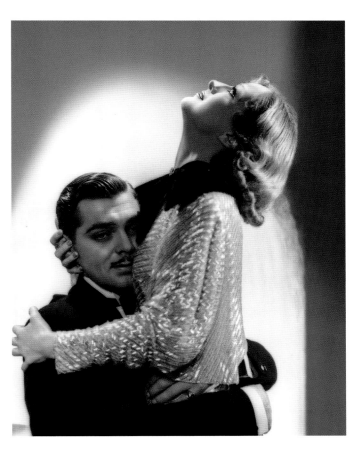

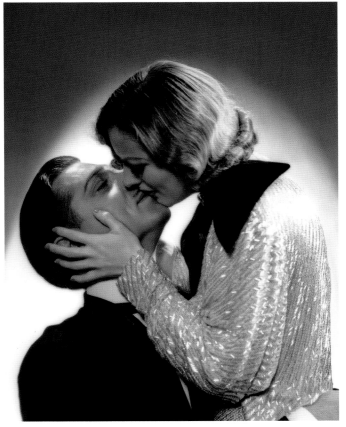

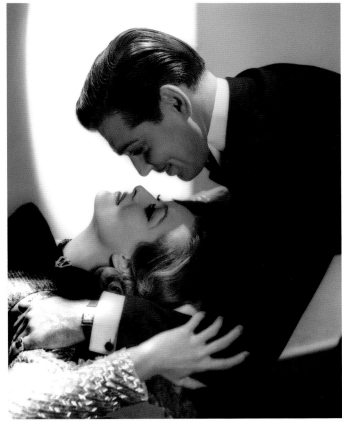

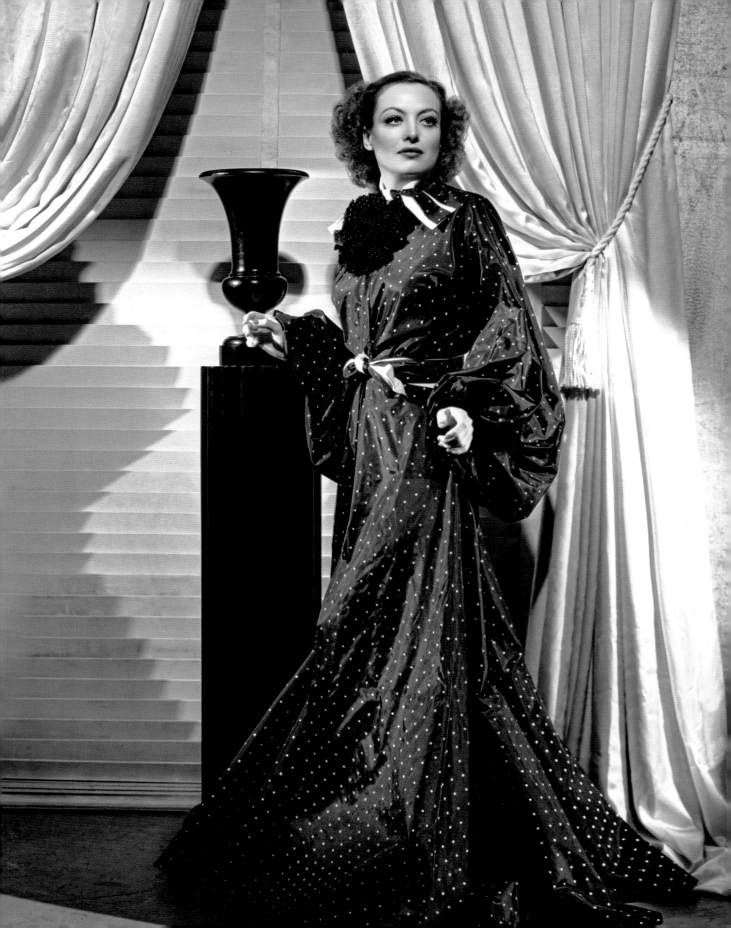

have been no rivalry, if such there was, as we were completely different in type and temperament. We should have been friends, and I wish we had." In later years, Crawford and Shearer would socialize, but in 1935, even though Thalberg was personally producing *No More Ladies* for Crawford, and she was dining at their home, she was grimly determined to monopolize Hurrell. In 1933 he had shot four sittings of her for one film, *Dancing Lady*. In 1935 she was determined to set some sort of record. There were sessions for *No More Ladies*, for *I Live My Life*, and a very involved home sitting. "Crawford would *work* at it," recalled Hurrell with a chuckle. Once she was in front of his camera, politics, competition, and rivalry were forgotten. "I loved posing," said Crawford. "It was hard work, but I loved it!"

"She was the most serious," said Hurrell. "She relished a full day's shooting. She'd put Bing Crosby records on."

"I loved torch songs," said Crawford. "I was always sad listening to Bing Crosby's records."

"Once when I was photographing her on the set of a picture," recalled Hurrell, "we had to stop so she could listen to a Bing Crosby broadcast. There was no radio on the set, so her limousine was wheeled in. Joan tuned in t he program on the car's radio and sat and listened until it was over."

After 1933, Crawford never came to Hurrell's studio. She preferred the individuality of posing on sets or at her home, which was located at 426 North Bristol Avenue. "Whenever we went to her house," said Hurrell, "I always started at nine or ten in the morning. I brought a truckful of canvas and covered her white rugs so we couldn't dirty them." Her house had been decorated by William Haines in a white-on-white Georgian Revival style, and Hurrell made ample use of it. "My assistant and I would go in and search through the house to see what would make the best-designed backdrop," said Hurrell. "We'd latch onto some architectural detail like a column or a vase or maybe

OPPOSITE: This portrait was made to publicize W. S. Van Dyke's *Forsaking All Others*, but this Adrian gown appears nowhere in the film; it was probably worn in a cut scene.

a decoration on the wall. But it had to have the glamour touch. In those days, there was no 'walk in and shoot 'em in the kitchen' stuff. Everything was selected for shape and for glamour. In terms of design, a chair is as important as a nose." Whether it was a chair, a candelabra, or a chaise longue, it could underscore a grand pose.

While Crawford was upstairs dressing, Hurrell (who was never invited there) would be visualizing his setups. "I would start out with some kind of different approach before she even arrived," said Hurrell. "Every time there was a different kind of lighting, to a certain extent, or different background or poses. In a sense, she used this opportunity to present a new image, one that might possibly work for her screen personality." Hurrell was working with Al St. Hilaire and a new Eastman Kodak film, Super Sensitive Pan film. It let him shoot at exposures as short as a tenth of a second. He had to be fast. When Crawford came downstairs, she was ready to work. "She would just go from one pose to another. Practically everything she did was a picture. She loved to be photographed. She kept me hopping, trying to keep up with her quick changes from one pose to another. I had to have Al handle the lights. I didn't have time to handle them myself and catch those changes."

"Hurrell would follow me," Crawford said. "His camera was on wheels and he'd follow me around. How he used to move that camera, shoot the picture, and move the key light with it, I'll never know! He looked like an octopus! But it all got there!"

"I used a fifteen-foot hose with a bulb on it because that big camera was stationary," recalled Hurrell. "We couldn't run around with it because the darn thing was on a tripod. But I was mobile. I'd be all over the place. To get her looking over there, I'd go over there, you know. 'Bam, bam, bam, bam, bam!' Like that! I had Al keep loading the film holders, and I'd check the focus once in a while to be sure."

"Hurrell worked to catch you off guard," said Crawford. "He'd talk to you constantly and his camera would go *click, click, click, click, click* while I was saying 'Nooowwww,' or 'Reeeeeaaaallly.' And he'd get pictures while I was talking, asking for a cup of coffee, whatever."

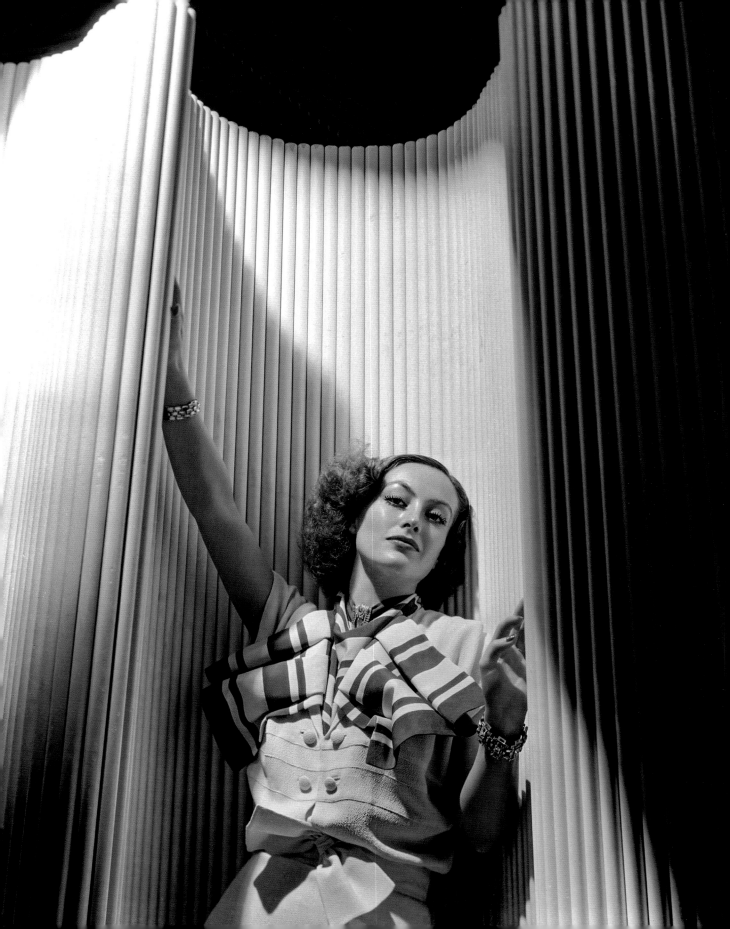

 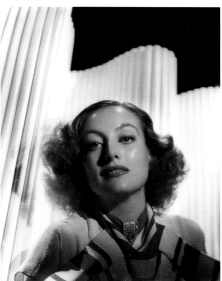 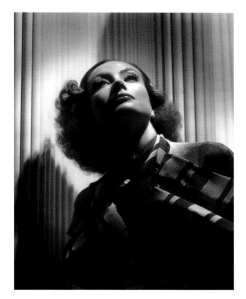

Each segment of the session usually began with full-length shots, and then moved closer and closer, until Hurrell was composing with just a face. Sometimes he would lean Crawford against a white wall, with a long calligraphic shadow extending from her head. "I was always considering compositions," said Hurrell. "That

OPPOSITE AND ABOVE: Hurrell found this background on a nightclub set built for a minor film called *Shadow of Doubt*. In this *Forsaking All Others* session, he made it a grooved cocoon. "Hurrell worked to keep you relaxed," said Crawford. "I don't know if he did that with everyone else because many people are very conscious of the camera. I'm not. I've always said my mother and father were both cameras. I've never known anything but a camera. That's why I'm so relaxed in front of them, I think." Music inspired Crawford to choreograph poses. "Hurrell always played music," recalled Crawford. "The later the hour, the gayer the music. To give you that lift."

OVERLEAF, LEFT TO RIGHT: Two 1934 sessions featured bold poses and subtle looks. "I was always working for that look, that expression, because without the expression, it's a dead face," said Hurrell.

came from having studied painting. So I'd compose with light if I didn't have anything else." Hurrell's most powerful images of Crawford were stark, like the black velvet gowns in which Adrian draped her.

"Adrian taught me so much about drama," said Crawford. "He dressed me in black for the dramatic picture. He said nothing must detract. Everything must be simple, simple, simple. Just your face must emerge." Crawford was impressed when Hurrell drowned her in darkness with the dramatic effects he pioneered in the *Letty Lynton* session. "Hurrell introduced the method of photographing me with an all-dark background and just one spotlight on my face," said Crawford.

"A lot of the things of her were done with one spotlight," said Hurrell. "Just a single light on the face, and everything else black. It gave a kind of dramatic look. But you had to be careful so you didn't get a photograph of a face hidden in the shadows." Indeed, this kind of lighting did not work for everyone. The model had to have symmetrical features, and the negative had to be exposed so that it could be printed both in an enlarger and by the machines that generated thousands of glossies. Using one narrowly focused spotlight required skill. "I used to get questions about the single light," said Hurrell. "You were expected to throw what we call fillers, to fill the shadows. Using as little light as possible was also so that the people [his subjects] weren't too conscious of the lighting. If the light was too

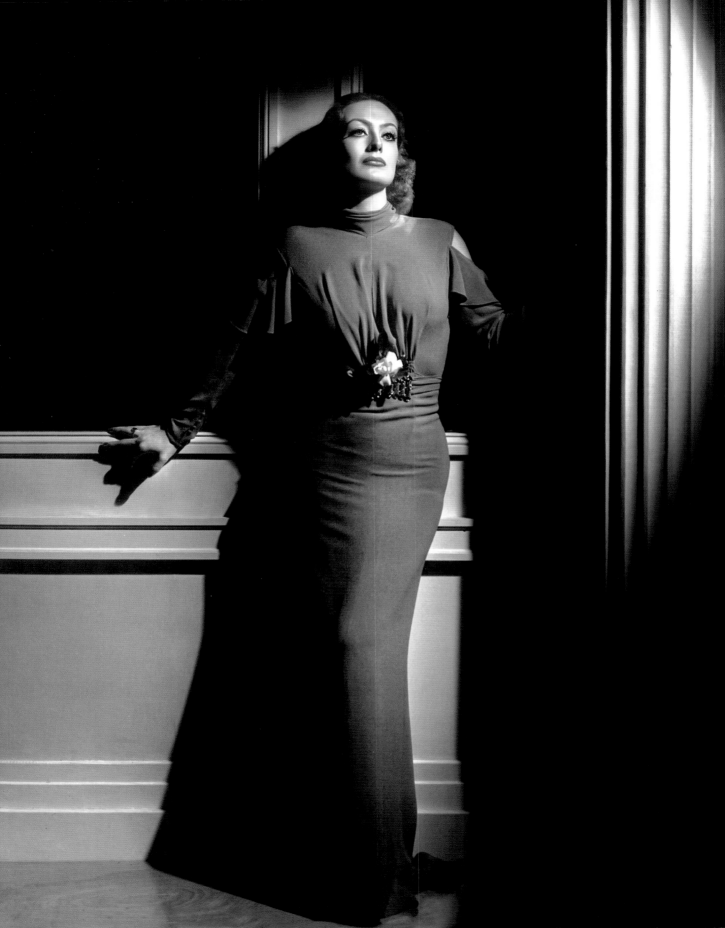

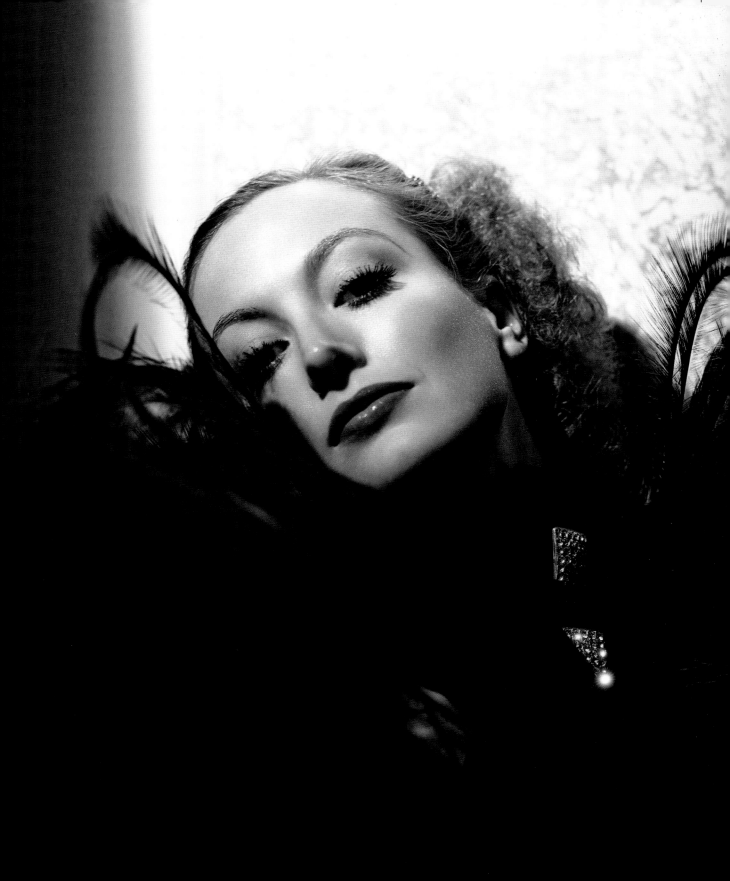

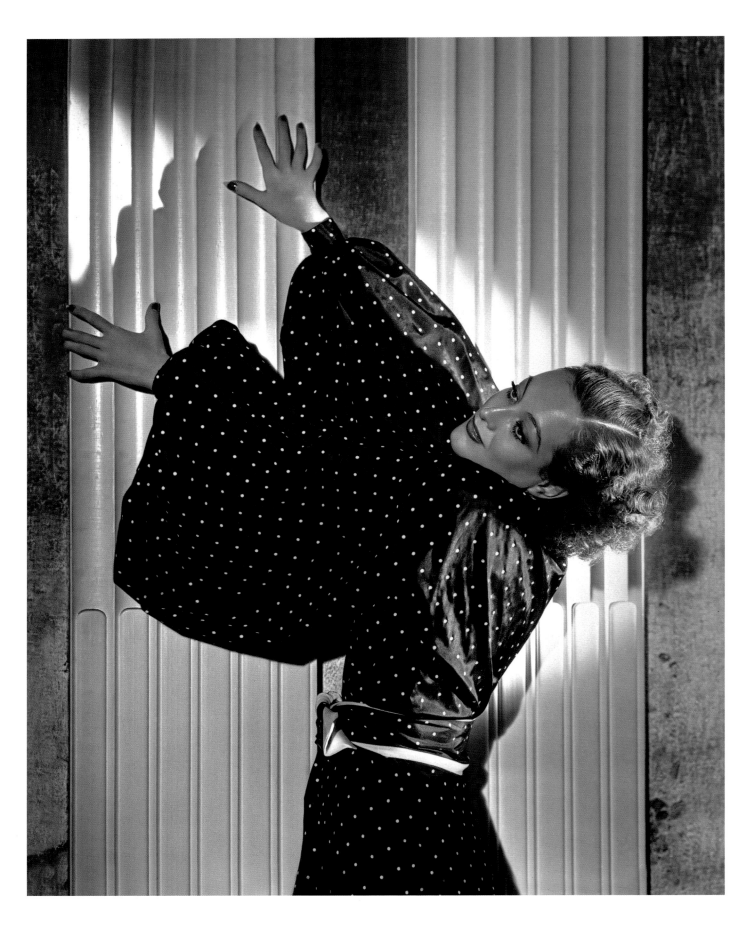

strong, they were blinking and being disturbed. Then, too, a low-quality light is better for skin texture in portrait work. You get more highlights. When the light is too hot on your face, the highlights burn out."

After shooting the tight close-ups, Hurrell would let Crawford go, and the next segment would commence. "She'd spend a whole day," recalled Hurrell, "changing maybe into twenty different gowns, different hairdos, changing her makeup, changing everything. And she'd spend maybe an hour between changes, just getting herself ready for the next attire. Sometimes I shot 150 negatives in one day. Sometimes by four o'clock I'd be tired and suggest that we finish up, but Joan never wanted to stop. She loved being looked at. 'Let's get one more, just for luck,' she'd say."

In late 1935, Hurrell went to Crawford's home for a special session. She and Franchot Tone had wed on October 11, and she wanted Hurrell to make the first portraits of them as a married couple. Crawford also wanted to include her Dachshunds, Bübchen and Baby, which took time and patience. Then there were shots of Tone by himself. Finally Crawford started shooting. She was indefatigable. She and Hurrell got so carried away that they exposed 500 sheets of film that day. St. Hilaire collapsed from exhaustion. Hurrell gave him the next three days off. Hurrell spent the weekend in Carmel with the Westons, painting landscapes.

A few years later, in an *International Photographer* interview, Hurrell said: "Joan Crawford is the most decorative subject I have ever photographed. There is a strength and vitality about her that prevails even in the finished print. If I were a sculptor, I would be satisfied with just doing Joan Crawford all the time."

OPPOSITE: Designer Gilbert Adrian resented Crawford's habit of stretching her arms during a costume fitting because it ripped the fragile muslin and necessitated a complete reconstruction. As this portrait indicates, Crawford wanted to be sure that the design would accommodate her extravagant poses.

OVERLEAF LEFT AND RIGHT: Hurrell's portraits of Crawford for E. H. Griffith's *No More Ladies* were made with the so-called "egg crate" light, a large rectangular fixture with six bulbs in it. Hurrell was always seeking new effects.

PAGE 190: Hurrell used a wind machine in this 1936 portrait of Clark Gable and Joan Crawford for W. S. Van Dyke's *Love on the Run*.

PAGE 191: A Hurrell portrait of Joan Crawford made in 1937 for Dorothy Arzner's *The Bride Wore Red*. After one more session with Crawford, Hurrell was terminated by M-G-M.

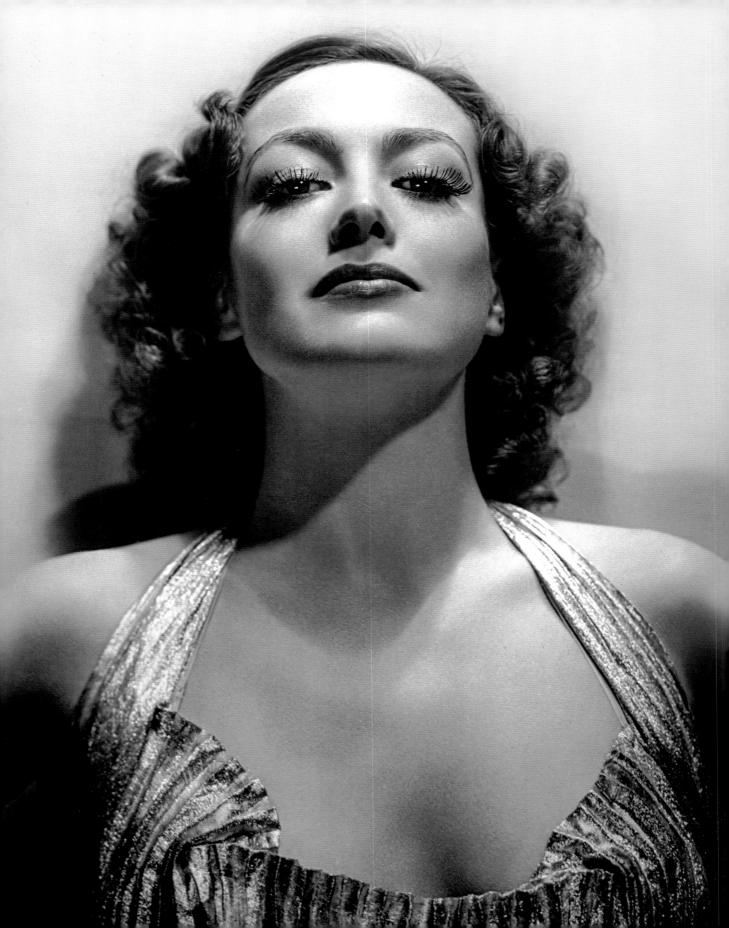

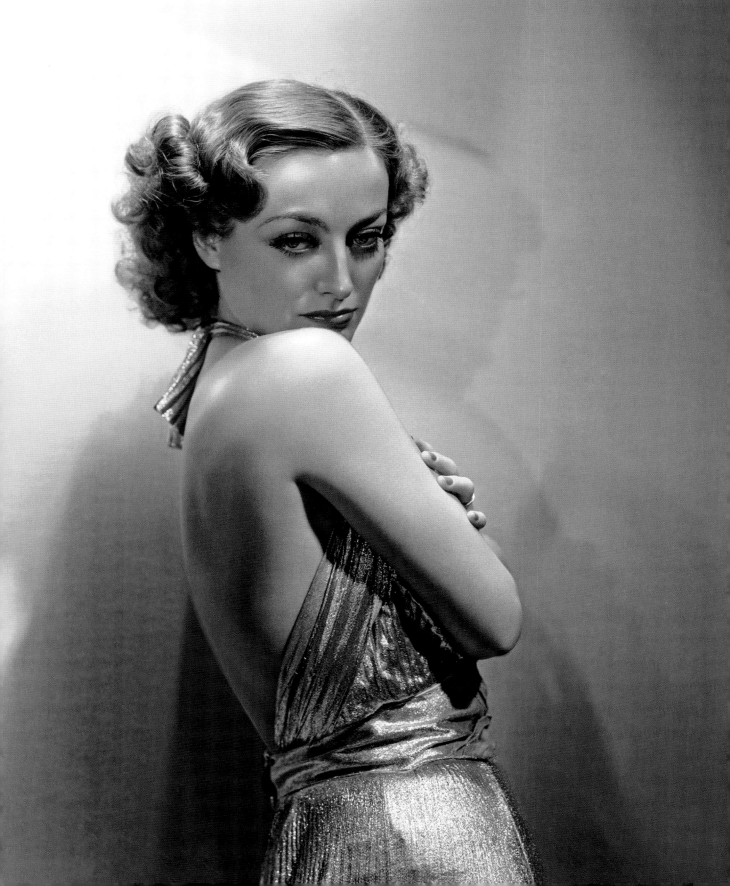

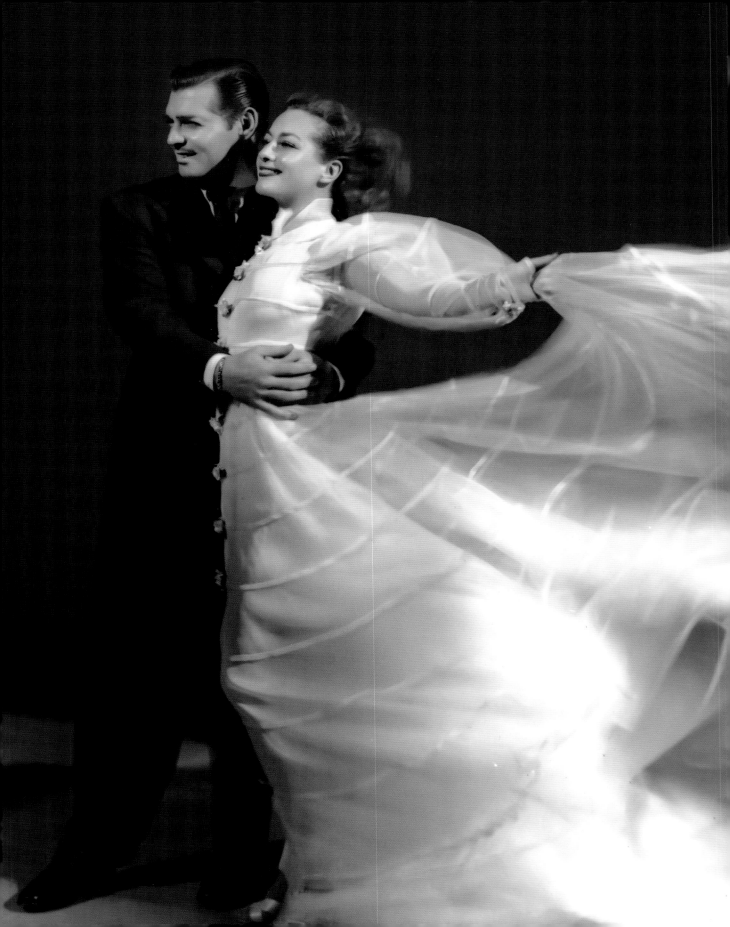

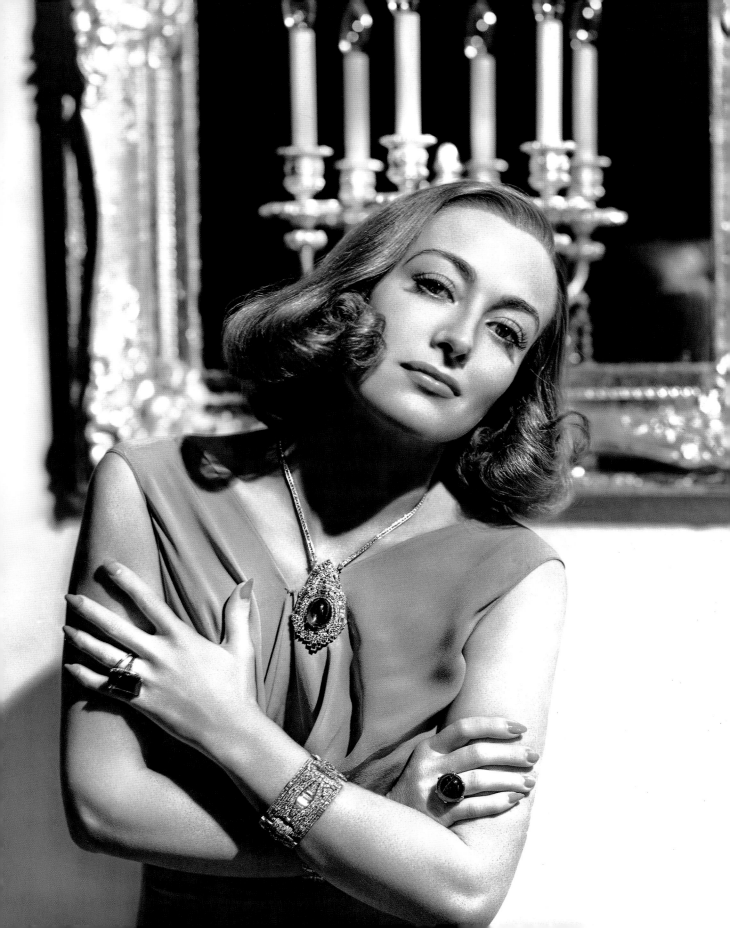

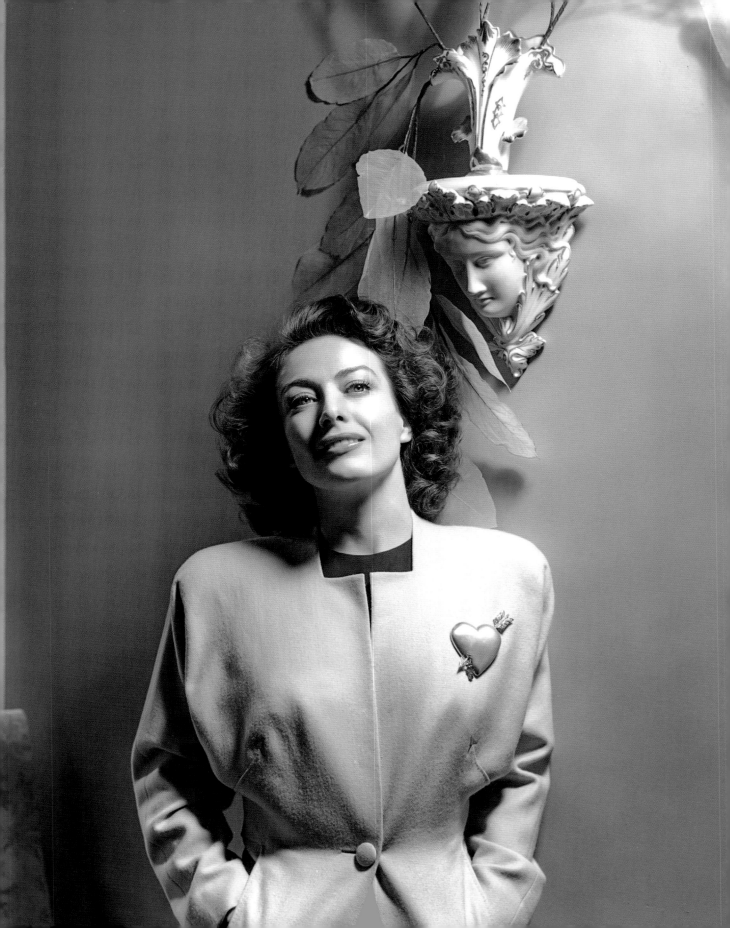

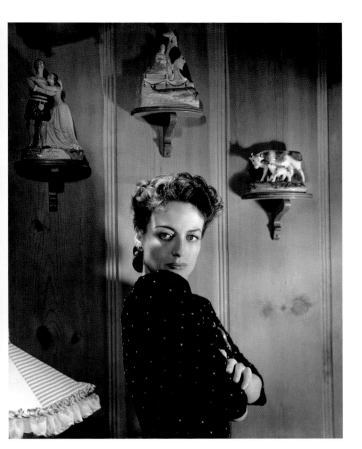
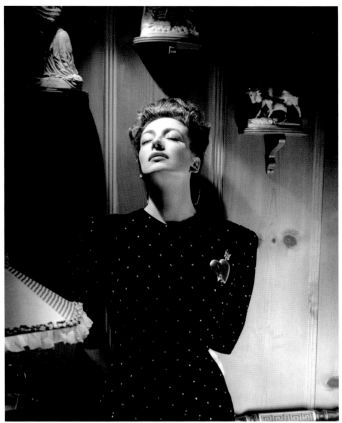

OPPOSITE AND ABOVE: Hurrell and Crawford
reunited in early 1941 for a session in her home. "Joan
loved to be photographed," recalled Hurrell. "I think she'd
rather do that than work in movies!"

THE STRAW BOSS

In the spring of 1938, George Hurrell had been working at 8706 Sunset for almost six years. This was a long time, considering how restless he was. Prior to this, he had lasted about two years in any given situation. From all available evidence, he did not like to be tied down or hemmed in. The saving grace of Hurrell Photography was that he had no boss. He was his own boss, with all the freedom that entailed. Of course it also entailed responsibility. Having gone to Catholic schools, Hurrell was scrupulously organized and frighteningly conscientious. Even so, six years was an awfully long time. The pressure was telling, and cracks were starting to show.

There were a number of episodes. One was when Paramount Pictures sent Claudette Colbert to Hurrell. She was hitting her stride and was known to be cool and businesslike. Like Carole Lombard, she had been in an auto accident and had to be careful how she was photographed. The bones in and around her nose had healed in such a way that the right side of her face was slightly different from the left. She had been photographed on the right many times in her early films, but cinematographer George Folsey told her to avoid it. When Colbert became powerful enough to do so, she laid down the law: no more close-ups from the right. Her right side became known as the "Dark Side of the Moon." And she became known as the "Fretting Frog."

John Engstead was at that time a Paramount publicity director. He oversaw Colbert's portrait sessions and accompanied her to Hurrell Photography. When Colbert sat down for Hurrell, he did the thing that was guaranteed to set her off. He lit her from the right side. Engstead was surprised that Colbert did not argue. She let Hurrell shoot that side. What she did not let him do was talk sexy. "That will be enough of that," she snapped at him. "I came here to work, not to hear a pornographic novel."

A week later, Hurrell had the dubious pleasure of passing the proofs to his client. "Colbert politely looked at the proofs of her right side," said Hurrell. "Then she shrugged her shoulders and tossed them away." There were other sittings with Colbert, with similar results. "She'd never let you shoot her except from one angle," said Hurrell. "I fought her many times on that. But she had very fixed ideas and nothing could budge her. She'd tear them up."

Another episode occurred one afternoon when Hurrell had locked both the front door and the screen door of his studio. He was in the darkroom with a young actress when he heard a persistent knocking at the front

OPPOSITE: Anna May Wong was listening to "All God's Chillun Got Rhythm" while George Hurrell shot this session.

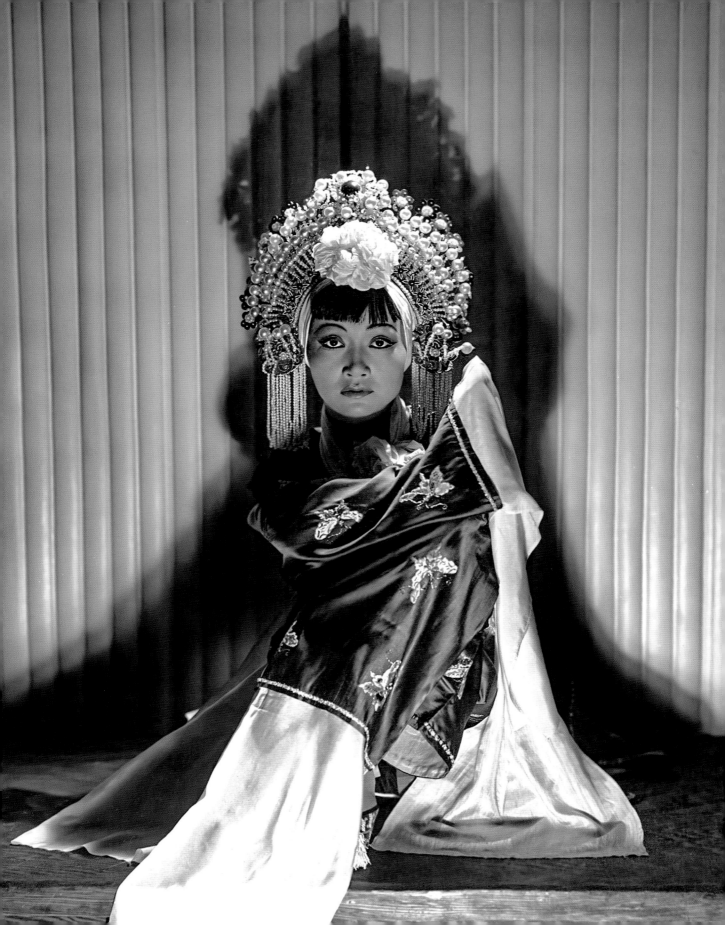

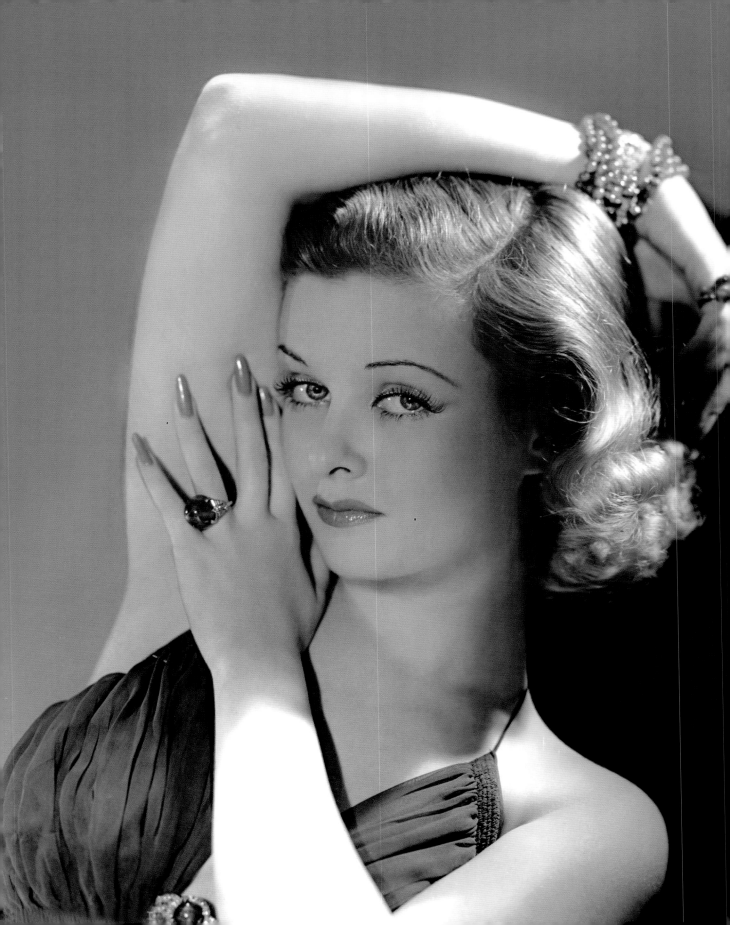

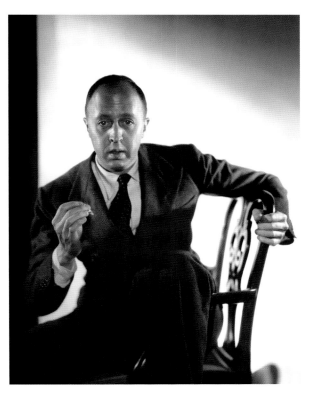

door. He waited for it to stop. It continued. Someone was trying the hasp. Hurrell and his guest hurriedly put on their clothes and left by the back door, hurrying down the stairs to the alley that led to Fountain Avenue.

Hurrell was sitting in his living room, flipping through a magazine, when his wife, Katherine, came in. "Where were you?" she asked. "I thought you had a client."

OPPOSITE: Over a period of eleven years, Hurrell saw Joan Bennett try a number of looks. In 1938, not long after she made this portrait for *The Texans*, she darkened her hair and boosted her career.

ABOVE, LEFT TO RIGHT: The facade of George Hurrell's studio featured a window display of a recent portrait; this one is of Dolores Del Rio.

Hurrell subscribed to Condé Nast publications in order to study the work of George Hoyningen-Huene, so he was pleased to meet the artist when he came to Hollywood on assignment in 1934. Hurrell made this portrait of Huene at that time.

"Why, no," he dissembled. "She canceled. So I went for a walk."

There were some clients whose sessions Hurrell would have liked to cancel. *International Photographer* magazine called Hurrell's April 1937 session with Marlene Dietrich "a big assignment." Shooting the highest-paid actress in the movies certainly was also a big headache. Dietrich was coming to Hurrell because she was in trouble with Paramount. Her last few films had not done well at the box office, and she wanted to give her publicists some exciting new portraits to use before she began filming *Angel* with Ernst Lubitsch. Unlike some actors, she took her portrait sessions very seriously, at one point saying that they meant as much to her as her movies. She knew the power of light.

Dietrich had been brought to Hollywood from Berlin in 1930 by director Josef von Sternberg. Paramount planned to make her the next Greta Garbo. Sternberg did better than that. Using light, shadow, styling, and settings, he created an original. Dietrich became an overnight sensation. To a certain extent, she owed her ascendance

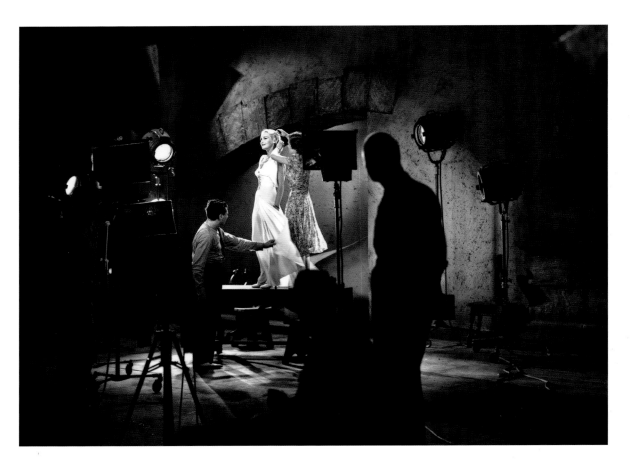

to lighting. Lee Garmes was cinematographer on her first American film, *Morocco*. He began lighting her from the side, the so-called "Rembrandt lighting" effect. "My God! I can't do this," he exclaimed when he saw the rushes. "It's exactly what Bill Daniels is doing with Garbo at Metro." He did not want Dietrich to look like a carbon copy of Garbo, so he moved her key light to a very steep position. It brought out her cheekbones and eyelids. She looked startlingly different, in fact, unique. "The Dietrich face was my creation," Garmes recalled in 1970.

Sternberg was fascinated by the possibilities that this effect offered and embarked on a creative journey that took him and Dietrich through seven films. He experimented with a variety of lights, filters, and poses. In each successive film his effects became more refined. By 1935, Sternberg had given Paramount a visual style—top-lit, diffused, and exotic. No one, other than Hurrell, had such a marked influence on Hollywood photography. Sternberg was steeply lit and soft-edged. Hurrell was bounce-lit and

ABOVE: David Selznick hired Hurrell to shoot Madeleine Carroll on the set of *The Prisoner of Zenda*.

RIGHT: When Hurrell photographed actress Sigrid Gurie for Samuel Goldwyn, she insisted that her ocelot pose with her. "My style was considerably cramped," said Hurrell modestly, because he did accomplish what is the most difficult kind of photograph, an animal portrait.

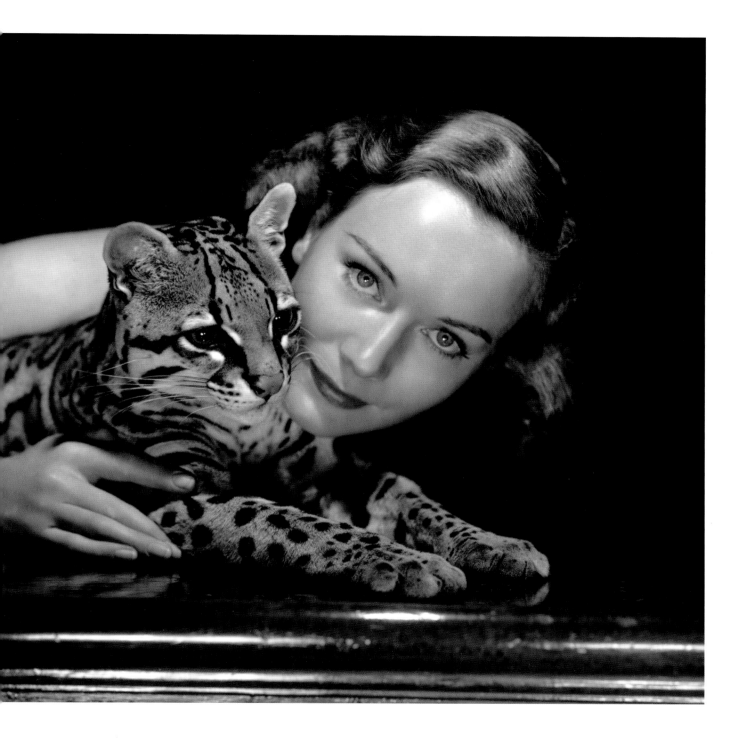

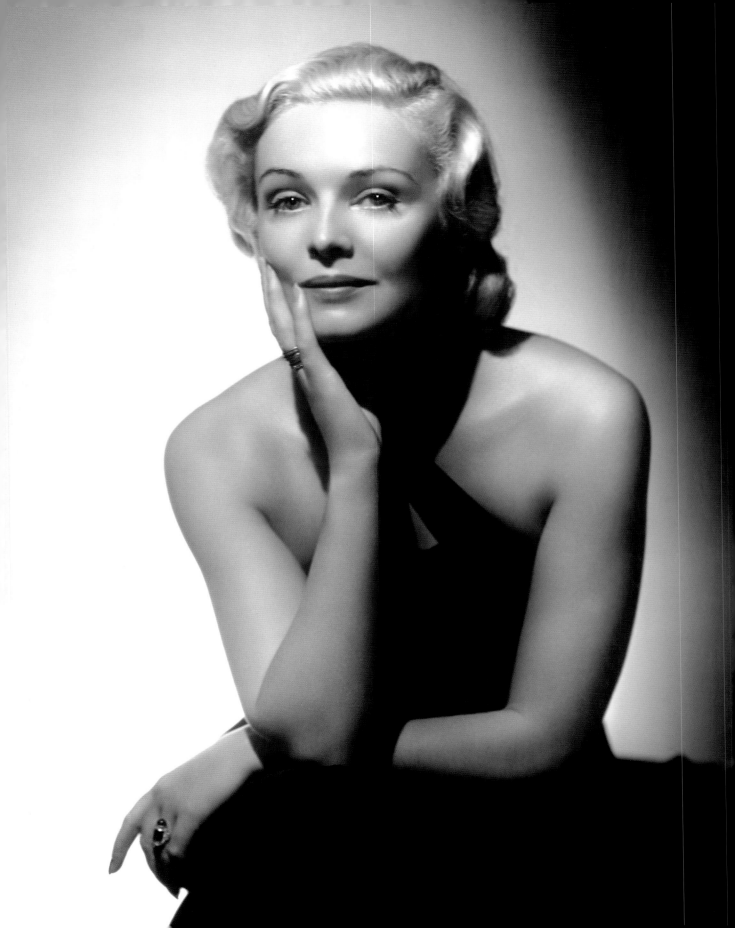

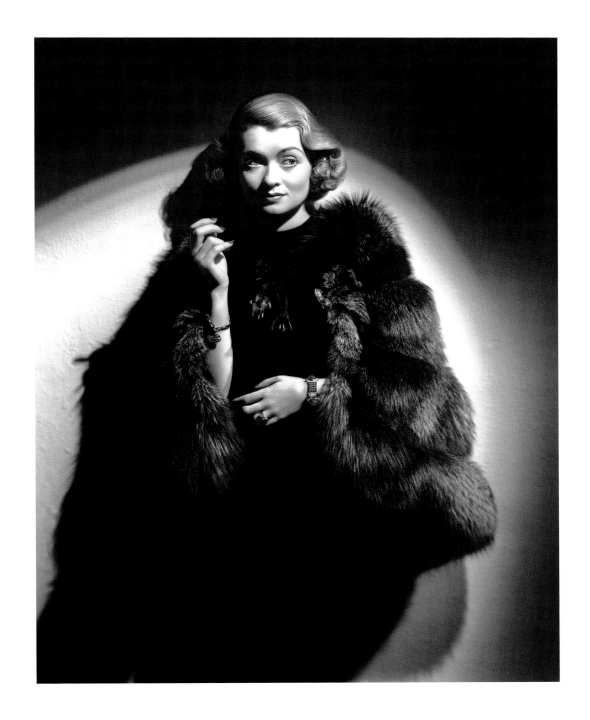

OPPOSITE: Madeleine Carroll posed for Hurrell in 1937.

ABOVE: Constance Bennett was one of Hurrell's most loyal clients, even as she moved from Warner Bros. to M-G-M, Twentieth Century Pictures, Twentieth Century-Fox, and Hal Roach.

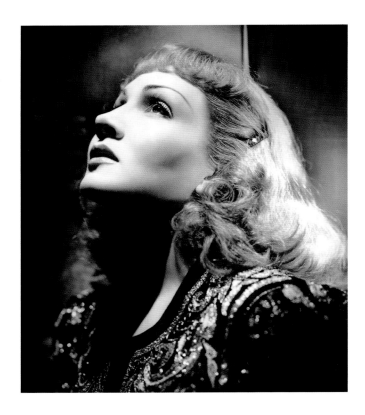

sharp-edged. When Dietrich came to Hurrell, she had learned enough from Sternberg to light her own close-ups. Hurrell was used to Norma Shearer's questions about fill light, yet he was unprepared for the degree of control that Dietrich intended to exercise.

First there was the mirror. Dietrich was used to having a full-length mirror next to the camera so that she could adjust her pose. Hurrell had put up with Shearer's full-length mirror for a time. "There are stars who want a mirror alongside the camera," he said, "so that they can decide whether or not they're posed to advantage. They don't want a photographer. They want an electrician." Finally Hurrell got fed up. He would have none of it. And this applied to Marlene Dietrich. "I just refused to have it there," he said. "I insisted that she could be freer, more spontaneous." Hurrell's style required both spontaneity and mobility. He was using two boom lights, and both of the light stands were on wheels. So was the camera. The mirror was not. "That mirror had to be as close to the lens as possible," he said. The camera was immobilized. And Hurrell was constrained. "Marlene would strike her own poses and when she was ready, she'd say 'Shoot, George.

Shoot.' Well, if I didn't like it, I'd say, 'Well, I don't like that.' And we were off on a rough track."

While Dietrich was in the dressing room, changing costumes and sprinkling gold dust on her hair, Hurrell would quietly roll the mirror away from his camera. As soon as she returned, she would say, "Where's my mirror?" Hurrell reluctantly restored the mirror to its position. Because of Garmes and Sternberg, Dietrich would not—could not—be lit in any way other than with the key light high above and on axis with her nose, the so-called "north light" or "Paramount light." This light emphasized the symmetry of her face, sculpted her cheekbones, and gilded her eyelids. "She always had to have that face right the way she wanted it," said Hurrell. "That light over her head. She'd see it in the mirror. She'd watch for it—this shadow and this look. If you didn't get it, then all hell broke loose."

Curiously enough, Dietrich did allow an occasional deviation from the formula, with the key light angled slightly to one side. And when Hurrell shot her in pro-file, she couldn't very well see herself. For the most part, though, every pose was designed and approved by Dietrich before Hurrell squeezed the bulb on his shutter release

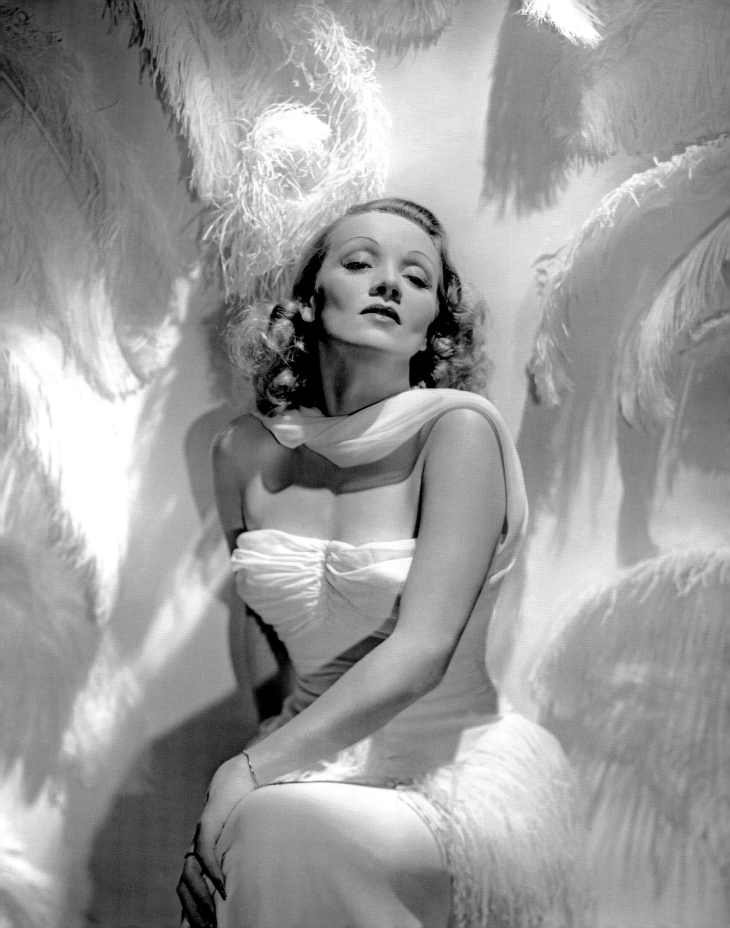

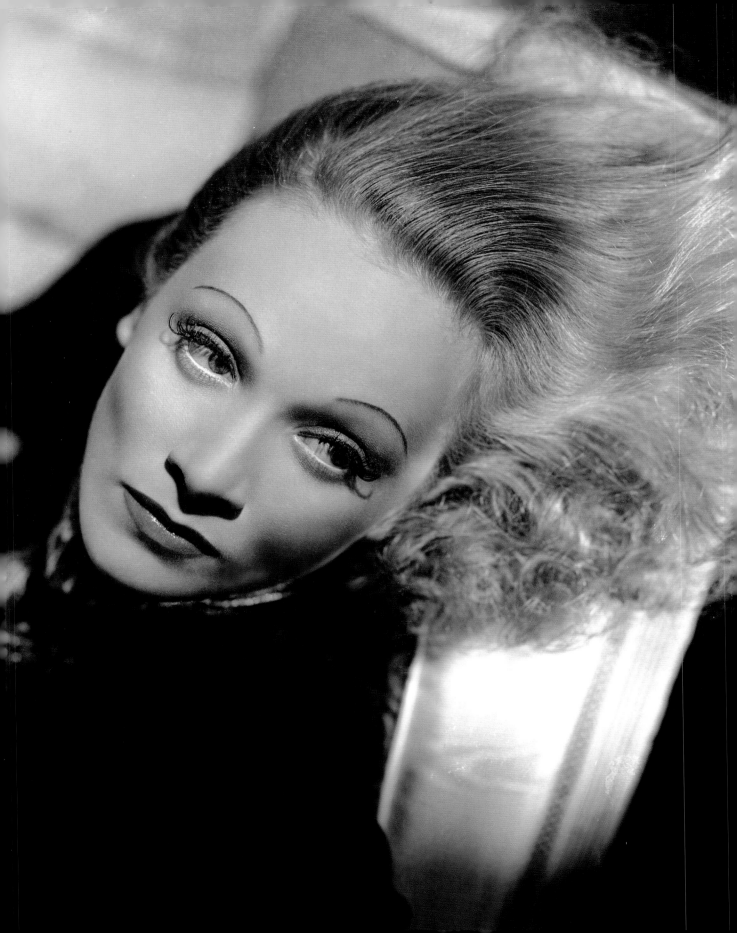

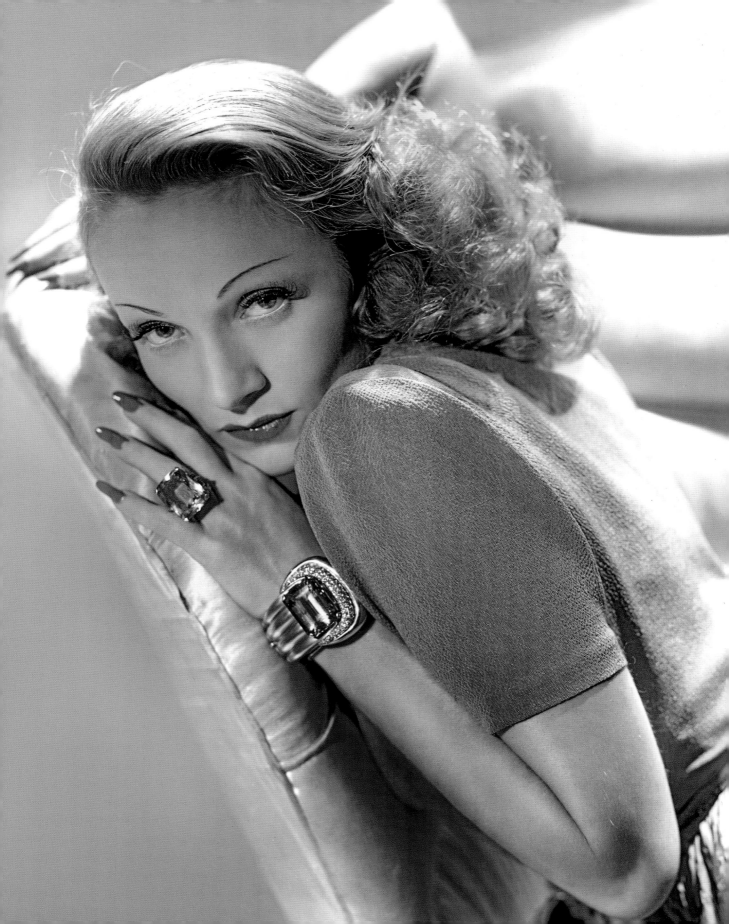

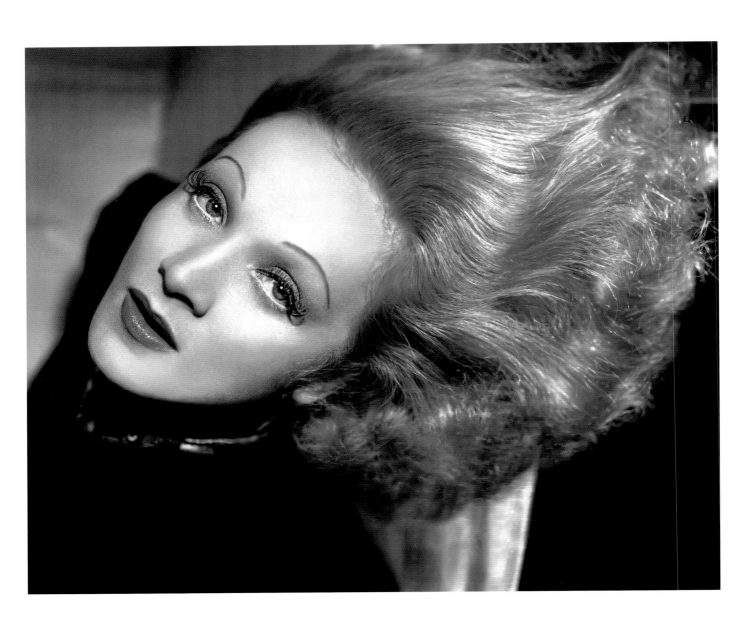

cable. A sitting scheduled for two hours stretched to six. He was not master of the situation. For this trying assignment, he was paid $1,000. "Those sultry, sexy poses were mostly her creations," he recalled. "I never knew anyone who was so hot for pictures of herself." Hurrell would later speak of other sessions with Dietrich, but there is no evidence that they worked together more than once. The experience had not been a happy one for either party. Paramount used the photos, but *Angel* ran into trouble with the censors, was severely recut, and, in this diminished form, failed at the box office. Dietrich was released from her contract. When Hurrell later encountered finished prints from the sitting, he had forgotten the stress. "I had to admit," he said, "that these were some of the best photos I'd ever taken."

Another episode occurred in 1937, when Hurrell made a portrait of the illustrator James Montgomery Flagg. The acclaimed artist was visiting Hollywood to create portraits of stars such as Jean Harlow. Hurrell was taken with one of the poses he had shot; Flagg's skin tones looked painterly, even without retouching. Hurrell gave it to the editors of *International Photographer* for a full-page example of his most recent favorite. When the magazine hit the stands, he got an irate call from Flagg, demanding to know why his unretouched face was in a magazine for the entire world to see.

There was more stress for the self-employed artist. He had come to expect a certain number of subjects from Howard Strickling at M-G-M. In July 1937 M-G-M hired a well-known European portrait photographer named Laszlo Willinger, and this time there was an ironclad contract. "After what happened with George," said Willinger, "Metro was not going to take any chances. My contract even included television rights." In short order, Hurrell was informed that M-G-M could no longer afford to send contractees to his studio. Hurrell was not able to appeal to his patron. In the aftermath of Thalberg's death, Norma Shearer had taken a leave of absence. She was not able to intercede, nor was Joan Crawford, whose popularity had taken a sudden dip. Louis B. Mayer had waited five years to punish Hurrell for his insubordination; he was finally able to do so. Hurrell's last sitting with an M-G-M star was in October, when he shot Joan Crawford at the completion of her film *Mannequin*.

Hurrell was losing patience. He was fed up with having to deal directly with clients, even if they were movie stars. "I got tired of being a businessman," he recalled, "having to greet people, and sit and discuss with them whether they liked the picture or not. Before that, I just took the picture and ran." But he could hardly run from his own reception area. There were questions, and no one but the artist could answer them. One day, a star looked at her finished print and criticized Hurrell's retouching. "That's not my mouth, George."

"Well, if it isn't your mouth, whose is it?" sputtered Hurrell.

"I don't know, but it's not mine. Fix it," said the unnamed star, whose studio was paying $1,000 for photos of her and her mouth. Hurrell had no choice but to unretouch the negative and then re-retouch it. He did not like it one bit and quoted James McNeill Whistler: "A portrait is a picture with something wrong with the mouth."

"I'm not a good straw boss," Hurrell said later. "I had to be everything—businessman, retoucher, salesman, collector, and sometimes comforter for people who didn't photograph as well as they'd expected." By the summer of 1938, Hurrell was bored silly. "Just about the time I was threatening to drink my hypo [i.e., sulfuric-acid fixing bath] to ensure a forced vacation," he said, "Warners sounded me out on a job."

OPPOSITE: Dietrich would find the exact lighting and position she wanted and would then say: "Shoot, George. Shoot!" Hurrell did not care for her exigent style.

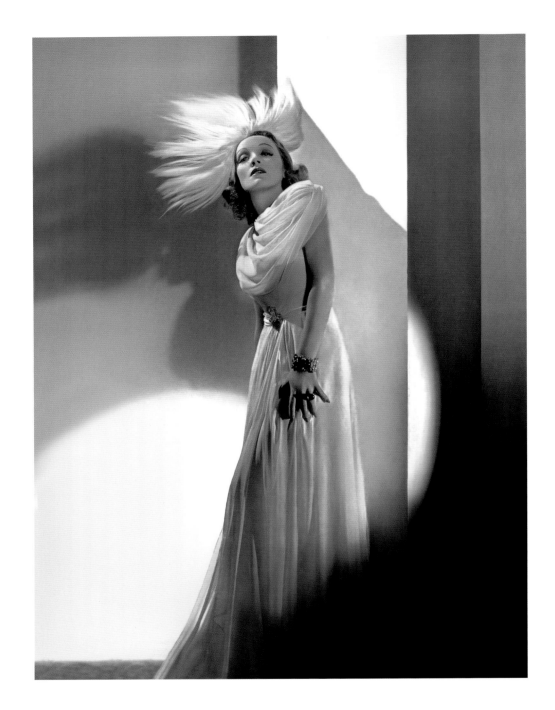

ABOVE AND OPPOSITE: Hurrell shot a great
variety of poses during this session. Dietrich at first
required that he keep the key light on axis with her nose,
as Josef von Sternberg had done. "If you didn't get it,
then all hell broke out," said Hurrell. Even so, he risked her
displeasure by moving the light to one side. Using her full-
length mirror, Dietrich saw that the "Rembrandt" effect
was as pleasing as her formula, and she allowed Hurrell
to continue. Not used to such domination, Hurrell was
irked—until he saw the results.

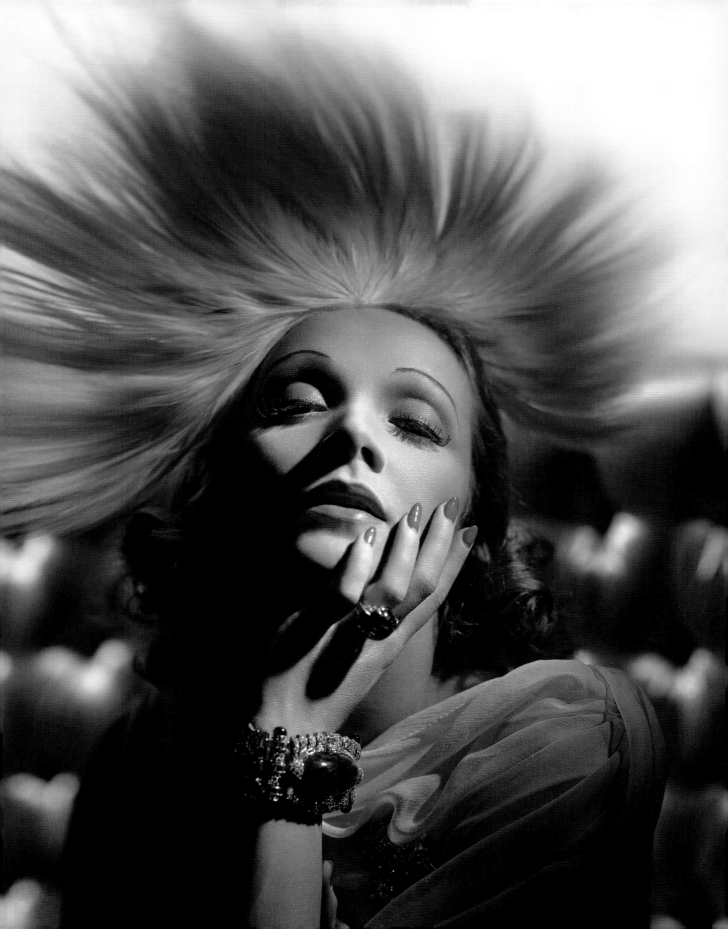

CHAPTER 4
WARNER BROS.

"OOMPH!"

George Hurrell's fifth period of artistic development began in September 1938, when he became a full-time, contracted employee of Warner Bros. An article in the *Hollywood Reporter*, written by a Warners publicist, described Hurrell as an "international portrait photographer" whose pictures had been "a regular feature in class magazines and other publications." An M-G-M publicist would not have described *Esquire* as a "class magazine," but then Warners knew what "class" meant, even as they were acquiring it. Warners had attained major-studio status by making the first sound films and then by specializing in historical biographies, musicals, gangster films, and confession films. "For a while we were known as 'Murder Incorporated,'" said producer Hal Wallis, "because the pictures we made were hard-hitting and tough." *Little Caesar*, *The Public Enemy*, and *I Am a Fugitive from a Chain Gang* set new standards for realism. "Jack L. Warner was tough," said producer Henry Blanke. "We were tough as a studio. That was our philosophy. If the other studios were tough, we'd be tougher. Our characters had to talk like real people." When Wallis replaced Darryl Zanuck as production chief, Warners' staff of writer-producers began essaying prestige projects, in part because the PCA had banned gangster films. Whether they were prestige pictures or programmers, Warners ground them out.

"It was not called the motion picture *industry* for nothing," said screenwriter Julius Epstein. "It was like working at conveyor belts in a factory. Warners turned out a picture a week." Why would Hurrell leave the autonomy of his own studio to work at the so-called "San Quentin of Hollywood"? Surely he must have heard about Jack L. Warner, whom *Fortune* magazine called a "jocose penny watcher." He and his brothers, Harry, Albert, and the late Sam, had come from nickelodeons and Rin-Tin-Tin movies. Albert Warner described his studio as "The Ford of the Movies." Jack Warner recycled scenarios and patrolled soundstages. He turned off lights left burning by errant employees. He had three portrait galleries. Why would he want to spend money on Hurrell?

The idea of Warner Bros. as a gritty, rushed, proletarian studio is not accurate. The Busby Berkeley

PREVIOUS: Errol Flynn had shot to stardom in the 1935 epic, *Captain Blood*, and he was one of the few Warners stars who had not spent years in B pictures. By July 1939, when this portrait was made, he was a superstar.

OPPOSITE: A beauty contest in search of "The Oomph Girl"—and George Hurrell's portraits—lifted Ann Sheridan from B pictures to stardom. "When people asked me what 'oomph' meant," she said later, "I told them that it was the sound of a fat man bending down to tie his shoelaces."

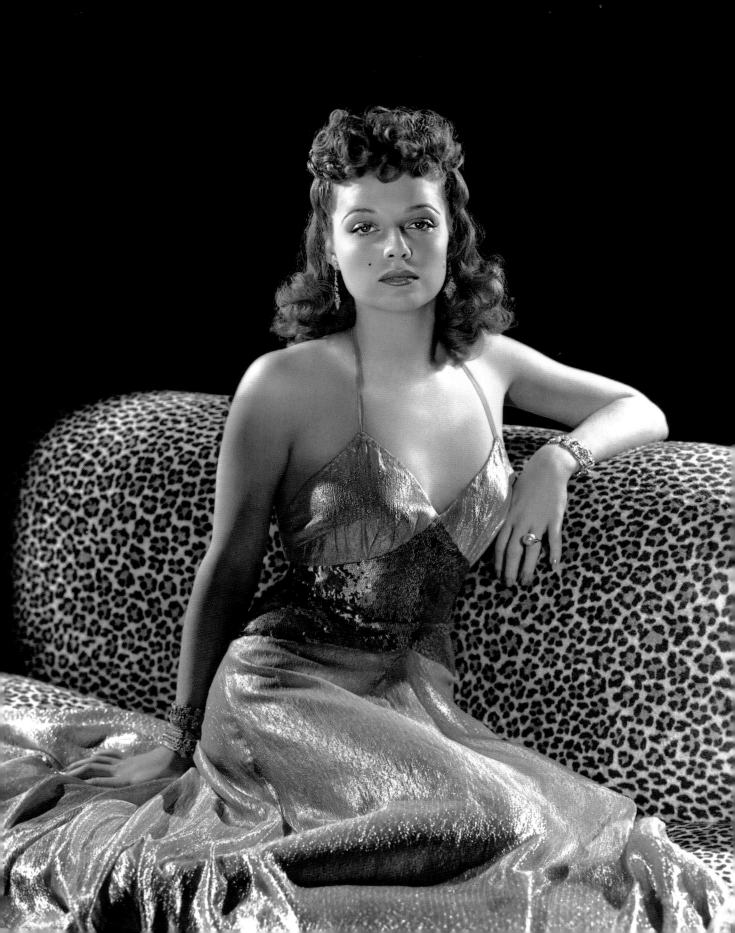

production number "Lullaby of Broadway" in *Gold Diggers of 1935* required as much taste and skill as the Agnes de Mille ballet in M-G-M's *Romeo and Juliet*. Warners' photographers customarily produced 500 key set stills per film, a luxury that not even M-G-M could approach, so Warners' sets had to look good. Furthermore, like every other studio, Warners was hiring pretty girls. "Who wants to look at an ugly dame?" asked producer Bryan Foy.

OPPOSITE: Moving to Warner Bros. gave George Hurrell a new type of subject. "I'm a mug," said John Garfield. "Just a mug." It made sense for Hurrell to let Garfield go at his own pace. "There was a frantic air about him that I understood because of my own restless nature," said Hurrell. "He couldn't sit still. Thank God I worked quickly, because I was able to catch him. He lent action to his shots."

ABOVE: Maggie Ettinger was still publicizing Hurrell. Thanks to her and Warner Bros. publicist Robert Taplinger, Hurrell became famous.

Warners had top-notch cinematographers. "Sol Polito just worked like a dog," recalled writer-producer Robert Lord. "Photographed women a 'tick' on the hard side. Very quiet. [Cinematographer] Tony Gaudio was a much more traditional Italian. Under pressure he would scream, yell, and curse in two languages. Really good with women stars. Used filters and gauzes and made them softer. Ernie Haller was wonderful with women, too. Made Bette Davis look lovely in *Jezebel*." One day on the set of a Davis film, Olivia de Havilland saw Ernest Haller arguing with assistant director Jack Sullivan, who then pushed Haller. From across the set came a woman's voice. "You leave Ernie *alone*!" It was Bette Davis. "She was like a volcano going off!" recalled de Havilland. "She was *that* violent." Yes, Warners was tough. "There was not the Norma Shearer elegance you found at Metro," said actor Ray Bolger.

Hurrell was being wooed because Warners needed the boost he could supply. After a couple of good years, the studio was in the red. Prestige pictures such as *The Adventures of Robin Hood* were costly. Hurrell had shot a portrait of Errol Flynn as Robin Hood earlier in the year and impressed the studio's publicity chief, Robert

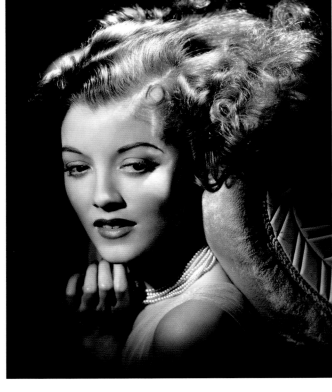

Taplinger, who could tell that Hurrell was tired of managing his own studio. In June Taplinger offered Hurrell the job of head portrait photographer for two years at $350 a week, with options for two renewals. On July 11, Hurrell wrote to Taplinger, saying, "Your figures were 350-350, 400-450, and 500.... If you would rearrange the figures to read 350-400, 400-450, and 500, it's a deal. In other words, an advance of $50.00 in the second year. This is on a fifty-two-week basis, of course. With kindest regards, Sincerely, Georgie." His request was refused.

Hurrell had to think. He was enjoying a comfortable existence, but he did have expenses. He and Katherine were renting a large apartment at 1360 North Crescent Heights Boulevard. She was used to shopping at Bullocks Wilshire and dressing for functions such as the baby shower for Joan Blondell at the Victor Hugo Restaurant in Beverly Hills. Hurrell was spending money to mount exhibitions at the Laguna Beach Art Gallery. If he gave up his studio and went to work in Burbank, he would be paid less than Elmer Fryer, a Warners veteran who shot portraits. There would, however, be a regular paycheck

and no ledgers to maintain. On July 20, Hurrell signed a contract with Warners. On August 1, he wrote his last check to Montgomery Properties, for $75, and closed down his operation at 8706 Sunset Boulevard.

On September 1, Hurrell made a twenty-minute drive through the Cahuenga Pass and reported to work at Warner Bros-First National. The hyphenate referred to Warners' acquisition in 1931 of First National's assets

ABOVE, LEFT TO RIGHT: This Hurrell portrait of Vincent Price was the first released by Warner Bros., which expected the unusual young actor to become a romantic lead.

Nell O'Day was a stage and screen veteran when she came to Warners for one film, *Saturday's Children*, but she nonetheless got the starlet treatment.

OVERLEAF: It was a red-letter day when Hurrell photographed Ann Sheridan for "The Oomph Girl" campaign. These photographs comprise a valuable record of his technique. They also show an amazing transformation. Sheridan looks like a giggling child while Hurrell is teasing her, but when he finishes, she personifies the eternal feminine.

and its sprawling Burbank facilities. Warners built new stages there but retained its white colonnaded building on Sunset and the Vitagraph lot on Talmadge Avenue. When Hurrell went to work in Burbank, he took over the most sophisticated portrait gallery in Hollywood. It was spacious, well appointed, and well staffed. One of three galleries situated in the center of the lot, Hurrell's new quarters had a storage loft and doors tall enough to admit upright scenery. Working in the other two galleries were Elmer Fryer and Scotty Welbourne. Other photographers—Madison Lacy, Buddy Longworth, and Eddie Stone—shot "cheesecake" and "leg art." This pinup material was aimed at unpretentious publications like *Film Fun*, *Snappy*, and *Screenies*. Warner paid these photographers up to $500 a week. Their nubile subjects got $50 a week for six months; then they put on their street clothes and disappeared.

The Warner Bros. stills lab was as imposing as its galleries. The lab employed a full-time film processor, six retouchers, ten printers, five print finishers, and turned out more than 100,000 prints a year. Most of them went to theaters and newspapers, but the important ones went to the fan magazines. "Those fan magazines were the greatest star builders that ever existed," declared longtime publicist Teet Carle. Publicity was Warners' life blood. It was no coincidence that Hal Wallis had started as a publicist fifteen years earlier. Jack Warner thought enough of the department to have it situated near his office, and he checked in every morning when he arrived. In fact, he checked everything at his studio. "Jack Warner even worried about how much paint was being used on the sets," said producer Henry Blanke. "He arrived each morning in those days, early, and went to each set. He was a real boss." Hurrell was advised to look busy if he saw Warner coming.

Warner saw him first, but in a good light, literally. Taplinger decided that Hurrell was a fine-looking fellow, so why not publicize him? Taplinger had him shoot a self-portrait and began placing stories about him, items such as "Landmark in Hollywood" and "Studio Photographer Confesses." Within a year, he was the subject of eight features. A colorful interview subject, he began to receive his own fan mail. He had been shooting movie stars

for Lux soap, so Taplinger got him onto the *Lux Radio Hour*, where Cecil B. DeMille introduced him, saying that "Hurrell is to a portrait camera what Rembrandt was to paint and canvas." Hurrell's contract excluded any outside work; he gave up Lux, but kept his *Esquire* account, with the provision that he shoot only Warners starlets for the publication. Up to this time, he had been shooting color with the unwieldy three-plate Grumbacher camera. He switched to Kodachrome 8x10 transparencies for his *Esquire* portraits and for the occasional Warners color. Black-and-white remained his unchallenged province.

The look of Hurrell's fifth period of work was in keeping with the typical Warners film: topical, hard-hitting, and slick. The studio's fare appealed to a proletarian audience, but it had to compete with the M-G-M gloss and the Paramount glow. So did Hurrell. His work gained a new look, a hard, lacquered reflectivity. There were technical reasons for this. First, he changed film stocks. For six years he had been using Super Sensitive Pan, even after Eastman changed its base from the unstable, inflammable nitrate to the easily storable diacetate. But the new "Safety Film" base made no difference to the film's sensitivity. It was rated at ASA 125, the equivalent of present-day ISO 125. In the late 1930s, Eastman introduced a number of "fast" new films: Super XX, rated at 200; Panchro Press, rated at ASA 250; Super Panchro Press, rated at ASA 400; and the ever-popular Tri-X, which was at that time rated at ASA 500. Film was becoming more sensitive without becoming unduly grainy. Hurrell chose Panchro Press because of its dramatic contrast. It made even contact prints sparkle and allowed him to shoot at an amazing tenth of a second—with his new 10-inch Goerz Celor lens stopped down to f/16. At this f-stop, his prints had an almost scientific clarity.

Hurrell also changed lights. His new workplace was equipped with not one but two boom lights. He had neglected to patent his invention, so it was being manufactured by many companies—Bardwell McAlister, Otto K. Oleson, and Beattie. Warners used the "Boom Lite" sold by Beattie's Hollywood Hi-Lite Company for the nominal fee of $68. This lightweight adaptation had superior maneuverability, enabling Hurrell to light his

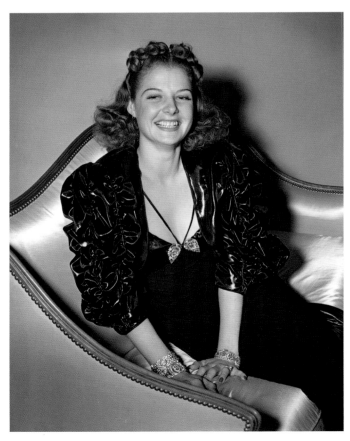

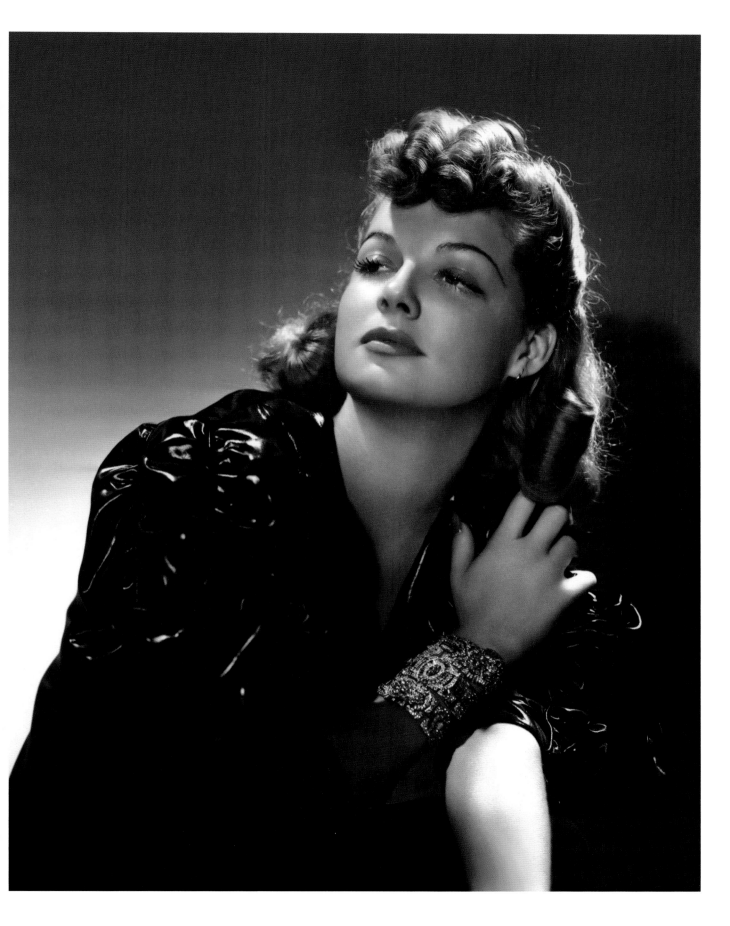

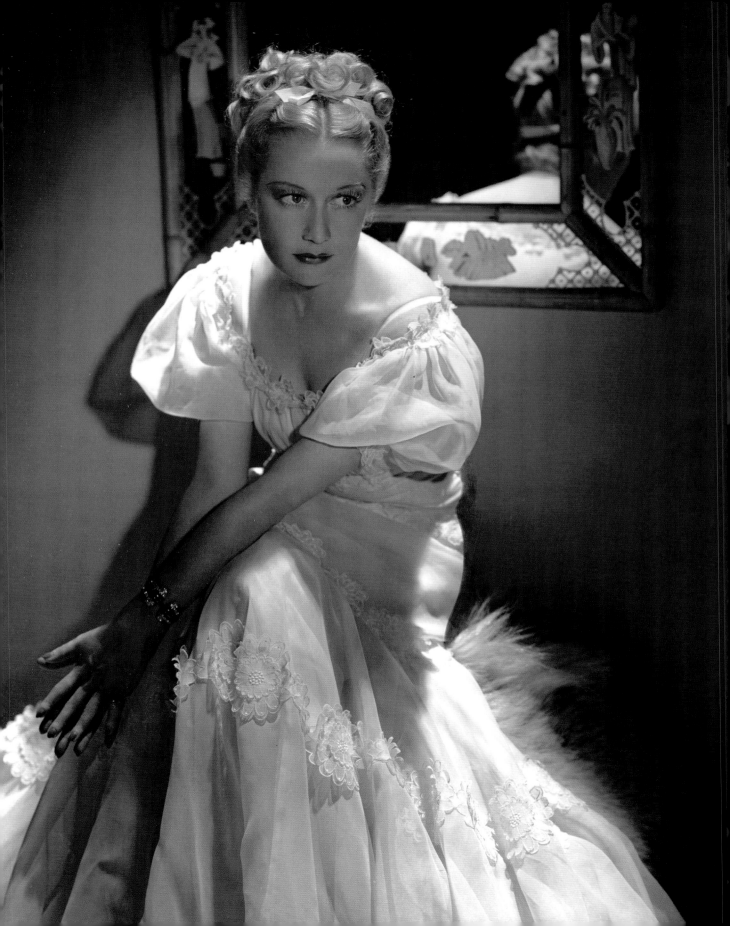

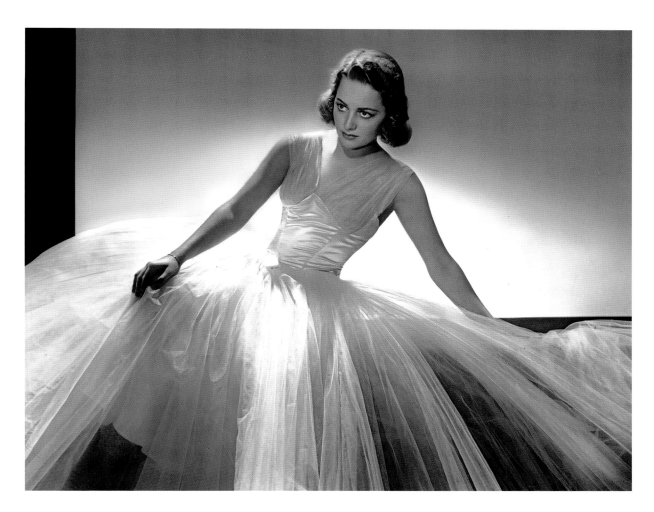

subject from angles that would be inconceivable with light stands. Using two boom lights at once made his work soar to new heights, both literally and figuratively. Further aided by the "boom" of the boogie-woogie music from a cabinet phonograph, he went to work.

This was where Hurrell went into high gear, leaving competitors and imitators behind, drawing from his own life to create tangible images of intangible fantasies. It

OPPOSITE: A Hurrell portrait of Miriam Hopkins from 1939, when she was preparing to work with Bette Davis in Edmund Goulding's *The Old Maid*.

ABOVE: Olivia de Havilland was often visibly uncomfortable in Hurrell portraits. She disliked his sexy talk.

began in 1933, when he had Maureen O'Sullivan lie across a black satin pillow, hair cascading toward the camera. He discovered that shooting down on a supine woman whose head was pointed toward the camera gave a look of unmistakable eroticism. "The power of glamor [sic] in a photograph consists of the evocation of sexual surrender," wrote Josef von Sternberg. Hurrell experimented with this effect over and over in his *Esquire* series. "You know," he said years later, "glamour to me was nothing more than just an excuse for sexy pictures, for saying, 'Come on, we're going to take some sexy pictures.'" He finally perfected this effect with a contract player named Ann Sheridan.

In 1938, the columnist Walter Winchell wrote: "There is this young Ann Sheridan and she's got an 'umphy' quality." No one knew quite what this meant. "Winchell used

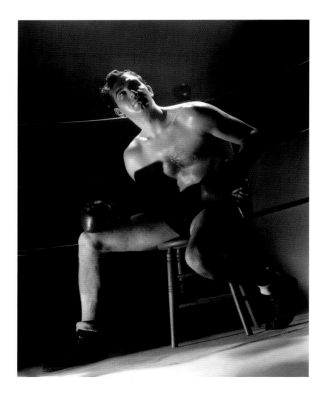

to make up those words," said Sheridan. "But there it was in print, and Bob Taplinger was looking for something that would get the studio into the papers. Mr. Warner had been sitting in his barbershop chair reading a paper, and not finding his name in it, had called Bob." Taplinger seized on this item, changed the spelling to "oomph," and called Hurrell.

"They got George Hurrell to take sexy-looking photos of me," said Sheridan. "He didn't know what 'oomph' was either, so he made me sit on a bear." Combining the word, the animal, and the young lady created a sensation. Sheridan was suddenly a name. She had bargaining power. "That 'oomph' thing snowballed," she said. "Before then I had no parts worth remembering. Molls and nurses. Whenever I tried to go for a part, they'd say, 'Oh, but you're not an actress.' I had to fight for everything at Warners. From the casting director up to Jack Warner. Everybody seemed to have to fight. Even Cagney and Davis. A knock-down, drag-out fight. You didn't always win, but it let them know you were alive. This Hurrell thing did give me a foot in the door."

Once again, a series of Hurrell photos had changed the course of a career. If he knew about it, he did not care. He had no investment in the studio's long-range plans. The most important thing to him was the next subject. "They are *all* sexy," he said in 1940. "Every one of them. They are the wickedest-looking women in the world. And my job, when they come to me, is to make them look even more wicked." He did it by turning on his formula—full force.

"I latched on to this big bear rug," he recalled. "I don't know why or how, but I got hold of it and one of the things I used to do was get them to lie on that rug. I'd get carried away and say, 'Lie down.'

"'What do you mean, lie down?' I'd get a reaction like that. And then, when I had them on the floor, I'd shoot down and automatically it changed the whole business of what they were going to do and the character of it." The business was often more goofy than sexy. One writer heard Hurrell say as he aimed the camera: "Oh, you're so good to me!" Another heard him say, "One more—for a hot cup of coffee!" A third heard, "Give!" In the studio, Hurrell was a law unto himself; at least he wanted to give that impression.

"Every now and then," said Hurrell, "I run across some new actress who approaches my studio with genuine fear. She has heard that I am a man who takes sexy pictures. And that most of the time I do it by concentrating on the bosom. She doesn't know what will happen to her once she gets into my studio. Will I order her to take off all her clothes right then and there? She suspects as much."

A born showman, Hurrell knew that hyperbole garnered newsprint. Reporters knew that there was never any question of familiarity between artist and model.

ABOVE AND OPPOSITE: Hurrell photographed John Payne in June 1939 for George Amy's *Kid Nightingale*.

OVERLEAF, LEFT TO RIGHT: Ann Sothern got the Hurrell treatment in 1940 for Lloyd Bacon's *Brother Orchid*.

Rosalind Russell was loaned by M-G-M to Warners for William Keighley's *No Time for Comedy*, so she got the Hurrell treatment again.

Sessions were conducted only during work hours and in the presence of two assistants, a makeup artist, wardrobe person, and a publicist. Hurrell enjoyed this sexy, silly act, and the press did, too. A New York writer named H. Allen Smith wanted to know more. Hurrell was far enough from Hollywood to be candid. "Well," he admitted, "it's chiefly the things I say that bring on those expressions in a gal's face." Allen did not believe him. Hurrell stood up to demonstrate.

"Hurrell began bouncing around, pretending to be snapping pictures and talking like a 42nd Street pitchman who sees a cop coming. And the things he said! The things he says to those actresses to get them wrought up! When he had finished we recovered sufficiently from the shock to ask: 'Do you mean that you really say those kinds of things to actresses?' He did mean it." In October 1939, Hurrell told *Coast* magazine that his rule was "Shoot for the sex angle first; you should try something else only if that fails." There was one time it did fail, and badly.

Shortly after Hurrell set up shop at Warners, Olivia de Havilland came to him for a session. She had been having a hard time at the studio, which was overworking her and ignoring her pleas for better parts. The stress was taking a toll. She was on the verge of a breakdown. She would burst into tears without warning or control. A neurologist friend helped her find a regimen and get through her crisis. He was the only help she got. "Jack Warner was totally indifferent," she said. When de Havilland went to Hurrell's gallery, she was hardly in the mood for a performance. Unfortunately, he went into the lewd routine he had shown H. Allen Smith. Olivia de Havilland turned rigid, stood up, and told George Hurrell to shut up.

How seriously did Hurrell take these sensational exercises? "There are friends," wrote *Esquire*, "who testify that after he had spent a day photographing the oomph girl in all her glory, he spent nine hours painting the gnarled trunk of a pine tree." A tree would be more cooperative than his next Warner Bros. subject.

OPPOSITE: Humphrey Bogart was playing second-lead criminals at Warner Bros. during the two years that George Hurrell worked there, so Hurrell never photographed him in his starring roles. Still, the portraits they created have a thoughtful, brooding quality. "Bogart was very serious about the work," recalled Hurrell. "He would strike poses that were familiar, and then he'd say, 'Okay, kid, let's do something different.' The music in the gallery was always loud and furious."

OVERLEAF, LEFT TO RIGHT: James Cagney was the actor's actor, a song-and-dance man who could do Shakespeare and everything in between, but he had one problem: his coloring made him photograph like a blank screen. "I never saw him without heavy makeup," said Hurrell. "He had sandy hair and pale eyebrows, and after he'd darkened them, why, I helped by putting the front light up high, unless he was wearing a hat. He was usually serious, and he handled a sitting just as professionally as he handled a character in a script."

Hurrell found Errol Flynn as engaging in the gallery as he was on the screen, a truly charming man.

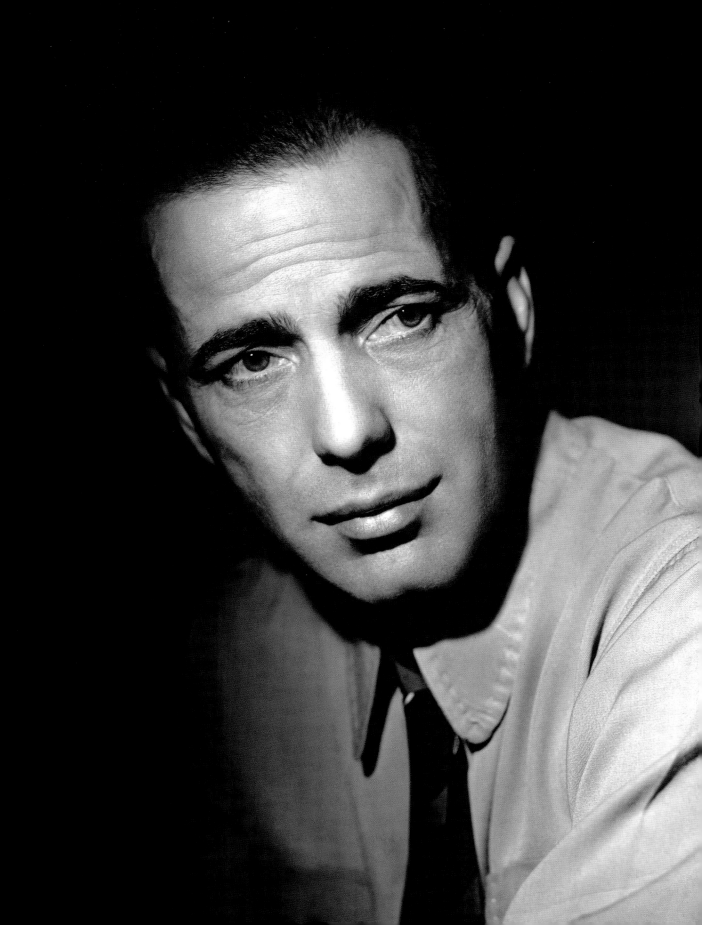

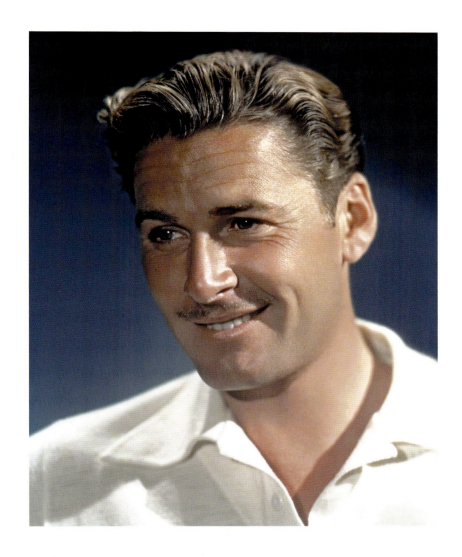

OPPOSITE: A 1939 Kodachrome portrait of Errol Flynn and Bette Davis made for Michael Curtiz's *The Private Lives of Elizabeth and Essex*.

ABOVE: An Errol Flynn portrait shot on Kodachrome transparency film in April 1940. Flynn was ambivalent about the stardom that *The Adventures of Robin Hood* and *The Sea Hawk* brought him. "I was labeled a 'swashbuckler,'" said Flynn. "I felt used. Used by the studio to make money. Used by the press for fun. Used by society to provide a dab of color." While he was being used, he managed to paint Hollywood his own shade of red, but Hurrell found him very pleasant to work with.

SHINY WAX FRUIT

In late 1938, George Hurrell spent his days at Warner Bros. and his evenings in a new house with Katherine. The rental was above Sunset, at 1348 North Miller Drive. Things were going well at Warner Bros., even though the studio was ending the year with a loss of $1.9 million. The company had struck gold with Errol Flynn and Bette Davis, and 1939 would be a different story. Flynn would have two hits in release, Davis would have a phenomenal four, and Hurrell would have two of his most sympathetic subjects.

Davis had struggled for years to be acknowledged as something more than a minor leading lady in drab, cheap little movies. "I was made to trudge through the professional swamp at Warners, brimming over with frustration and rage," recalled Davis. "I dreamed that someday Warners would give me the glossy productions that M-G-M gave its players. The girl I was playing would never have a gown by Adrian with a supersonic collar like the one Joan Crawford wore." Davis made a film with Crawford's husband, Franchot Tone—*Dangerous*—and she won an Academy Award for it. However, she had to fight Jack Warner in court before she was given quality scripts like *Jezebel*. By the time Hurrell encountered her, in the fall of 1938, the actress was Warners' biggest moneymaker. An exhibitors' poll declared her America's most popular star. "Bette Davis was the queen and we all knew it," a retired Warner Bros. hairdresser told historian-filmmaker James R. Silke in 1975. "She made the money, not the brothers."

The fan magazines were festooned with portraits of her by Elmer Fryer, but the portraits were mostly in character. After all, she was a unique Hollywood commodity: "The Actress" more concerned with performance than with appearance. She used no full-length mirrors on set and apparently had no vanity. Then Bob Taplinger decided that Davis must be glamorized. She was less than enthusiastic. "I don't want some glamour girl stuff," Davis said. "I want to be known as a serious actress, nothing else." She had seen Hurrell's portraits of Crawford, whom she called "that mannequin from Metro." She was unimpressed by the effects Hurrell achieved with Crawford's skin. "I don't want to look like a piece of shiny wax fruit," sniffed Davis. Whatever Davis thought of Hurrell, posing for publicity was in her much-contested contract, and she had no choice but to show up. Hurrell greeted her, at first effusively. "You're the most glamorous gal in pictures and I'm going to prove it!"

"Go easy on the glamour, George," she warned. "I'm not the type."

OPPOSITE: George Hurrell's most prestigious—and ultimately rewarding—assignment at Warner Bros. was Bette Davis. He was inspired to make her image more abstract than any other he shot in Hollywood.

WARNER BROS.

Sensing he had perhaps come on too strong, Hurrell looked Davis in the eye and said, "You're beautiful, Bette." Then he turned on the phonograph, loud. Davis asked why he played it for his subjects. "I don't play the music for them," he answered. "I play it for myself. I've got to keep myself pepped up."

Davis was used to being the performer, but that day Hurrell was on stage, playing the madcap, running to and fro, singing with Cab Calloway records, pushing a light, tripping over the thirty-foot hose that ran from the shutter release bulb. "All I had in my hand was a bulb," said Hurrell. "The shutter would open and close based on the air pressure in that bulb. The subject wouldn't know when the actual photograph was being taken because I would make much more noise pushing the air out of that bulb than the shutter would make. This would defeat their interest in holding a pose."

Davis began to respond to Hurrell's zaniness. "I don't remember what I said to her, but it broke her up so much that tears would run down her face. That caused makeup problems, but her smiles were real, not forced." When Davis saw the proofs, she exclaimed, "Hell, these are fine!"

After this success, Taplinger commissioned a session to comprise a new ad campaign. "Study This Face" challenged Hurrell to create new faces for the most recognizable face at Warners. The campaign was intended to promote Davis's film, *Dark Victory*. In it, she played a spoiled, willful society woman who discovers that she has terminal cancer and then musters the courage to put her life in order. Hurrell's camera saw not only Davis's sensitive portrayal but also her emotional turmoil.

"There was something in her face that I'd not seen before," said Hurrell. "I'd always considered her attractive yet now she had a special kind of beauty. I played classical music, which I didn't often do for her, because we both liked upbeat tunes. When I looked through the lens, there was a compelling force about her, a kind of inner anguish that could only mean that she was going through a difficult time emotionally." Hurrell could not ascertain the reason for her sadness but felt that it gave the portraits an added resonance. In fact, it was rumored that she was distraught over a harrowing series of events. While making *Jezebel*

earlier in the year, she and her director William Wyler had embarked on an extramarital affair. In September, when she had refused to divorce her husband, bandleader Harmon Nelson, Wyler married actress Margaret Tallichet. On the rebound, Davis took up with Howard Hughes. To complicate matters, Nelson caught them in the act and threatened blackmail. Davis managed to avert that but had to submit to a divorce. Thus, when she arrived at Warners to begin shooting *Dark Victory*, she was, by all accounts, a mess.

By the time of their next session, Davis's usual cheer had returned, but she could still impart whatever mood Hurrell required. "She had the ability to switch from a gay, laughing pose to a completely dramatic attitude in a matter of seconds," he recalled. Robert Taplinger needed something unusual for the centerpiece of the "Study This Face" layout. Could Hurrell make Davis look transfigured, spiritual? What was needed was the apotheosis of Bette Davis. To accomplish this goal, Hurrell implemented new techniques.

When shooting the average portrait, he used 500-watt lights. "If you can keep the light low-key," said Hurrell, "that's to your advantage. People aren't too conscious of the lighting—or blinking." He found that 500- or even 200-watt lights were better than 1,000-watt lights. Lower wattages were less hot and they allowed for more bounce light, which made for a translucent skin texture. "When the light is too hot," warned Hurrell, "you lose highlights."

To get the desired effect, Hurrell broke this rule. He put a 1,000-watt spotlight two feet away from Davis's face and purposely overexposed the film, shooting various angles. Then he underdeveloped the film, thereby retaining the highlight detail that would ordinarily have been lost. His next step was to retouch the negatives as usual. He then projected two of these negatives onto one sheet of direct positive film, creating a double exposure in the darkroom. The result was an image combining technical wizardry and dreamy beauty.

By the summer of 1940, Hurrell was feeling the old itch again. Working feverishly in the same room for nigh-on two years had gotten to him. "You think about shooting people day in and day out for two years at a stretch," he said, "especially when they are the same kind of people—to keep getting variety is maddening." One

way to get variety was to shoot on standing sets, but it was expensive. Taplinger preferred that Hurrell stay in the gallery, but Hurrell wanted to work on the magnificent castle set that Anton Grot had designed for Michael Curtiz's film of Maxwell Anderson's play, *Elizabeth the Queen*. Taplinger got approval for the additional crew members this required and scheduled a session with Errol Flynn and Bette Davis. She had objected to the new title, *The Knight and the Lady*, and Warner promised to

change it. After filming with Flynn for a week, she learned that the title had not been changed. She stormed Warner's office. "A queen doesn't take second billing," she screamed at Warner. "And *I* don't take second billing!" The title was changed to *The Private Lives of Elizabeth and Essex*. After enduring this and okaying an on-set session, Warner was slightly piqued.

While waiting on the castle set for the stars to arrive, Hurrell chatted with a gaffer. A peremptory question came

ABOVE: Hurrell featured Davis's luxuriant head of hair in her portraits, capturing it in sharp detail, which was one of his trademarks.

STUDY THIS FACE!

You'll never forget it. For here are forever written
the ecstasy and pain of woman loved and loving.
Here is the face of Bette Davis in her supreme
dramatic triumph, "Dark Victory." Here is the
screen's most gifted actress in a role which is
destined to win for her another Academy Award.
Watch for "Dark Victory"—a Warner Bros.
presentation—in America's leading theatres soon.

from behind him. "Well, what are you doing?" asked Jack
Warner, who looked like a foreman castigating a goldbricker.

"Waiting to take some shots, Mr. Warner."

"I'm not paying you to stand around talking," said
Warner, who walked away and then laughed with his
associates at Hurrell's expense. The humiliation of this
pointless incident stayed with the artist. "I'd seen him pull
this stunt on others," recalled Hurrell. "But this was the
first time he pulled it on me—and the last."

Hurrell's final Warners session with Davis was in
the summer of 1940, for William Wyler's *The Letter*.
She was at the peak of her fame, but Hurrell was slowing
down. Still, his images were no less carefully composed,
dazzlingly lit, or emotionally charged. His fifth period
of creative development was no less inspired than
its predecessors.

Hurrell was growing restless again. In December 1939
he and Katherine had sailed to Hawaii for a vacation. "I
want to get my feet back into the soil," he had explained.
In July 1940, Hurrell left Warner Bros. for a three-week

unpaid vacation. He went to New York and worked for
some ad agencies. His absence stretched to six weeks. Bert
Six had to finish Davis's portrait art for *The Letter*. Warner
put Hurrell on suspension. He did not care. In September,
when his contract was up, he declined to renegotiate it.
Hurrell worked off the six weeks of his suspension, and
then, on October 15, he went to Jack Warner's office, told
him what he thought of his cheap stunt on the sound-
stage, and then turned on his heel and walked out. Hurrell
was jumping ship again, but this time he knew where he
would land.

ABOVE: A "Study This Face!" ad used Hurrell's work to
advertise *Dark Victory*.

OPPOSITE: "An actress's success is as much dependent
on her photographic beauty as on her acting ability," said
Hurrell. "She must maintain the illusion of perfection."

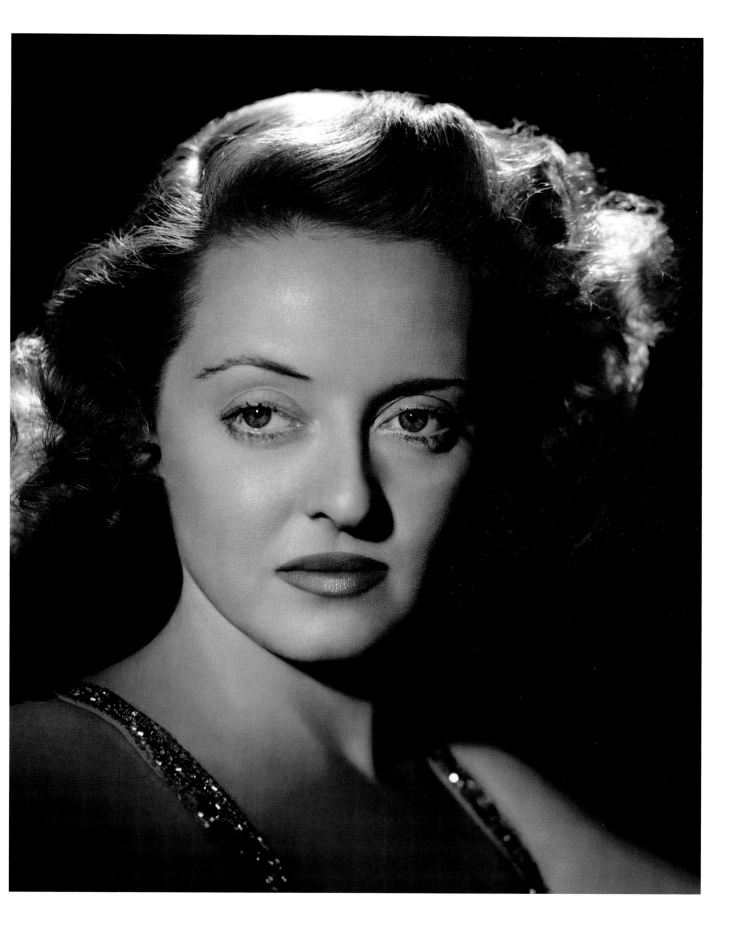

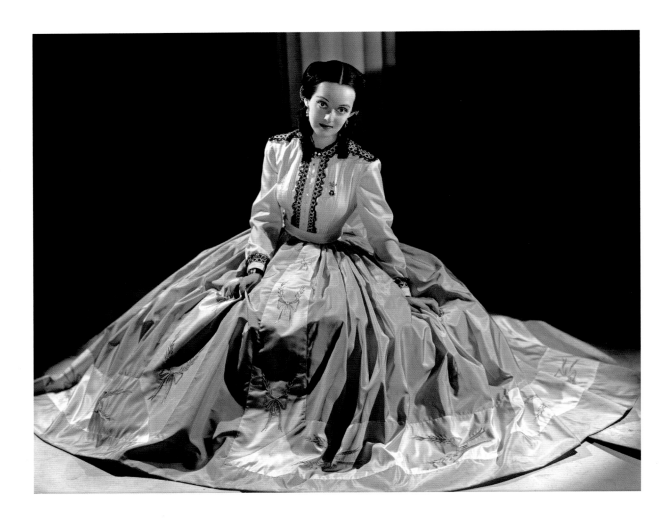

ABOVE: A portrait of Davis in character as Empress Carlota in William Dieterle's *Juarez*.

OPPOSITE: Bette Davis had personal problems when Hurrell made the *Dark Victory* portraits; some of them show this. Still, Davis was pleased with the session. "George Hurrell was the greatest," she recalled forty years later. "He took fantastic portraits of me."

OVERLEAF LEFT: This Schuyler Crail photograph shows Hurrell and his assistant, Al Harvey, shooting Bette Davis in *Juarez*. At this point Hurrell was using two boom lights.

OVERLEAF RIGHT: When Hurrell shot Davis, he never knew who she would be, Empress Carlota or Queen Elizabeth. "Hurrell's studies of me were an immense contribution to my career," said Davis. The two artists worked together a dozen times between 1938 and 1974.

PAGE 242: A portrait of Bette Davis made for *Juarez*.

PAGE 243: This Kodachrome portrait of Bette Davis was made by Hurrell to help promote interest in *The Old Maid*.

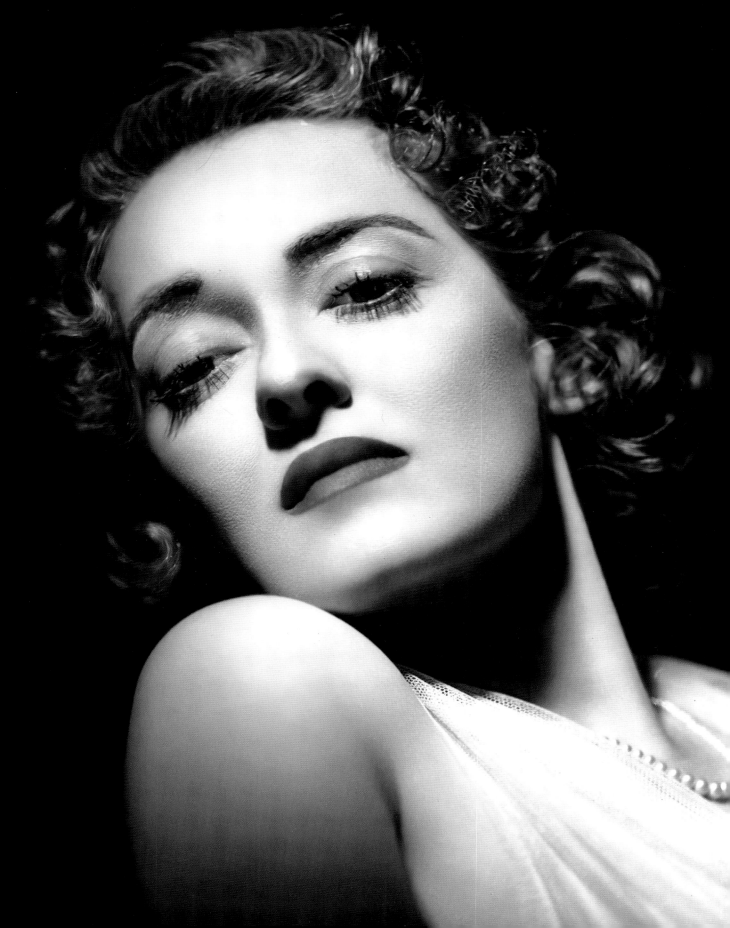

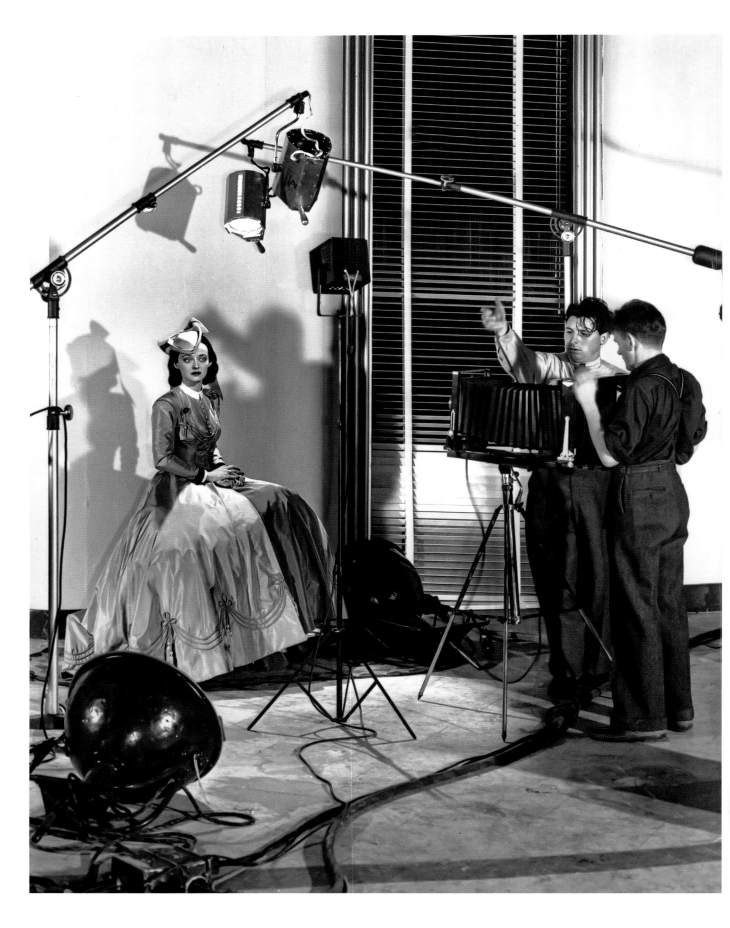

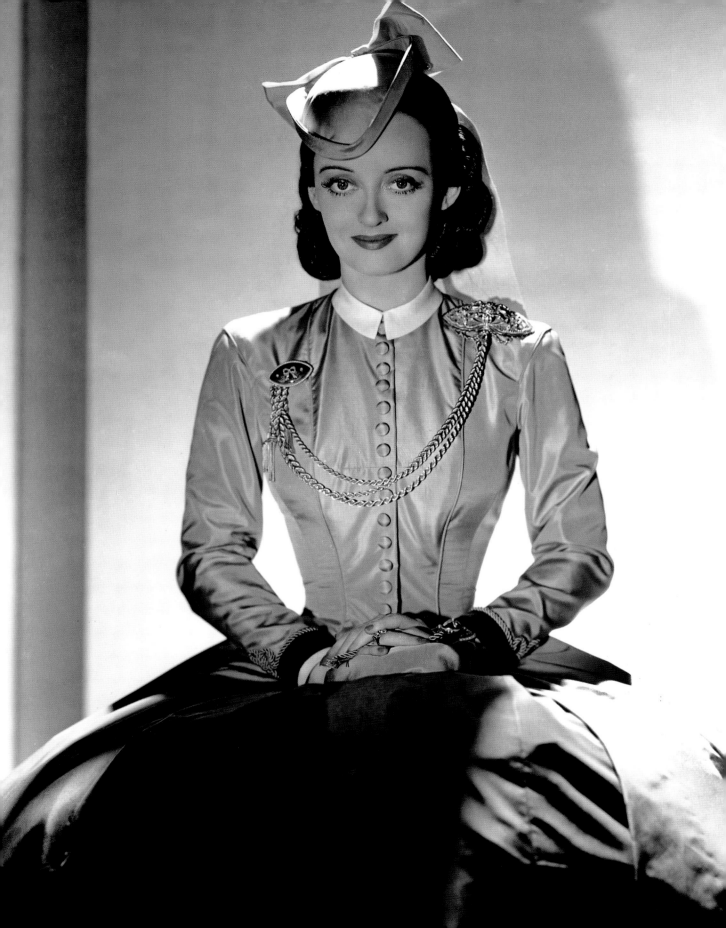

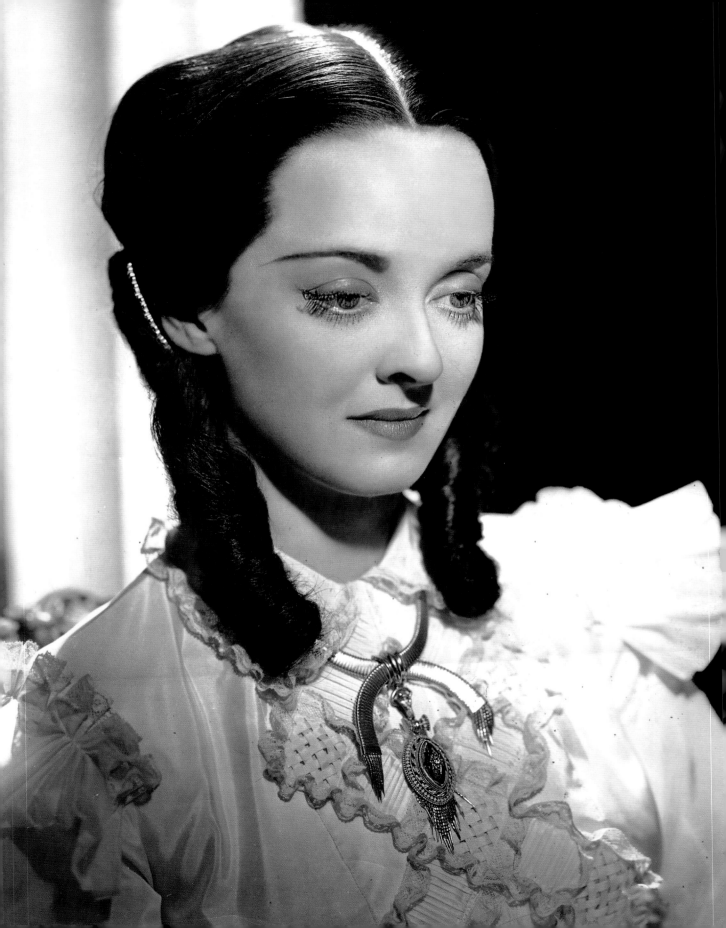

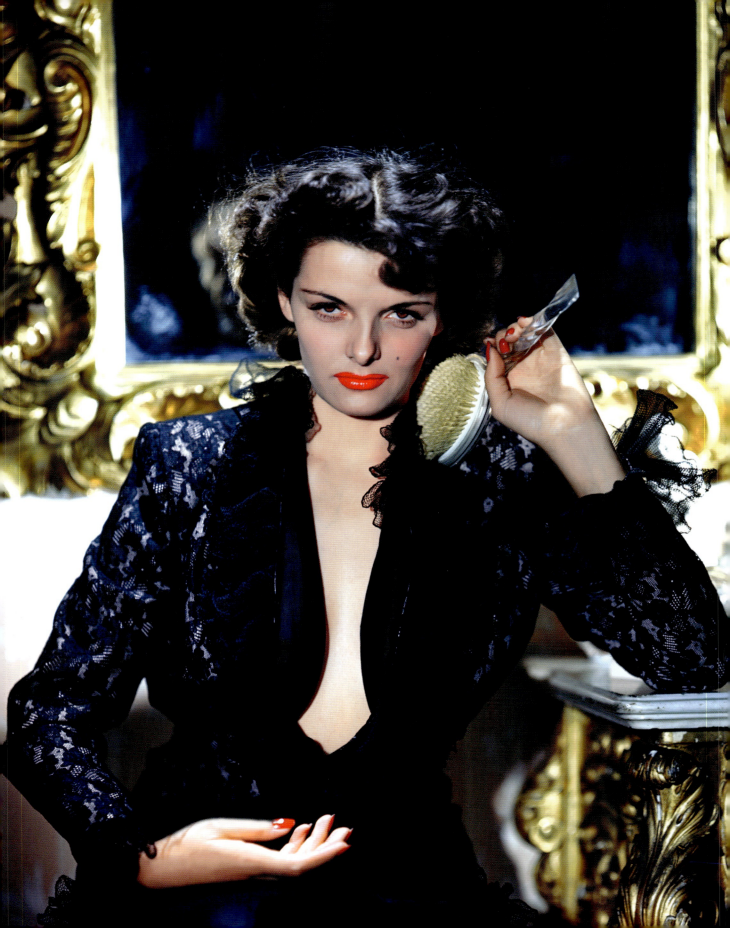

CHAPTER 5
RODEO DRIVE

THE PHOTOGRAPHER AS STAR

George Hurrell had continued his friendships with Maggie Ettinger and Helen Ferguson. When he moved to fashionable Beverly Hills, they made sure that the world knew about it. He and Katherine had saved most of his Warner Bros. wages, so they could afford a commercial space at 333 North Rodeo Drive. Hurrell had learned a great deal from the Warners facility. He envisioned a studio where he could shoot both portrait and commercial work. He still had the *Esquire* account and was free of Warners' restrictions. He could shoot for whomever he wanted. He commissioned architect Douglas Honnold to design a functional, elegant studio on the Rodeo Drive premises.

Like 8706 Sunset, 333 was a narrow storefront set in a commercial property. Unlike it, this space extended behind neighboring shops, giving the gallery a width of forty feet. The gallery, reception area, and offices had airy twenty-foot ceilings. This height was broken by a catwalk and second-floor darkrooms. On the first floor there were also a women's dressing room, a men's dressing room, and a storage room. Hurrell's wry theatricality came into play with the interior decoration, which was executed by Joseph Copp Jr. Hurrell painted the brick-and-plaster walls pink so they would photograph properly, and because Katherine forbade pink at home. The focusing cloth on his new Korona view camera was dyed the same shade of red as the roses on the wallpaper in the women's dressing room. The reception desk was the sawed-off base of a huge gold

column. Writing in *U.S. Camera* magazine, G. T. Allen called the studio "a triumph of modern design."

With construction under way, Hurrell loaded his Buick station wagon with camera gear and drove to New York with his former Warners assistant, Al Harvey. As he had done years earlier, he leased a space in the Waldorf Astoria Hotel and spent a few months shooting socialites such as Doris Duke and Helena Rubinstein. When he returned to California in January 1941, the studio was not ready, so he rented a small space at 8404 Sunset Boulevard to shoot his monthly *Esquire* work.

In August 1941, he finally opened his smart new studio. One day in November, he was surprised to find Greta Garbo in his reception area. "Alloo, Mister 'Urell," she said in her distinctively low voice. "I thought I would come by and see how my new tenant is doing."

"You're my landlady?"

"Yes," she said. "It pleases me very much to have you on my property. Show me around, please."

PREVIOUS: The star-making campaign that dwarfed all others took place in 1941 at the behest of billionaire Howard Hughes.

OPPOSITE: In 1941 Hurrell photographed the newly arrived star, Veronica Lake, for a Paramount Pictures "Personality Poster."

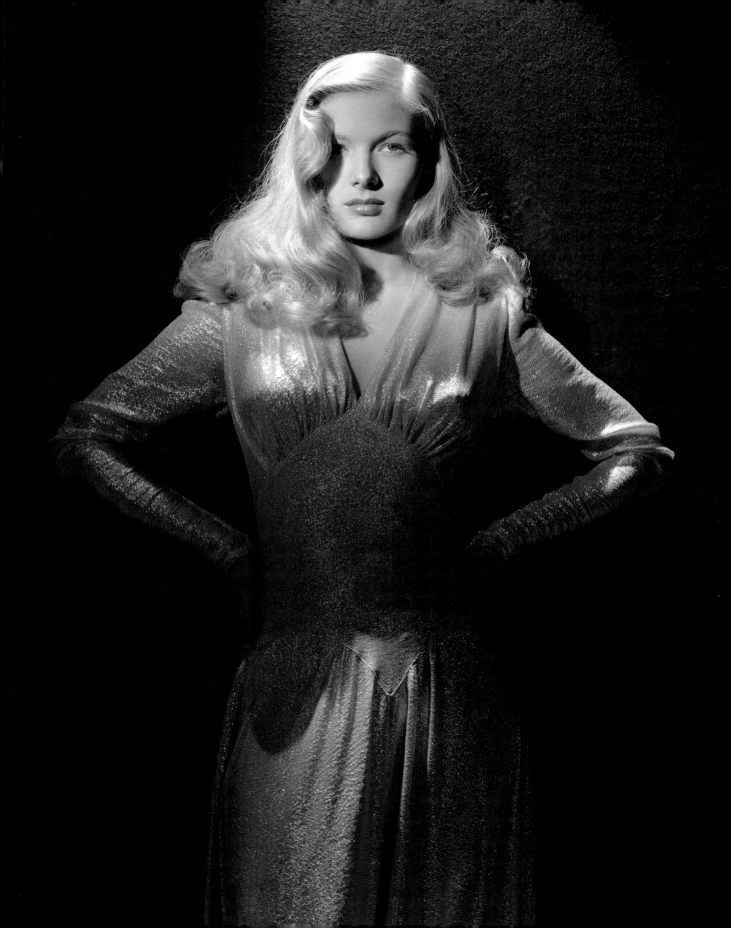

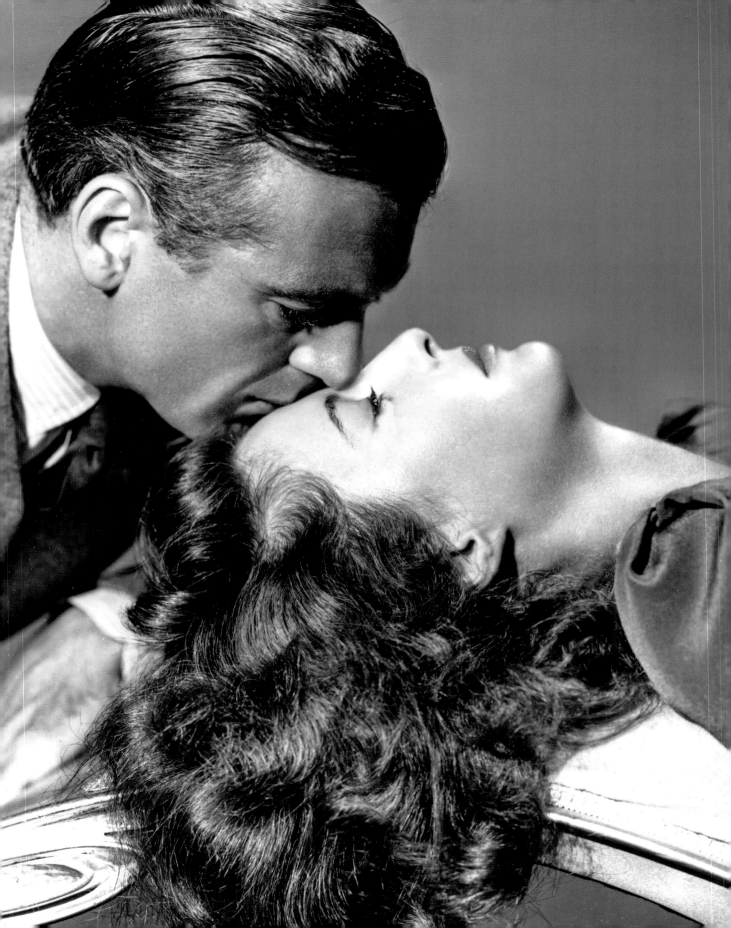

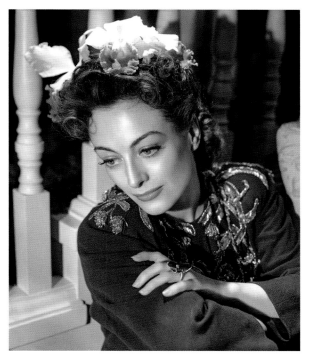

Hurrell gave her the grand tour, and when she commented on the lightweight Korona camera, he saw that here was another movie star who was "very astute and completely knowledgeable." She was also pleasant and chipper, even laughing occasionally. "I found out she was a happy person by nature," said Hurrell. "Why hide it? She liked to look grim and dramatic, as if the world were coming to an end. But that wasn't the only way for her to look."

As Garbo started to leave, Hurrell popped the question: "How about some shots?"

"Oh, no, no, Mister 'Urell," she said with a smile. "I am not photographed anymore." She waved and was gone. Hurrell could not conceal his disappointment. He had hoped to make up for the perceived failure of his 1930 sessions with Garbo, but she was not about to cooperate. "She was probably the sexiest gal among the whole bunch of them," he said in 1969, "but that wasn't what she was selling."

Garbo had bought the building in October for $68,750. What Hurrell did not know was that on October 3, she had had her last session with Clarence Bull. Her next film, *Two-Faced Woman*, was a qualified failure; it made money but retakes had pushed its cost to the point where it needed the foreign market to make a profit, and with World War II being fought, there was no foreign market. Garbo was still signed to do another film, but M-G-M could find no suitable project. She returned her money to Louis B. Mayer and left the studio. She did not fully realize it, but her career was over, and within a year, many of her contemporaries would also leave Metro:

OPPOSITE: In 1941 Hurrell had the pleasure of photographing Gary Cooper and Barbara Stanwyck for both Goldwyn (*Ball of Fire*) and Warners (*Meet John Doe*).

ABOVE, TOP TO BOTTOM: Visitors to Hurrell's studio on Rodeo Drive in Beverly Hills were greeted by a 40x50 enlargement of his recent work. Who better to represent him than his muse?

Here is the Joan Crawford portrait that was enlarged for the façade.

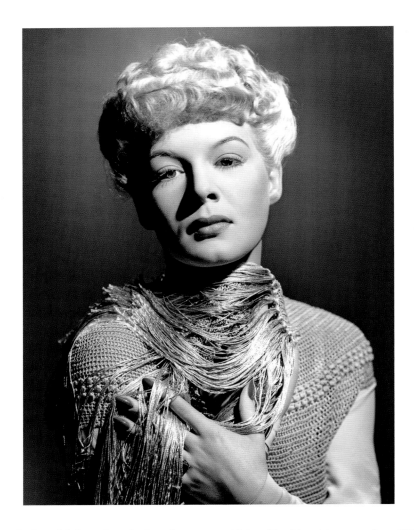

Myrna Loy, Jeanette MacDonald, Joan Crawford, and Norma Shearer.

"I'm often asked," said Hurrell. " 'Who was your favorite star?' Well, there can't be any favorite star—they were all so different! There was nobody like Jean Harlow nor was there anybody like Norma Shearer. Nor was there anybody like Joan Crawford. Or Greta Garbo, for that matter. I found a great satisfaction in each one as a personality. If I hadn't, I wouldn't have been able to make any pictures."

The stars that Hurrell had spent a decade polishing were burning out one by one. This was the Twilight of the Goddesses. An era was ending. "There was a certain kind of fantasy, a certain imagination that is not accepted now,"

said Ann Sheridan thirty years later. "The world is too small. Those were glamorous days."

ABOVE: Betty Hutton had just come to Hollywood when Hurrell photographed her in late 1941. She was energetic and vivacious yet he chose to show her vulnerability. In three years Hutton would be Paramount's highest-grossing star.

OPPOSITE: Paulette Goddard was often photographed in a bathing suit or a bathtub. Hurrell made her look sexy without these effects. Goddard was a sparkling conversationalist. "I always looked forward to my sittings with Paulette," recalled Hurrell.

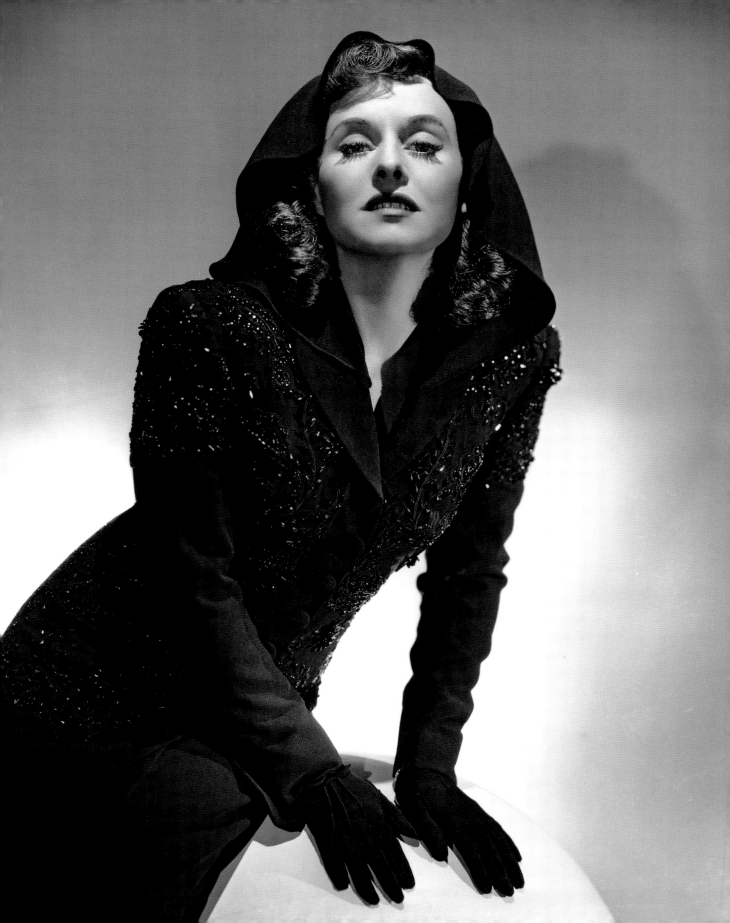

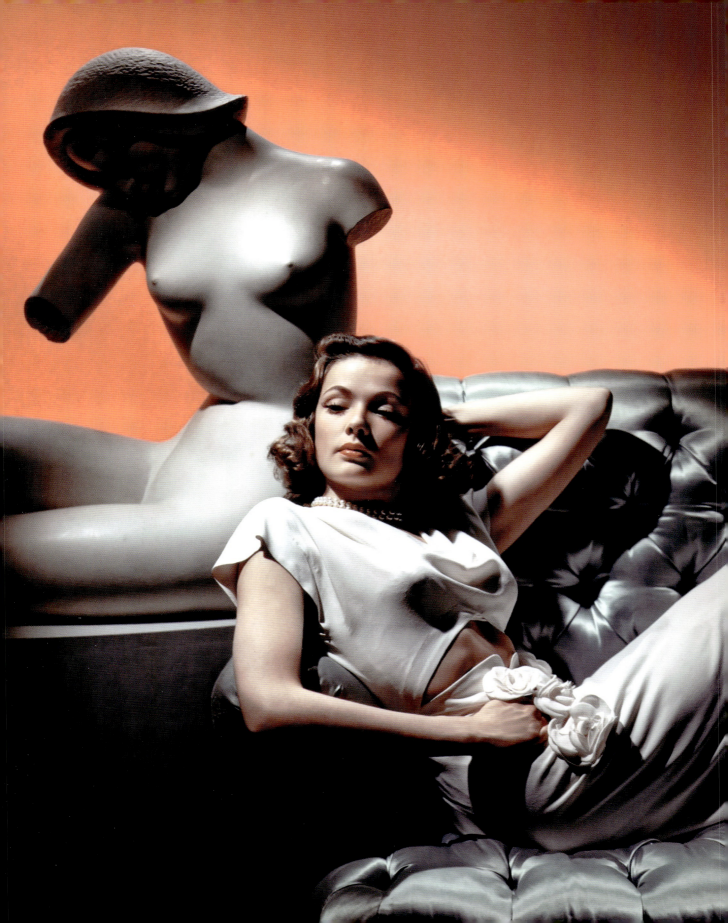

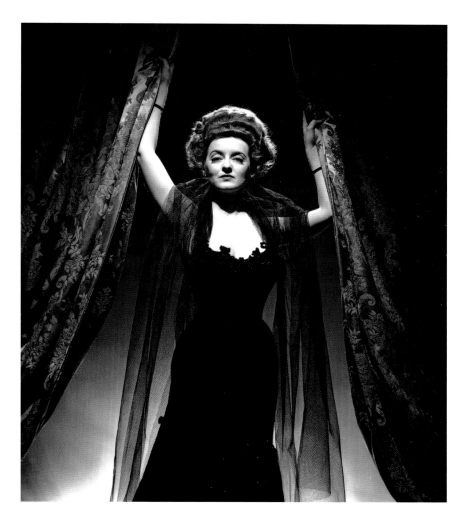

In 1941 there were changes behind the camera, too. Paramount's publicity department was "reorganized," which meant that Eugene Robert Richee and John Engstead were fired. This ill wind blew good things to Hurrell. While the department was being restructured, Paramount sent its most important players to him. Veronica Lake had been shot by Richee shortly before the axe fell. Apparently, Paramount was not pleased with his work, because they wanted Hurrell to shoot her in the same costumes she had worn for Richee. The studio needed an image for a "Personality Poster," so Lake was rushed to Rodeo Drive in a limousine, directly from the set of Preston Sturges's *Sullivan's Travels*. She was tired, hungry, thirsty, and cranky. Recalled Hurrell: "Veronica angrily blew her 'peek-a-boo bang' off her right eye and demanded: 'Well, where do you want me?'" Despite this inauspicious start, the session produced superb images. Paramount got the "Personality Poster" and then some.

As 1941 drew to a close and the film industry counted revenues of $800 million, Japan bombed Pearl Harbor. Everyone took a nervous breath and kept working. George

OPPOSITE: Shooting for *Esquire* magazine was a significant part of Hurrell's workload. This portrait of Gene Tierney was made in the early 1940s.

ABOVE: In 1941 Warners lent Bette Davis to Samuel Goldwyn for *The Little Foxes*, William Wyler's film about the poisonous power of avarice.

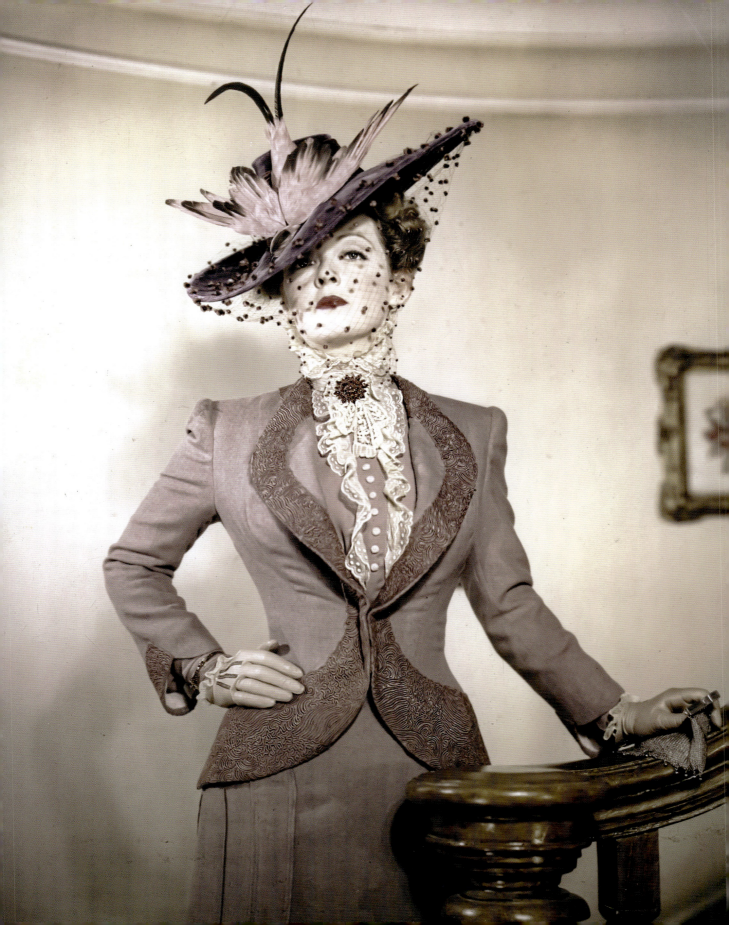

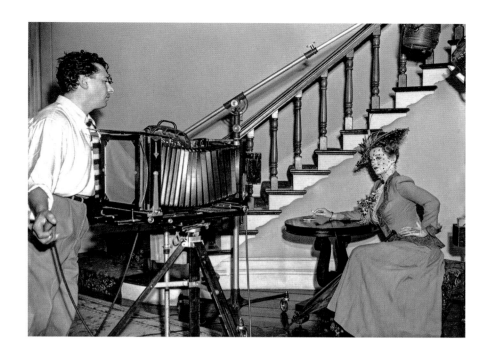

Hurrell was no exception. His first few months in Beverly Hills had been outstanding, and he had just bought a house at 3309 Tareco Drive, overlooking the Cahuenga Pass. He was loath to have his work interrupted when every major studio was sending stars to him. Paramount was sending the delicious Paulette Goddard. Barbara Stanwyck had been sent by Warners and then by Goldwyn. Bette Davis was also making a film at Goldwyn, William Wyler's *The Little Foxes*. Goldwyn publicists had the task of selling her to the public in an unsympathetic, heavily made-up period role, so they hired five noted photographers to interpret her Regina Giddens: Ned Scott, Charles Kerlee, Paul Hesse, James Doolittle, and George Hurrell. Hurrell's portraits were by far the most flattering, with spectacular lighting effects facilitated by the new Super XX film, and by Kodachrome color transparency film.

Even M-G-M called Hurrell in 1941, albeit at the behest of an old friend. Joan Crawford requested that he shoot a fashion layout in her home, and they worked together for the first time in four years. His studies of her revealed a new poise, as well as the same timeless beauty. Whenever he was asked for a favorite image, he would present something from this elegant sitting. He would admit that Crawford was his favorite subject, but he resisted the term glamour photo as a literal description of work with her or anyone else. "All of us glamorize everything," said Hurrell, "including the documentaries who glamorize filth and squalor. Even Weston does it, taking a picture of a gnarled tree trunk. It's a question of emphasizing…the dirt or the beauty." When pressed for a formula, Hurrell would grudgingly say, "Bring out the best, conceal the worst, and leave something to the imagination."

OPPOSITE: To impersonate the icy Regina Giddens, Davis wore a special rice-powder makeup created by Perc Westmore. Hurrell shot this portrait on Kodachrome transparency film.

ABOVE: "George Hurrell shot magnificent pictures," said Bette Davis, "but his photographs of me as Regina were the best of all."

THE OUTLAW

One of George Hurrell's first jobs in his grand new studio was a propitious one. He was being paid the astounding sum of $4,000 to glamorize an unknown. Jane Russell was a twenty-year-old receptionist in a Van Nuys chiropodist's office when Howard Hughes saw photos of her in photographer Tom Kelley's studio. Hughes signed her to a contract in January 1941 and cast her in *The Outlaw*, a Freudian retelling of the Billy the Kid legend. The film was finished in March and promptly submitted to the PCA, where it provoked polysyllabic censure. "Bathycolpian" was the word used to describe the offending portions of Russell's anatomy. Hughes was outflanked. He used an optical printer to darken Russell's cleavage in offending shots, and the PCA reluctantly gave the film a seal. Just as *The Outlaw* was about to go into limited release, it ran into problems with local censors. Then Twentieth Century-Fox refused to distribute it. While Hughes contemplated his unshowable movie, he heard about Hurrell's new studio. Hughes's publicist was the irreverent, irrepressible Russell Birdwell. He called Hurrell. A session was scheduled.

Hurrell must have sensed history in the making, because he invited the noted photographer Will Connell and writer G. T. Allen of *U.S. Camera* to witness the first of several sessions with Russell. The result was a word-for-word transcription of a Hurrell session (see overleaf).

LEFT: An image of Russell from a momentous session.

OPPOSITE: George Hurrell put Jane Russell on a haystack in his new studio for the aviator-filmmaker Howard Hughes.

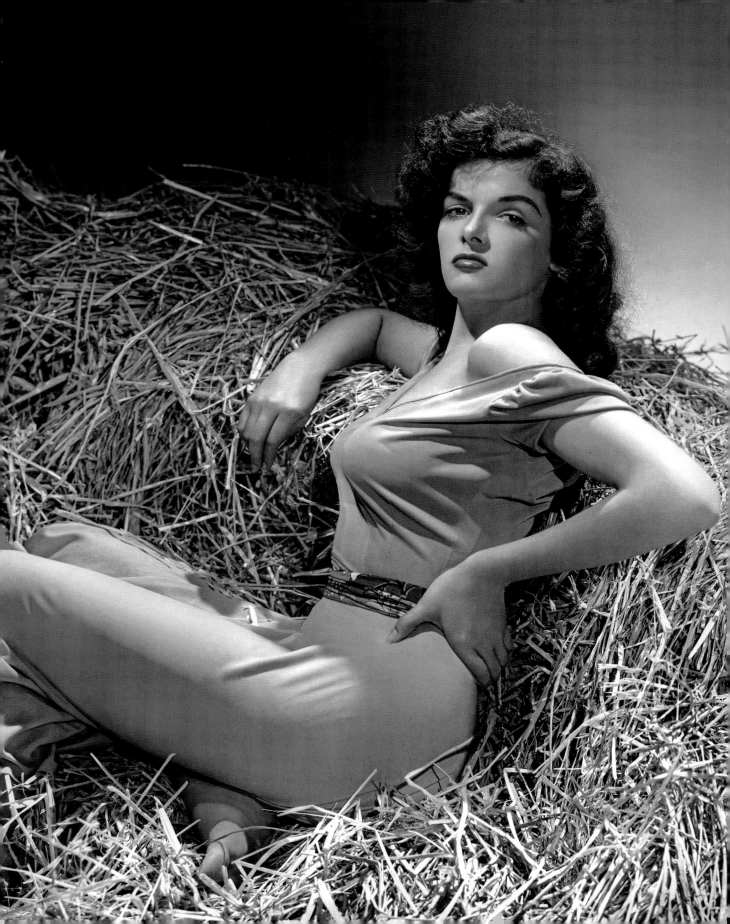

AS APPOINTMENT TIME NEARS, Hurrell and his assistant pull out the lights—a power line and six lamps. The assistant pulls the green curtains half closed over the north windows, George throws some chintz cushions from the sofa onto the model stand, covers them with a bearskin rug. That's the extent of his preparation. The model arrives—Jane Russell. George has never shot her before. He studies her a moment, says to her publicity man [Russell Birdwell], "She's a good-looking girl."

Jane: "I feel like a guinea pig."

Geo: "You won't when we've finished with you."

Jane goes into the dressing room, puts on a creation of satin and lace....

Geo: "Kind of housewifey, don't you think? Try the other one. It might be better, simpler. All this dizzy design up here might not be so good."

Jane changes and comes out.

Jane: "Did you say the other one was fussy?"

George groans: "The first one was best."

Jane changes back.

Geo: "Ah, yes. This will have the boudoir flavor, which we want."

George puts Jane on the bearskin, tries different poses, all recumbent, pulls at her dress, walks off, and starts the phonograph, pulls the green curtains completely shut, snaps on the lights, squints through the camera, slides up to the model stand. "Can't you lose this leg?"

Jane obeys. George fusses some more with the folds of her satin skirt. Jane pulls a comb through her hair, tucks comb and mirror out of sight. Music, hot and boogie-woogie, floods the studio, low in volume, but insistent. With the music, George's timing changes from that of a shuffling, thinking, puttering man to a dancer come to life.

From this point, the shooting of Jane is a process that defies explanation, a process lightning-fast, sensitive, unified, as George fox-trots his camera tripod over the cement floor, seeks the right camera angle, shifts a light before the assistant can reach it, changes an angle of Jane's arm and wrist.

The big studio falls out of the picture. There is nothing except the magic circle of light, the camera, George, and the model, nothing except the music which is around them, part of George, the powerful determinant of his tempo and rhythm. It is the music, both the tonic and George's other self, to whom he talks, mumbles, and shouts. He bends, twists, trots, dances his tripod to the position he wants, crooning, "Now, let's see," whispers to Jane, "Look," points, presses the bulb.

George's "Shooting Blues" song strings out to half-hour length.

Sung to any music:

Now let's see

Where was we?

Now we're getting places and doing things.

That's it. That's what the doctor ordered.

Now we're getting places and doing things.

Now let's see where was we?

It's funny stuff, this bizness.

Now let's see the best picture of the year.

That's it.

Oh, Little Joe

From Chicago

Where was we?

That's it.

It's good.

Too good.

Much too good for them.

It's the picture of the age.

That's good, just the way it is.

It's the picture of the age.

But good.

Ah, the frightful significance of it all!

Rhythmically flashing through the sitting, George's actions form a repeat pattern, a work pattern, repeated as often as the bulb is pressed. At each exposure, George is at lens position, checking the direction of Jane's eyes. If it isn't what he wants, he shoots again. If it's right, he glides into the next. It's a symphony, and you don't interrupt to ask the whys and hows of shading. Yes, there are lights, six to begin and one to finish. Changes flow from one arrangement to the next too fast to be checked or diagrammed. Hurrell's right when he says, "A man's a goat to try to explain how he shoots."

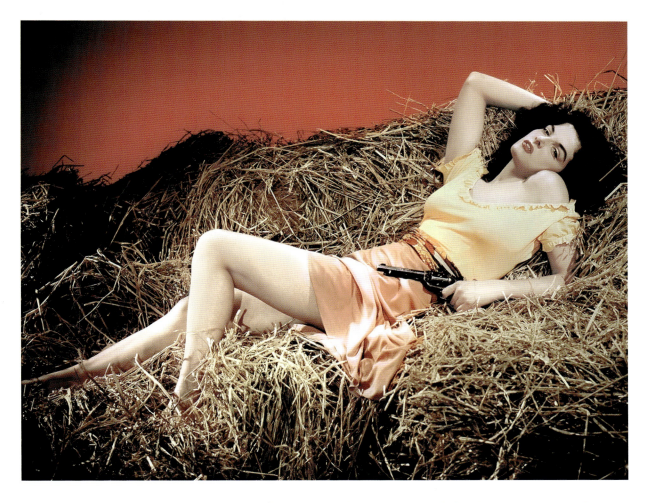

Befitting Hurrell's importance in the world of photography, the *U.S. Camera* article was part of a major feature on him, one of many to appear in the coming months.

The concept of Hurrell's next session with Jane Russell came from a barnyard seduction scene in *The Outlaw*. "A haystack!" he shouted at Birdwell. "I'll shoot Jane Russell in a haystack!" In short order, a truck from a Santa Monica feed-and-seed store backed into the studio through the twenty-foot-high doors, unloaded a half ton of hay, and drove off. "We just had a haystack there," said Hurrell. "But one funny thing about it is that I realized,

ABOVE: A newly restored color pose from the *Outlaw* session.

'She can't get up on the hay. She's going to keep falling off.' So I had to put steps under the hay just to get her up there. She was a great gal."

Russell's expressions in the second session were much more convincing than those in the first. She was studying acting with the venerable Madame Maria Ouspenskaya. Whatever strain of Stanislavski she was miming, it worked; she became a lusty frontier gal.

Hughes had thoughtfully designed and constructed a cantilevered brassiere for Russell to wear under her silk jersey blouse. "You could see the seams of a regular bra," said Russell, "so Howard wanted to design one that was seamless. He was ahead of his time. Well, it didn't work so well. I put my own bra on and covered it with Kleenex. They looked and looked and said, 'It's going to work.'" Russell

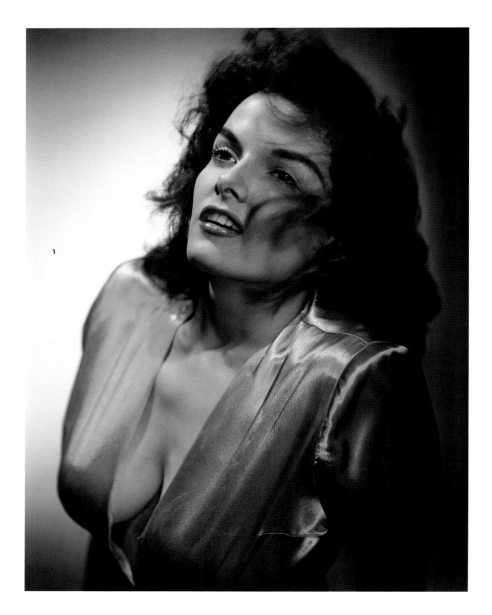

was caught in the proverbial whirlwind of publicity. A "star photographer" did not register with her. "You know," she said in 2010, "I was photographed by so many people that year, that this was just another one. Mr. Hurrell was nice and all, but I didn't think about it until the pictures began appearing everywhere."

Birdwell used Hurrell's photos aggressively—make that violently—to promote *The Outlaw*. A citizen could not turn a corner without being confronted by the sultry girl in the haystack. The campaign worked. Everyone wanted to see if the film was as racy as the images implied. "Jane Russell, not yet seen on the screen, is still busting out in all our magazines," wrote Hedda Hopper in the *Los Angeles Times*. "And I do mean *busting*."

Hughes continued to stall, but the haystack pictures had a life of their own. Everyone knew who Jane Russell was. "You don't make a star on the strength of a photograph," Hurrell stated in 1980. Perhaps not, but you can make a celebrity. It may have been to Russell's advantage that *The Outlaw* remained unseen until 1943. While the film sat on a shelf, Hurrell's images made Jane Russell a household name.

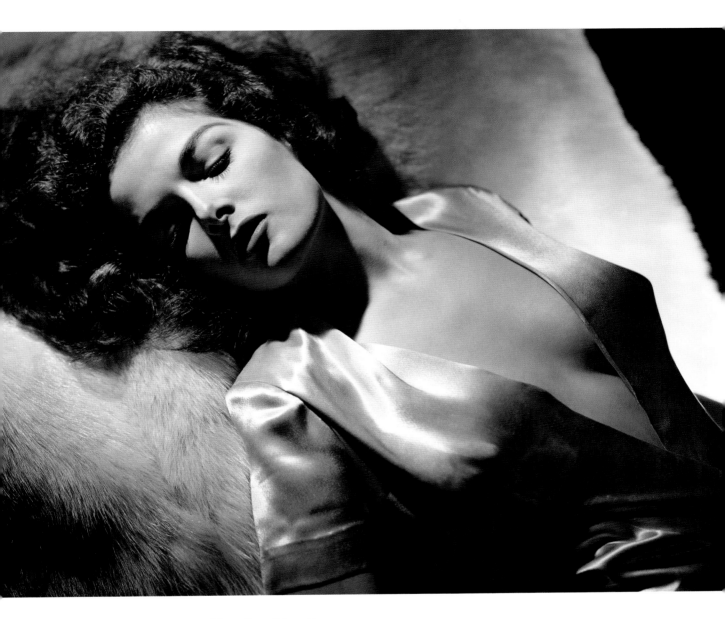

OPPOSITE: A rare image of Jane Russell from the same session.

ABOVE: Hurrell shot this pose of Jane Russell with his camera elevated. To look through the camera, he had to climb a ladder next to it. "I would be up that ladder, focus, down again, and shoot the picture in maybe two or three seconds," said Hurrell. "I worked so fast—it was as if I were out of control. I *had* to do it fast, all that yelling, hollering, moving things around, keeping up the pace. You can't just stand there, saying, 'Look this way. Look that way. Now smile.'"

COLUMBIA PICTURES

In 1942 the "Hurrell" stamp was appearing on the backs of many different types of photos: portraits, products, and events. The swanky studio at 333 North Rodeo Drive was so busy that Hurrell had to hire photographers to cover parties and nightclubs. Hurrell continued to shoot (and give interviews), but he was not needed at his studio every day. Robert Taplinger chose this time to tempt Hurrell with another offer. Taplinger had left Warner Bros. and was working for Columbia Pictures, the smallest of the major studios. The studio at Sunset and Gower was upgrading its product, and Taplinger knew Hurrell could bring distinction to it if Rodeo Drive could do without him for a year. In July 1942, Hurrell went to work for Columbia Pictures as head portrait photographer. He was working on Sunset Boulevard again, but this was a far cry from the Strip.

Columbia was run by the redoubtable Harry Cohn, and it was run cheaply. "The stills gallery was located below street level, beneath hair-dressing and makeup," recalled Hurrell. "The place was barely adequate—a cubicle compared to the galleries at Twentieth and Warners." He adjusted to it, but occasionally went shooting on sets or even on the roof. Still, he found the cheapness of the studio oppressive. One day Cohn called him on the carpet for spending $30 to rent a negligee from Western Costume. Waving his riding crop, Cohn shouted at him, "If I were you, I'd use our own wardrobe! Savvy?"

Despite these limitations, Hurrell made quality images. Rosalind Russell earned the honor of being his most-retouched subject; she habitually returned prints for more work. "You'd retouch until you couldn't put any more lead on the emulsion," said Hurrell, "because that mucilage retouching fluid only held so much lead and then it got slippery. So you'd have to work on the base side of the neg. My God, she wanted her face ironed out!" Russell did not want her contours changed; she wanted the smoothness she had had at M-G-M—seven years earlier.

Hurrell's most important subject at Columbia did not care how her pictures looked. Rita Hayworth was Columbia's answer to everyone else at every other studio. She was a dancer, a glamour girl, and even an actress. Hurrell was expected to register all these aspects, and he usually did. "She had a nice personality," he recalled, "but could be rather subdued. But if she was experiencing a case of the blahs, all I had to do was place a tango, samba, or rumba record on the phonograph, and her spirits would perk up." As photographers such as Robert Coburn would discover, Hayworth's concentration was a sometime thing, but her

OPPOSITE: Rita Hayworth posed in her own clothes for this Hurrell portrait. "Rita Hayworth has a slumbrous, seductive quality all her own," said Hurrell in 1942. After seven years in Hollywood, the actress was coming into her own.

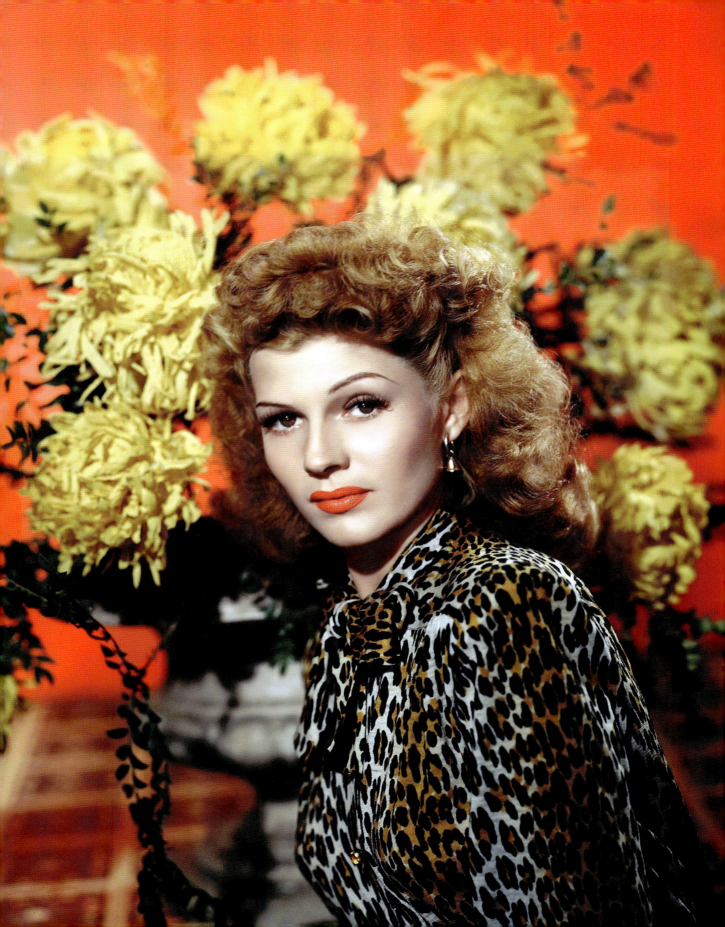

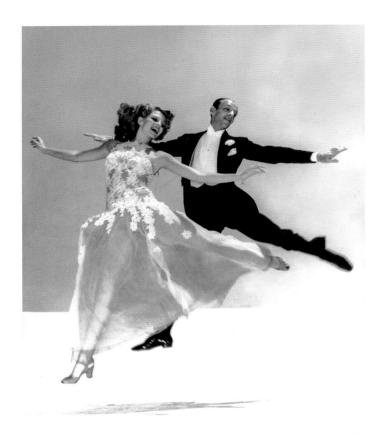

innate sensuality was worth the extra effort. "Rita projected," said Hurrell. "She was a very emotional person. It was all instinct, and that comes across in a picture. It's alive."

In the fall of 1942, Hurrell found himself distracted by personal problems and unengaged by his work. It was bad enough to toe the line for an autocratic penny pincher, but worse to do it in the service of uninspiring material. He was approaching forty, but he had to expend the same energy in order to jump from one banal subject to another while hamstrung by cheap settings and talentless "talent." Even though he was losing steam, he never compromised his work. Even in cut-rate circumstances, he never cut corners.

Irene Dunne was doing a series of trendsetting screwball comedies, but the ladylike star did not lend herself to the Hurrell treatment. He had shot her in 1931 at M-G-M and in 1936 at Universal (for *Show Boat*), yet she always appeared uncomfortable when posing for him, much the same as Olivia de Havilland, as if expecting an assault. Dunne dutifully reported to Hurrell and was grimly cooperative. "Irene Dunne was Irene Dunne," recalled Hurrell.

"Her attitude was, 'Here I am, Mr. Hurrell, why don't you do something with me?' Do what? There was nothing I could do."

His other subjects were starlets such as Marguerite Chapman and Adele Mara. The portraits he made of them were pleasing, but lifeless. "You can't work with a person and be exactly cold-blooded," said Hurrell, "because there's got to be a rapport, there's got to be that quality, that something that rings between the two of you. If it doesn't, well, you might as well quit and go home."

ABOVE: George Hurrell needed to shoot Fred Astaire and Rita Hayworth dancing on the set of William A. Seiter's *You Were Never Lovelier*, but his 8x10 camera shutter was too slow to freeze them in motion, so he took them to the roof of a soundstage and used a 4x5 Speed Graphic to make this shot.

OPPOSITE: A portrait of Fred Astaire, for once not in motion.

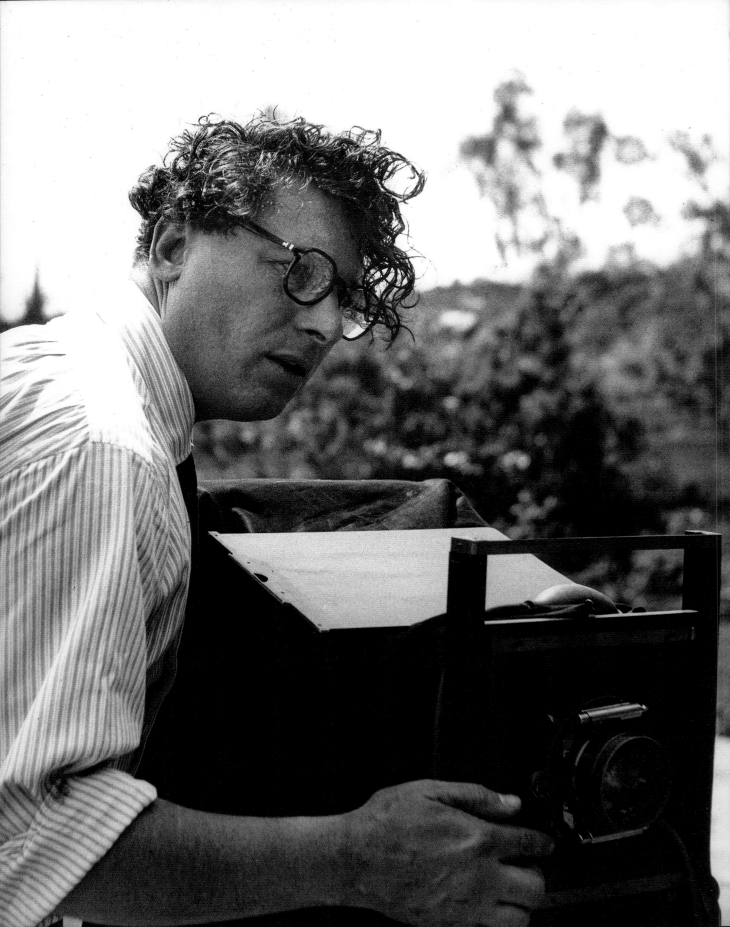

CHAPTER 6
THE FALL
FROM GRACE

WAR AND SCANDAL

George Hurrell was impatient in the extreme. When he felt imposed upon, hemmed in, or just plain bored, he did not negotiate. He picked up and left. First it was his parents' home. Then it was a succession of art schools and apprenticeships. In 1932 it was Hollywood's biggest studio. In 1938 it was his own studio. In 1940 it was Warners'. By 1941, he was in command of his emotions. Or was he? An article in *Motion Picture* described a restive artist. "He's a compact bundle of nervous energy," wrote Roger Carroll. "He's quick-witted, quick-motioned, and quick-spoken, with a broad, mobile face, a pair of appraising brown eyes, and a thick thatch of brown hair that's never under control. Away from his studio, he's brisk and restless and looks vaguely unhappy." This "vague" unhappiness would get him into trouble.

The trouble began in May 1941, when Hurrell returned from the busman's holiday at the Waldorf. His Rodeo Drive studio was still under construction, so he worked out of 8404 Sunset Boulevard, where he functioned as head of *Esquire* magazine's West Coast photographic department. He was beset and besieged, what with portraits of Joan Crawford and Bette Davis, a monthly layout for *Esquire*, the new home at 3309 Tareco Drive, and a procession of beautiful young models. "I would pick a gal," said Hurrell, "and do a kind of bedroomy-looking thing. Kind of cheesecakey but more subtle. Dave Smart, who was the owner, wanted it that way. But so did I. Stars

didn't like to be shot that way, so most of the time I'd take second-degree actresses."

In years of working with ambitious young women, Hurrell had been tempted more than once, but as far as anyone knew, he had resisted. "I was a real romantic young fellow," he recalled. "A lot of that came from being with these gals so often. They'd put themselves in your hands, so to speak, to develop this kind of effect. And the two of you were tied so closely together that after a long session, you got to the point where you were almost making love to the gal. And one thing could lead to another."

Hurrell was mercurial in the best of circumstances, but in 1941 he became especially moody. There was a sudden disagreement between him and Katherine, and she left for Mexico. "Upon my return," she later told a judge, "he met me at the station and acted very strangely. He told me he had met a girl model and that he was in a jam with her. He said matters were complicated because she was the niece of a studio executive."

When Katherine asked Hurrell what he was going to do about it, he told her that he was in love with the

PREVIOUS: George Hurrell at work, when he was happiest.

OPPOSITE: When George Hurrell photographed Gilbert Roland in 1942, war was in the air.

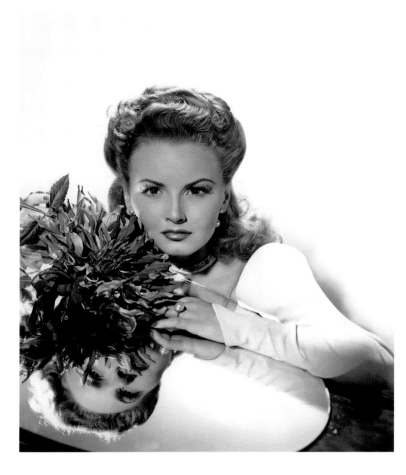

LEFT: Janet Blair was one of the actresses Hurrell photographed at Columbia Pictures before he was drafted into World War II.

OPPOSITE: When Hurrell returned from the Army Air Force in April 1943, he had a pleasant assignment, to photograph fifty-year-old Mae West for Gregory Ratoff's film *The Heat's On.*

girl—and living with her. Katherine and Hurrell separated on March 11, 1942. Hurrell filed for divorce on September 16, 1942, charging extreme cruelty. He asked for a restraining order against his wife, claiming that she had hidden his clothes, books, and $40,000 in cash. The order was granted on October 23. A week later, Hurrell received a letter. "I had been drafted into the First Motion Picture Unit of the United States Army Air Force," he said. On November 2, 1942, he left for Monterey, California, to become a private. Several days later, he found himself peeling potatoes with composer David Rose. "We looked ruefully at each other," said Hurrell, "and then burst out laughing."

On December 16, Katherine Cuddy Hurrell testified in court that Hurrell knew very well where his personal effects and funds were. Then she came forth with some

newsworthy revelations. "He became infatuated with a model whom he photographed while I was away," she told the judge. The story was all the more hurtful because of an interview Hurrell had given the previous January, gushing about Katherine's beauty and glamour—while he was philandering. Louella Parsons came to Katherine's defense, calling her a "gallant lady." That Parsons, who was a long-time client and booster—and Maggie Ettinger's cousin—would side publicly with Katherine, did not bode well.

On December 31, Katherine sued Hurrell for divorce, after Hurrell's attorney, George Stahlman, read an affidavit in which Hurrell dropped "all charges of impropriety or dishonesty." The uncontested divorce was granted on March 2, 1943, and included a property settlement in which Hurrell paid Katherine $10 a month until the war ended. After that, he would pay $300 a month in alimony,

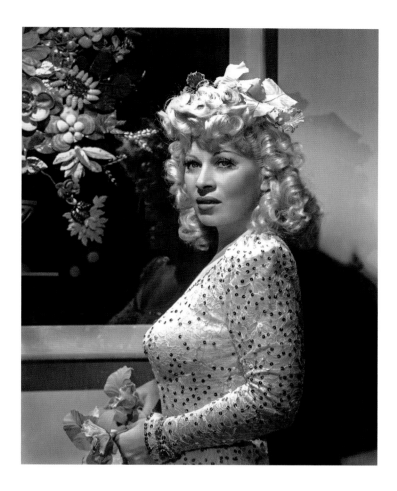

for five years or until she remarried. (On July 19, 1946, Katherine married Twentieth Century-Fox producer Ralph Dietrich.) By the time of the divorce decree, Hurrell was serving his tour of duty in, of all places, Culver City. Hal Roach Studios had been converted to a production unit for military films. "I shot stills of personnel involved in training films produced by the unit," said Hurrell.

One day in March 1943, Hurrell got leave, drove to Long Beach, and married the twenty-four-year-old model Phyllis Bounds. Like Katherine, Phyllis was from Washington State. For a young model, Phyllis was surprisingly well-connected. She had been married twice; first to a filling station attendant at the Walt Disney Studios, and then to a writer at the same studio. She was familiar with the Disney company because her aunt Lillian was married to Walt.

Hurrell's old friend Pancho Barnes had acquired a number of influential friends in her years as a flier. One of them was General Henry ("Hap") Arnold, who was Commanding General of the U.S. Army Air Forces. She asked him to see if he could do something for Georgie. "I was at the Pentagon after that," said Hurrell, "shooting mostly portraits of generals." Hurrell's military stint brought him close to a huge audience for his art— soldiers—and he saw it from their point of view. "When I was in the army," he said, "those photographs of Jane Russell haunted me everywhere I went; every boat, every locker room, every latrine." Howard Hughes was making a star, and, in a way, Hurrell was boosting morale. He shot propaganda posters showing an RKO starlet named Margie Stewart giving advice to departing soldiers. "Please get there and back," said the caption under her glamour photo.

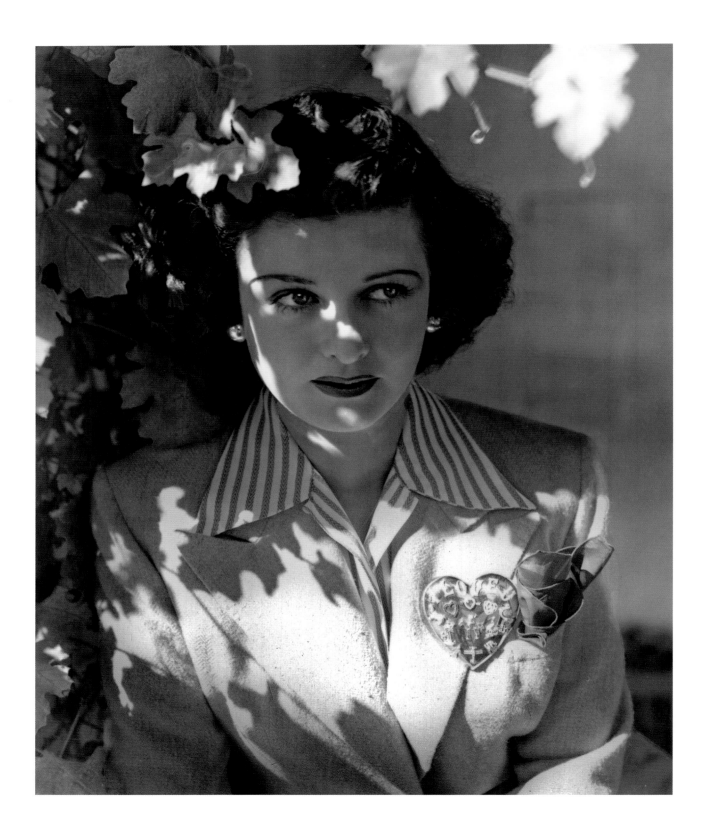

"Be careful what you say or write." Then, as quickly as it had begun, Hurrell's tour of duty ended. In April 1943, because of his advanced age of thirty-eight, he was mustered out. He quietly returned to Columbia.

Hurrell soon found the work mundane and unchallenging. He was photographing starlets, not an unpleasant task, but his greatness lay in his ability to tap a subject's depth, even uniqueness. If the subject was naïve, there was little he could elicit, even if she was attractive. "It's a physical quality first of all," he said. "But they have to think sexy, too. It has to be a combination. Just the physical quality without thinking doesn't work." There was little he could do with bland starlets. "Except for Rita, there was nobody to shoot there," said Hurrell. "Adele Mara. Marguerite Chapman—she was one you couldn't do anything with. She didn't inspire anything. Just a funny dame, sort of."

Hurrell's only interesting subject at Columbia in 1943 besides Rita Hayworth was Mae West, who was making her first film in three years, an ill-advised, unfunny comedy called *The Heat's On*. Looking at West's voluptuous curves and smooth skin, Hurrell found it hard to believe that she was fifty. The sexy persona she had created at Paramount had survived the slings and arrows of censorship, more or less. "I found her to be the same witty, down-to-earth lady," recalled Hurrell. "The only change was that she had grown more cognizant of technical aspects. Her knowledge of lighting and camera angles was truly astonishing." West was still writing her own ribald dialogue, too. "Her brilliance was sometimes hidden under a rather vague manner," said Hurrell. "I'd be lulled along, shooting quickly, and she'd come up with a one-liner. It would break me up!"

In August 1943, M-G-M released the musical comedy *DuBarry Was a Lady*. It featured the song "I Love an *Esquire* Girl," with lyrics praising "those lovely pictures by Hurrell." This sort of fame was of small comfort to Hurrell when bad press and financial problems were vying for his attention. In October 1943, he left the Columbia Pictures portrait gallery and returned to 333 North Rodeo Drive. His fifth period of artistic development was ending.

Hurrell continued to shoot for *Esquire*, but Hollywood assignments began to dwindle when the press hinted that in 1941 he had asked Katherine to hide the funds he later

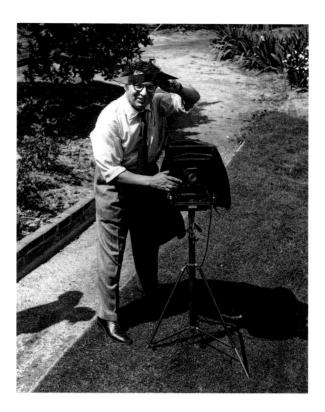

accused her of stealing. It was implied that he had done this to prevent his creditors from seizing them. "As a partner in a mining company, he owes that concern's creditors $29,433." In March 1944, Hurrell declared bankruptcy.

These reverses put the artist back where he was in 1927, but he was no longer a young man, and the jaunty grace of the Jazz Age was gone. The world had changed, and photography with it. Large-format cameras and posed pictures were shunned by news editors. "A new form of photography was started by *Life* magazine," recalled Bette

OPPOSITE AND ABOVE: In 1944 Hurrell photographed Joan Bennett in and around her home, which was at 515 South Mapleton Drive in Holmby Hills. "I wanted to shoot her in natural light," said Hurrell. "Dietrich or Shearer would have immediately questioned why I wasn't using reflectors for fill light and whether the sunlight, filtering through the branches of a grape arbor, was casting unwanted shadows, but Joan was unconcerned."

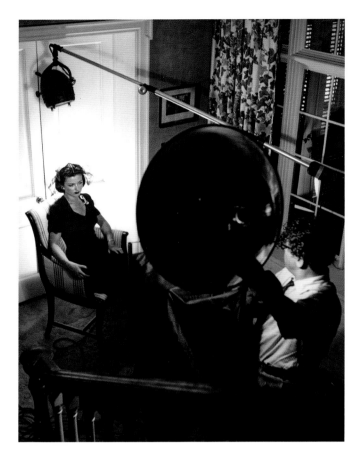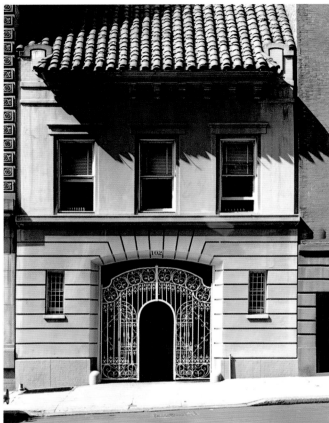

Davis. "Their photographers started using the candid camera, which meant you never posed for them and for the most part were unaware that they had taken a picture of you. This meant that the photographs taken in this way were less static." The photos were less pretty, too. "Life in the raw is seldom mild," said *Life*, and candid pictures proved it. Candids were taken only with medium- or small-format cameras. They were never retouched. "The glamour ended when we stopped using 8x10 cameras," said Hurrell.

Lighting techniques were in a state of flux, too. Conservative M-G-M portrait photographer Clarence Bull was experimenting with scientist Harold E. Edgerton in the use of stroboscopic flash. Hurrell could adapt to new technology, but how far could he go in the politically charged climate of Hollywood? Philistine publicists wanted him to demystify the stars; the stars would not cooperate. "I'd get bored with movie stars," he admitted later. "They're all a pain in the ass. So I'd go to New York. I wouldn't know

what I was going to do, but I would get there and figure it out."

In 1946 the peripatetic artist did just that. First, however, he shot his thirty-third (and last) portrait sitting with Joan Crawford. It was for her first film with Twentieth Century-Fox, Otto Preminger's *Daisy Kenyon*. Then Hurrell took his wife, Phyllis, and their one-year-old daughter, Victoria, to New York, where he rented a converted carriage house at 102 West 40th Street, near Park

ABOVE, LEFT TO RIGHT: Hurrell also made shots of Joan Bennett indoors. At this time he was still using the Bardwell McAlister boom light but had adopted a "Sky Pan" for use as his key light. No one could accuse Hurrell of being predictable.

Hurrell's New York studio was located at 102 West 40th Street, near Park Avenue.

OPPOSITE: For the next six years, Hurrell signed his work for advertising agencies, not Hollywood stars.

knew as much about photography as any studio pro, and she had requirements: a spotlight on axis (the so-called "Paramount Lighting" devised by her mentor, Josef von Sternberg), cloth diffusion instead of glass diffusion, a slight "tilt" to the back of the view camera to elongate her legs, and a full-length mirror in which she appraised each pose. Hurrell had not worked with her since 1937, but he remembered that mirror.

When Dietrich came to Rodeo Drive, Hurrell brushed aside her requirements. He shot her without the "Paramount" key light, without diffusion, and without the mirror. When Dietrich reviewed the unretouched proofs, she was less than pleased. "George," said the fifty-one-year-old star, as she frowned at them, "you don't take pictures as well as you used to."

"But Marlene," Hurrell answered, "I'm fifteen years older." Dietrich got the point. She destroyed the negatives and took her business to John Engstead, who was compliant. Hurrell was fed up with silly starlets and aging queens. He closed the Rodeo Drive studio and began to devote himself full time to Hurrell Productions.

Years earlier, Hurrell had toyed with the idea of becoming a director of photography. "Joan Crawford wanted me to become a motion picture cameraman," said Hurrell, "but I couldn't stand it. I was too energetic, too nervous. I lasted two and a half days." Portrait photographer Ted Allan remembered the M-G-M tryout, which took place in the mid-'30s. "Hurrell couldn't cut the politics," said Allan. "He started yelling, ordering these guys around. You can't do that on a set and last any length of time." Of course that was years earlier. Hurrell had mellowed.

Ensconced on the Disney lot, Hurrell Productions was going strong for two years. Then there was a conflict. Hurrell wanted to produce a series based on the legend of Zorro. He negotiated a deal with Mitchell Gertz, who had acquired rights to the character from its creator, Johnston McCulley. Hurrell negotiated with Gilbert Roland to play Zorro, and scouted locations in Mexico. Just as everything was set to go, Walt Disney took a look at Roland and said, "He's too old."

"If that's the way it's going to be," Hurrell said to Disney, "you can have it then. To hell with it." Disney,

Avenue. Two more children were born to him and Phyllis; Clancy in 1946 and Alexandra in 1948.

For six years Hurrell shot a combination of editorial and advertising work. When he shot with the carbro color process, the separation negatives and matrices were processed by the photographer Paul Outerbridge, whose pioneering work in color photography had been derailed by a scandal involving sexual fetish images. (Until a Supreme Court decision in 1968, shooting full-frontal nudity was against the law, regardless of artistic context.)

In 1947 television was beginning to attract attention. Hurrell tried to get in on the action by producing his own show, *Camera Highlights*, on WABD, the New York affiliate of the DuMont network. Hurrell would do interviews, give advice, and demonstrate photographic technique. Due to poor scripting and production, the show only lasted a few episodes. *Variety* praised Hurrell's on-camera presence, however. For the next five years, his charm was mostly confined to the world of advertising.

In 1950 Phyllis helped effect an alliance with her uncle. Walt Disney was desirous of getting into television production but wanted to do it without committing his company name. In December Hurrell joined with Walt's brother Roy, Gunther Lessing, and Paul Pease to form Hurrell Productions. The unit would function on the Disney lot, filming a variety of projects. Because of advertising commitments, Hurrell remained in New York and Phyllis began producing.

In 1952 Hurrell returned to Rodeo Drive and shot a few portraits. His clients included Maureen O'Hara, Arlene Dahl, Yvonne de Carlo, and the film star who would soon be the toast of Las Vegas, Marlene Dietrich. Dietrich

sensing that Hurrell was about to bail out, offered to buy Hurrell Productions. "You can't have my name," said Hurrell. "My name is mine."

Hurrell became increasingly "argumentative," according to Phyllis. On September 10, 1954, he and his wife separated. On November 24, she filed for divorce, claiming that his behavior was hurting their production company. "He has a violent temper," Phyllis testified, "and argues all the time, upsetting me and the children." For the record, Phyllis was known to be a tough cookie, a hard-drinking, chain-smoking, rough-talking boss. She was also creative, inventive, and industrious. And she was consistent in a way that her husband was not. Before the year was over, Hurrell left for New York, and Phyllis took over the company.

Hurrell went to work for the J. Walter Thompson advertising agency, shooting ads for Flair and Revlon. On May 18, 1955, Phyllis Hurrell was granted a divorce and awarded $600 a month in child support, as well as a substantial property settlement. Not long afterward, Hurrell married his third wife, Elizabeth Willis, in Elton, Maryland, and moved to Connecticut to start a new family. "I'd get bored with New York," he said, "so I'd move out to the suburbs. I'd get bored with the suburbs and move out to the country. I'd get bored with that goddamned train ride in and out every day. And then I'd just get bored." Meanwhile, new technology was revamping every studio and darkroom in the country. As America rocketed to new prosperity, Hurrell went into a tailspin.

OPPOSITE: This 1942 portrait of Marguerite Chapman shows that Hurrell's use of color was as audacious as his lighting design. The reproduction in magazines of the period muted the colors to a certain extent, so Hurrell's hues looked softer in print than they do in this, the original Kodachrome transparency.

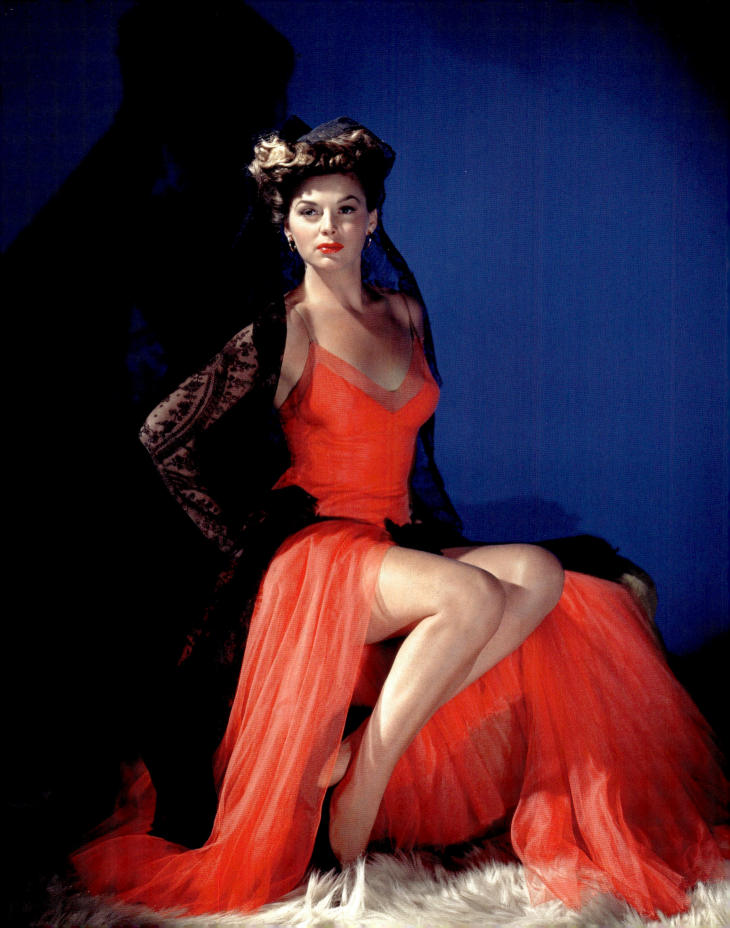

THE LEAN YEARS

George Hurrell's downward trajectory began in 1956, when he summarily left the East Coast and moved to Laguna Beach. He rented a two-bedroom apartment over a gas station but found nothing to do in the suburbanized art colony, so he moved his growing family to a tract home on Allott Avenue in Van Nuys and surveyed the job market. There was aerospace and there was television, which was consuming the movie industry. One of the most formidable men in television was "Uncle Walt" Disney. When Hurrell had trouble finding work, it occurred to him that he and Disney had not parted on good terms. Hurrell had not been blackballed. He had been away too long, and the industry had changed too much. In 1959 he tried to raise backing for portrait studios in both Hollywood and Laguna. He failed.

Grim years followed. Hurrell was trying to raise three children and pay child support for three more. "The great Hurrell is available to create the super-jet photos you need for your Marilyn Monroe production," he wrote producer Jerry Wald on April 8, 1960. He did not get that job, or any other. He had no choice but to buy small-format cameras and shoot whatever work he could find. At one point he was reduced to standing outside the Beverly Hills restaurants where he had once eaten, grabbing shots of arriving stars. Even though he was there as the representative of a small agency, it was a shameful comedown. In the era of rock and roll, his genius was worthless. George Hurrell,

once the most famous photographer in Hollywood, was a forgotten, humbled man.

"In 1962 Hurrell came to me because he knew me from Metro," recalled Ted Allan. "I was in with Sinatra and Bill Daniels and that gang, working all the time, and Hurrell needed work badly. He was awfully pleasant and humble then."

Allan helped Hurrell get hired onto the Sinatra Rat Pack film *Sergeants Three*. His title was unit still photographer and he was paid $500 a week. It was a long way from being head portrait photographer, but by the late 1960s there were no portrait galleries, let alone portrait photographers. It was newsworthy when he was hired in 1967 to shoot "special art portraits" of Julie Andrews as Gertrude Lawrence for Robert Wise's *Star!* Hurrell shot the portraits with a medium-format camera, but on sets he was made to shoot "scene stills" in 35mm. It was grueling, and it was not portraiture. "There's no way you can shoot

OPPOSITE: George Hurrell's star portraits found a new use in the 1950s when Hollywood studios began selling their film libraries to television. Movies from another era were suddenly available for viewing around the clock and had to be advertised in local papers. It was disconcerting, though, to see a young Shirley Temple in *Heidi* on the afternoon movie and to then see an adult Temple on her own show in the evening.

portraits with a goddamned Nikon slammed up against your eyes," said Hurrell. "You have to be able to communicate with your subject."

Stuck with a small-format camera, he had to use stroboscopic flash. "It's beyond me how anyone can keep that sparkle in their eye with a flash going off in their face," said Hurrell. Clarence Bull had come to agree. "Those speedlights are the worst thing that ever happened to photography," said Bull in 1975. "Strobe lighting doesn't have enough variety," added Hurrell. "It's too flat and too much of one source. That's why I use spotlights." These issues concerned the quality of portrait photography. Publicists did not care about photography. "How many rolls of film did you shoot?" was the question Hurrell heard most often. "I take a hundred shots and end up with one so-so shot I would have rejected before," he lamented.

For a man approaching retirement age, Hurrell was essaying a hopeless task. The unit still man operated in a stressful universe where he had all the responsibility and none of the authority. Ordered to grab shots of uncooperative actors during rehearsal, he was then prevented from getting too many shots by pushy assistant directors. In the behind-schedule flicks of the '60s, the still man was the scapegoat, constantly being elbowed out of the way. For Hurrell, being chided by a mogul was one thing; being shoved by some punk was another. Yet there was nothing he could do about it. "Working on a movie now," said Hurrell in 1969, "is like being a combat photographer." The once-outspoken artist kept quiet and tried to shoot.

The *Los Angeles Times* reporter Frank Taylor witnessed one of Hurrell's trials during the making of George Stevens's *The Only Game in Town*. At an on-set birthday party for Elizabeth Taylor, Hurrell was instructed to shoot both the cake and the star. Only the soundstage work lights were lit; the stage was dark. "You can't expose film without light," said Hurrell.

"Mrs. Burton won't permit flash guns," sniffed an assistant.

OPPOSITE: In 1967 Hurrell was hired to shoot Julie Andrews for Robert Wise's *Star!*

Being treated this way must have been unbearably demeaning for Hurrell. Yet this is how he saw out the '60s—paying for his children's education. His credits included *Beneath the Planet of the Apes*, *Butch Cassidy and the Sundance Kid*, and *Justine*. In October 1969 he was working on a troubled production, *Myra Breckinridge*. Because the film starred Raquel Welch and Mae West, he was allowed to shoot portraits, but they were off-set, small-format, and rushed. The stills he shot were among the oddest he had ever done; the film was based on Gore Vidal's novel about a transsexual who takes Hollywood by storm.

Day after day Hurrell stood in the shadowy perimeter of a soundstage at Twentieth Century-Fox, patiently waiting, an enigmatic figure in flak jacket and khaki pants, bedizened with Nikons. He peered through black horn-rimmed glasses and rubbed his gray Van Dyke beard while director Michael Sarne tried to calm a feud between West and Welch. Seventy-six-year-old West had a contractual stipulation that allowed her to wear costumes of only black or white, a sure way to stand out in a color film. Welch had shown up in a white dress. As the long-haired young director tried to referee these divas, Hurrell stood on the sidelines and sighed. In the old days, he had called the shots. Now he waited for them.

Outside the buzzing soundstage stood a tall, elegant young man in a corduroy sports coat, watching studio employees come and go. He was a journalist from England. The unit publicist did not want him to overhear the sniping between Welch and West. There had been a lot of bad press. "I've never seen so many personality conflicts on one picture," admitted Richard Zanuck, studio president, production chief, and son of Darryl F. Zanuck. The publicist was loath to have a foreign journalist add to the firestorm of gossip, so there he stood, in the glare outside the door, holding his notepad. His name was John Kobal.

Hurrell grabbed a quiet moment to shoot West in her Edith Head gown, and they made the best of it, recalling the session in 1933 when she had dropped her peignoir. Here they were, two fading legends, stuck on this stupid excuse for a movie. Even so, it was show biz and they were working. They were troupers. The unit publicist knew

that Kobal was interested in Hollywood history, so when Hurrell got bored and wandered outside, he introduced them.

"George, this is John Cueball," said the publicist. "He's from London, covering the show. He's a real film buff."

"Hi!" said Hurrell, shaking Kobal's hand with a very strong grip.

"Hi," said Kobal, rubbing his hand. "Did you ever photograph Miss West before?"

"Oh, yeah, sure, when she first came out here. I even did some nude shots for her own private use."

"So she's not a man?"

"God, no," chuckled Hurrell. "She's a small woman, very voluptuous, not the way the gals were in those days, you know. They all wanted to be very slim so they would look good in clothes, but Mae had the best figure I'd ever seen for the kind of round, curvaceous sort she was." Hurrell was surprised that this aggressive young man was less interested in *Myra Breckinridge* than he was in Hurrell's early work. Kobal wanted to hear stories about his favorite, Rita Hayworth. He wanted to hear about the old M-G-M days, about "Joan and Norma." Hurrell was puzzled. Why would a journalist care about that stuff? "You're a writer?" Hurrell asked in his flat, scratchy voice.

"Of course," Kobal answered in a booming, slightly accented voice. "But I'm something of a collector as well."

"A collector," repeated Hurrell, hearing this word for the first time in the context of his own work.

It was on that day in 1969, between two soundstages at Twentieth, in the smoggy glare of what was now called "LA," that George Hurrell began his return from the ashes.

———

John Kobal grew up in Linz, Austria, and then in Canada and Britain, a "child of the cinema," as he once told me. He worked as an actor and then as a writer, all the while collecting the movie stills that lay in stacks inside theater storerooms. Eventually, his collection was large enough to be marketable. Kobal was marketable too. He had a flair for essay, an eye for design, and a winning charm. He made connections in the publishing world and wrote books on Garbo and Dietrich. His were the first books to use "motion-picture stills" as something more than illustrations. In his books, the pictures were thoughtfully and cleverly chosen, telling the story as well as the text did. His books emphasized the process by which stars were made and were the first to credit photographers. Until this time, the one and only book to credit Hurrell had been Joan Crawford's 1962 autobiography, which was aptly titled *A Portrait of Joan.*

Kobal's books explored the mythology of stardom and considered the correspondence of movie publicity to religious iconography. He was fascinated by Rita Hayworth, who he felt had created glamour from a deprived and bitter life. By the time he met Hurrell, Kobal had authored nine books. Commuting between New York and London, he cultivated patrons in the art world and laid the foundation for the Kobal Collection, a photographic rental agency. He began to interview stars and filmmakers, building an impressive archive of lore and images. As his name began to appear in the London press, he started his own climb to celebrity.

Writer David Chierichetti was then a budding film historian, accompanying Kobal on interviews and acting as a technical interpreter. "John was at that time very young and agreeable and moving in all directions," recalled Chierichetti in 1995. "He liked to regale people with his tales of Hollywood." With his good looks and booming banter, Kobal cut a stylish figure at parties, an Edwardian dandy steeped in silver nitrate. He was grand, expansive, and quotable.

"He was a lot of fun to know, but he always wanted attention," said Chierichetti. "He appreciated attention more than he appreciated real friendship. He would use people up." Horror collector David Del Valle remembered it differently. "John was guarded until he was sure you were sincere," said Del Valle. "Then he was loyal, making sure you were included in his circle, meeting Warhol or whomever. But, yes, he had his moods. When he was depressed, he would grab a file of Dietrich portraits and flip through it, stroking these stills. Before long, he felt better."

Friends and employees alike never knew what to expect from Kobal, honest praise or withering derision. "There was a duality about him," said Matthew Daniels, a

former employee. "He could be sharing some secret about Dietrich with you and in the next breath telling you to stack your dishes properly."

"He was one of the most generous men I ever knew," said Del Valle. "I wouldn't have a still collection if not for him. But if you encroached on his favorites, say Dietrich or Hayworth? Uh oh!"

"John was a true Gemini," said the actor and astrologer Jeremiah Sullivan. "The meaning of the word! He had two personalities. Coffee in the daytime and alcohol at night."

ABOVE: One of the few Hollywood assignments granted to George Hurrell in the 1950s was an on-the-set portrait of Peter Lawford while he was filming a series at NBC.

In one thing, however, Kobal was consistent: he respected Hollywood photography of the Golden Era.

Hurrell respected it, too. He did not put it in the same category as Edward Weston's work, but he admitted that his 1930s work was far superior to what he was doing in 1969. He was shooting stills in order to raise his children. He and Elizabeth had three: Daphne Ann, born in 1956; George Edward Jr., born in 1959; and Michael Anthony, born in 1960. When John Kobal visited the Hurrell home in North Hollywood, he saw their pictures on the wall, and a few half-finished paintings, but no Hollywood portraits. Why not?

"After you've looked at them half a dozen times," said Hurrell, "you just get tired of looking at them." But the

Hollywood
studio magazine

COLLECTORS
EDITION
and
AFI PROGRAMME
"The Best of
Bette Davis"

American Film Institute's
Salute to
Bette Davis
the
QUINTESSENTIAL
STAR

"CUCKOO'S NEST" PRODUCER SPEAKS OUT:
COMEDIENNE IRENE RYAN "GRANNY TO MILLIONS"
WANTED: AVID MOVIE GOERS/1977 OSCAR AWARDS

VOLUME LI NO. 6 / $1.00

OPPOSITE: In the early 1970s Hurrell took time off from shooting stills on movie sets to do publicity sessions for Bette Davis.

RIGHT: Mae West was seventy-six and George Hurrell was sixty-five when he shot this portrait of her for Michael Sarne's *Myra Breckinridge*. The last time she had been shot on a set—in 1943—Hurrell had been her photographer. No one in Hollywood could quite understand why Mae West was appearing in this very strange film. "It can't miss," she said quixotically. "The older people will come out to see it, and now I've got this young crowd interested in me, too." *Myra Breckinridge* was a colossal flop, but it introduced Hurrell to a young man who would change the course of his life.

Hollywood stuff was what Kobal had come to see. He sat in Hurrell's den as the photographer brought out a few boxes. Kobal tore into them, blowing off dust, asking question after question of the serene old man. "Hurrell had now reached a point in his life when it seemed that his career was over," wrote Kobal. "He saw no chance of its return and didn't think about it or pine for it, and everything about 'those days' made him laugh a lot, like you might find yourself laughing on awakening and retelling this incredible dream you just had." Kobal could not fathom why Hurrell had so few pictures and why they were boxed and kept out of sight. "If I look at them for any length of time," Hurrell explained, "I start to wonder why I did this or that. Pretty soon I hate the picture."

Kobal was incredulous, but had no time to object. Each "old" photo rising from a box silenced him. "Hurrell's work became clearer, stronger, increasingly hypnotic, and we both came to a discovery about the uniqueness of these people he'd photographed. A Crawford, a Gable, a Shearer became a forceful presence in the room, and words like 'old' meant a craft now lost."

Before long, Kobal was calling each photo an "image." He was looking for symbolism in poses and props. He was likening the subjects to Botticelli angels and Raphael Madonnas. When he used the word "icon" it was not George who had created it, but "Hurrell." At age sixty-five, George Hurrell became "Hurrell." A photo was not a movie still. It was "a Garbo by Hurrell" or a "Hurrell Crawford." Or just "a Hurrell."

After three interviews, John wrote an article that ran in the July 1971 issue of British *Vogue*. The magazine was not distributed in Los Angeles, so the highly complimentary piece (titled "Hurrell") had no effect on its subject's career. Hurrell appreciated the trouble Kobal had gone to, but what was the point if it did not lead to any work in LA? And anyway, these were old photos. What could you do with them? John Kobal had an idea what to do with them, and he began to work on it.

Three years passed. Hurrell was seventy. One day he was approached by Bette Davis, who was collaborating on a critical biography with writer Whitney Stine. Hurrell used medium format and shot book jacket portraits of

them. When Stine proposed the idea of a bio, Hurrell was friendly but noncommittal. He did not let on that he had been working with John Kobal, preparing notes for the Trewin Copplestone Publishing Company in London. On May 13, 1974, Hurrell wrote to Kobal: "This is getting to be embarrassing. I get all churned up to get on the book and then calls pour in, and what can I do?" In short order, he had gotten several TV pilots and a series of executive portraits for Rockwell International. Then Raquel Welch wanted him on her new film, *The Wild Party*. What could he do?

John Kobal was in New York, gathering material for a Hurrell book and supplying stills for *Interview* magazine. Paul Morrissey was there, having just directed *Andy Warhol's Frankenstein*. Kobal told Morrissey a curious story: he had gone to a certain lab in the photo district where it was possible to order prints from the old studio negatives that were stored there. According to Kobal, the following exchange had taken place in this den of Chanel-scented ladies and purple-shirted men, all of whom responded to his grandiose charm. "I understand you have things on file that you're dumping," said Kobal. "Would

you mind if I went through them and took what I want?" The smiles behind the counter froze until Kobal blithely peeled off a few hundred-dollar bills.

"John just went through box after box and held them up to the light," recalled Morrissey. "He recognized what they were because he'd been collecting the same stills already. So he simply took packs of them. And then boxes full." Kobal had achieved something remarkable. What he had first seen in an Austrian theater was now contained in the 8x10-inch sliver of history he was holding up to a hotel room light. He spent solitary hours identifying and labeling each precious negative.

Then he had cheap contact prints made, rushed them to Hurrell, and left for London. In November 1974 Kobal mounted a unique exhibition at the Victoria and Albert Museum, "Hollywood Still Photography, 1927 to 1941." Interspersed with vintage prints from the Kobal Collection were contact prints made from his New York acquisitions. The handsome, well-curated show created a sensation in London, making a celebrity of John Kobal and establishing the primacy of his collection.

In January 1975 Kobal received a letter from Hurrell. "I've tried to get some writing done," said Hurrell, "but it's such a slow procedure with my shooting schedule. Also, most of the notes land in the wastebasket when I reread them." Hurrell closed by saying that until he retired (in 1976), he would have no time to write a book, " if there is a book market left for Hollywood stills of the glamour era." The tone of Hurrell's letter was typical Hollywood: "Don't call me. I'll call you."

ABOVE: Hurrel made this portrait of John Kobal in December 1975, when they were contemplating a project.

OPPOSITE: When John Kobal interviewed Ann Sheridan in 1966, he was also writing books on Garbo and Dietrich and wanted to hear Sheridan's thoughts. "You see, John," she said, "Dietrich is glamour! Like Garbo was, still is, glamour. There is a mystery to them—and I never had that, dear. I don't think any American personality had it. We couldn't possibly touch it. We were just well-dressed, well-made-up motion picture actresses. We never had the mystery, the touch these women had."

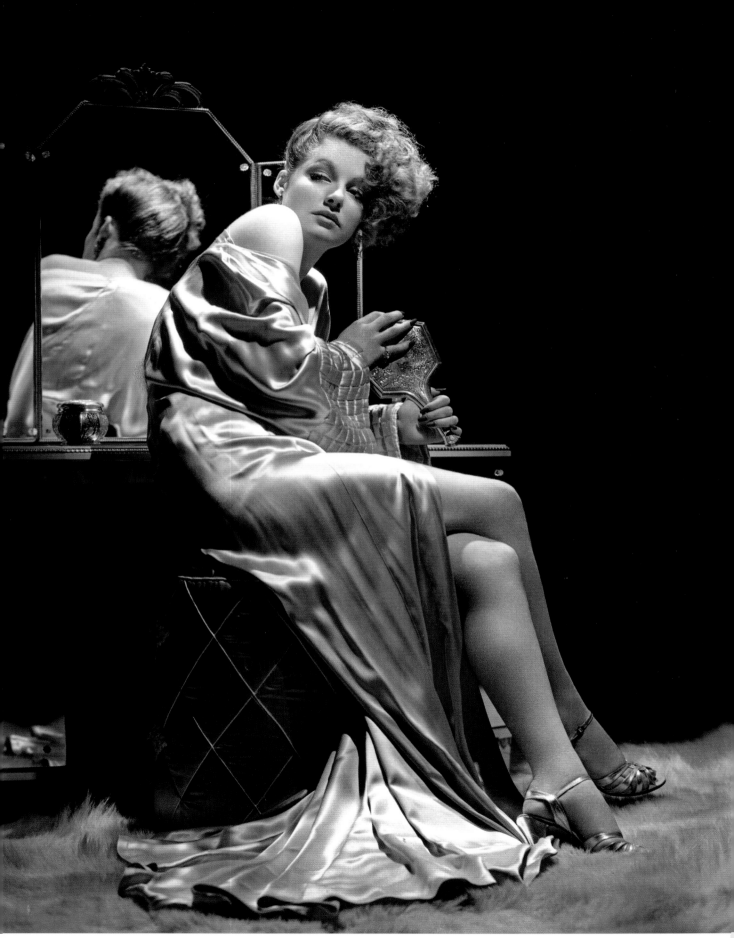

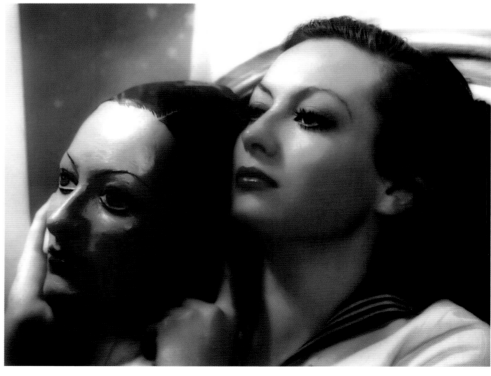

portrait studio, Apeda. When a movie was reissued, Apco lent the negatives to National Screen Service. When prints were needed in Culver City, Apco printed the negatives. By the 1960s, Apco was printing the "negs" for another group: collectors.

The still collector cult was born when thousands of young men came to Los Angeles in the postwar boom, drawn by the vaunted glamour of Hollywood. Hurrell collector Bill Chapman, for example, came from Kansas City, Missouri, with a master's degree in art, to avail himself of the opportunities that only a city of this size had to offer. Where else could you find bookstores that also sold pictures of movie stars? There were mountains of movie stills lying around Los Angeles. Wartime paper drives had not made a dent in them, and no one threw them away. "You can throw away a newspaper, but a still is different," said still collector Richard Braff. "It's cruel to throw away a real photograph."

As the demand for movie stills increased, bookstores such as Larry Edmunds on Hollywood Boulevard became movie memorabilia stores. When movie magazines and newspapers failed, inventories doubled overnight. When a silent-film actor died, bookstore employees would rush to the widow's home with cash and return with boxes of stills. Studio basements yielded stills, especially at night. Legend has it that a studio guard named Ken Hollywood spent weeks on the graveyard shift carrying boxes of "key set stills" from the basement of a certain movie studio in Culver City, the studio that had lost its hyphens in the '50s. These stills were soon available for purchase in a store on Gardner and Melrose. In those early days, stills sold for a quarter and the supply was endless.

Movie studios did not interfere with the stores. How could they? They had no legal claim. They had never bothered to copyright the negatives. They had not copyrighted the stills. They had given the stills away.

More importantly, the stills were from "old movies." At a quarter a throw, these pieces of paper were of no interest to multimillion-dollar corporations.

Furthermore, many studios were in transition at this time, so they did not notice that repositories were now printing original studio negatives for collectors and for stores. When John Kobal learned of this, he thought it might solve his research problems. He wanted to write a book about George Hurrell, but was stymied by the poverty of Hurrell's collection. He began to order prints from Apco, which had the M-G-M and Universal negatives, and from VitaPrint, which had the Warners, Columbia, and RKO negatives. He also began to cultivate collectors.

When I arrived in Los Angeles in 1973 to pursue a graduate degree in film production, there was an established community of still collectors. I learned about them through their latest initiate, a young but accomplished collector who was also attending the University of Southern California. When I gave a speech at the Ambassador Hotel in honor of veteran cinematographer Lee Garmes, this collector invited me to see his collection of stills from *Strange Interlude*. I expected to see photos that recorded Garmes's cinematography. Instead, I saw stunning portraits of Norma Shearer. I turned one over and saw a purple stamp that read: "Photo by Hurrell."

"Who was Hurrell?" I asked.

My ignorance could be excused. It was a result of the cultural climate. Nineteen-fifties Hollywood, like the pharaohs of yore, had tried to erase every vestige of the previous dynasty. Old movies were derided as "corn," then tolerated as "camp." Norma Shearer was attacked by Pauline Kael and Richard Schickel, and stamped in the public's mind as the untalented obsession of a myopic executive. But when the studios one by one dropped their libraries into television, something happened—the Morning Movie, the Early Show, the Late Show. In 1957, when I achieved the age of reason, twenty years of studio product was on view. There were naysayers, many of them in Hollywood. "I wouldn't say the old films have any future on television," said Frances Marion, who had written dozens of them. Bookkeepers at MCA, NTA, and M-G-M would have to contradict her. Old Hollywood was the new product, and children like me wondered why the air in films like *Grand*

Hotel looked silvery; it would be years before I learned about diffusion disks and glamour lighting.

In the early 1970s we began "Rediscovering the American Cinema." The classics—and Shearer—bounced back, first on college campuses and then in revival houses such as Berkeley's Telegraph Repertory, where Shearer's performance in the 1931 *Private Lives* got standing ovations. The directors, writers, and cinematographers of the Golden Era were enshrined in a cinematic pantheon, but there was no room in it for still photographers; hence my ignorance of Hurrell. Once I discovered this unknown artist, though, I began to venture off campus for a biweekly treasure hunt.

In 1974 Hollywood Boulevard was a fetid, smoggy backwash, a cultural void. Its fabled glamour had long since evaporated, leaving a shabby thoroughfare beset by inflation, recession, and an energy crisis. What had once been golden was now barely tinseled. I was not put off by the shabbiness; I could not see it. I saw a shimmering mirage of past glories, and beyond that, a treasure trove. A hundred million movie stills beckoned me to Hollywood Boulevard.

Braving the polyester glare, I walked from shop to shop, looking in file after file, box after box. I found the occasional Hurrell original, and I also found a network of kindred spirits. There was a group of still collectors that congregated at the Hollywood apartment of a friendly, gentle fellow named Myron Braum. Myron hosted small parties at 1535 North Las Palmas Avenue, where guests could buy stills, discuss films, or just peruse Myron's Norma Shearer collection. Each collector had his or her specialty. Joanna Morgan was a Greta Garbo collector. Bill Chapman was both a Judy Garland and a Greta Garbo collector. Dore Freeman was *the* Joan Crawford collector.

The atmosphere at Myron Braum's was redolent with oatmeal cookies, English Leather, and envy. Half a dozen middle-aged men sat on sofas, trading stories and passing prints. With his slight stammer and irrepressible smile, Myron was a genial host and sometime referee. The competition for new stills appeared friendly, but there was an undercurrent of one-upmanship and obsession. I watched, listened, and learned.

Every collector I met that year was upset that the stores were now charging as much as three dollars apiece for original stills. Collectors were forced to buy less, but they kept on buying. They were compelled to buy. Each new purchase cried out for company in its file folder. And beyond the quirks and the constancy of collecting, there was a common theme: idolatry. Collecting still photos brought the collector closer to the magic of the star. "It's like they want to touch their idol," said David Del Valle. "And if they collect enough photographs, say, enough to reach the size of a human being, well, they've brought them back from the dead. It's a little like necrophilia." Stills also extended the movie experience; they were something tangible after it ended.

When I met Myron Braum, he was using his collection to write a book, *The Films of Norma Shearer*. I helped him by supplying frame enlargements I had made from a 16mm print of *Marie Antoinette*. I was thrilled to be involved with a book. Much of my emotional connection with Hollywood came from books in the Oakland Public Library. I was in awe of authors such as Raymond Lee (*Gloria Swanson*), Marc Ricci (*The Films of Greta Garbo*), and, most of all, Daniel Blum (*A Pictorial History of the Talkies*). Their books had been my grammar-school bibles. If I had known that these writers were collectors, and how they acquired their collections, I might not have been so admiring. The film and theater historian Miles Kreuger recounted the tale of a Manhattan tea party hosted by actress Fritzi Scheff, where her retired friends were talking about their careers. "It's very modest of you, Fritzi," said actress Hazel Dawn, "not having pictures of yourself on display."

"Oh, I used to have lots of pictures," replied Scheff, "but I lent them to Daniel Blum for one of his books and the publisher lost them."

"Suddenly there came the sound of teacups dropping to saucers all around the room," said Kreuger. "Every actress there could tell the same story."

I was hearing similar stories in Los Angeles, where the pickings were much better. The elderly animation artist Marcel Delgado allowed a young collector named Bob Scherl to borrow his priceless, one-of-a-kind *King Kong* production shots, ostensibly to make copies. Scherl brought them back on time but then made a hasty departure. Poor Delgado discovered that Scherl had made copies, all right, but had kept the originals. And Scherl had

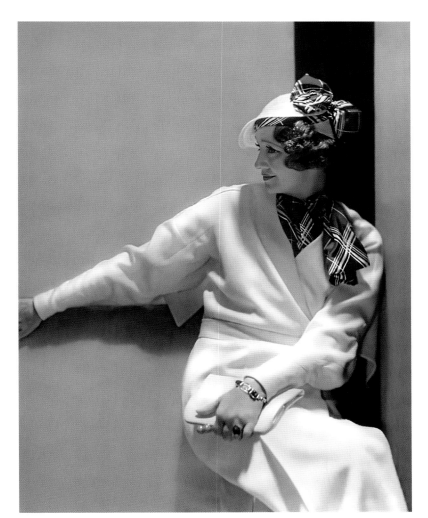

given Delgado a false name and phone number. Several years later, I saw copy prints of the Delgado photos. They were on sale at a movie memorabilia convention. Sitting at the dealer's table was the obese Bob Scherl. Twenty years later, when Scherl reached four hundred pounds, he committed suicide.

Collector stories could be as macabre as they were appalling. Another collector jammed so much ill-gotten

ABOVE, LEFT TO RIGHT: When Hurrell saw a portrait of Hedda Hopper he had made in 1932, he vividly remembered her voice coming out of the phone.

Basil Rathbone's complexion lent itself handsomely to Hurrell's retouching technique.

gain into his apartment that his boyfriend threatened to leave him. The collector could not stop collecting. The boyfriend had a breakdown and became disabled. "I guess the collection won out," he told anyone who would listen. After he died, I offered my condolences to the collector. "I know it's kinda sad," he said after a poignant pause. "But I guess it gives me more room for my collection."

Hurrell had no contact with the collector world, and his view of the art market was correct—so far. These collectors did not value their stills as fine art or as self-sustaining artifacts. The stills were looked on as pieces of a giant, never-to-be-completed puzzle. Film director Paul Morrissey watched these collectors from the vantage point of Andy Warhol's *Interview* magazine. "To them," he said, "it was 'Oh, I've got another Garbo.' Or, 'Oh! I've

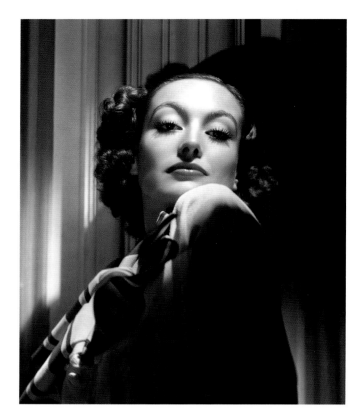
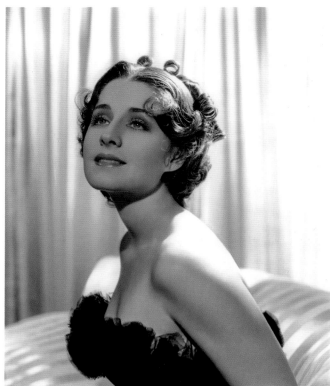

got another Crawford!' It was never that these were great photographic art." That was John Kobal's vision.

To me, Hurrell's photographs were something else, a path beyond my film studies. His work showed me that it was possible to use light as both a means and as an end. To that extent, I did perceive it as fine art, and I wanted to learn more. When I abandoned my film studies, the boss at my work-study job at the USC School of Dentistry created a full-time position for me. I became a staff photographer, shooting portraits of dentists in a well-appointed studio and making prints of them in a spiffy darkroom. I was warned not to expect much in the way of salary or raises, but I was free to use the studio and darkroom after hours. Room 303 became my home away from home, an enchanted retreat where I learned large-format photography and practiced Hurrell techniques on family and friends.

My boss laughed at me for trying to practice an out-moded technique. Everyone else was using 35mm cameras and strobes to "tell it like it is." I used a view camera, incandescent lights, and pencil retouching. Why? Because

the Hollywood glamour technique, more than any other, made my subjects look good. Because of Hurrell, I believed that physical beauty should not only be recorded but also enhanced.

In 1975 the casting director Marvin Paige generously referred actors to me. (He referred actress Fifi D'Orsay to Hurrell, too.) I photographed Anna Lee, whom Paige had gotten onto *General Hospital*. I also photographed Henry Wilcoxon, whom Cecil B. DeMille had cast as Marc Antony in the 1934 *Cleopatra*. While perusing my portfolio, Wilcoxon stopped and made a comment. "You must have a good 'camera-side manner,'" he said. "You're able to photograph thought." I was not sure how to accept this compliment. I wanted to do better. I wanted to learn more.

Another Hollywood veteran who helped me was Dore Freeman, the head of the stills department at latter-day M-G-M. I had met him during my first summer at USC,

ABOVE: These were two of the exquisite Hurrell portrait prints that Dore Freeman had in his collection.

when I boldly walked into the Thalberg Building with a fellow student named P. R. Tooke, and asked to meet someone who had known "the great stars of the Golden Era." A nonplused receptionist sent us down the hall, where we met this executive who hired Hurrell to shoot stills. Freeman was also on a first-name basis with Norma Shearer, Merle Oberon, and of course, Joan Crawford. In the collectors' world, Dore Freeman was the "ultimate Joan Crawford collector."

Freeman was also an unrepentant lecher, and no young man who entered his home was safe from his advances. My friends tried to treat it as a joke, calling him "that tacky old queen with the turquoise jewelry." John Kobal called him "that old spider monkey." After all, Freeman was in his sixties and most of us were in our twenties. Kobal was also compassionate. "You won't always be twenty-five," he told David Del Valle. "One day you'll be his age, and maybe you won't behave that way, but for now, appreciate why he does." There was plenty to appreciate. Dore's usual opening line was: "Wanna fuck a pretty actress?" Suffice it to say that he was neither.

Sexual tension was an element of the scene, but not all collectors were as subtle. A collector named Jim Jeneji greeted me bare-chested and proceeded to show me his in-progress hair transplant plugs. I did not find them sexy. When I went to visit Marvin Paige on a Sunday morning, I was treated to the sight of a praying mantis in a bath towel. My teeth on edge, I tried to look through his file cabinets. Within twenty minutes, he was asking me to rub his back. I had gone there to look at forty-year-old photos, not a forty-year-old torso, so I beat a hasty retreat. In Hollywood, there was the casting couch and the "collecting couch."

At my first visit to M-G-M, Dore Freeman took advantage of my preoccupation with a key stills book from *Gone with the Wind* and ran his predaceous fingers through the curls at the back of my neck; this, after a mere two hours of acquaintance. When I went to his home, I made sure to bring along a friend, the same young collector who had introduced me to Hurrell's work. Freeman could not molest both of us, so the evening proceeded to its stated purpose: to look at his collection of Hurrell prints. My friend and I sat nervously on the couch as Freeman carried several boxes of 8x10 prints to us. When he opened

them, we were stunned. Then we competed for adjectives. "Incredible!" "Fabulous!" "Unbelievable!"

Dore Freeman had what was probably the best collection of custom-printed Hurrell originals in the world: we saw Jean Harlow, Norma Shearer, and of course, Joan Crawford. (When Crawford had gotten Freeman a job in the M-G-M publicity department in the 1930s, one of his duties was to discard key set stills of artists whose contracts had expired. Somehow the proscribed photos never made it to the incinerator.) Hundreds and hundreds of mint prints, unseen since the '30s, emerged from nondescript Kodak boxes. Myron Braum's collection was beautifully organized and concentrated, but this was "far out!" This was the only way to see what Hurrell had done at M-G-M—in one superb, creamy, silvery double-weight 8x10 after another, for hours and hours and hours. Freeman almost had to throw us out. We could not stop looking.

I was not surprised that my friend wanted to return to Freeman's house a few days later. I was surprised that he went alone, and more surprised when he showed me a print of Jean Harlow that Freeman had given him. "He actually gave you this?"

"Mm-hm," my friend answered. Then he produced another still, and I gasped. It was MG42141, a 1934 portrait of my favorite star, Norma Shearer. Of all the thousands of stills I had seen at Freeman's house, it was the one that had stayed with me, the one I now coveted. Hurrell had shot Shearer over a mirror-topped table and used the light bouncing from the mirror and from wax flowers to turn Shearer into an icon. It was a masterpiece. My friend handed it to me. "This is for you," he said.

"For me?" I asked in disbelief. "Oh, my God!" I stared at the print, and then turned to him. "Well, you really are my best friend!" Then I paused. "Wait a minute. How did you get Dore Freeman's two best stills?"

"How do you think I got them?" he smiled inscrutably.

"Oh," I said, and sighed. "Welcome to Hollywood." I did not berate him—or return the still. I was becoming a hard-core collector. What he did with Freeman was his business. I had MG42141. Now, I thought, if I can just get Hurrell's phone number.

I continued to call Freeman, and when he saw that I was sincere and serious, I no longer needed a chaperone. I showed him my lighting experiments, he critiqued them, and we became friends. He lent me dozens of stills to study (and copy) and appraised numerous portrait experiments. He even gave me Hurrell's phone number. I was on my way.

Hurrell had gotten good news from Whitney Stine. Two years of shopping had paid off. The John Day Company in New York wanted to publish a pictorial biography that was to be called *The Hurrell Style*. Hurrell agreed to do the book as long as he would not have to spend a lot of time on it or actually write anything. Stine interviewed him several times, borrowed his scrapbook of clippings, and then realized that there was a problem. The publisher expected to use 300 photos, but Hurrell only had about 75 prints. He also had 500 negatives, but they were mostly unretouched ("killed") poses.

Stine had sold the book on the basis of the photos. If Hurrell did not have them, if he could not get them from the movie studios (who also did not have them) or from the recently spurned John Kobal, well, the deal was off. Then Stine remembered his Bette Davis project, the effusive fans, and their photos. He brought this up to Hurrell, and Hurrell remembered Dore Freeman, the head of publicity at M-G-M—the Joan Crawford *collector*. Of course! Collectors!

But collectors were funny people, not inclined to part with precious originals, especially for the year that a publisher would need to keep them. Freeman was no different. (He had heard the Daniel Blum tales.) He would, however, allow his prints to be copied. That was where I came in. By this time, my copy work was good enough to sell to both collectors and authors. I had been pestering Hurrell for a year, but he had not been interested in meeting a USC Dental School photographer. Now he needed copy work, so he agreed to an audience. A meeting was set for Saturday, November 1, 1975.

From the outside, 122 South Almont Drive was not unusual. It was not built in the Normandie Village or Mother Goose architecture that one might expect for such a singular enclave. So when George Hurrell entered Dore Freeman's home, there was a moment of silence. Even this show biz veteran was taken aback. Before him was an array of Joan Crawford material unmatched anywhere in the world, and roughly 40 percent of it had been created by him. Everywhere he looked, he saw Joan Crawford—in stills, in oversize portraits, in lobby cards, in sheet music, in posters, in oil paintings, and even in life-sized cutouts. This was Freeman's shrine to the woman with whom he had carried on a fifty-year, long-distance love affair.

I was introduced to Hurrell, and he began to stroll around the house, studying each item of Crawford memorabilia. He was short, stocky, and full of verve. I thought that he looked more like a beatnik artist than a studio photographer. He asked Freeman if Joan had ever been to his home. Freeman answered no, with some regret but no resentment. His notion of a star was that of a being set apart, unfettered by social obligations, a notion born of forty years in the studio system. Then he produced his latest letter from Joan, as if to affirm their unique bond.

On the archway over the dining room hung a life mask of Joan Crawford made in 1953. Hurrell chuckled at it, and then followed Freeman into the dining room to look at my portfolio of portrait work. Hurrell flipped through it, turned to Freeman: "I thought you said he needed help." Then he turned to me and said, "You don't need any help. These are fine." He closed my portfolio. "You have a good feeling for black and white." I thanked him, and then we got down to business, going through Freeman's collection.

As we went through binders and boxes, I asked questions like "Why do you use a pin spot for a fill light instead of a double broad?" Hurrell was surprised that I knew so much about his technique. He made some preliminary choices, and then he treated us to lunch at the Hamburger Hamlet at Beverly and Robertson and reminisced. "Joan's problem was that she couldn't stand getting old," he said. He had last seen her in August 1972, "on some silly show at Universal." She had been drunk.

OPPOSITE: Hurrell made this portrait of Joan Crawford for *No More Ladies* in 1935. This print was sitting with a hundred others in a Kodak photo paper box in Dore Freeman's hall closet in 1975. The studio had told him to throw them in the trash thirty years earlier, after Crawford left the studio.

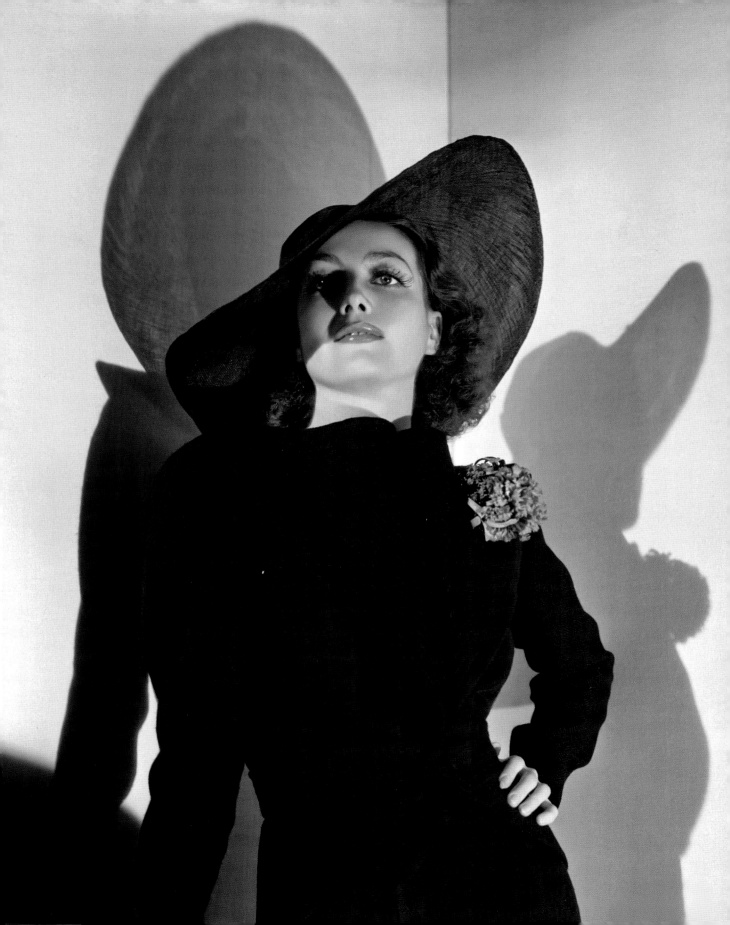

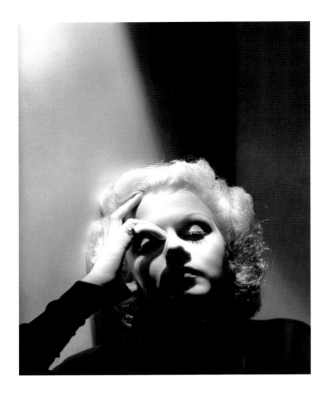

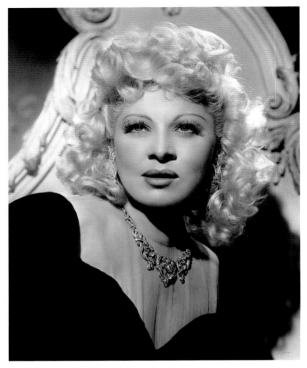

For the next six months I shot copy negs of Freeman's Hurrell originals. Sometimes I would deliver them to Hurrell's home on St. Clair Avenue in North Hollywood and sometimes he would come to my Santa Monica apartment and treat me to dinner at Casa Escobar. He liked Mexican food. When I visited him, I met his wife, Betty, and his son, George Jr., and drank gin-and-tonics with him. I brought old movie magazines and asked him questions about his work. My questions usually prompted memories.

On seeing a 1932 image of Hedda Hopper, he said, "That was before she got so big-headed as a gossip columnist. After that, she used to call me up and try to get gossip out of me. I wouldn't tell her anything, and she'd start cursing at me: 'You goddamned son of a bitch!'"

Occasionally I would bring my own work for him to critique. One time, Betty walked into the room, saw my portfolio, and said, "Well, are you going to be the next Hurrell?"

"One's enough!" snapped the original Hurrell.

I never forgot the awkward silence that followed.

As 1975 turned into 1976, George Hurrell became increasingly fussy about the prints I was making for him from my copy negatives. In one case, I went to the trouble of copying a friend's print of Norma Shearer from the historically important first sitting. My friend express-mailed the print from New York. Then I rushed to shoot it at USC, rush-processed it, and rush-printed it. I drove to North Hollywood with it, only to have Hurrell say, "You need more skin texture on the left side of her face here."

"But look at the original," I said. "There's no skin tone there. It's pure white."

"Well," he drawled in that raspy voice of his. "Burn it in. Put some tone in there."

"Okay," I said feebly, thinking to myself, *How the hell am I going to do that?* Indeed, the result was rather muddy-looking, but when I delivered it, he grunted, paid me, and took it. Before long, the copy work slowed. When it stopped altogether, I knew why. Hurrell was getting prints of his work from an unlikely yet obvious source.

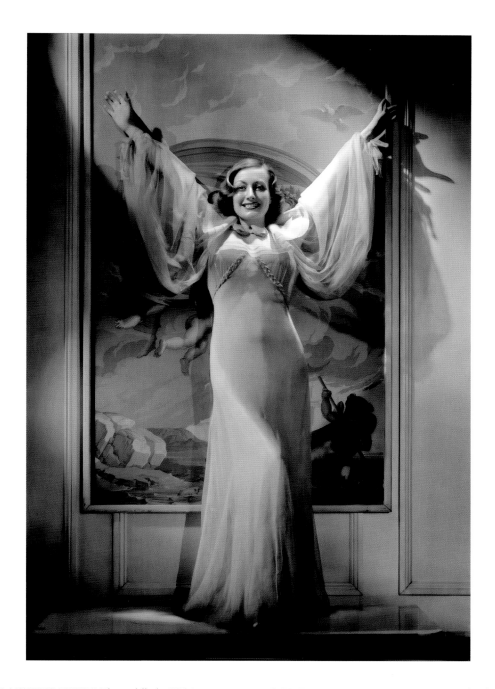

OPPOSITE, LEFT TO RIGHT: This oddly lit 1934 portrait of Jean Harlow was hidden in a box at Dore Freeman's.

When this photo of Mae West emerged from Freeman's "Miscellaneous" box, Hurrell said, "I shot that with 4x5 film."

ABOVE: Dore Freeman was Joan Crawford's most ardent fan. His home was a shrine to her. A life-sized cutout of this Hurrell portrait stood at the entrance to his dining room. If not for collectors like him, the aesthetic legacy of Hollywood's Golden Era would have been incinerated.

DREAMS FOR SALE

The Great Work of Hollywood Still Photographers (1927-1949)
Coordinated by John Kobal & Assemblages by Sabato Fiorello

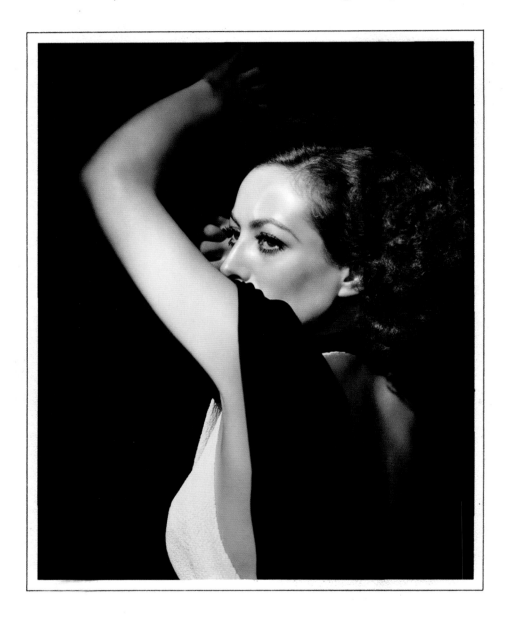

Presented by the Municipal Arts Department in association with
The Los Angeles International Film Exposition · February 28 - March 28, 1976
Los Angeles Municipal Art Gallery

RETURN FROM THE ASHES

THE NEGATIVES

In 1975 John Kobal was in New York, still acquiring original studio negatives and still trying to have them printed properly. By the 1970s, most photo labs were unwilling (or unable) to enlarge 8x10 negatives. They would only make cheap contact prints, and when Kobal complained that the prints were too contrasty and not properly balanced, a lab tech would snap at him: "What do you expect? It's an old negative!" Kobal did not know enough about photography to challenge this excuse for sloppy work. He was stuck. "John never bothered to learn the very basic work of photography," said David Chierichetti. "He couldn't make a print." Kobal showed the cheap contact prints to Paul Morrissey and asked his advice. Morrissey studied them and said, "John, you know these portraits are among the best ever done by any photographer. You have some extraordinary negatives here."

"What does that mean?" Kobal asked. "What do I do?"

"What *we* have to do," answered Morrissey, "is present them as fine art photographs—printed on matte paper, 8x10, gallery style."

"Oh, no, no, no," objected Kobal. "That's not Hollywood! Hollywood is big, *big*, BIG!" Kobal needed enlargements to prove his point, but the New York labs were impossible. He flew to California. At a fortuitous moment, he rang up Hurrell (who was still seeking pictures for his book). Hurrell agreed with Kobal about the enlargements. Yes, 8x10 negatives could be enlarged to ten feet

without a loss of quality. Of course, Hurrell did not have a darkroom, but he would help Kobal, that is, if Kobal would help him with—guess what—his own book project. John Kobal swallowed hard when he heard that Whitney Stine was writing it and it would be titled *The Hurrell Style*.

Kobal recovered himself, went to Gary Essert of the Los Angeles Film Exposition (FILMEX), and showed him the contact prints. Essert agreed to underwrite an exhibit of large prints of Hollywood photography. Kobal triumphantly returned to Hurrell and together they went to Bob Olson Photo BlowUps on Beverly Boulevard, another link in the chain of events leading to Hurrell's return.

On February 27, 1976, the Los Angeles Municipal Arts Department, in association with FILMEX, presented *Dreams for Sale* at the Barnsdall Park Municipal Art Gallery in East Hollywood—in the same Hollyhock mansion where Hurrell had delivered prints to the Laguna artist, Julia Bracken Wendt, fifty years earlier. The opening-night reception was a splashy, well-publicized affair, attended by celebrities, art patrons, politicians,

PREVIOUS: In February 1976 John Kobal, with Hurrell's help and counsel, mounted a groundbreaking exhibition.

OPPOSITE: A vintage 1933 camera negative of Jean Harlow shot by Hurrell in the Directoire Room of Bullocks Wilshire department store.

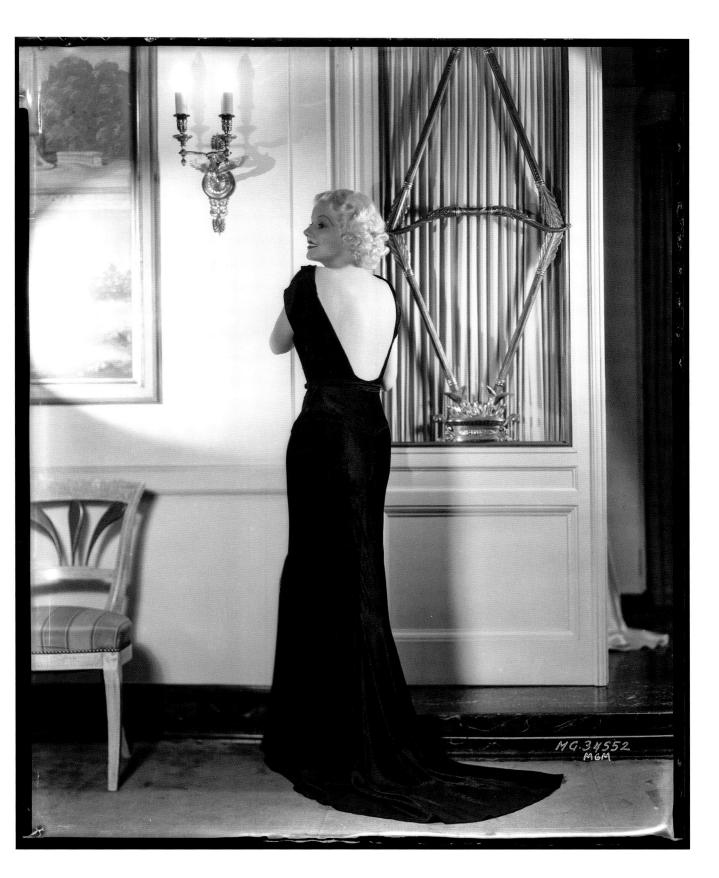

MG.34552
MGM

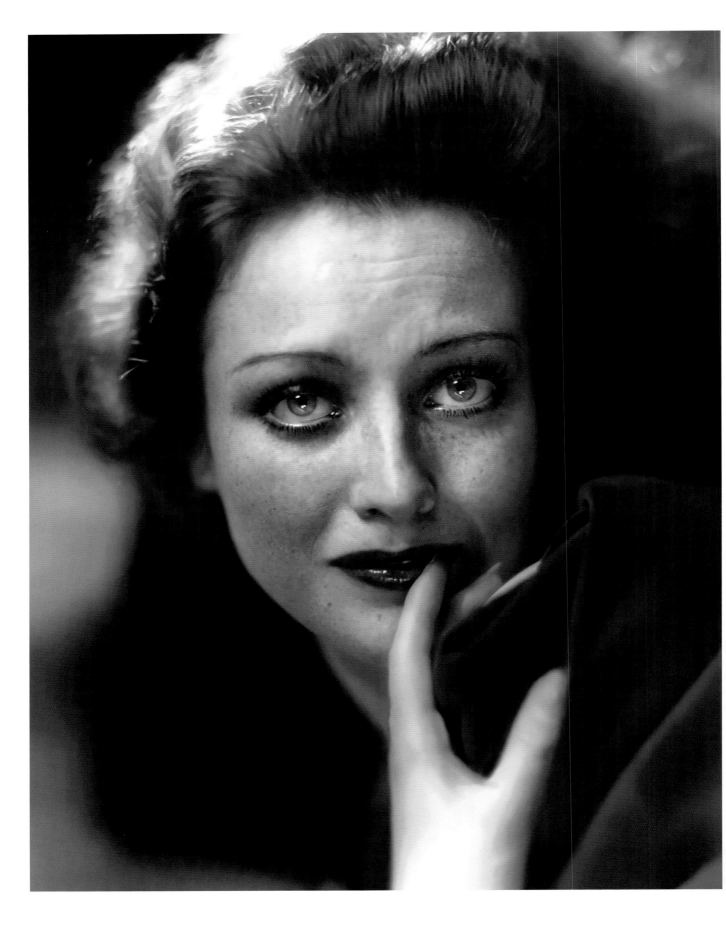

socialites, but few collectors. "With this show," said Simon Crocker, who was later Kobal's manager, "John Kobal became more than just another collector of old stills. He separated himself from the pack. It was because of his intellectual inquisitiveness and that creative capacity he had, that people began to look at Hurrell and these others differently."

The 200-print show ran only a month, but its influence was far-reaching. Kobal got a book deal from Dover Press to publish a monograph on the show, *Hollywood Glamor Portraits*, and Hurrell's book project was given an early push by all the media attention Kobal was getting. Hurrell's photos made up only a tenth of the show, but they were most prominently displayed, and one of his 1934 portraits of Joan Crawford was the cover of the program. He was pleased, but reminded Kobal that he had been in a show before. In July 1965 the Museum of Modern Art in New York mounted a show called *Glamour Poses*. Hurrell's work was in the company of Edward Steichen, Irving Penn, and Richard Avedon.

Dreams for Sale was generating much more publicity, though, and that impressed Paul Morrissey, who still felt that Hurrell's Hollywood work could be presented as fine art photography. He suggested to Kobal that they discuss this idea with Hurrell. Kobal put him off. He was too busy with interviews, parties, and research. He was now working on a new project, a biography of Rita Hayworth. To that end, he was canvassing various collectors, including the generous Myron Braum, who knew how much I admired Kobal's books and that I had not been invited to the reception by George Hurrell, Marvin Paige, or Dore Freeman. On March 31, 1976, Braum introduced me to John Kobal.

OPPOSITE: In April 1976, when Hurrell was finishing his book, he sent a newly made print to Joan Crawford. "I've always thought the soulful, tender beauty in the enclosed print was among our best efforts," he wrote. "The depth of feeling and emotion you expressed in this pose has a dramatic quality that only a great actress could reveal." For whatever reason, Crawford did not provide an endorsement quote for his book. She may have been too ill, for she died on May 10, 1977.

ABOVE: Hurrell's pictorial autobiography was released in the fall of 1976 and promptly sold out.

I had met some colorful personalities in my first three years in LA, but Kobal was in his own category. He had come to embody the larger-than-life glamour of "Olde Hollywoode." He was too big for Braum's living room. He had a resounding voice and every third word was italicized. I quickly noticed (but pretended not to) that Kobal suffered from a strabismus. I had seen this in some family members over the years. Recognizing this as a handicap, as something that must have caused him pain as a child, I could understand a little better why Kobal was such a bombastic self-promoter. I was impressed by him and he was impressed by me—at least by my photography. In turn, I praised his books. "A lot of people have liked them," he said.

"They've really helped me—"

"In fact, they've liked them so well that they've taken to copying photos out of them," he averred.

"Oh, really," I said, and nodded, while thinking to myself, "What? There are photos in your Garbo book with huge moiré patterns on them because you copied them out of *The Films of Greta Garbo*!"

The conversation turned to Hurrell, and I showed Kobal some prints that I was going to lend Hurrell for his book. "Oh, that profile-to-profile shot of Garbo and Barrymore from *Grand Hotel* isn't one of Hurrell's."

"No?" I asked.

"No," he answered. "It was made by a stills man called Fred Archer. There was a photographers' strike or something and Hurrell couldn't work, so they had to get somebody who wasn't in the union."

"Hm," I said, not convinced. "That's interesting."

For all his bombast and prevarication, I enjoyed Kobal and I could see why he was accomplishing so much. "There's no money in film books," he said emphatically but impressed me as the quintessential author. Yet I could see why a number of collectors were bad-mouthing him. One night he kept me waiting twenty-five minutes in his room at the Sunset Plaza while he hollered into the phone about his Rita Hayworth book. "What she needs is her own Norton Simon! Well, of course she's going to see me, you fool!"

"John had strong opinions and was not afraid to express them," said Simon Crocker, Kobal's manager. "And he did ride roughshod over a lot of people. He made enemies." After our first meeting, I was not one of them. I was an incipient fan.

I was starstruck the next night, too. George Hurrell visited my apartment to look through my own collection of originals. He stopped at a print of Virginia Bruce with her head sideways and said, "What the hell was I trying to do here?" He continued looking and finally selected one image, my print of the Garbo and Barrymore profile-to-profile pose from *Grand Hotel*. He paid me thirty dollars and headed for the door.

"Don't you want an envelope?" I asked.

ABOVE: Hurrell began to get calls for portrait work after his book came out. This is Anne Archer by Hurrell.

OPPOSITE: This is Keith Carradine, shot in conjunction with Hal Ashby's *Bound for Glory*.

"Naw, that's all right," he said, rolling up the 8x10 gloss-ies and shoving them into his oversized pants pocket. After he left, I wondered why he would want that profile-to-profile image if someone else had shot it. Then I decided that he must surely know what pictures he had shot.

Attribution was a problem. If the print had no Hurrell stamp on its back and if you had not seen it in a 1932 issue of *Photoplay* with a Hurrell credit on it, you had to wonder. "My original set was stamped 'cause I would send it out that way," Hurrell told Kobal in 1969. "But if the studio, say, Paramount, made the prints, then they didn't stamp them. I used to try to get them to do so. Sometimes they did—M-G-M did. I gave them a stamp, but some of the studios wouldn't bother." A lot of people were wondering about attribution that year because the images in the show and in the book invited collection. In the summer of 1976, Bill Chapman turned the focus of his collecting from Judy Garland to George Hurrell and began referring to himself as "the first Hurrell collector."

So did a young man named Louis D'Elia, but he had been collecting since 1967, when Claire Steinberg, his photography teacher at Pacific Palisades High School (and the first female editor of *Popular Photography* magazine), recommended that he study Hurrell's work. D'Elia did not know (or care) who the old stars were. He was fascinated by the art. Thirteen years later, he met Hurrell through a chance encounter at Producer's Photo Lab. The old artist and the doctoral student hit it off. They lunched on a regular basis as D'Elia completed his degree at UCLA. Hurrell was interested in D'Elia's studies and willing to chat about his work. There were probably other people collecting Hurrell. The important thing is not who was first, but that they were collecting at all.

Morrissey kept after Kobal, and they finally paid a visit to Hurrell. Holding a selection of Hurrell negs in his hand, Morrissey said, "Listen, I think if you print these and sign them in a limited edition, these things can go

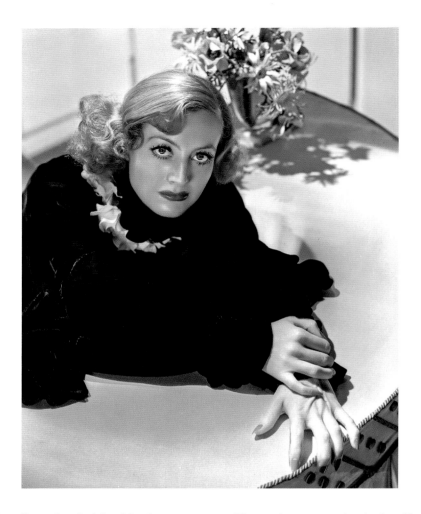

into art galleries." Hurrell was skeptical, but Morrissey persisted. "I said I was going to get them printed somewhere," said Morrissey, "and that he could supervise, but he said, 'No, no. I'd like to print them myself.' He was a short, very strong guy, like a little bull, really. He said, 'I have a garage and an enlarger. If you can get me a dryer, I can print here.'"

Morrissey and Kobal went through the negatives later, arguing about selections. "John liked certain corny, kitschy things, like somebody holding up a mirror and smoking a cigarette," recalled Morrissey.

"Look, John," he said. "We're trying to compete with Steichen and all those portrait photographers. We're trying to say that these are not movie kitsch. We have to go totally into formal, dramatic portraits."

They took some negatives back to Hurrell and then returned to New York, where Morrissey started to sound out investors. On June 7, 1976, Kobal received a letter from Hurrell, in which he sent an agreement for Kobal to sign. He was optimistic about his forthcoming book. The publisher had chosen 252 photos and it was at the press. "And the goose hangs high," said Hurrell in closing. [This 1880s expression meant that the goose was suspended high enough to prevent foxes from stealing it.]

Kobal did not sign anything that Hurrell's lawyer had sent but instead asked Hurrell to hold off until Morrissey came through with his investors. Hurrell reluctantly agreed to wait. Before long, he grew impatient and began printing Kobal's negatives at the Christy and Shepherd Studio in Hollywood, five blocks from where I was living. East

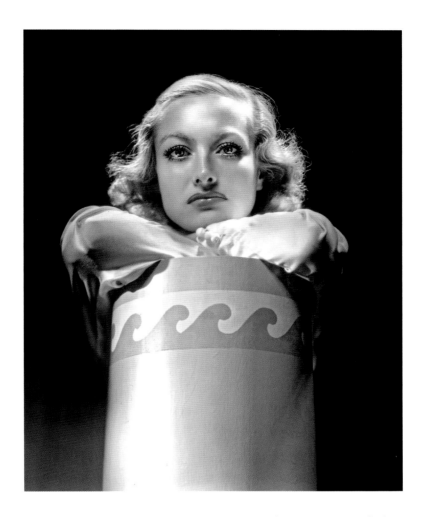

Hollywood was more economical than Santa Monica, especially if you wanted to continue collecting.

I was still collecting and still making calls to Hurrell. I would ask for stills I had lent him or offer to print for him in the USC darkroom. As his name regained currency, I found him less and less chatty, and he usually terminated the conversation with "I'm just too goddamned busy." *Click*. John Kobal tried to rationalize it. "Some rather odd people have gotten George's ear," he said. But I continued to hope.

OPPOSITE AND ABOVE: Hurrell and Kobal worked side by side in a garage darkroom, making prints for a gallery and publishing venture. These 1933 portraits were among the images Hurrell printed.

On July 17, 1976, I supplied a 4x5 view camera, lights, and twenty sheets of Tri-X so that George Hurrell could shoot a twenty-first birthday portrait of the same friend who had introduced me to his work two years earlier. I acted as photographer's assistant. To the best of my knowledge, it was the first time Hurrell had used a large-format camera in twenty years. I snapped the shutter for him when he was ready with each pose.

Watching him work was a treat, although he did not jump, holler, or dance. Not that he lacked the energy; my friend was too excited to need Hurrell's famous brand of coaxing. I supplied music, though, and Hurrell appreciated that. His work, both indoors and out, was incisive and sure. Years of small-format grab shots had not diminished him. His compositions were both startling

and airtight. The USC tripod had no receptacle for film holders, so Hurrell just dropped them into those expensive pants pockets. I had just seen Francesco Scavullo shooting Margaux Hemingway in *Lipstick*. This was much more fun.

As Hurrell was leaving, I proffered a pitiful $75 for his time. He reluctantly took it and then kindly and patiently made sure that I understood how to print the negs after retouching them. "Print them down," he said. "Y'know, for the highlights, not for the shadows. So the highlights will shine. Oh, well, you know what to do." Then he ambled out of the garden and drove to Christy and Shepherd's to print Kobal negs.

Processing Hurrell's negatives in the USC darkroom was as momentous for me as processing Edward Steichen's negatives had been for Hurrell in 1928. The difference, of course, was that Hurrell was not standing behind me. I wanted his input. I felt the need to work more closely with him, and to work with him. Better than anyone in his orbit, I understood his technique. I could be a great help to him, especially as he was getting busy with glamour portraits again. With this in mind, I retouched and printed several of the portraits he had shot of my friend. If Hurrell could see what I did with his new work, he would surely hire me, both to retouch and print. Perhaps I could become his assistant on shoots, too. This would be a worthy direction for my energies.

I called Hurrell to make an appointment. He started in with his rote response of "I'm too goddamned busy." I said that I just wanted to show him something; it wouldn't take too much of his time. He told me to come to Christy and Shepherd's on the morning of August 6. I cleared the tracks so that I could take my lunch break early and drive to Wilton and Fountain with the prints.

On that day, as luck would have it, there was an emergency oral surgery that had to be photographed, and I was tapped for the job. It ran past noon. I dropped the intra-oral camera off in the studio and hustled my Volkswagen Squareback to Fountain Avenue. When I entered the lab, I was told that Hurrell had just left.

I called Hurrell from work in the afternoon, but he was not home yet. Then I got off work and went to the house where I was renting a room. The house was quiet. None of my roommates had returned from work. I went to the phone in the living room, and looking up at some framed prints of my recent portrait work, I dialed Hurrell's number.

Betty Hurrell answered. "Yes, he's here," she said. "Let me see if he can come to the phone." I thought this was a little odd. I waited. Then I heard his voice. Or what I had to assume was his voice. It was not the voice of the man I had come to know. It sounded to me like the voice of a drunken madman. I could not make out a word. Then he hung up on me. I just sat there. My head was pounding. I was nauseated.

I could barely comprehend what I had just heard. It was not coherent. It was not human. It was possessed.

I tried to reconcile this with the artist whom I had come to respect, to idolize. Yes, Hurrell could be gruff, even curt, but I had never seen him angry or, as in this case, out of control. Out of control? No, he sounded more like he was out of his mind. Perhaps there was more to his legendary moodiness than anyone knew.

I immediately mailed the prints and the negatives to my friend. I told no one what had happened. I tried not to think about it. I did not want to be entrusted with such an ugly secret. I wanted to forget it, but it stayed with me. As a result, two years passed before I could bring myself to speak to Hurrell.

Kobal was moving forward with his project and bestowing treasures on the artist. On September 29 Hurrell wrote to Kobal, thanking him for a negative of Loretta Young and Tyrone Power from the 1937 portrait sitting for *Love Is News*. He had already used a print of it for the cover of the forthcoming *Hurrell Style*, and now it would also be part of their "art gallery deal." He acknowledged receipt of $1,500, reported that he was setting up the darkroom, but again asked for a more formal agreement. He was concerned that something could go awry and leave him with an "infinitesimal" return. Paul Morrissey, meanwhile, was negotiating with photographer Peter Beard and Kenyan investor Harry Horn to back the Hurrell venture. Then Hurrell's book hit the stores.

RIGHT: In July 1976, I was hoping to work with Hurrell. I borrowed a Calumet 4x5 view camera, a 240 mm lens, and lighting equipment from my job at the University of Southern California School of Dentistry so that he could shoot large-format film for the first time in twenty years.

The Hurrell Style had only 185 plates, and its layout and choice of images left much to be desired. So did its text, which Whitney Stine had culled from Hurrell's clippings and other secondary reference material. Fine art photography dealer David Fahey was then working for the G. Ray Hawkins Gallery. "*The Hurrell Style* was poorly designed and poorly edited and terribly reproduced," he said, "but it was the first chance anybody'd had to see these pictures. It was a 'better than nothing' kind of thing." I was disappointed that Hurrell had not used any of the images in Dore Freeman's collection, which to me was the essential Hurrell collection. John Kobal thought that Hurrell had used too many "also ran" shots, lesser images. "I don't know who George listened to!" Kobal said. "Dog's dinner!" My collector friend turned up his nose at it. Nobody liked Hurrell's book—nobody but the public.

In the fall of 1976, people were hungry for glamour. Movies were gritty and grainy, and celebrity photos unflattering. Disco had arrived, and we were looking for our reflections in a mirrored ball. *The Hurrell Style* and Kobal's *Hollywood Glamor Portraits* were splashes of expensive cologne. Both books did extremely well. Even before his

book tour, Hurrell became a frequent interview subject, for publications ranging from the *Los Angeles Times* to *Hollywood Studio Magazine*. He was articulate, his reminiscences fresh and piquant.

He finally retired from Local 659, but still needing work, he looked for a photographer's agent. Paramount's head of publicity, Arthur Wilde, sent him to Marysa Maslansky, who was a West Coast photographers' representative for the Parisian agency Sygma. "I had absolutely no idea who he was," recalled Maslansky. "He came to my home, which was also my office, and he showed me really bad party pictures he'd taken with a motor-driven Nikon. And then he said, 'Oh, but you know, in the old days, I used to do these kinds of pictures.' And he showed me some *incredible* black-and-white portraits."

"That's what you should do again," said Maslansky.

"Oh, no. Nobody wants those anymore."

"Let me try," she said. "Maybe they will."

In December 1976, George Hurrell's publisher announced a second printing, and the artist tried shooting another large-format portrait, this time of Tere Tereba, a designer friend of Paul Morrissey's. The old workhorse

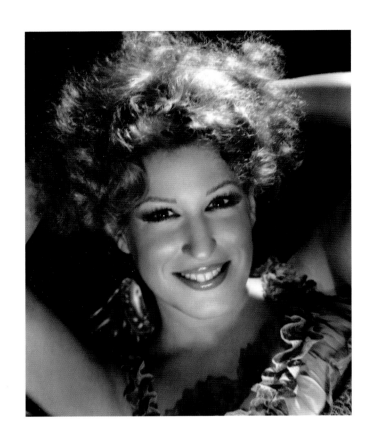

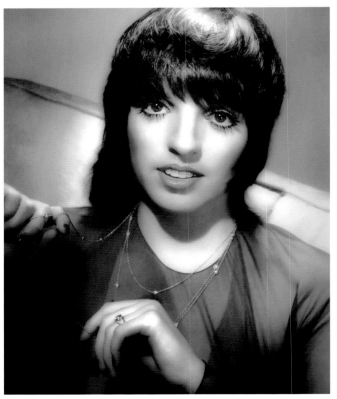

was happy to be under the black cloth again. Marysa Maslansky began to find assignments for him. At first they were on speculation, and then they were well paid. Nineteen seventy-seven dawned bright and prosperous for Hurrell.

The Hurrell Style was earning a tremendous amount of press, and Marysa Maslansky let Hurrell use her home for shooting sessions. The first art director to hire the well-publicized old artist was Lloyd Ziff of *New West Magazine*. Hurrell shot an editorial spread that included John Dean and Bianca Jagger. Everyone in Los Angeles saw the issue and Maslansky's phone began to ring. In short order, Hurrell shot Morgan Fairchild, Joan Rivers, Tom Waits, and Liza Minnelli.

In May, Hurrell finally signed a contract with Paul Morrissey, Peter Beard, Harry Horn, and John Kobal. The contract specified that he print a variety of portfolios, each containing twenty prints. The contract did not specify how many portfolios he was to print, what they would contain, how much they would sell for, or how they would be sold. It made Hurrell and Kobal dependent on the marketing skills of the "Photo Publishing Company," which comprised Morrissey, Beard, and Horn. The company was contracted to pay Hurrell and Kobal each 25 percent of the gross, minus costs or one-sixth of the gross, if greater.

Hurrell was ready to roll, except for two minor problems. First, Los Angeles was in the midst of a drought. The water shortage was imposing use restrictions, a hindrance to an archival printer. Second, when he went to buy photographic paper (Agfa Portriga Rapid PRW 118), all the stores were sold out. Black-and-white

photography, especially on fiber-base paper, was in eclipse. Companies like Agfa were slowing production of their black-and-white product. Hurrell ordered Agfa paper with the company's money and then did what he liked least. He waited.

In the months since he had gotten the negatives from Kobal, he had been working in Tom Kelley's lab on Seward Street and had made an impressive set of Joan Crawford prints. I was used to looking at soft, silvery vintage prints at the homes of collectors. I had found the show of large prints at Barnsdall Park imposing, but felt that the printer's use of Kodak Mural R paper had made most of the enlargements too contrasty. Nineteen-thirties studio negatives were routinely processed in a three-step developer called Pyro. The resulting density was usually contrasty, dictating the use of a low-contrast paper. Kodak Mural R, the paper used at the Barnsdall Park exhibit, was only manufactured in one contrast grade, "Normal"; hence, the contrasty look.

Not until I saw the set of twenty-five Crawford prints did I realize the extent of George Hurrell's mastery. The images were unseen poses from the greatest sittings: *Possessed*, *Letty Lynton*, *Chained*. The prints were 11x14 images floating on 16x20-inch paper, the so-called "gallery matte" cropping. These were better than anything I had seen in his book, better than any print in the show. They were even better than the vintage prints from the 1930s. They were the best prints he had ever done (or ever would do). They were alive. Joan Crawford looked as if she was about to speak.

On May 10, 1977, Hurrell's favorite subject died. On May 20, Hurrell wrote to John Kobal: "It was sad indeed to hear that Joan Crawford is gone. She passed away in her sleep, so the dear girl did not suffer, altho [sic] her desperate loneliness in recent years was suffering enough. Right to the bloody end, she maintained that 'STAR' image, which is more than the others have done. God Bless Her."

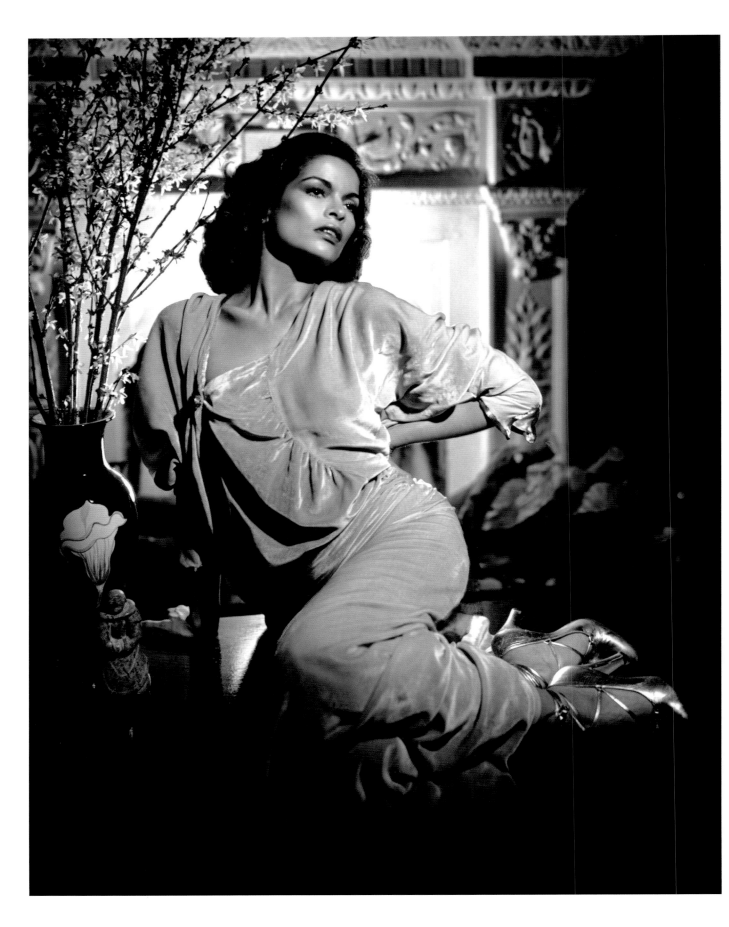

THE BIG HURT

By mid-1977, Paul Morrissey had sent Hurrell $5,000 to cover expenses, and, despite the shortage of utilities and supplies, the printing was coming along. There was no shortage of energy. At seventy-three, George Hurrell was still capable of making thirty custom prints a day, a healthy total for a lab tech half his age. Some days John Kobal worked with him, moving prints from tray to tray so that Hurrell could build up speed at the enlarger. Working for long hours in close quarters should have created a bond between the two men. Perhaps Kobal believed it had. Perhaps he began thinking of himself as a creative director. He began to suggest ways to improve each image. Hurrell did not always agree.

One day Hurrell was cropping an image. Kobal thought it looked better without cropping, so as to show an ostentatiously decorative pedestal. "It's supposed to be a picture of Joan, not of a pedestal," barked Hurrell from the enlarger. Kobal deferred to Hurrell's judgment this time, but just as often, Kobal would offer some insight that had never occurred to the man who had originally created the image. Hurrell would agree, and a collaborative interpretation would result. "They never really became friends," said David Del Valle. "George tolerated him." George Hurrell Jr. was more frank, saying, "My dad never liked Kobal at all."

When they were not printing, the two men busied themselves with separate exhibitions. Kobal opened *The Golden Dream* in Holland and then *Hurrell and the Hollywood*

Photographers at the Chicago Museum of Science and Technology. Hurrell returned to Laguna Beach in triumph, where the Laguna Art Museum was helping him promote *The Hurrell Style* with a show of his early work. The promotion included a limousine, a motorcycle escort, searchlights, and a black-tie celebrity banquet. Fifty years after he had left the art colony, Hurrell was remembered. His book continued to sell, and he was in demand.

He wrote to Kobal on October 3 from Bermuda, where he was a guest speaker on a Cunard cruise ship. He was happy to report that his latest portrait commissions were Lockheed executives and that the Agfa Portriga Rapid PRW 118 was finally arriving. Once back in Los Angeles, he resumed printing, as well as shooting and giving interviews, but his letters to Kobal evinced a concern with Paul Morrissey's long silence. What was happening with their marketing plan?

Kobal was now moving full speed on a book that would showcase all the Hollywood portraitists. He was interviewing, among others, the witty, acerbic Laszlo Willinger, and the modest, well-spoken Ted Allan. Both of them had succeeded Hurrell at M-G-M in the '30s. He was also interviewing eighty-year-old Clarence Sinclair Bull, the dean of them

OPPOSITE: David Bowie sat for a portrait by George Hurrell.

LEFT: In 1977 Hurrell and Whitney Stine were traveling to book signings.

OPPOSITE: Hurrell painted with words as well as light when he photographed Harlow, transporting her to another place and eliciting erotic expressions. In this sitting Harlow's skin looks different because she insisted on wearing a makeup base. She and Norma Shearer were the only stars to whom Hurrell made this concession.

all, and Hurrell's one-time boss. I was fortunate enough to visit Bull several times. He was wizened, wise, and patient. When asked about Hurrell, he replied, "George was a good photographer, but he always used that same light."

When Kobal wanted to check quotations and compare facts, he wrote Hurrell. In a letter dated January 3, 1978, Hurrell set him straight: "I am not free to give away my secrets on lighting, etc. from now on. Your book will have to depend on whatever information you have." Kobal was startled. What was wrong with George? Then, without warning, Hurrell stopped printing.

On Sunday, February 12, Paul Morrissey went to see him. "Look, I don't want to do this anymore," said Hurrell. "Why don't you take whatever I have and let's quit." Morrissey asked why. "Well, I don't think I'm going to see a lot of money out of this. It might take too long." Morrissey took the prints and notified Kobal.

"I regret that my health and my age is catching up with me," Hurrell wrote Kobal. "At 74, I don't have time to waste. I would like this matter to end in a friendly fashion and I'm sure you will too. I deeply regret this turn of events." He felt that since the company had gotten nine sets of twelve prints each from him, he could bow out of all financial interest. "The garage roof sprang a dozen leaks during this past

recent rain storm we have had," he continued, "so the garage has been unworkable. With me and everything else breaking down, the best thing to do is salvage what we can from this experience." Kobal turned the salvage work over to a new manager, Simon Crocker. "It was pretty unsalvageable," recalled Crocker. "Basically, John and George were delivering their part of the bargain. Paul and Harry and Peter had never really gotten their end together. It was dragging on and it was hard work for George to make these prints. He was an old man. He'd signed an agreement in good faith, and they weren't really delivering."

But Morrissey and his partners could not deliver. They were learning what Marysa Maslansky had already learned. "I took George's work to the G. Ray Hawkins Gallery, this man who handled fine art photographs," recalled Maslansky. "He looked at the photographs and laughed me out the door."

Hawkins had opened his gallery at 9002 Melrose Avenue in February 1975. Interspersed with prints by Steichen, Stieglitz, and Adams were a few Hurrells and Bulls, priced at $75. "I haven't sold one," Hawkins told Morrissey. Wherever Morrissey took Hurrell's prints, he heard the same thing: "Hollywood glossies are not fine art photographs."

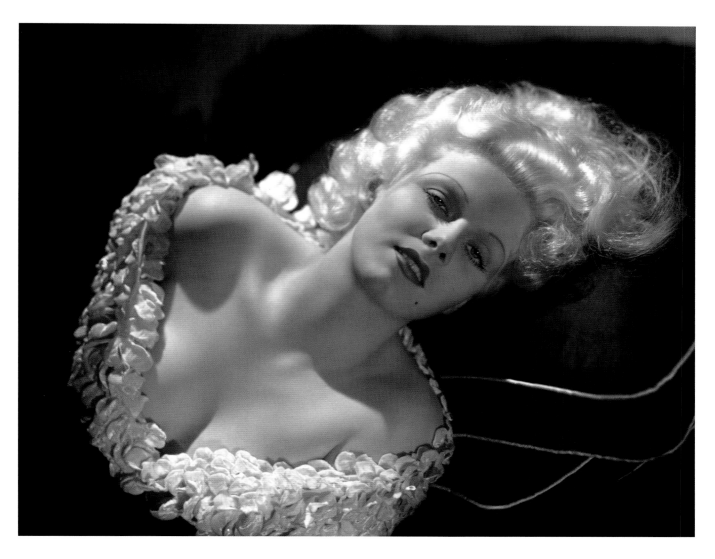

On February 25, Kobal wrote Morrissey, telling him to reason with Hurrell and to remind him of all the work and money he (Kobal) had expended to get the project rolling and line up exhibitions in Chicago and Paris. "The book he did with Whitney Stine came about as a result of the interest I had started to create with my exhibitions," said Kobal, "and not the other way around. Paul, I don't begrudge him the deals he can make on the side with the Laguna Art Museum or whomever—but it isn't fair that those who come along as a result of the hard work I have done should benefit while I lose. Talk to him, but don't pressure him. He's a decent man."

Morrissey spoke with Hurrell; he would not change his mind. Kobal and Simon Crocker came to Los Angeles, first

stopping to show more prints to G. Ray Hawkins. "No one in this town is interested in these kinds of things," Hawkins told them. "The studios have been giving them away for years. There is never going to be a market for this stuff."

Kobal and Morrissey then met with Hurrell, who proceeded to drop a bombshell. "Well, I've been offered a whole bunch of money by this other group," he said coldly. "They'll print my negs somewhere and all I have to do is sign them. They say it's going to bring in hundreds of thousands of dollars."

Kobal was at first stunned, then outraged. "He admired George so much that he bit his tongue and kept quiet," recalled Crocker. "He held himself in at a time when he would have lost it with anyone else. He knew George was

behaving like a cantankerous old bastard. But George was a great artist."

"We didn't make an issue of it," said Morrissey. "I said, 'If you want to do that, George, it's perfectly okay. Do whatever you have to do.' We couldn't have been friendlier about the whole thing. George gave John back his negs." At least they thought he had.

In actuality, Hurrell kept more than a few, including the *Love Is News* neg of Loretta Young and Tyrone Power. In addition, he had shot a copy negative of every new print he had made from a Kobal negative. He had also made a copy neg of the Garbo-Barrymore profile-to-profile *Grand Hotel* print he had gotten from me. He turned these negatives over to his mysterious new partners and continued shooting celebrities.

After eight years of cultivating Hurrell, John Kobal had been dumped. He went back to his book, angry and betrayed. "John basically felt that he got fucked by both

sides," said Crocker. "He didn't get paid by his partners, and he got blamed by George. He felt for George, because Paul, Harry, and Peter had really not come through. And John had been in the trenches with George. And he thought George was being really unfair. Now John was no saint. He could be pretty bloody difficult and sail close to the wind, but in this instance, he played fair. And he was hurt." A bigger hurt was on the way.

In 1978, while still employed as a staff photographer at USC Dental School, I was securing portrait commissions of my own. One of them was a glamour portrait of actor Susan Tyrrell. As was customary, I delivered the proofs not to her, but to her manager, Carl Parsons, who also managed Lainie Kazan. "You know George Hurrell, of course," said Parsons.

"Yes, I do."

"Then you must have heard that some friends of mine are getting him on the right track. You know Allan Rich, don't you? No? It's a much better arrangement than George had with Kobal and those others." I was obviously (and happily) ignorant of what was becoming a messy business.

As it transpired, Hurrell's new partners had met with Kobal and Crocker. "They were trying to buy original negs from us," said Crocker. "John refused. They became nasty, saying that they knew guys who fitted one-arm bandits, and if Hurrell got upset, these guys would get upset. And they couldn't be responsible for the consequences. John, being John, walked out. After we were out of there and standing at the elevator, John turned to me and said: 'Goddamn it! They were threatening us, weren't they?!'" Kobal put away the Hurrell prints and began to work on a Clarence Bull portfolio. Hurrell ingratiated himself with his new partners.

Allan Rich was a New York actor who was blacklisted and then became a Wall Street broker, then an art dealer, and finally an actor again. A bit part in the 1973 film *Serpico* led him to agent John Crosby at ICM. "Mr. Crosby, I can do anything that Lionel Barrymore could do, anything Eddie Robinson could do, in fact anything Jack Barrymore could do. Do you think you could get me a job?" Crosby sent him

ABOVE: A Hurrell portrait of Neil Diamond.

to Jeffrey Fisher, a casting director on the TV show *Baretta*. Fisher asked him what he'd been doing all these years. "I've been living the parts you want me to play."

In 1979, Rich was playing an art dealer. The Allan Rich Gallery at 787 Madison Avenue had done well with artists such as Miró, Calder, and the flamboyant Salvador Dalí, possibly because of Rich's show biz bent. Rich laced his pitch with an overripe huckstering. With a narrowed eye and a rasping growl, he almost dared a customer not to buy. When someone brought him a portfolio of George Hurrell prints, Rich roared, "This man is a genius!" He pointed out the influence of Vermeer and Rembrandt on Hurrell's lighting and opined that Hurrell must have been a painter as well as a photographer. A meeting was arranged. He and Hurrell hit it off. Then he asked Hurrell what he could do about securing enough images for a show and a portfolio.

Hurrell told him not to worry about that. He had found new images of Hepburn, Gable, and others. What he did not tell Allan Rich was that only some of them were Kobal negs; others were "killed" poses; i.e., shots rejected by the star, the studio, or the photographer. These killed negatives had lain unseen in Hurrell's garage until the summer of 1975. He had been desperate for prints to show Whitney Stine and potential publishers. He had grabbed the best of the "kills," sat down at a small light box, and done just enough retouching to make the killed shots look like the famous, fully retouched poses from the same sittings. (Of course, he did not have to do this to copy negatives such as the one of my print from *Grand Hotel*; they had already been retouched.)

Presenting partially retouched kills as fully retouched original negatives was perhaps the artist's prerogative. On the other hand, presenting copy negatives as originals was unethical. He must have known that. He must also have known that certain images were not his. He must have known that he had not shot Greta Garbo on the set of *Grand Hotel*. But then, maybe he had. Maybe Kobal was talking through his hat.

My curiosity was piqued, so I did some research at the USC library. By perusing the trade magazine *International Photographer*, I determined that the event Kobal had cited was apocryphal. There was no camera strike in late January 1932; it was more than a year later. But, as it turned out, he

was right. In another magazine, I found a credit. Fred Archer had made the famous profile-to-profile pose—not George Hurrell. And why? Because Hurrell had made such a bad impression on Garbo during the *Romance* sitting in April 1930 that she stipulated he never photograph her again.

Nevertheless, Hurrell presented this copy negative, and several others, as his own unseen work. Years later, I was able to print other negatives from this same sitting. On the edge of the negatives, sure enough, was the M-G-M lab imprint of January 27, 1932. This proves that Hurrell could not have shot it. He insisted on processing his negs outside the M-G-M lab, thus his negs never had dates on them. Of course, there's one more item of proof: the lighting of the profile-to-profile shot is distinctly unlike the other shots he did for *Grand Hotel* and distinctly un-Hurrell—no boom light or bounce light.

Allan Rich may not have been able to differentiate between levels of Hurrell achievement or authenticate credit, but he knew genius when he saw it. And he was shrewd. He knew about Hurrell's book, knew the art market, and saw the potential of a smaller portfolio. He went after Hurrell, who at first played hard to get.

In May 1979 Marysa Maslansky was in the hospital, having her second son. "When I came home," she recalled, "I found out that George had signed with Allan Rich. He had never even consulted me." Rich sat down with Hurrell and they chose ten negatives. Hurrell got to work on the scaled-down portfolio, with help from Knight Harris at Producers Photo Lab. "He oversaw every print and okayed each one before he signed it," said Rich. "Out of 5,000 prints, there were maybe five where the washing wasn't exactly correct. He did a wonderful job."

Then the new company, Creative Art Images (CAI), did what is called a "buyout." Rich and his partners, Ron Davis and Irv Resnikoff, paid Hurrell $180,000 for the ten negatives in the first portfolio. These negatives were then "retired"; i.e., they were put into a vault, never again to be printed. In this way, the portfolio was guaranteed to be a limited edition. Its wholesale price was set at $1,500, and retail at $7,500. Rich then marshaled resources in three areas: public relations, art galleries, and the film community. He had thirty years of connections in each.

RIGHT: George Hurrell did not make this famous photograph of Greta Garbo and John Barrymore on the set of *Grand Hotel*, yet he planned it for his first art publishing venture.

When he rented a print of it from me in early 1976, John Kobal warned me that Hurrell had not really taken this picture. It sounded implausible. Would a photographer forget what he had shot? Years of detective work followed. In the meantime, Hurrell included the image in his first portfolio, claiming authorship.

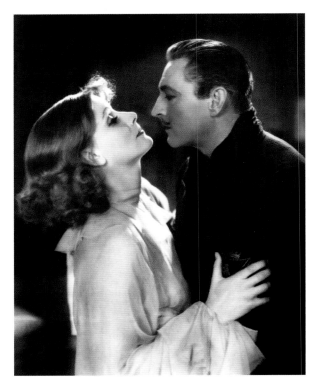

The Hurrell portfolio image

First, he found an aggressive public relations firm, the Irvin Atkins Agency. With them, he designed a combination of tirage and press kit. Then he did a mass mailing, and began to call in old favors.

On July 27, 1979, George Christy, the influential *Hollywood Reporter* columnist, devoted his entire "Great Life" column to Hurrell and the portfolio venture. The column began with a flourish: "When *Vogue* photographer Richard Avedon met George Hurrell, he fell to his knees in obeisance and whispered Hurrell's name with ecclesiastical reverence." Allan Rich also had a quotation in Christy's column: "I feel like Ambroise Vollard when he discovered Renoir." Said Christy: "I'm not somebody to toot my own horn, but I do think I wrote the first major piece about George. I'd like to think that I was somewhat instrumental in his revival."

In the summer of 1979, John Kobal was in hot pursuit. He was working with Clarence Bull to print portfolios of that artist's work. Progress was slow but steady; Bull was 83 and frail. Time was running out, so Kobal took a

portfolio of ten prints to gallery owner Edward Weston [no relation to the photographer Edward Weston]. Weston did not laugh. He admitted the possibility of marketing Bull. Kobal promised to deliver 100 portfolios. Weston agreed to wait. Kobal returned to London, leaving Paul Morrissey to have the prints completed and signed by Bull. Suddenly, in September, Clarence Bull died. Morrissey called Kobal with the sad news. There was a pause, and then Kobal asked, "Did he finish signing the prints?"

Allan Rich, meanwhile, had recruited photographer Helmut Newton for his media barrage. In December 1979, Newton wrote this ode on Beverly Hills Hotel stationery: "I vividly remember, as a young photographer in the early Forties, discovering the portraits of George Hurrell in the pages of *Esquire*... women and men of such beauty and perfection, the likes of which I had never seen before in any photograph. How were they done, I asked myself, these stunning pictures of gorgeous women posed on white satin and polar bear rugs? I discovered for the first time the word *glamour*."

RIGHT: To prove that Hurrell had shot the picture, it would be necessary to see that the edge of the negative was blank. Because Hurrell refused to let the M-G-M lab process his film, his negatives were not flashed (per that lab's practice) with the identifying data of date, film, exposure number, and photographer. Thus, if he had shot the picture, the edge of the negative would be blank.

When I finally tracked down a vintage proof print showing the edge, it was not blank. This shows that the edge of the film was exposed on January 27, 1932, for production number 603 (*Grand Hotel*), exposure 1,682—in other words, someone other than Hurrell shot it.

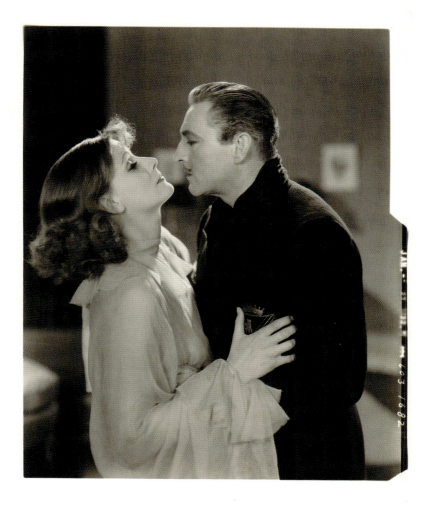

The original negative

The edge of the negative

Allan Rich's style was arrant, but it worked. By the end of 1979, everyone in Los Angeles wanted to see these vaunted portfolios, and everyone wanted to know where to buy them. The hurdle that had stopped Morrissey and Maslansky was the fine art gallery. It did not stop Allan Rich. He went to G. Ray Hawkins and pitched his marketing plan. After four years of saying no, Hawkins relented. He agreed to give Hurrell a one-man show in June 1980.

What changed his mind? "When Allan Rich approached me and explained his pricing and marketing strategy," said Hawkins, "I thought it really made sense. Of course, his theatrical hype was a problem at certain levels of the art world, but his concept was brilliant. He was applying the principles of marketing limited edition lithographic prints to fine art photography. This was something that no one had ever thought of before."

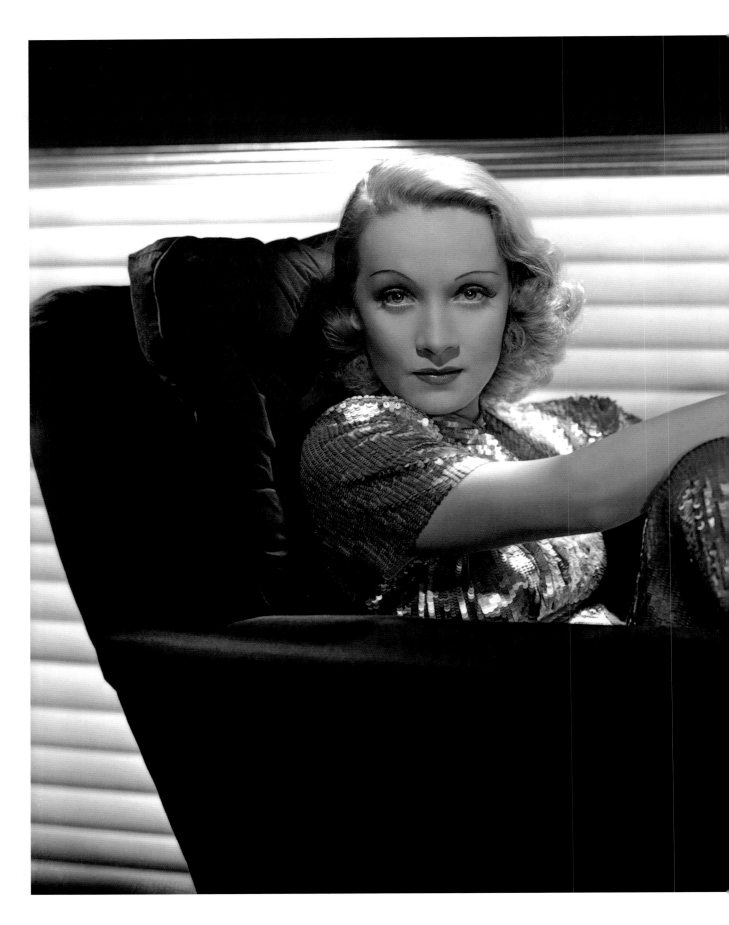

THE MILESTONE

Allan Rich was never content to rest on his laurels—or wait for them. In early 1980 he rushed George Hurrell to Chicago, Tulsa, San Francisco, and Palm Springs, showing prints, arranging interviews and press conferences. Anxious for media, he risked his Hawkins show by having Sotheby Parke Bernet prematurely auction one of the portfolio prints, an image of Marlene Dietrich. The image was printed from a fully retouched original camera negative. Fortunately, Rich chose to make Hurrell's first splash with the genuine article, not a hastily retouched killed shot. The Dietrich image was judiciously chosen and perfectly printed. The print fetched a surprising $1,100, and his June date was not jeopardized; in fact, it was given a boost. Early interest led to an auction at Christie's in May. Dietrich sold for $1,300 and Gable for $1,100.

Interest continued to build, but the G. Ray Hawkins Gallery would be the test. How would Hollywood portraits fare in such a setting? Realizing the potential of this show (and wanting more money), Hurrell insisted that Creative Art Images buy vintage prints from him and include them in the show. Rich agreed, and he paid Hurrell an additional $30,000. And so Hurrell sold 230 precious, irreplaceable vintage prints—for a paltry $130 apiece. They joined the

LEFT: Marlene Dietrich was the first image in the 1980 Hurrell portfolio to get attention.

Portfolio I

Jean Harlow, 1934 Joan Crawford, 1932 Gary Cooper, 1937 Marlene Dietrich, ca. 1938 Greta Garbo and John Barrymore, 1933 Bette Davis, 1938 Rita Hayworth, 1941 Katherine Hepburn, 1941 Clark Gable, 1932 Loretta Young and Tyrone Power, 1937

Portfolio II

Greta Garbo, 1930 Ramon Novarro, 1931 Douglas Fairbanks, 1933 Jane Russell, 1946 Robert Taylor, 1936 Dorothy Lamour, ca. 1936 Johnny Weissmuller, 1932 Hedy Lamarr, 1938

Portfolio III

Anna May Wong, 1938 Charles Boyer, 1938 Joan Crawford, 1932 Jascha Heifetz, ca. 1937 Ann Sheridan, 1939 Gilbert Roland, 1939 James Cagney, ca. 1938 John Barrymore, 1933 Veronica Lake, 1941 Gene Tierney, 1944

The Double Portfolio

Humphrey Bogart, ca. 1937 Marlene Dietrich, ca. 1938

ten newly struck "modern prints" in the gallery on Melrose Avenue. This was one decision that Hurrell would have reason to regret.

While the show was being readied, Hurrell shot portraits, many of which Allan Rich arranged. Rich did not ask for a commission when he sent him Sylvia Kristel, star of Just Jaeckin's *Emmanuelle*. Hurrell charged her $1,500. "He made her look so damned vulnerable," said Rich. "Sylvia! Now who else could have done that?" The 1980s were here, and the glittered shellac of the previous decade was flaking. Hurrell could expect more clients who wanted to escape their strobe-lit pasts. Rich knew everyone and loved to refer, but there was a possible conflict of interest; after all, he represented Hurrell as an artist, not as a photographer.

On June 5 Hurrell wrote to Rich about Sylvia Kristel. "You will receive 25% of the fee. This goes for the future,

too—so there. We can't have you working your ass off for nothing—and NO ONE but Betty (our bookkeeping brains) will ever know." One can only speculate what Marysa Maslansky would have thought of this gesture.

On June 14, 1980, the G. Ray Hawkins Gallery became the first art gallery in America to exhibit a Hollywood portrait photographer in a one-man show. Just two weeks after his seventy-sixth birthday, George Hurrell became an art world milestone.

Interviewed by Hawkins's assistant, David Fahey, Hurrell said, "You don't make a star on the strength of a

ABOVE: Art dealer Allan Rich entered George Hurrell's orbit with a novel proposition. Why not sell photographs in limited edition portfolios, as if they were lithographs?

OPPOSITE: Hurrell made this portrait of Jean Harlow in her living room on October 19, 1934, for *Vanity Fair*.

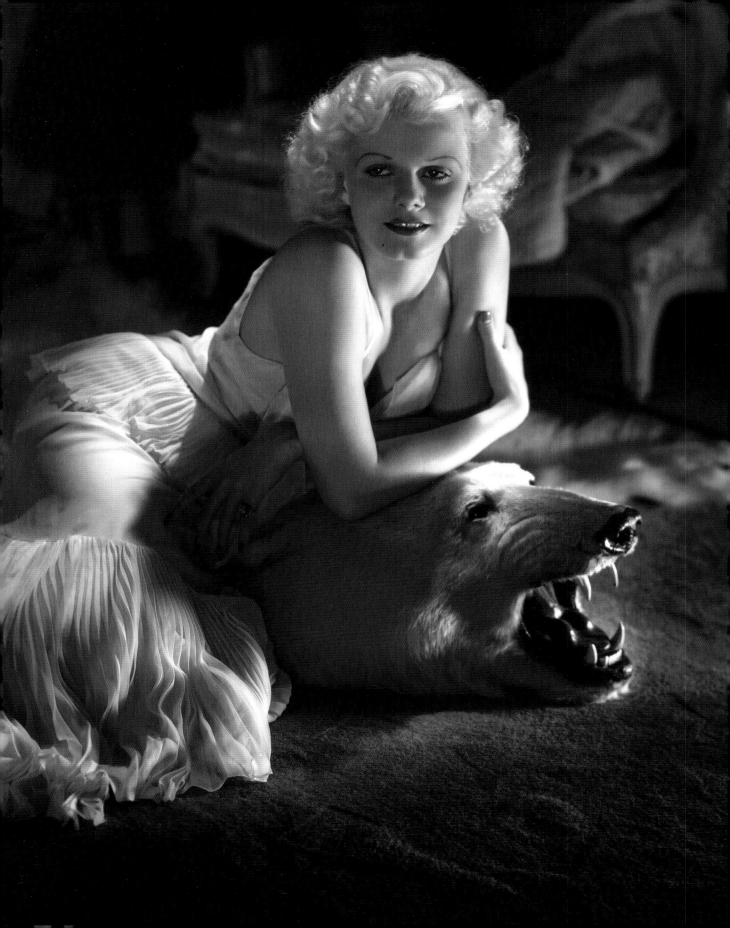

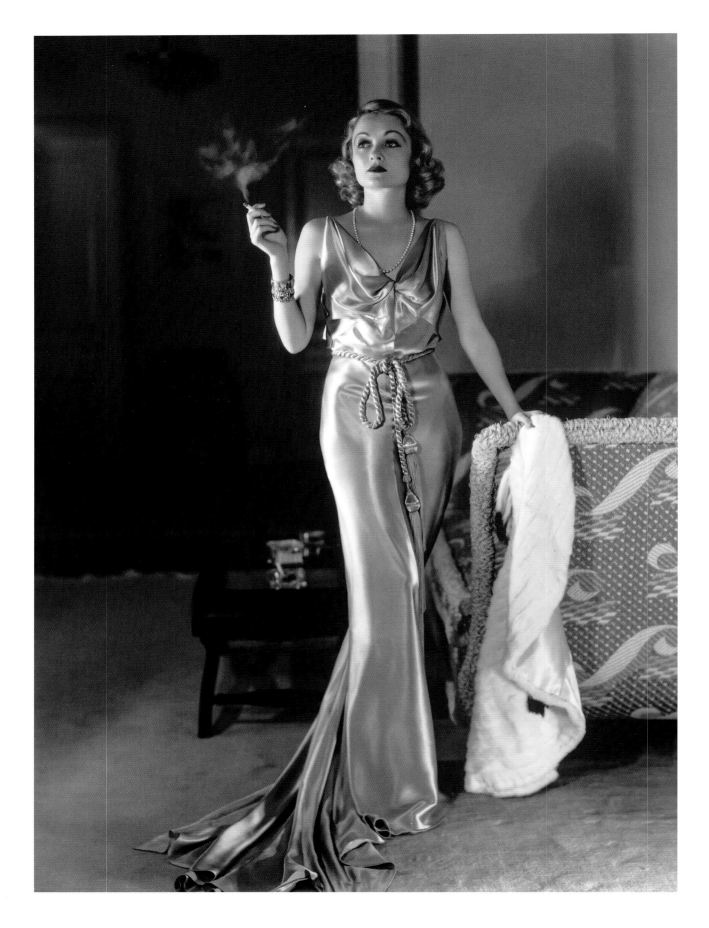

photograph." The photographs on the gallery walls might not agree. Each of them was playing its part in Hurrell's stardom. But were they art? "With every kind of photography," said Fahey, "there is a time when it starts to transcend its original function, whether commercial, utilitarian, or journalistic, and it becomes art, collected by museums and sold at galleries. If Arnold Newman and Alfred Eisenstaedt had been based in Los Angeles, their subject matter would have been Hollywood. They weren't more important than Hurrell because they photographed East Coast personalities and not movie stars."

In late June, my USC collector friend and I visited the Hawkins Gallery, curious to see what Hurrell treasures were being offered. I knew about the show, not from Hurrell, but from a flyer at the rental darkroom in Los Feliz where I was making prints for clients. I had cut the USC umbilical in October 1979 and gotten a job as unit still photographer on a Sylvia Kristel film, Alan Myerson's *Private Lessons*. I learned my lesson; I never shot stills on a movie again. And Sylvia was not vulnerable. She asked me how I got so many ugly people to pose for my portfolio.

As I looked at the juxtaposition of vintage prints and modern prints, I wondered what John Kobal would think of this show. An eager gallery employee tried to sell the portfolio to my friend and me. We counted the number of prints that were either kills or copies. There were four out of ten: Clark Gable was a killed negative from the *Dancing Lady* sitting; Katharine Hepburn, Joan Crawford from *Chained*, and the *Grand Hotel* profile shot were copy negs. My friend withheld his opinion until he was safely out of earshot, ambling down Melrose Avenue. "Most people sell out when they're young and they have to," he sneered. "Why would Hurrell sell out at his age? That portfolio is shameful!"

John Kobal was catching up. In December 1980, *Hollywood Portrait Photographers*, a show of 112 prints, opened at the Museum of Modern Art in New York. Not coincidentally, Alfred Knopf was publishing Kobal's new book, *The Art of the Great Hollywood Portrait Photographers*. "Why did he have to say 'great' Hollywood photographers?" Paul Morrissey asked.

"The title didn't need that. But that was John. Gilding the lily." The opening was attended by many of the artists being exhibited. Ted Allan, who had replaced Hurrell as Kobal's printing partner, was there, as well as Laszlo Willinger, who customarily refused Kobal's printing advice. Hurrell was also there, and he pointedly snubbed Kobal. A few days later, Kobal received a note. "My wife Betty balled [sic] me out," wrote Hurrell. "She said I was not very circumspect in greeting you at the exhibit. Please accept my apology. Your book is great, the VERY BEST that's been done on Hollywood." The show was as impressive as the book, a testament to Kobal's taste and industry. Its only flaw was its location, in the museum basement, in a hallway leading to the restrooms.

Within months, Hurrell was counting receipts from two auctions and five shows. He was shooting regularly and was a guest on talk shows hosted by Dinah Shore and Rona Barrett. December 5 was "George Hurrell Day" in Manhattan, followed by an interview with—who else—*Interview*. Crawford and Gable were gone. Garbo and Dietrich were hiding. George Hurrell was everywhere. And, if he could not literally be everywhere, there was the near-ubiquitous Rich. In a letter to Rich dated September 30, 1980, Hurrell wrote: "I am relying on you to pass judgment [for authenticity] on any prints that turn up in the marketplace." Hurrell was concerned that unauthorized prints of his work (from Kobal's negs, for example) could diminish the value of the CAI portfolios. Yet this begs the obvious question. If Rich could not see the inconsistency in Hurrell's portfolio, how could he see it elsewhere? Hurrell was not worrying about that.

One day in 1980, I gathered my courage and called the master, excited about an original negative of Norma Shearer that had fallen into my hands. I thought he might like to print it. He heard my voice and immediately assumed that I was trying to inflate its value through my connection with him. "If you want me to sign any print you make from it," he said, "that'll cost you $250."

OPPOSITE: This 1937 portrait of Constance Bennett was one of the vintage prints included in the Hawkins show.

THE ART OF THE GREAT HOLLYWOOD PORTRAIT PHOTOGRAPHERS

JOHN KOBAL

LEFT: John Kobal continued to work on behalf of the art idiom that he had discovered, named, researched, and publicized.

OPPOSITE: Hurrell made this portrait of Jascha Heifetz at Warner Bros. in 1939. It was included in his portfolio series.

I said thanks, but no thanks, and hung up, stung and deflated. My only concern was that he should be printing his portfolios from original negs, not from kills or dupes. I wondered if I was the only person who saw this—and thought it fraudulent. Years later, I broached the subject to Rich; he flatly denied it. "I made him put in writing that these were original negs," he said. "Had he given me dupes, I could have sued him. And that I would have done."

I asked David Fahey about the issue of an artist's printing copy negatives instead of originals. "There are instances where original negatives are scratched, damaged, or lost," he replied. "Then it's entirely the artist's prerogative to make a copy negative from an existing print and to make prints from it and call them original prints. There's

nothing that says that a picture is more important because it's from the original negative. That's an implied perception. If George, as the ultimate deciding figure, says, 'This print from my copy negative is as good as any print I would make,' one can only take it as truth."

Implied perception? Truth? Didn't Ansel Adams say, "All truth is in the negative"? To anyone in the art world—to an untrained eye—a side-by-side comparison of: a) a Hurrell print made from an original negative and b) a print made from a copy negative, would silence this sophistry of truth and prerogatives. There is no comparison between the two—unless you want to sell portfolios.

His "Portfolio I" contained a killed negative of Clark Gable. It was indeed Hurrell's work, and it was an original camera negative. But it had been hastily retouched and

then printed by a hired lab tech with an excess of diffusion. The Crawford copy neg had been shot from a print made from the original neg lent by Kobal. It is easy to tell an original Hollywood negative from a copy negative: the original has retouching on its emulsion side, but a copy does not. All the pretty gallery lighting in the world could not improve the contrast in these prints. They were dupes and they looked like dupes.

Representing dupes as products of his studio-era oeuvre, in the same caliber as his pristine prints of Jean Harlow on the polar bear rug or Marlene Dietrich, was a betrayal of Hurrell's art. Representing the profile-to-profile shot of Garbo and Barrymore as his own work was worse than that. A scandal had sent Hurrell plummeting before. And art fraud was the stuff of scandal. To paraphrase Rich: I

could have exposed Hurrell. But that I would not do. I was awestruck, and I still hoped to work with him.

Hurrell sailed into 1981 with a flush that rivaled his 1930s success. Revved up to an unnatural speed, the veteran photographer went to Paris and labored on an entire issue for French *Vogue*, came back and shot album covers for Melissa Manchester and Chevy Chase, and glamour portraits for Frank Perry's ill-fated attempt at Crawford-bashing, *Mommie Dearest*. In a temporary rapprochement (effected by a check in the mail), Hurrell wrote Kobal. "I am back in harness," wrote Hurrell, "shooting big film again. Everything in Paris was 8x10, thirty pages done in a week's time, working night and day. I must be healthier than my doctors claim because I came through it all without any problems at all, altho [sic] the equipment is a little

heavy for the old horse." His earnings helped Marysa Maslansky leave Sygma and open her own Sunset Strip photo agency, Visages.

In 1981 Hurrell's face grinned from the pages of *Petersen's PhotoGraphic*, *Los Angeles*, *Us*, the *Los Angeles Times*, and *Life*. Allan Rich began hawking Portfolio II. Unbeknownst to him, Hurrell had created this one entirely from killed poses, even though he could have gotten retouched studio negs of his work from Kobal, me, or a dozen other sources. Meanwhile, Rich approached the Academy of Motion Picture Arts and Sciences, proposing that Hurrell be given a special Academy Award. He was turned down. No matter; the Library of Congress soon added a Hurrell portfolio to its permanent collection of photographs. There was a flurry of publicity. Hurrell had crossed a new threshold. The man who had spent his life creating celebrities was himself a celebrity, insulated from the vicissitudes that had spoiled his middle age. Had he outgrown his impatience and restlessness?

"'Familiarity breeds contempt' has always been one of my pet theories," he told Fahey. Rich smelled something brewing. "I've dealt with a lot of great artists," he said. "They all have difficulty with commercial people. They're frightened of being taken advantage of." Hurrell had no reason to worry about that. He was on top of the Hollywood heap, famous and unassailable. Only his own demons could unseat him. When a forgotten print lifted him to the summit of the art world, they almost did.

———————————

At the bottom of the Hollywood heap, at the neglected intersection of Las Palmas and Yucca, Bill Chapman was doing business as Chapman's Picture Palace, a modest movie-still emporium. At age fifty-five, he was still ferreting out Hurrells. The gallery madness spawned by Rich and Kobal affected him, as it affected all the collectors. It made his collection more precious; it made adding to it more expensive. Like the poster collectors, he was more apt to trade than to buy. Every so often he found a bargain—a Hurrell portrait of an obscure starlet. More often, though,

he was importuned by some hard-up collector wanting to sell him prints at inflated prices. It was tough being a collector.

Myron Braum, once the hub of the still collector scene, had decamped to San Diego. His last few months in Los Angeles were spent liquidating his collection of costume stills, since he was loath to haul six file cabinets down Interstate 5. He did not drive and besides, he had a new obsession: antique fashion prints cut from the pages of an 1840s fashion magazine called *Godey's Lady's Book*. I knew collectors were unpredictable, but this shocked me.

I was talking to Bill Chapman about it in his store one day in the summer of 1980 when he showed me his latest acquisitions. Simone Simon fashion shots did not do much for me; they had not done much for Hurrell when he shot them. Then Chapman pulled some 11x14 glossy prints out of an envelope. I caught my breath. My pupils dilated. I was looking at a complete selection of poses from Hurrell's 1929 sessions with Ramon Novarro, the work that led an unknown painter to the gates of Hollywood. I had heard about it, read about it, but because Hurrell had neither prints nor negatives from it, I had never seen it. No one had. Yet here it was, in a tiny shop in the Hollywood ghetto. "Where did you get these?!" I asked.

"Oh, I bought them from Eastman House," Chapman answered offhandedly. "They're selling off some of their duplicate Hurrells, you know, of lesser people."

I was sorry to hear Novarro described as "lesser," but in truth he was a has-been only five years after posing for these studies. I asked Chapman if I could shoot copy negatives for myself.

"Oh, I don't think so, really. I don't want to have them spread all around. They're valuable, you know."

I knew the images were valuable. I did not know how valuable. Until the spring of 1981, no one did. There was one image among them that I recognized from the walls

OPPOSITE: This 1937 portrait of Gary Cooper was also in the portfolio.

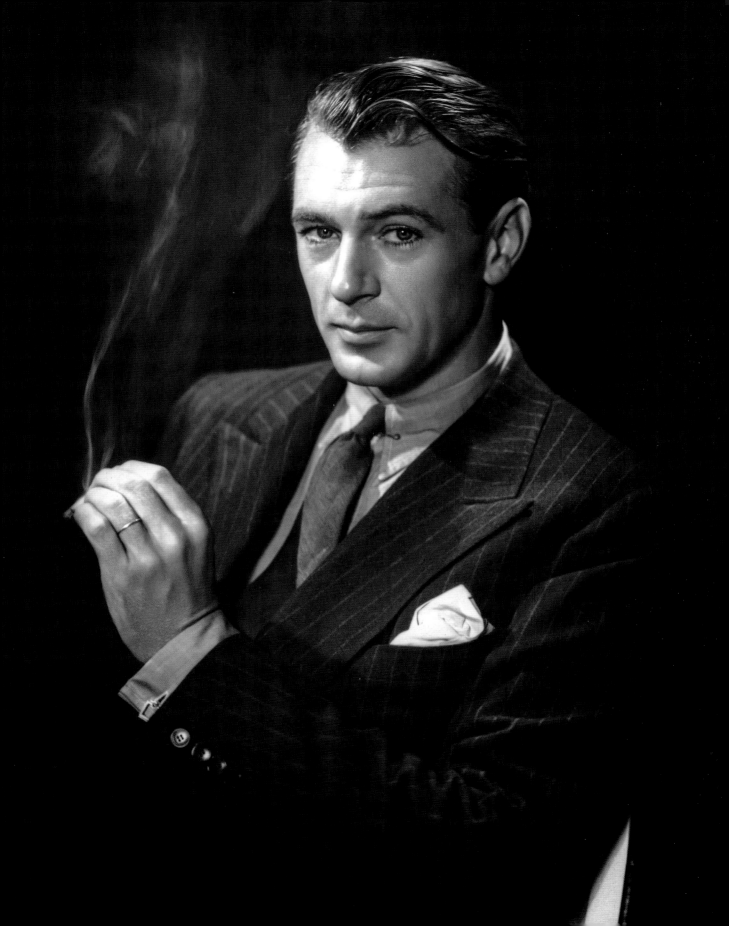

of the Hawkins Gallery. It was "The New Orpheus." But there was something about it that struck me as odd. The print at the gallery was 4½ x 6⅜ inches; Chapman's was an imposing 11x14. Hurrell was shooting 8x10 negatives in his studio on La Fayette Park Place, and he had an 8x10 enlarger. How could he have made a print so small from a large negative? Something did not add up.

The small print in the gallery was one of the 230 vintage prints that Rich had bought from Hurrell for $130 each and then sold to Hawkins. "I didn't really want to sell them to G. Ray," said Rich, "but he kept insisting. I said to my partner, Ron Davis, 'Forget it. Let's put a big, hefty price on them. He'll never bite.' So we put a $1,500 price tag on each of them. He bought six! And then he let one of them go to some anonymous American collector—the little Novarro print." The Hawkins show had indeed been a success. No one seemed to notice that the little print was not an original. As I well knew, Hurrell had used 8x10 film for the Novarro sitting. To make a

print that small, most likely for use in a brochure, he would have had to make a copy negative. This was a dupe masquerading as an original.

In the spring of 1981, this selfsame print of "The New Orpheus" turned up at Christie's East. The *ART Newsletter* reported on June 9: "The most feverish bidding of the Spring Auction was for George Hurrell's portrait of Ramon Novarro, 1930 [sic], 4½ x 6⅜ inches, estimated between $1,800 and $2,200, but was bid up to the astonishing price of $9,000 in a bidding fight among collectors Paul Walter, John Waddell, and Pierre Apraxine of New York, with dealer Keith DeLellis jumping in late in the bidding for a client. Apraxine was the top bidder, setting a record for the photographer and for any Hollywood portrait."

In August, *American Photographer* revealed Apraxine's boss. "The Gilman Paper Company paid a staggering $9,000 for a portrait of actor Ramon Novarro by Hollywood portraitist George Hurrell—an auction record price for a portrait by a living photographer."

OPPOSITE: Hurrell's renewed visibility and the stewardship of agent Marysa Maslansky brought portrait commissions. This is a Hurrell portrait of Fleetwood Mac, made in conjunction with the album *Mirage*.

LEFT: A Hurrell photograph of Chevy Chase.

George Hurrell now had his own category in the art world. Oddly enough, the magazine quoted the director of photographic collections at George Eastman House, Robert Sobieszek, who was apparently unaware that his staff had let a much better print of "The New Orpheus" out the back door a year earlier. "There is no relation at all between the auction price and the absolute value of a piece," said Sobieszek. "Pictures aren't being collected for their aesthetic or historic value as much as on the basis of what they will be worth later."

G. Ray Hawkins saw it differently. "In that photograph," he said, "George Hurrell captured the masculine sensitivity, sexuality, and strength of character of Ramon Novarro. There are moments when the most common of men and women will become heroes. Hurrell captured that moment. At that point, Hurrell could have walked away from his photography, knowing he'd created a masterpiece. But happiness is knowing you can do it a second time."

"And I'm sitting at home one day," said Rich, "and the guy calls me up and says, 'That little Hurrell print brought $9,000! The highest price ever paid for a living photographer!' I tell you, I fell off the chair." But what about Hurrell? "I think that $9,000 sale ruined our relationship," said Rich. "I think it just hit him in the stomach."

It must have stayed there, too, because Hurrell soon grew difficult. While in London, Rich found a beautifully restored view camera. He sent it to Hurrell as a gift. "I don't like it," said Hurrell, and he sent it back. Then he wrote to John Kobal, complaining that "The Boys," as he referred to CAI, were "flirting with postcard entrepreneurs, but I've discouraged it." Even though his new security derived from the efforts of people like Rich and Maslansky, Hurrell begrudged them their managerial imperative. He regarded his prosperity as his own doing. Little by little, he turned suspicious and resentful. The classic Hurrell was returning.

ABOVE, LEFT TO RIGHT: A 1980 portrait of Barry Manilow by Hurrell.

A 1985 portrait of David Byrne.

OPPOSITE: A 1979 portrait of Aretha Franklin by Hurrell. Music stars had become as iconic as film stars, and Hurrell was happy to glamorize them, considering the part that music played in his "camera-side manner."

CHAPTER 8
THE LIVING LEGEND

THE MACHINE

From 1982 through 1984, both Kobal and Hurrell had traveling exhibits, and they were making money. Kobal now had a loft in Greenwich Village, as well as a flat in London's Drayton Gardens. "It was like a movie set that hadn't been struck," recalled David Del Valle. "You know, a couch that could have come from an Anna May Wong movie, a poster of Cocteau's *La Belle et la Bête* hanging over the fireplace, ostrich plumes in a jardiniere. He had a great eye for color and design. This man loved to live! And he did want to be famous."

In 1983 Hurrell was renting a studio from photographer Richard Settle. Hurrell's most notable subject that year was Joan Collins, of TV's *Dynasty* fame. "She's the only star today I can think of who has a vigorous amount of real glamour," said Hurrell. *Playboy* magazine's art director, Marilyn Grabowski, hit upon the happy idea of having Hurrell shoot nudes of Collins. When Hurrell finished, he complained to Marysa Maslansky, "I'm going to have to retouch those negs with a chisel!"

An uncredited *Playboy* interviewer asked Hurrell if he had ever been involved with any of his subjects. The artist almost lost his composure, sputtering, "Whatever went on was just between them and me!" His bursts of impatience, whether directed at cheeky journalists or at trendy galleries who were serving him to the public with their hors d'oeuvres, bespoke a growing disenchantment with his media-fed phenomenon. George Jr. hypothesized that his father

saw it all as a "Giant Publicity Machine." Allan Rich had gotten it rolling in 1979; now it was rolling too fast and too far. Hurrell was tired of trying to keep up with it.

He was tired of boring receptions. He was tired of fatuous questions about movie stars he had never known that well. He was tired of shooting would-be stars who "just sit there like rag dolls and expect you to invent it or something." He was tired of the New Hollywood, mistrustful of G. Ray Hawkins and Marysa Maslansky, and genuinely suspicious of his partners.

Hurrell suspected that Allan Rich and CAI had concocted the portfolio structure in order to take advantage of a tax loophole that would grant huge breaks if the art was donated to an institution within a certain amount of time. Was this true? It may have been, but the real issue was not the mechanics of this machine; it was his dependence on it. It was tying him down, and what was he really getting from it? He brooded over that print of Novarro—and the $9,000 he had not gotten.

PREVIOUS: This photograph was taken on June 14, 1980, at the opening of the G. Ray Hawkins exhibition in Hollywood. Just two weeks after his seventy-sixth birthday, Hurrell became an art world milestone.

OPPOSITE: Hurrell's 1985 portraits of Diana Ross were among his very best, recalling the high glamour of the 1930s.

Ned Scott portrait commissioned by Bogart's company, Santana Productions. I'd seen vintage prints with Scott's stamps and even printed the original negative for a New York collector. If the collector had the original Scott negative, what was this "Hurrell image"? Incredibly, both editions sold. Hurrell was fooling the public and fooling Rich. Was he fooling himself, too?

On June 1, 1984, George Hurrell turned eighty. Before long, the genius turned mean. The turning point was an assignment to shoot Grace Jones astride a Kawasaki motorcycle. Hurrell shot the assignment outdoors, but did not bother with the accepted practice of shooting at twilight to avoid glare on the vehicle's surface. The agency complained that Hurrell had not lit the motorcycle properly. It would not separate from the background and it looked too dark. All hell broke loose. Hurrell was enraged and fired everyone who was working for him or with him: Allan Rich, CAI, Marysa Maslansky, and G. Ray Hawkins—everyone who had contributed to his current status. "George often 'shot the messenger,'" said Hawkins.

Once again Hurrell had committed career suicide. Yet he emerged intact, for once without Norma Shearer's help. Perhaps it was the era of bad manners in which he lived. People talked in movie theaters and made dirty gestures through car windows. Perhaps it was the vicious milieu in which he worked. "The music industry is an open sewer," said my collector friend, after quitting a job with *Soul* newspaper. Perhaps it was because Hurrell was powerful, a "living legend." For whatever reason, the calls kept coming.

On August 2, 1982, he visited Bill Chapman's shop as the guest of honor at a small exhibit, *The Genius of George Hurrell*. What should be looking at him from a wall but an 11x14 print of "The New Orpheus"? He could not ask Chapman to take it down, but its presence certainly made that $9,000 sale look stupid. All he said to Chapman was, "That's one negative I wish I still had." Another photo caught his eye. "Who is that?" he thought aloud. Then he chortled. "Oh, that's my first wife! I thought she looked familiar!"

By this time, Hurrell was a little touchy about his "archive." Rich needed more portfolios. Each time, Hurrell had a harder time coming up with unseen images. In Portfolio III, five out of eight images (Anna May Wong, Charles Boyer, Gilbert Roland, James Cagney, and Gene Tierney) were kills. One image, Ann Sheridan, was printed from a lackluster copy negative. The final portfolio comprised only two images. It was called the Double Portfolio. The Dietrich portrait was a poorly retouched, overly diffused dupe. The Bogart portrait was not even Hurrell's work. It was a copy negative made from a 1948

ABOVE: The Hurrell rediscovery made even portraits of non-movie stars valuable, which was only fitting, considering the integrity that Hurrell brought to every subject. This is the sculptor Boris Lovet-Lorski.

OPPOSITE: Hurrell's portfolio included a seminude portrait of Anna May Wong shot at the same time as her 1938 studio portraits. Because she had taken the negatives from him, he had to make a copy negative in order to print this image.

Art directors went around Marysa Maslansky in order to have Hurrell shoot the Talking Heads, Harrison Ford, and Paul McCartney. Only Rich continued to represent his interests, albeit without help or thanks. "I made an agreement with the Cincinnati Museum to do a full retro, which I arranged," said Rich. "George found out about it and wrote Dennis Kiel [the assistant curator] a scathing letter. He wanted Dennis to call him—not me—directly."

The show was a success, of course, eventually being adopted by the Smithsonian Institution. "Incidentally," adds Rich, "my company never charged any museum a dime. All the money went to Cincinnati and the Smithsonian."

Smiling businessmen who sensed that the old man was floundering began to court him. "There were these guys," recalled Rich, "in 1986, I think. Who knows? He went with these guys, and they really raked him over the coals. I don't know what the hell they did, but he called me and he said, 'You've got to get me out of this!' So I got him out of it somehow. And he came back to the fold."

In 1987, G. Ray Hawkins's assistant, David Fahey, was working with the Los Angeles County Museum of Art to honor all the Hollywood photographers: portraitists, still men, and "special art" men. There would be a show and a book, both called *Masters of Starlight*. "Had I walked in there two years before," said Fahey, "they would have laughed me out the door. It has to do with timing. The right person goes in at the right moment, and all of a sudden, Hurrell and forty-three other photographers are in a major museum in a major city. It's looked on in a different context. That's the key: hindsight."

ABOVE: A Hurrell portrait of Arnold Schwarzenegger.

OPPOSITE: Hurrell's session with Kathleen Turner and Michael Douglas caused problems for Allan Rich.

Perhaps that was Hurrell's problem. Like Marshall McLuhan's "Forward through the rearview mirror," Hurrell was stuck between eras. He was profiting from the past, but living in a present whose manners, culture, and mores were radically different. Polluted by cars and TV, his world had changed, and was still changing. Said G. Ray Hawkins: "George didn't understand what was happening. When he'd been at the top, he was in charge of his life. He understood his job. He knew his place. When you're rediscovered, all that changes."

There was also the possibility that he had not fully recovered from his fall from grace. "You know," said Rich, "he was not a very happy guy. He was rejected for a long, long time. He was really whacked around. I thought he was always haunted by that."

David Fahey saw Hurrell's return from the ashes in a larger context. "What is the most popular thing in Hollywood? To pump people up, make them superfamous, and then to tear them down. And then Hollywood loves

a comeback, being all very sympathetic. Look at Cybill Shepherd, John Travolta, any number of them. It's the most common theme in Hollywood: drama. The Drama of Life. George mirrored that."

Hurrell had always displayed a kind of superiority to Hollywood. After all, he had never intended to become a photographer. He had gone to Laguna Beach to become a painter. The Hollywood connection was an accident. Perhaps that was the deepest cause of his bitterness. He had never fulfilled the promise of his "artistic" talent. Photography, once seen as the bastard stepchild of painting, had seduced him from his goal and given him a shallow, wayward life.

"Painters are individualists," Hurrell once said. "They seldom think alike. They're rebels. But photographers think alike. They're pretty much all alike." Hurrell's ambivalence toward photography was evident in the first hour of our first meeting. He told Dore Freeman and me that his favorite activity was taking off to Mexico on the

weekends to paint landscapes. There was a kind of shy pride in the way he described it. Dore Freeman missed that entirely and made the insensitive suggestion that Hurrell do oil paintings of his great glamour portraits. Hurrell sniffed at this, closed up, and said no more about painting for as long as I knew him. But I had heard it, and I never forgot it.

After the esteem and celebrity of the '80s, Hurrell still had the ambivalence, the confusion. There was also the darkness, the private torment that I had stumbled on in 1976. Add to that his legendary restlessness, mix in some paranoia, and you have a troubled—and troublesome—man.

Some people mellow with age and come to terms with their quirks. Hurrell could be insightful and introspective. More often, he was vinegary. Of course, he had his sweet moments. When Helmut Newton took him to the swanky Sunset Plaza restaurant Le Dome, he was as sugary as the Old-Fashioneds they downed. He was "a kind gentleman" to Lou D'Elia, who lent him prints to copy, and to Bill Chapman, who had an ever-growing cache of Hurrell originals in his Hollywood Boulevard apartment. Chapman was willing to let Hurrell use them for magazine spreads. When old Georgie turned on the charm, everyone was happy.

In 1989 Allan Rich arranged for Hurrell to shoot Kathleen Turner and Michael Douglas. Rich provided his home for the session. By 10:00 A.M. it was teeming with public relations people, hairdressers, makeup artists, and gophers, but no Hurrell. At 11:00 A.M., the stars were made up and ready, but the artist still had not arrived. Twenty anxious minutes later, George Hurrell strode in, followed by his son, who was carrying the camera, tripod, and a lighting kit.

"George, are you ready?" Rich asked politely.

"Oh, yeah," Hurrell drawled over his shoulder as he and his son hurriedly set up. Then Hurrell walked toward Michael Douglas. "What's his name? You: what's your name?"

"My name is Michael Douglas. Don't you remember me? From *The Streets of San Francisco*?"

"Oh, yeah," Hurrell laughed. "I was on that show. Good. Very good." He looked around the room. "What's your name? Oh, you're Kathleen Turner. I remember you now. Well, okay. Come here, honey. You sit over here on his lap. Allan, you put the music on."

Rich assumed the role of disc jockey as Hurrell positioned a single spotlight and aimed it at the two superstars. Then he pushed the camera across the smooth hardwood floor, looked through it, jammed a film holder into it, pulled the slide, and said, "Okay. That's…it!" Then he turned off the spotlight, signaled to his son, waved at everybody, and headed for the door.

Rich rushed after him, saying sotto voce, "George, where are you going?"

"That's it," said Hurrell. "It's in the can. It's perfect."

"No, George. They're here. You have to photograph them."

"I did. I told you. It's perfect."

The publicist did not agree and started to make a ruckus. There was, after all, Hurrell's $5,000 fee. Rich calmed everyone down and got Hurrell to do more poses. In an hour, he had shot twenty more sheets of film. Now everyone was happy.

"When the proofs came in," said Rich, "they were glorious. And of course, which one was the best one? The first one. He'd hit it right on the money."

As the 1980s came to a close, the name "Hurrell" was becoming a generic term. Howard Mandelbaum, the owner of Photofest, an agency that rents photographs to publications, said, "The word 'Hurrell' was starting to be used like the word 'Kleenex.' People would ask us for 'Hurrells.' And I'd ask them, 'Do you want a specific star by him?' And they'd answer, 'No, no. We want those kinds of pictures. You know, the hair flowing and the satin and like that.'"

The combined efforts of Kobal, Rich, Hawkins, Maslansky, and others had trained the public to identify

OPPOSITE: A Hurrell portrait of Grace Jones and Dolph Lundgren.

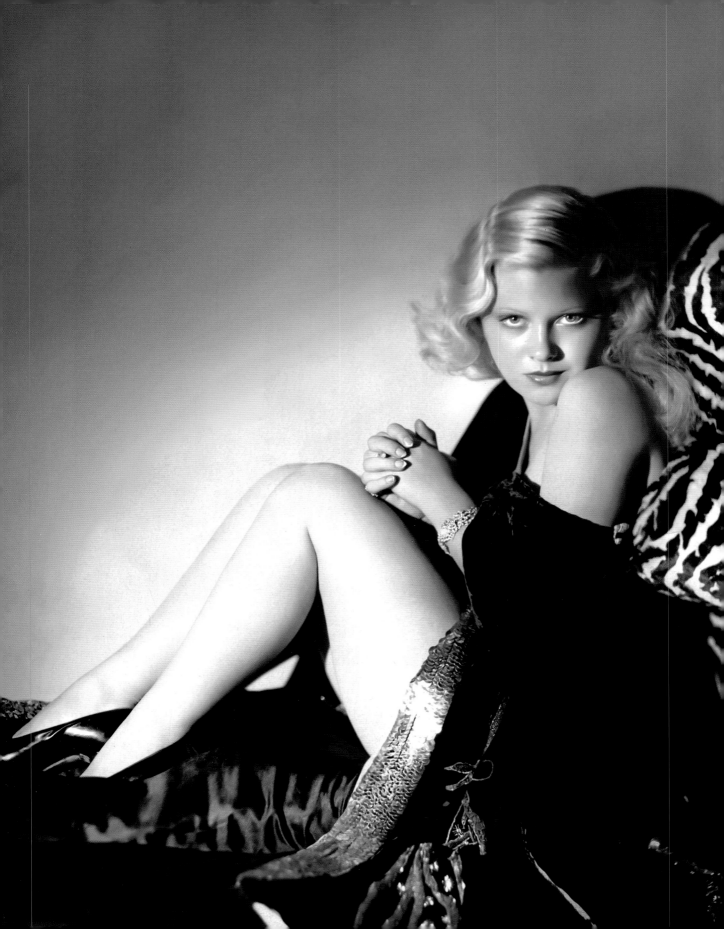

this idiom with Hurrell. Technology was keeping Hurrell's classic subjects recognizable, too.

While the stars of an earlier generation—Lillian Russell, Anna Held, Sarah Bernhardt—were lost in misty anonymity, Hurrell's subjects were immortal. Most films of the 1930s were extant, and many were now available for viewing in the home, thanks to videotape and cable networks such as American Movie Classics and Turner Network Television. The cathode glow of some stars was pale when compared to the Hurrell images in books, posters, calendars, datebooks, and magazines, but many more—Shearer, Gable, Crawford—had gained a secure place in our cultural mythology. With their help, Hurrell kept chugging along.

When David Fahey invited him to participate in the *Masters of Starlight* show at LACMA, Hurrell could not be bothered unless the show was devoted solely to him. Eventually he softened and gave prints to the show and to the book that followed, but he later disavowed any connection with the consortium that resulted from the show, the Hollywood Photographers Archive.

This was another Hurrell trick. He would leave partners in the lurch, on uncertain terms, and then vilify them to anyone who would listen. "He was funny," said Fahey. "He would talk about 'those people' as if he'd had enough of them and was never going to deal with them again. Then I'd turn around and he'd be with them again, doing some project or opening some show."

I still had Hurrell's phone number, and I still wanted to work with him even though I had moved to the Bay Area in 1981. The most obvious skill I had to offer was retouching. I was now proficient enough to retouch any 8x10 negative to the polished smoothness associated with the Hollywood glamour portrait. I knew Hurrell had hundreds of unretouched negatives in his garage. Why not approach him with

OPPOSITE: Hurrell bristled when impertinent journalists asked about "sex with the stars." He did, however, tell me that he had dated actresses Conchita Montenegro and Mary Carlisle (pictured here). But that was all he said. For all his sexy affectations during shoots, Hurrell was the consummate gentleman with his subjects.

the idea of doing portfolios that truly matched his classic work? As his fame had increased, my skills had evolved. Perhaps it was time to call again. I was hesitant, though. I remembered that remark about "the next Hurrell."

I had never wanted to be "the next Hurrell." I did not want to be a Hurrell clone. I did believe that his technique was the best ever devised for capturing beauty on film. There had been an avalanche of advances—strobes, miniaturization, digitalization—but none improved on the creamy clarity of the Hollywood glamour portrait. I knew that none ever would. I persevered. I continued to light, shoot, retouch, and print exactly as Hurrell and his colleagues had done in the 1930s: incandescent light, not strobe; large-format negative, not medium or small format; lead pencil retouching, not airbrush or dye; and fiber-base paper prints, not resin-coated paper. I was a purist.

Starting in 1982, my purism got some support. The first came from Edd Hearn, who was an assistant cameraman on the TV show *Dallas*. In his off time he was a West Coast equivalent of John Kobal, saving equipment that was about to be junked by the studios. In the loft of a Paramount soundstage he found a portable Agfa Ansco 8x10 view camera that had once been used to make scene stills on sets. At Universal, he found the 8x10 Eastman Century Studio Camera that had been used in the portrait gallery by Roman Freulich and Ray Jones from 1928 to 1968. Hearn put together a package for me and I secured a $5,000 bank loan. Now I was able to shoot classic Hollywood portraiture with classic Hollywood equipment.

Of equal importance was the Saltzmann 8x10 enlarger I bought from Edd. I no longer took 8x10 negs to other labs, hoping they would interpret them properly. I began to shoot more of my clients on 8x10 film, and I began to contact the various repositories of original 8x10 Hollywood negatives, telling them that they could finally see their negs "printed like originals!"

A number of private repositories took me up on my offer, and I began enlarging original Hollywood negatives—scenes, behind-the-scenes, and portraits—printed on Agfa Portriga paper and dried on a huge Pako drum dryer, all in

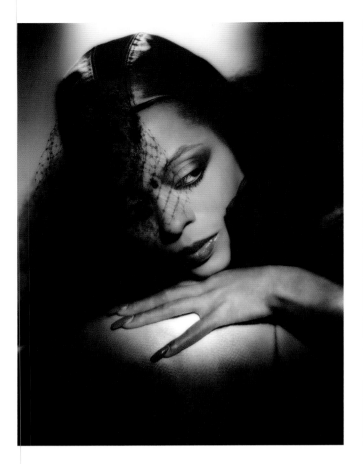
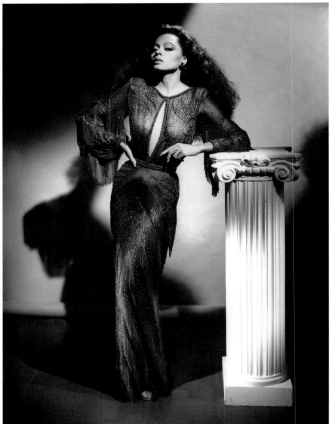

my parents' garage. Within a year, I had several sources of negatives, and as many still customers, sending me orders and checks, back to back.

My next wave of support came from a long-sought source. In January 1985, after sending numerous packages of sample prints, I finally got an appointment with John Kobal. He was almost as famous as Hurrell, at least in Europe. Nine years had not slowed him. He was the same tornado of taste and oratory. He picked up one of my sample prints, a scene still from *The Women*, and pondered it. "You really love these things, don't you?"

"I guess I do," I answered, taken aback by his directness.

"It shows," he said, as usual, with conscious irony. "Let's go!"

"Where?"

"I want you to meet Laszlo Willinger."

I rode with him to meet the seventy-four-year-old photographer whose portraits of Vivien Leigh and Clark Gable now sold at the Staley-Wise Gallery in New York. On the way from West Hollywood to Van Nuys, we stopped at a lab to pick up proofs of vintage Willinger negs. I watched Kobal stand at the counter, choosing images to present to Willinger. Kobal had the ability to flip through 8x10 prints as if they were playing cards, all the while judging them for composition, lighting, expression, pose, and impact. His eye was infallible.

Sitting in Willinger's living room an hour later, I noted the difference between this Austrian-born artisan and Hurrell. Willinger had an old-world graciousness and a caustic wit. He was unsparing in his print critiques. "Why didn't you burn this more?" he asked me. "It's distracting."

"Well," I explained, "my enlarger doesn't focus perfectly from edge to edge unless I stop down to f/16. And this neg was so dense, that if I had to burn it, I would have been there for five minutes."

"Why not purchase a new enlarger?"

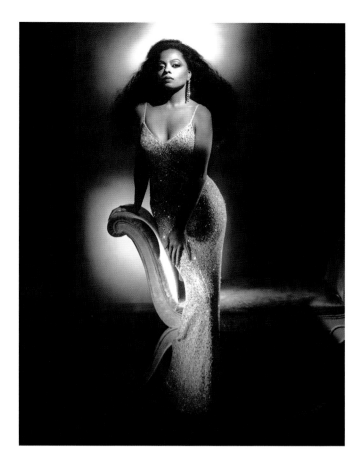

"Because he spends all his money on collectibles," Kobal cut in.

Unkind cuts and all, that afternoon yielded work and knowledge. I spent the next four years printing for Kobal and Willinger. This led to contracts with other archives, including Photofest, Memory Shop West, and the Academy of Motion Picture Arts and Sciences. What I learned from John Kobal and Laszlo Willinger (and from Ted Allan, to whom Kobal also introduced me) was something that I probably never could have learned from the restless Hurrell. I learned to look at each negative, to see it in a fresh and unbiased way, and then to make a conscious decision about how to interpret it.

After a few months with Kobal and Willinger, my printing attained a new sophistication. I began, for example, to routinely "burn" (i.e., darken) the corners of each print, so that the viewer's eye would move inward, to the important part of the picture, the eyes. I began to print with a bit of "diffusion," to soften the retouching

on "big head" portraits. I even customized the physical presentation of the prints. I put half-inch borders on glossy prints and then ran them through the Pakosol and the dryer a second time—"unglossing" them slightly—so they would have a lustrous finish, like the DuPont paper of the 1930s.

I had known many of these techniques before, but Kobal and Willinger pushed me to use them in concert. As a result, I reached a new level of technical mastery and artistic sensibility. When my work appeared on dealers' tables at movie conventions, collectors would recognize them and say, "Mark makes them look better than originals!" Compliments were nice, but I wanted approval from the Master.

OPPOSITE AND ABOVE: In his 1985 portraits of Diana Ross, Hurrell used a fresnel spotlight to paint the studio wall behind her with shadows and nimbuses, changing the background for each image.

GENIUS AND MEANNESS

In 1986 I was ready to approach George Hurrell. I assembled a package of my prints, flew to Los Angeles, dropped it off at Visages, and waited. John Kobal visited me in San Francisco in February of that year. He was on a book tour for *People Will Talk*, a collection of showbiz interviews. Fame was perplexing to Hurrell. To Kobal it was the elixir of life.

My next boost came in 1987, when I signed a contract with American Graphic Systems, a San Francisco book packager, to write my own book, *Hollywood Portraits: 1929–1941*. Using my still collection, I wrote about my mentors: film editor Chester Schaeffer, cinematographers Lee Garmes and William Daniels, and of course, George Hurrell. Just as I was finishing the first draft, I got up the nerve to call Hurrell.

I was in the garage darkroom at my parents' home in Castro Valley; that was one umbilical I had yet to cut. I was printing negatives of Jean Harlow for Carole York at Memory Shop West in San Francisco. Harvey Stewart, a clever, garrulous friend, was acting as my lab assistant. He sensed what I was up to. "Child," he said in his Charleston accent, "are you calling Hurrell *again*?"

I knew Hurrell's number by heart. He answered in his usual no-nonsense manner. Yes, he remembered me, and no, he could not help me. "I'm too busy to do a book jacket for you. Anything else?"

"Didn't you get the package I sent to you at Visages? There were prints in it that I did from one of your original negs. I restored the retouching on it, and—"

"I'm not with those people anymore. You'll have to pick it up from them. I can't be responsible for your prints. If that's all, I—"

"Mr. Hurrell, I just want to tell you that I've learned so much from your work, and after all these years, you are still an inspiration to me—"

"Well, thanks. Look, I gotta run now. Bye."

"Good-bye."

Harvey moved a print from one tray to another. "Child," he said, "Hurrell just changed the channel on you." That was the last time I spoke to Hurrell, but it was not the last time our paths crossed.

Allan Rich was still plugging Hurrell, and Hurrell was still letting him. "In '87 we went to Jordan Marsh in Boston with Kathleen Turner, Michael Douglas, Danny DeVito, and George and Betty. We had a wonderful time. George could be the most charming man you ever met. Full of hell—and laughter. He loved to laugh. He loved Chinese food, too. We were friends. Until the silliness occurred."

OPPOSITE: George Hurrell's 1985 session with Paul McCartney was the happy collaboration of two legends.

Rich had not been able to get Hurrell a special Academy Award. The Academy claimed that there was no precedent for it. Rich reminded them of 1940s awards to three still men, Robert Coburn, Frank Powolny, and Roman Freulich. Rich aimed higher. Kobal shows featuring Hurrell prints had been touring under the auspices of the Smithsonian. Why not try the Smithsonian? With his usual perspicacity, Rich went to work on this, his most daunting project. What had Hurrell managed to line up? A show of his recent work hung in the lobby of a small Hollywood lab called Photo Impact.

The setting was not impressive, but it occasioned an interview. Tricia Crane of the *Los Angeles Herald-Examiner* wrote: "At 84, Hurrell is fiery, frank, and, at least initially, rather imperious. Taking a long look at his portrait of Brooke Shields, Hurrell sighs. 'I started out to be a painter, you know,' he says wearily."

Besides the sporadic photo shows, Hurrell dabbled in teaching. Now that everyone knew what "the Hurrell Style" was, everyone wanted to try it, thinking it could be learned as easily as the lambada. The results were mixed. "I tried a couple of times to teach," he said. "I would always have to quit after three or four sessions because of dumb questions like 'Why did you put the light there?'"

"I said, 'Can't you see? You see what the light's doing. If you can't see that, throw that camera away!'"

Hardly obtuse, Hurrell adopted an anti-intellectual pose. "I don't go around thinking about photo theory. And I still insist that most of this should come from inside you as an impulse. If you don't have that, the rest is incidental." As often as he could, he turned his back on "the rest"— interviewers, students, groupies. Then he was free to do what he liked best: go fishing, cook, fool with an unfinished

RIGHT, TOP TO BOTTOM: Sherry Lansing sat for Hurrell in 1989, when she was president of Twentieth Century-Fox.

A Hurrell portrait of actor Dean Stockwell.

OPPOSITE, TOP TO BOTTOM: A Hurrell portrait of writer Henry Miller.

A Hurrell portrait of Tracey Ullman.

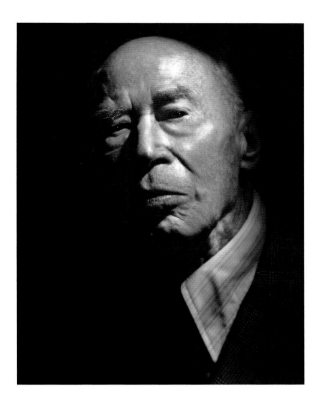

landscape painting—or head to a portrait sitting with George Jr. "That was what he was really interested in," said his son. "The next job. The next portrait. Not a lot of art gallery receptions and questions about old movie stars. That whole Publicity Machine, that got old really fast. He hated that."

In 1988, Allan Rich's wooing of the Smithsonian paid off. The Institution agreed to a one-man show for Hurrell. Rich then scheduled a series of glittering receptions and prestigious speaking engagements for his distinguished artist. George Hurrell was about to receive his country's highest artistic honor, and with it, unqualified acceptance of the art form he had perfected a half century earlier. For once, an artist would be recognized while he was still alive.

Yes, George Hurrell was still alive. And he was quite well, what with $5,000 portrait fees and portfolios yielding twice that. He was a candidate for *Lifestyles of the Rich and Famous*. He was also the irascible artist who had once told L. B. Mayer to go to hell. Hurrell enjoyed the benefits of fame, but he bristled at its price. He had lived a media-fed phenomenon. He had returned from the ashes of his first career. Now he was sated with the demands of a second. He felt that he was being fed to Allan Rich's Publicity Machine, bit by bit.

Hurrell had long since wearied of art gallery openings. He was sick of vapid compliments and tactless questions about the same dead stars. Didn't these jackasses know that there was a caste system in Hollywood? You didn't socialize with stars. You worked for them. In the sixteen years he had shot in Crawford's house, he had never once been allowed to go upstairs.

Hurrell was sick of being called a genius by people who did not know the difference between a view camera and a viewfinder. He was disgusted by leering interviewers who asked if he'd slept with his subjects. He was fed up with the phonies and the flakes. He'd had it with the hype.

Hurrell called G. Ray Hawkins about Allan Rich's coup. "Can you believe that guy? He actually expects me to go to Washington, DC, for an opening!"

"But George, it's the Smithsonian," said Hawkins in measured tones. "This puts you in the company of Outerbridge, and Steichen, and your friend Weston."

"What's in it for me?!" Hurrell demanded.

What could Hawkins say?

A limousine pulled up to the modest ranch-style home in North Hollywood, and the driver scanned the porch. He saw no luggage. That was odd. He had been told that the elderly couple was ready. He got out, went to the door, and rang the doorbell. A grizzled, hostile old man answered it. "Yeah?"

"I'm here to take the Hurrells to LAX."

"The Hurrells aren't going," snapped the man, and he slammed the door.

The limo driver called the dispatcher, and the dispatcher called Allan Rich. Two hours of frantic negotiations ensued. George Hurrell refused to go to Washington, DC, to be honored by the Smithsonian Institution. So George Hurrell did not go. Allan Rich had to clean up an embarrassing mess of fouled receptions and canceled speeches. But Hurrell was still famous. And still working.

In the years since 1976, *The Hurrell Style* had begun to look a bit second rate, especially when compared to books such as Kobal's *The Art of the Great Hollywood Portrait Photographers*. Hurrell thought he deserved a book worthy of his new stature. Publishing the definitive Hurrell book now became his quest. He entertained proposals from various publishers, most notably Jack Woody of Twelvetrees Press, who had recently done a large-format gravure volume, *Lost Hollywood*. Woody courted Hurrell, but when the intractable old man demanded that the book contain only work shot after 1977, Woody was aghast. The project was abandoned.

ABOVE, LEFT TO RIGHT: Harrison Ford's place in film history was secure when George Hurrell made this 1984 portrait.

A Hurrell portrait of Kathleen Turner.

OPPOSITE, LEFT TO RIGHT: A Hurrell portrait of Doris Duke, who was an art collector and philanthropist.

This Hurrell portrait of Loretta Young was made in her home to publicize a 1989 TV movie, *Lady in a Corner*.

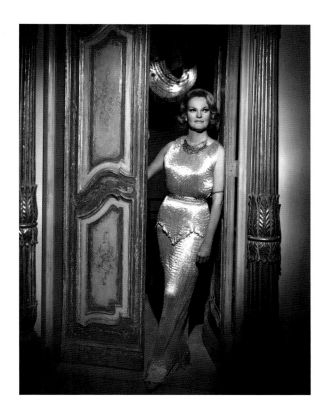

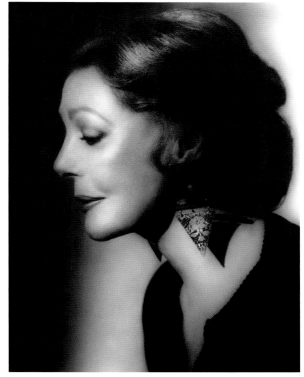

John Kobal had a string of hits. *Rita Hayworth* became a TV movie, his Hollywood portrait books were reprinted numerous times, and Knopf published *People Will Talk* and *Legends*. His twenty-seventh book was already in the works. It was tentatively titled *DeMille and His Artists*. His editor at Knopf, Vicky Wilson, gave him a green light to do the most extravagant film book ever, a tome that would dwarf even Ron Haver's 1980 epic, *David O. Selznick's Hollywood*. I saw Kobal in June 1988, and with some trepidation presented him an inscribed copy of my newly published book, *Hollywood Portraits: 1929–1941*. He flipped through it, praising with faint damns.

I then shot his portrait, which was for a cable TV show. I was short of cash, and asked him if he would spring for the rental of incandescent lights. He declined, and I was forced to shoot with available light, at which he commented, "Oh, you're doing me like George did Garbo, with a skylight."

"Right. Your tan should really look nice with this bounce light—"

"That was the worst sitting George ever did. He shot me, you know."

"And Laszlo. And Ted. I know."

Despite Kobal's misgivings, the sitting went well. As he was leaving, he showed me a carload of oversize landscape prints by the esteemed William Mortensen. "Wow," I said. "Where did you get them?"

"I'm doing research for my book at the DeMille estate."

I knew better than to ask if he had been given them or had simply helped himself to them. Perhaps those tales of wheelbarrows and raincoats full of negatives had been true.

Despite his misgivings, the sitting went well. When he saw the finished prints, he said, "You little genius. I look like I'm lit from within!" (He had not been; there was no coffee in the home where I shot him. Or liquor.)

Lothar Schirmer of Schirmer Art Books, who knew Kobal quite well, asked him for Hurrell's address. He approached Hurrell with the idea of doing a book. Schirmer was enthusiastic about using prints from

the Kobal Collection, which would make possible a complete survey of Hurrell's work. Hurrell grew livid and said he would never consent to any project using Kobal material.

Kobal, on the other hand, had never stopped sending royalty checks to Hurrell for Kobal Collection postcards and gallery commissions. "George always sent the checks back to us," said Simon Crocker. "He was sort of petty, really."

The rank of veteran collectors was thinning. Myron Braum died in 1986. Within a month, his Norma Shearer stills began to flood the collector's shows. Dore Freeman lost his unique collection of double-weight 8x10 prints in the summer of 1981 when two men visited him, ostensibly to drink and talk. One man occupied Dore in the den with

sexual blandishments. The other man made his way down a darkened hallway, removed eight boxes of stills, surreptitiously put them outside, and then returned to the den. Days later, when Dore discovered his boxes missing, he proceeded to call every collector he knew—including me—and accuse him of the crime. The thieves went unpunished, and it was not long before the prints started showing up at a now-defunct store on Hollywood Boulevard.

ABOVE: Roger Taylor, Brian May, Freddie Mercury, and John Deacon, the members of the rock group Queen, were shot by Hurrell in 1986 at the West Hollywood studio he rented from photographer Richard Settle.

OPPOSITE: Hurrell photographed Farrah Fawcett at the same studio in late 1981.

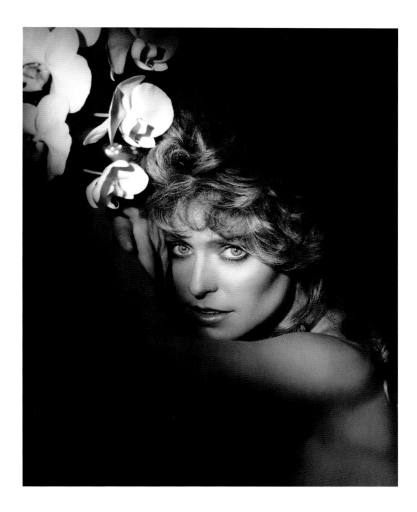

Dore Freeman died in December 1988, aged 77. Within a week, collectors were fighting to get at his Crawfords. I broke with the friend who had originally introduced me to the work of George Hurrell. After telling me, "You'll do anything to get stills," he stole a Hurrell portrait of Norma Shearer from me. Photo archivist Joan Rose said: "The most distasteful experiences I ever had in Hollywood were with collectors." There is honor among thieves, but not among collectors.

In 1989, John Kobal momentarily put aside his DeMille book and edited a well-mounted monograph about Clarence Sinclair Bull. He chose photos and used biographical notes he had purchased from Bull's widow. The book was titled, much to his dislike, *The Man Who Shot Garbo*. I was working on my second *Hollywood*

Portraits book when I started getting frantic intercontinental phone calls. Kobal needed images that existed only in negative form in the Turner/M-G-M Collection housed at the Motion Picture Academy. I used my connections there to get them and print them for him, hoping that this was the first step to writing the text of the Bull book. I was soon disabused of this notion. I received a polite call from the actual author, Terence Pepper, who was curator of the National Portrait Gallery in London. I helped Pepper with his research and then billed John Kobal for printing—and legwork.

Kobal was irate when he got my $400 bill. Why? It wasn't coming out of *his* pocket! Then he rebuked me for using his name when filling out the required Turner Entertainment Corporation release. I had to dun him

twice. After a terse exchange, he did not speak to me for a year.

I spoke to Jeremiah Sullivan about this. His ex-lover, Matthew Daniels, was working with Kobal on a manuscript. "Oh, let John stew in his own juice," said Sullivan. "He's pissed because people know that Matthew is ghosting a lot of his chapters. He's pissed because Matthew doesn't want to sleep with him. And he's pissed because you're writing books. He may call you 'the little genius,' but to him you'll always be the little tyro. Just ignore him and keep writing."

Both of my books paid homage to Hurrell. My parents would point out the latest news item about Hurrell and ask if I had given him a book yet. I was printing Hurrell negatives for collectors, shooting in his style, and praising him in interviews about my work. Yes, it made sense that I give him an inscribed copy of *Hollywood Portraits*. After fourteen years, I was still hoping for work, for some acknowledgment from him, for *something*.

I called Hurrell and got his answering machine. I called again. Same thing. And no return call. I called again. And again. No response. One day, when Harvey Stewart and I were printing—what else—Hurrell negatives, I picked up the phone. "Maybe he'll answer this time." All I heard was Hurrell's voice on the outgoing message tape. My face turned red. I heard the beep. I spoke.

"Hello, it's Mark. Again. You have not returned my calls. Well, I guess you can do without my book. And without my retouching. And without my printing. Well, anyway, thank you for returning my calls. Thank you for everything. Thank you. And fuck you." I slammed down the receiver. Harvey just stared. For once in his life, he was speechless.

About this same time, Allan Rich got his own surprise call. His partner asked him, "Did we authorize George to use our images in datebooks for Pomegranate Press?" Rich could not believe that Hurrell would knowingly sell images owned by CAI, but when he got the datebook, there they were, half a dozen exclusive images. CAI was not mentioned anywhere, and the captions were sophomoric and inane, making a travesty of the work. (One example: "Norma Shearer was the Joan Crawford of

her day." How did she manage *that*?) "You can imagine how angry we were," said Rich. "When I spoke to the guy at Pomegranate, I immediately found out that he had nothing to do with it. He got the rights directly from George, and he thought he was getting the rights from the horse's mouth."

Rich and Davis resolved the problem by having Pomegranate pay a commission on future sales, but Rich had finally had enough of Hurrell. He cut off all contact with him. "Look, I felt sad about it," said Rich. "And we could have sued George, but everything doesn't have to end in a lawsuit. I have a philosophy: Turn the page and move ahead."

George Hurrell was still angling for a book deal. While he waited, there was a call from the one arena in which he had not worked since his return from the ashes: Madison Avenue. (The Kawasaki fiasco did not count; that was actually a tie-in portrait of Grace Jones for M-G-M–UA's *A View to a Kill*.) In October 1989, David Leddick, who had spent decades directing Revlon and L'Oréal ads, was hired as a freelance creative director by the advertising firm of Avrett Free Ginsberg (AFG). The New York agency was competing with forty-one other agencies for the Campaign of the '90s. Lorillard Tobacco was spending $26 million to reposition Kent Cigarettes. To find the best agency, Lorillard was holding auditions. The theme was "Portraits of Pleasure." Frank Ginsberg, one of the partners of AFG, remembered a book, *The Man Who Shot Garbo*. He asked David Leddick to find someone who could shoot in that style.

Leddick, an avid art collector, knew about Hurrell. He called him, introduced himself, and explained that AFG needed a knockout audition piece. According to Leddick, Hurrell was "very pleasant and wanted very much to do it." He wanted to know if he could shoot the audition in Los Angeles and if he could suggest talent.

"I had no real objection to that," said Leddick. "We were doing a talent search ourselves in New York. So I thought, There's no harm in that."

Hurrell sent Leddick photographs of three subjects who he thought would be good models. Leddick's concept was to imitate Clarence Bull's dreamy 1934 portrait of

Gary Cooper smoking. He evaluated Hurrell's submissions. "They were okay, but not particularly movie star–looking. I don't really know who they were. I called him back, saying that I didn't think that any of these people were right for our project and that we would take care of the casting." Hurrell turned on him.

"He suddenly became a different type of person altogether. It was like Dr. Jekyll and Mr. Hyde. He went into a very long harangue about advertising people, how they always order you around and how they treat people terribly and how they cheat people. And he just blew his stack and said he didn't want to do the project and hung up."

Leddick told Ginsberg that AFG could not afford to embark on a major audition with someone who

might walk off when they could least afford it. Ginsberg had an assistant call the Kobal Collection's New York office. Kobal's assistant, Bob Cosenza, took the call. "Where can we reach this man who shot Garbo?" asked the assistant.

"Sorry. Clarence Bull has been dead for ten years," said Cosenza. "But I can refer you to someone who shoots in that same style. (He could do this because Kobal was not in the office.) The man in California who prints Bull's negatives for us, Mark Vieira."

"Never heard of him."

"Call him," said Cosenza. "He's good."

I shot the Lorillard audition. My work got AFG the Kent account. I got to shoot "Portraits of Pleasure." And that was the last time my path crossed George Hurrell's.

ABOVE: Hurrell made these portraits of Paul McCartney in 1985.

REFLECTIONS IN A LENS

Nineteen ninety arrived, and the culture continued to change. Next to goatees, tattoos, and body-piercing, the glamour of old Hollywood was increasingly exotic. Jean Harlow was mistaken for someone trying to look like Madonna. Videos of Joan Crawford persuaded viewers that there was more to her than the apocrypha of abuse. The term "pre-Code movies" entered the lexicon and accelerated the Norma Shearer rediscovery. Everything old was new again, yet at age eighty-six, George Hurrell had not snagged that second book he sought. Publisher Lothar Schirmer was interested, but reluctant to base a book on Hurrell's insubstantial collection, so Hurrell began paying visits to Bill Chapman, who by now had amassed 2,000 original prints. Hurrell had some leverage there, because Chapman wanted to rent Hurrell images to magazines through Joan Rose, who had gone from being a poster dealer to being a photo rep. Hurrell wrote Chapman a letter, granting him permission to use his work. Then he brought art dealer David Fahey over to look at Chapman's collection. By this time Fahey was running the Fahey-Klein Gallery and had edited a number of monographs. Doing a book with Chapman's collection looked like a natural. "After two meetings," said Rose, "I could see that it really was not going to go anywhere. None of them spoke the same language."

For a time, Rose acted as an informal rep, renting Hurrell's own prints to selected magazines, but from 1990 on, the grand old man had no agent, either as a photographer, as an artist, or for the book contract he finally signed with Lothar Schirmer. He had gotten as far as saying to David Fahey, "I would like you to represent me," but nothing was ever finalized. Hurrell was always talking about being taken advantage of. "At that point in time," said Chapman, "he was mad at John Kobal and Allan Rich. I told him I didn't care for them either. And he said, 'Well, at least we have something in common.'" Joan Rose said, "I think George could get along with people as long as he didn't feel nailed down or hemmed in."

In 1990, Graystone Books, in conjunction with the G. Ray Hawkins Gallery, prepared to publish *The Portfolios of George Hurrell*. A series of postcards was printed in advance of the book. Now the shoe was on the other foot, and Hurrell was stamping it. "Postcards—how belittling can you get?" he wrote to Allan Rich on June 28. "What else are you going to do to degrade the value of a Hurrell photo? And since when do you have the legal right to do postcards or anything else besides the original purpose described in our contracts. I guess it is time to talk to a lawyer about your sneaky practices and claims. And—let this be the end of any further pretense of friendship."

OPPOSITE: In 1991 Hurrell photographed Natalie Cole for the cover of her album *Unforgettable...With Love.*

Allan Rich responded on July 2, 1990, in a letter that began: "I have belittled you in the same fashion as the Rijksmuseum who published postcards of Vermeer." After citing six museums and sixteen artists, Rich concluded: "I give these to you as a gift of recognition. I do hope that before you sue us, you read your contract." Hurrell shut up, and Rich went back to writing the Motion Picture Academy, asking that Hurrell be given a special Academy Award. When Karl Malden turned him down, he gave up.

Portrait commissions enlivened 1990 and 1991 for Hurrell: Johnny Mathis, Warren Beatty, Sharon Stone, and

OPPOSITE: Hurrell shot this portrait of Rita Hayworth in 1942. When author David Stenn interviewed Hurrell in 1991 for *Bombshell*, Hurrell shared stories about Hayworth, too.

ABOVE: John Kobal's death was a sad, premature end to a rich, productive life. A significant part of our cultural history would be landfill had he not applied himself to both gaining and sharing knowledge. The portrait was made by me in 1988.

Natalie Cole among them. At eighty-seven, Hurrell showed no signs of slowing; nor did his marketability. Auctions and galleries were now selling portfolio prints for $12,000 to $15,000 apiece. Everyone should have been pleased. But the angry correspondence continued.

The vintage prints of Novarro, Dietrich, and others that Hurrell had given Fahey for *Masters of Starlight* in 1987 now turned up in a catalog put out by Fahey's former partners. The poses looked identical to some of CAI's exclusive portfolio images. Rich was suspicious, and he wrote to Hurrell. On June 24, 1991, Hurrell replied, first disavowing any connection with Fahey's former partners, whom he described as crooks. Then he explained photography to Rich.

"There may be similar images to the CAI negatives in MY VAST COLLECTION—what I call 'look-alikes,' which are mine and mine alone," said Hurrell. "My years of photographing movie stars—creating images—and shooting so fast that there will be three or four negatives so similar in pose and expression that even I cannot tell them apart. Perhaps your Novarro negative is a 'look-alike' and perhaps some of your other negatives also may be. I wouldn't know. I am still a busy photographer making my living shooting—in the same old way—with the same old 8x10 camera—and with the same old clientele—movie stars—and as the saying goes, 'It's a living.'"

I was able to compare the two images in question. They came from a Novarro sitting done in connection with the 1931 film *Daybreak*. This is what happened: Hurrell supplied one of his partially retouched killed negs to Rich in 1980 for Portfolio II. Then in 1987, he supplied a vintage M-G-M print of a similar pose to the competing entity. Unless you put them side by side, they looked like the same image. Why was Hurrell protesting so much? Surely he knew that the vintage pose was dangerously close to the portfolio pose and would set off alarms. Was he doing it to spite Rich?

After Hurrell signed the contract with Schirmer Art Books, he began to visit Bill Chapman, looking for images. "He would call me about ten minutes to nine. He couldn't quite wait until nine A.M. to call. His voice was gruff: 'George here.'" Then Hurrell would visit, going through binder after binder of double-weight originals. Occasionally, he would stop and say, "I'd like to copy this.

That way I can crop it, make it darker here and there. You know, *improve* it."

Chapman was mystified by Hurrell's newfound fixation with "improving" his vintage prints, trying to make everything dark, dark, dark. My suspicion was that he wanted to conform his work to the stereotype of "The Great Hurrell" that Rich had sold the media. "Rich really thought that Hurrell was the Rembrandt of photography," said G. Ray Hawkins. You would not see a bright Rembrandt, reasoned Rich. So Hurrell's prints must not look too bright—even if they had been lit as high-key images.

Chapman was not interested in lending photos, for copying or otherwise; he wanted to sell them. Hurrell was unwilling to pay Chapman's prices, so they parted company, but amicably. Hurrell had heard from Kobal and Rose that Chapman had a reputation for being vindictive. "Look," Rose said. "Bill has things you need. That I need. But he has a history of emotional problems. He was very effeminate. He was beaten badly as a boy and he was assaulted in the service. He's never recovered from that. If you want to use his material and get through a project with him, you're going to have to kiss his ass."

Hurrell politely distanced himself from Chapman, at least until he could find another source. But he still refused to use photos from the Kobal Collection. Once again, Hurrell had painted himself into a corner. Why? He had no choice but to assemble a book from his own inferior collection. He began printing copy negatives in his garage darkroom. The copy negatives were of good quality, but he did ill-advised things with them. He diffused them and burned them and printed them on matte paper. As a result, they looked murky, flat, and lifeless. He shipped 300 mediocre prints to Germany and let Schirmer worry about screening them. Hurrell would have done better to buy the Chapman Collection, but he was either too proud or too cheap. Once more, he sold the public a flawed vision of his work.

When Hurrell printed for Schirmer, he made additional prints from the same negatives. "He wanted to leave something for his children," said Lou D'Elia, who was still dining with Hurrell on a regular basis. D'Elia was a practicing neuropsychologist and was also teaching at UCLA. Hurrell would call him and they would meet for lunch at Musso and

Frank in Hollywood or Cheerio in Santa Monica (until it closed in the late '80s). D'Elia noted the décor of the places Hurrell liked; dark wood paneling, red leather banquettes, and subdued lighting, usually from tiny spotlights. He asked Hurrell if there was any reason for always eating in places that had this look. "The bounce light from the white tablecloth and the red leather is flattering," answered Hurrell.

In 1990 Richard Settle was undergoing cancer treatment and had to be away from his studio. Hurrell called him at least once a week to inquire after his health. Settle considered Hurrell a friend. Over a period of ten years, they had worked on more than forty sessions together. Hurrell told him stories about the studio days, and even about Walt Disney. "Walt was allowed a certain amount of liquor per day," Hurrell told Settle. "When he'd gone through that, he came to my office and got into my bottle." At one point there was talk of a star on Hollywood Boulevard for Hurrell. "I don't want to be on a sidewalk," said Hurrell. "I've been stepped on and walked all over by enough people in Hollywood." Settle saw Hurrell wince when sycophants referred to him as a legend. "I'm not a legend," said Hurrell. "Legends are stuck up on a shelf and left there. I'm working."

In September 1991, George Hurrell was interviewed by author David Stenn for *Bombshell*, a definitive biography of Jean Harlow. Stenn's editor at Doubleday was Jacqueline Onassis. She suggested that Stenn commission a book jacket portrait by Hurrell. "I said he'd never do it," recalled Stenn. "He'd made it clear he was turning down offers." According to Bill Chapman: "Madonna wanted him to take her picture, so she invited him to one of her concerts. He went, but he didn't take her picture. He said she was too masculine." There was more to the story. Hurrell and George Jr. were invited backstage but were made to wait so long that Hurrell said: "To hell with her. Let's go."

Hurrell was declining other invitations. According to Joan Rose, he dropped Helmut Newton because he was tired of answering technical questions, even over free lunches at Le Dome. He told Bill Chapman that he turned down a chance to meet the famous Karsh of Ottawa. "I don't want to be introduced to him," said Hurrell. "All we would do anyway is sit around and discuss photography. I don't want to do that."

None of the people who idolized Hurrell knew that he derived real enjoyment not from eating in overpriced, pretentious restaurants but from fishing and cooking. "He loved to fish," said D'Elia. "His clam sauce spaghetti was a delicacy. He really just enjoyed the company of his wife and children." When he had gone to Paris for *Vogue* (in January 1981) and the trip ran over its expected length, he wrote D'Elia that "Betty is going to kill me if I stay here any longer." He was joking, of course, because he missed her as much as she missed him. "After the unhappy marriage with Katherine," said D'Elia, "and the trouble with Phyllis, George had finally found his soul mate. He was very happy with Betty."

When David Stenn interviewed Hurrell at length about Harlow, Hurrell warmed to the writer. He admitted that there were people that he was actually interested in photographing: Meryl Streep, Barbra Streisand, and Pope John Paul II. Why was Hurrell so forthcoming? "Because I was able to tell him things about Harlow that even he didn't know. There was some reciprocity there. I think he was used to interviewers not doing their homework." Perhaps there were other reasons for Hurrell's affability. Stenn was an influential writer-producer on a major network. His editor was one of the most famous Americans of the century. Hurrell, for all his defiant posturing, was impressed by power. He agreed to shoot Stenn.

The sitting was Saturday, September 14. Two days before, Stenn took Hurrell to lunch at Musso and Frank. Hurrell's standing order since 1931 had been a Manhattan and Steak Diane, but he instead ordered a beer and Shrimp Louie. He insisted that Stenn have the same. As he talked with Stenn, he studied his face. "This is what I always do," he told Stenn. "I like to sit down with people first. I don't like them to just walk in and expect me to go to work. I need to look at them, to see what's there." Stenn warned Hurrell that he was no Gary Cooper. Hurrell was unfazed. "Looks only get you so far," he said. "It's what's inside that takes you all the way there." He confided to Stenn that one of his famous portfolio portraits, a shot of Rita Hayworth

ABOVE, LEFT AND CENTER: This portrait of Ramon Novarro was a killed shot. Hurrell made it for Jacques Feyder's 1931 *Daybreak*. When Hurrell included the image in Portfolio II, he chose not to retouch the negative, which was not in keeping with the tradition of the Hollywood glamour portrait. A retouched version of this image appears above, center.

ABOVE RIGHT: Hurrell ran afoul of his business partners when he contracted with a competing art publisher, and worse, supplied an image that was too similar to the portfolio image.

leaning back on her elbow and laughing, was a last-ditch attempt to wring emotion from her. "She was gorgeous, but there was nothing else there. I had nothing to photograph, so I just told her to lie down. She fell into a pose like that, and so I shot her in profile."

Stenn's sitting took place at Richad Settle's studio. Stenn brought along a Benny Goodman compact disc, which worked wonders. Perhaps Hurrell, with his legendary record collection, had played that very recording (in a 78 rpm version) in his Rodeo Drive studio fifty years earlier. Stenn was transported.

"I went into this sort of zone," said Stenn. "He never stopped talking to me, but it wasn't conversational. More like a drill sergeant, giving orders. 'Move your arm to the right. No, a little less. No, a little more.' I mean, he was meticulous.

"And if he felt your energy slipping, he'd say 'boo' or growl—or jump! He was spry. I don't think he ever became an 'old man.' You know how some people just stay hip? He had a young spirit. And whatever he was looking for, he wanted to make sure he got it."

Did he? How did the pictures turn out? What could an eighty-seven-year-old artist do? Stenn recalled his first look at the prints: "You look at them and you think: Who's that? Because you've never seen yourself look so good. And at the same time, you think: Well, yes. This is the person that I always thought I was, way deep down inside—on my best day. Like he said, 'It's what's inside that counts.' That's what George got."

Hurrell kept in touch with Stenn. He'd call up to chat. "Hello, David? This is George Hurrell, the photographer, calling." In December, Stenn asked Hurrell whom he'd been shooting lately. "I haven't been working," answered Hurrell. "My shingles have been

ABOVE: David Stenn got a book jacket portrait from Hurrell. The September 1991 session was Hurrell's last at Richard Settle's studio.

OPPOSITE: Hurrell's last movie-related job was shooting Warren Beatty and Annette Bening for Beatty's 1991 film *Bugsy*.

bothering me." Stenn sensed some deeper problem, but did not ask. Hurrell had not shot at Settle's studio since Stenn's session.

On October 28, 1991, John Kobal died of AIDS. No one I spoke with across years of research knows if he and Hurrell ever reconciled. All I could confirm was that Kobal had never gotten over Hurrell's betrayal. "George just wouldn't talk to John," said Simon Crocker. "I think he somehow convinced himself that John had gotten the better of him. But John always said good things about George. I never heard him put George down."

Kobal had written to me in early 1991. It was a rambling, effusive letter that did not say much except "I'm lonely." It ended on a plaintive note. "Be well, Mark. That's the most important thing. Be well."

"Had John lived," said David Del Valle, "and gotten to be older and more comfortable in his celebrity, he would have been a great teacher. Because he was always learning. I'd visit him at the Marmont and he'd show me a picture and say, 'Look at this. No, really look at

it! Notice this shadow here?' He wanted to impart that knowledge to other people. We'll never get to see that side of him."

What is John Kobal's legacy? Without a doubt, it was he who pushed the Hollywood glamour portrait into the world of art. Before Kobal, these photographs were scrap paper. After him, they were "images." How did he do it? He got negatives. He got them first. He had them printed better. He had them printed larger. He showed them out of context. And he used the force of his personality to sell them. This was his achievement, a cultural epiphany.

One of Hurrell's last social engagements in 1991 was a visit to Bill Chapman's apartment. Schirmer's expensive folio, *Hurrell's Book of Stars*, had just been published. Hurrell shared it with Chapman and Joan Rose. Together they turned page after page of the large, heavy book. "Too dark," said Hurrell over and over again. "Too muddy." Chapman glanced over at Joan Rose. She was looking at the ceiling.

In January 1992, the Vermont art gallery owner J. Grier Clarke realized a cherished ambition. He was producing a documentary about George Hurrell, *Legends in Light*. Hurrell agreed to be his subject, as long as he did not use: "any photos from Allan Rich, CAI, the Kobal Collection, the Photographers Archive, etc., etc., etc.!"

Clarke's video camera followed the revered artist from a shooting area set up in a hotel to a photo lab, and then to the Granada Buildings, to the suite where he had first shot Novarro and Shearer. Hurrell was chipper, creating an abnormally jovial character, but as the weeks passed, he began to look drawn. When he went to work on Sharon Stone, however, old "Georgie" held back nothing. The images he created were masterly and original.

These were Hurrell's last days behind a camera. In April 1992 the "shingles" were diagnosed as bladder cancer. Hurrell had first been diagnosed with this disease in the late '70s but had beaten it, or so he thought. He began chemotherapy, tried to complete the video, and then dropped out.

The therapy continued through May. Hurrell called Chapman and made a lunch date for May 21. Hurrell was hospitalized in Cedars-Sinai. Clarke asked him to record voice-overs from his hospital bed. Hurrell agreed. On May 16 a doctor came to Hurrell's bedside and told him that his life would soon be ending. "Party's over," said Hurrell. "Time to go home."

George Edward Hurrell died on May 17, 1992, fourteen days before his eighty-eighth birthday.

OPPOSITE: A video camera preserved Hurrell's ritual magic in 1992, when J. Grier Clarke made the documentary *Legends in Light*. One of the delights of the film is watching Hurrell light Sharon Stone. Hurrell would be gone a few months later.

EPILOGUE

This artist's life was a rare one. George Hurrell supported himself with his art and he prospered with it. When it became passé, he adapted himself to new techniques. Twenty-five years later, his art was powerful enough to give him a second career. This one lasted fifteen years, surviving even his personal problems. How many artists have one career, let alone two? How many have been so honored in their lifetimes? And how many have been ambivalent about it?

George Hurrell's Hollywood has characterized the artist as a complex, abstruse, and somewhat perverse man. Researching his life granted no clues to his duality, other than his religious training, his refusal to discuss his parents, and the unhappy experience I had with him. An artist's work cannot be separated from his life, but seeking the cause of his temperament is as frustrating as isolating the source of his creativity. When all is said and done, what does it matter? From what I have learned, he found joy in his family and satisfaction in his art. That is what matters, not my unmet expectations of the man or some critic's opinion of his work. When I look at a Hurrell portrait, I see his gifts, not his failings. The movement and emotion with which he imbued a stationary piece of paper convey to me the pleasure he found in his art. That is what remains. And if this book conveys that, then the work I began with Hurrell in November 1975 has come to fruition.

In closing, I can only consider the words of the people he touched, and his own cryptic reflections.

David Fahey said, "His real passion was painting. He always wanted to be a painter in Laguna. He really didn't have the appreciation for his own photography that everybody else did."

Allan Rich said, "The story of Hurrell is the story of an innovative American artist. And boy, that's where the ball game is. What he was as a man was his problem. What remains is the brilliance of the human being. And a human being is so bloody imperfect to begin with."

John Kobal wrote: "George wasn't perfect. But almost. He snaps his bulb and a bit of a man's mortality is now become immortality, for at least as long as there is someone to see it, or until the day that negative dies, disintegrates, and releases its stolen life back into the void."

In 1969 George Hurrell said: "I wish to hell I'd stayed with painting, now that photography has gone to hell. I wish I'd stayed with painting."

My favorite George Hurrell quotation comes from a 1981 interview: "I had no formal training in photography. I just knew what I wanted to do. I followed my own drive and emotional concepts. That's part of it. You have to dream more."

OPPOSITE: This photograph of George Hurrell was taken in 1982 at Chapman's Picture Palace, the movie memorabilia store operated by collector Bill Chapman.

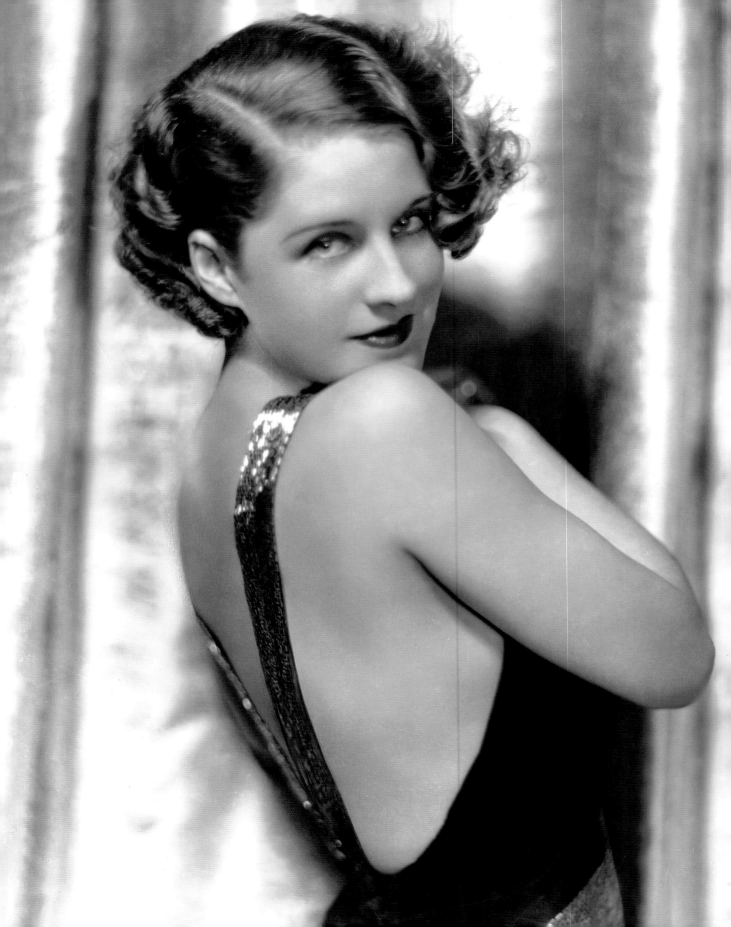

SELECTED CHRONOLOGY

1925
Edgar Payne
William Wendt

1926
Julia Bracken Wendt
Frank Cuprien
Florence Barnes

1928
Mary Forbes
Florence ("Pancho") Barnes

1929
Ramon Novarro
Irene Homer
Norma Shearer

1930
Anita Page
Joan Crawford
Wallace Beery
Johnny Mack Brown, *Montana Moon*
Robert Montgomery, Anita Page, *Free and Easy*
Buster Keaton, *Free and Easy*
Norma Shearer
Lottice Howell
Anita Page, *Our Blushing Brides*
Kay Johnson
Raymond Hackett, Dorothy Janis
Lewis Stone, *Strictly Unconventional*
Dorothy Sebastian
Chester Morris, Robert Montgomery, Wallace Beery, *The Big House*
Buster Keaton, Sally Eilers, *Doughboys*
Greta Garbo on the set of *Romance*
Ramon Novarro

Joan Crawford (beach)
Greta Garbo, *Romance*
Lon Chaney, *The Unholy Three*
Joan Crawford, Douglas Fairbanks Jr.
Harriet Lake
William Haines
Robert Montgomery
Cliff Edwards
Leila Hyams
Marie Dressler, Wallace Beery, *Min and Bill*
Grace Moore
Kay Francis, *Passion Flower*
Marion Davies
Anita Page (home)
Buster Keaton, *Parlor, Bedroom, and Bath*
Constance Bennett, Robert Montgomery, Adolphe Menjou, *The Easiest Way*
Lili Damita
Marie Dressler
Clark Gable

1931
Ray Milland
Norma Shearer, *Strangers May Kiss*
Lupe Velez
John Gilbert
Anita Page
Buster Keaton
Edwina Booth
Neil Hamilton
Clark Gable, Norma Shearer, *A Free Soul*
Gwen Lee
Robert Montgomery, *Shipmates*
Lilian Bond
Joan Crawford, *This Modern Age*
Neil Hamilton

Alfred Lunt, Lynn Fontanne, *The Guardsman*
Lois Moran, *West of Broadway*
Marion Davies, *It's a Wise Child*
Gwen Lee
Jackie Cooper
Erin O'Brien Moore
Marjorie King
Joan Crawford (home)
Joan Crawford, Clark Gable, *Possessed*
Madge Evans
Anita Page
Kathryn Crawford, Bert Lahr, *Flying High*
Leila Hyams
Myrna Loy
Norma Shearer, *Private Lives*
Wallace Beery
Dorothy Jordan

1932
Joan Crawford
Wallace Beery
Lionel Barrymore

John Barrymore, *Grand Hotel*
Una Merkel
Joan Crawford
Madge Evans
Wallace Ford
Alexander Kirkland
Jackie Cooper
Norma Shearer, *Strange Interlude*
Nils Asther
Norma Shearer, Clark Gable, *Strange Interlude*
Joan Marsh
Jean Harlow
Joan Crawford, *Letty Lynton*
Erich von Stroheim, Hedda Hopper, Melvyn Douglas, *As You Desire Me*
Robert Young
Jean Harlow, *Red-Headed Woman*
Anita Page
Thelma Todd, *Speak Easily*
Robert Montgomery, *Letty Lynton*
Karen Morley
John Gilbert, *Downstairs*

OPPOSITE: George Hurrell made this portrait of Norma Shearer in 1931 to publicize George Fitzmaurice's *Strangers May Kiss.*

LEFT: On June 30, 2008, Canada Post used it as the basis for a postage stamp in its "Canadians in Hollywood" series, honoring Shearer, and indirectly, Hurrell.

Leslie Howard, *Smilin' Through*
Jean Harlow
Myrna Loy
Norma Shearer, *Smilin' Through*
Joan Crawford
Lilyan Tashman
Joan Bennett
Norma Shearer
John, Lionel, and Ethel Barrymore
Warner Baxter, *Dangerously Yours*
Irene Ware, *Chandu the Magician*
Boots Mallory
Miriam Jordan
Laurence Olivier
Lupe Velez
Norma Shearer
Sally Eilers
Joan Crawford

1933

Joan Crawford
Mae West
Carole Lombard
Hedda Hopper
Helen Hayes
Marian Nixon
Mary Pickford
Douglas Fairbanks Jr.
Eugenie Leontovich
Helen Chandler
Myrna Loy
Sally O'Neil
Jean Harlow, *Dinner at Eight*
Maureen O'Sullivan, *Stage Mother*
Nancy Carroll
Eleanor Roosevelt
Jean Harlow (for first issue of *Esquire*)
Norma Shearer
Madge Evans
Joan Crawford, Clark Gable, *Dancing Lady*

Loretta Young, *The House of Rothschild*
Joan Crawford, Franchot Tone (home)
Jean Harlow, *Bombshell*
Anna Sten, *Nana*
Jean Harlow (at Bullock's [1])
Jeanette MacDonald, *The Cat and the Fiddle*
Loretta Young
Constance Bennett, *Moulin Rouge*
Karen Morley

1934

Grace Moore
Wallace Beery, *Viva Villa!*
Mae Clarke, *This Side of Heaven*
Janet Beecher, *Gallant Lady*
Norma Shearer, *Riptide*
Mary Carlisle
Ann Sothern
Constance Bennett, *The Affairs of Cellini*
Fay Wray
Joan Crawford, *Sadie McKee*
Ginger Rogers, *Change of Heart*
Alice Faye
Franchot Tone
George Hoyningen-Huene
Marian Nixon, *The Line Up*
Jean Harlow, *The Girl from Missouri*
Anna Sten, *We Live Again*
Mary Brian, *A Private Scandal*
Joan Crawford, *Chained*
Norma Shearer, *The Barretts of Wimpole Street*
Jean Harlow
Paulette Goddard, *Modern Times*
Ethel Merman, *Kid Millions*
Mary Pickford
Jean Parker
Robert Montgomery

Jean Harlow (home)
Norma Shearer (Irene gowns)
Jean Harlow (*Vanity Fair*)
Doris Kenyon
Ralph Bellamy
Joan Crawford, *Forsaking All Others*

1935

Myrna Loy
Frances Dee
Joel McCrea
Merle Oberon, *Dark Angel*
Joan Crawford, *No More Ladies*
Mary Pickford (book jacket portrait)
Franchot Tone
Clifton Webb
Margo
Jean Harlow, *Reckless/China Seas*
Charles Farrell, *Forbidden Heaven*
Johnny Weissmuller
Jeanette MacDonald
Rosalind Russell
Joan Crawford, *I Live My Life*
Shirley Temple, John Boles, *The Littlest Rebel*
Norma Shearer
Carole Lombard (color cover for *Photoplay*)
Jean Harlow (at Bullock's [2])
William Powell
Gene Raymond
Nelson Eddy
Bill Robinson
Miriam Hopkins, *These Three*
Merle Oberon
Joel McCrea
Samuel Goldwyn
Fritz Lang
Kitty Carlisle

Joan Crawford, Franchot Tone (home)

1936

Norma Shearer, Leslie Howard, *Romeo and Juliet*
Simone Simon
Ida Lupino
Luise Rainer
Jeanette MacDonald
Rosalind Russell, *Trouble for Two*
Carole Lombard, *The Princess Comes Across*
Josephine Hutchinson
Joan Crawford, *The Gorgeous Hussy*
Irene Dunne, *Show Boat*
Frances Dee
Joan Crawford, Clark Gable, *Love on the Run*
Joan Bennett
Madeleine Carroll
Robert Taylor
Constance Bennett

1937

Shirley Temple
Alice Faye
Loretta Young
Tyrone Power
Warner Baxter
Ronald Colman
Madeleine Carroll, Douglas Fairbanks Jr., *The Prisoner of Zenda*
Robert Taylor
Jean Harlow
William Powell
Robert Montgomery
Joan Crawford, *The Last of Mrs. Cheyney*
Marlene Dietrich
Carole Lombard
Anna May Wong
Betty Grable
Joan Crawford, *Mannequin*
Paul Muni

Shirley Temple, *Heidi*
Dolores Del Rio, *Lancer Spy*
Alice Faye

1938

Jean Muir
Errol Flynn, *The Adventures of Robin Hood*
Ronald Colman, *If I Were King*
Claudette Colbert, *Bluebeard's Eighth Wife*
Joan Bennett, *The Texans*
Anna May Wong, *Dangerous to Know*
Charles Boyer
Janet Gaynor, *The Young at Heart*
Katharine Hepburn
Ann Sheridan, *Angels with Dirty Faces*
John Garfield
Humphrey Bogart
George Brent
James Cagney
Olivia de Havilland
John Payne
Jane Wyman
Paul Muni
Errol Flynn
Bette Davis, *Dark Victory*

1939

Bette Davis, *Juarez*
John Payne, *Kid Nightingale*
Ann Sheridan "Oomph" Campaign
Priscilla Lane
Humphrey Bogart
James Cagney, *The Roaring Twenties*
James Cagney, *The Oklahoma Kid*
Vera Zorina, *On Your Toes*
Bette Davis, *The Private Lives of Elizabeth and Essex*
Margaret Lindsay

Olivia de Havilland
Bette Davis
George Brent
Miriam Hopkins, *The Old Maid*
John Garfield
Nell O'Day, *Saturday's Children*

1940

Helen Vinson
Olivia de Havilland, *Santa Fe Trail*
Bette Davis, *All This and Heaven, Too*

1941

M. F. K. Fisher
Joan Crawford
Bette Davis, *The Little Foxes*
Barbara Stanwyck, Gary Cooper, *Ball of Fire*
Barbara Stanwyck, *Meet John Doe*
Alexis Smith
Veronica Lake, *I Wanted Wings*
Paulette Goddard
Betty Hutton
Jane Russell, *The Outlaw*

1942

Michele Morgan
Maria Montez
Fred Astaire
Rita Hayworth
Rosalind Russell
Loretta Young
Mae West
Margie Stewart

1943

Adele Mara
Marguerite Chapman
Rosalind Russell
Claire Trevor, *The Desperadoes*
Joan Crawford

1944

Fanny Brice
Joan Crawford

1945

Esquire

1946

Joan Crawford
J. Walter Thompson
 Agency advertising

1952

Marlene Dietrich
Arlene Dahl
Ann Sheridan
Maureen O'Hara
Yvonne De Carlo

1954

J. Walter Thompson

1957

Peter Lawford, *The Thin Man*

1962

Sergeants Three

1964

The Dick Powell Theatre
The Loretta Young Show

1965

Julie Andrews, *Star*

1968

Mod Squad
Mannix

1969

Justine
Flare-up
Che
100 Rifles
The Only Game in Town
Myra Breckenridge

1970

Beneath the Planet of the Apes
John Kobal

1971

The Mephisto Waltz
The Brady Bunch

1972

Mama Cass Elliott

1974

Bette Davis
Raquel Welch, *The Wild Party*

1975

John Kobal
Fifi D'Orsay
Keith Carradine

1976

Tere Tereba
Margaux Hemingway
Anne Archer

1977

Natalie Wood
Joan Rivers
Bette Midler
Neil Diamond
Tom Waits
John Dean
Bianca Jagger
David Bowie
Alex Haley

1979

Lionel Richie
Aretha Franklin
Chevy Chase
Erte

1980

Rona Barrett
Sharon Gless
Clare Booth Luce

LEFT: Hurrell's own reflection can be glimpsed on the back of his camera.

1981

Haute Couture Collection
 for Paris *Vogue*
Barry Manilow
David Byrne
Fleetwood Mac
Lindsay Buckingham
Faye Dunaway
Brooke Shields
Jessica Lange
Farrah Fawcett
Ryan O'Neal

1982

Anthony Geary
Alexander Godunov
David Soul
Peggy Fleming
Lesley Ann Warren
Helen Reddy
Morgan Fairchild

1983

Eric Douglas
Chris Lemmon
Joan Collins

1984

Harrison Ford
Terri Garr
Jamie Lee Curtis
Paula Prentiss
Suzanne Pleshette

1985

Diana Ross
Paul and Linda McCartney
Laurie Hendler
Arnold Schwarzenegger
Talking Heads
Grace Jones
Dolph Lundgren

1986

Queen
Molly Ringwald

1987

Alexander O'Neal
Pointer Sisters

1988

Teaze
Basia
Ry Cooder
Bryan Murphy
Jefferson Wagner
John Sedler
Dean Stockwell
Tracey Ullman
Barry Levinson
Helmut Newton
Don and Cheryl Weinstein

1989

Emilia Crow
John Candy
Glen Scott
Ed Harris
Jeff Daniels
President Ronald Reagan
Loretta Young

Desmond Child
Sherry Lansing

1990

Johnny Mathis
Pet Shop Boys

1991

Sharon Stone
Richard E Settle
David Duchovny
Michael Biehn
Tony Peck
Mario Van Peebles
Jeff Fahey
Warren Beatty,
 Annette Bening, *Bugsy*
Natalie Cole
David Stenn

1992

Sean Young
Raquel Welch
Sharon Stone

COLLECTING HURRELL

George Hurrell's photographs continue to be a presence in the marketplace, in spite of economic trends and permutations in media. I would like to share a few highlights of my experience, both as a collector of Hurrell prints and as an archival printer. I hope that these will help the reader who would like to own a photo by Hurrell or who just wants to know a bit more.

I will begin with studio portraits made between 1930 and 1943. During Hurrell's first year at M-G-M, he made most of the 10x13 enlargements himself. These are known as "custom prints." He always used the same enlarging easel, so these prints are identifiable by a tiny notch toward the left of the inside upper border. It is possible that he filed the notch himself or that the easel was old and damaged. These prints are also recognizable by their color; many of them faded a few years after Hurrell printed them because he used exhausted fixer. Important: a print that has yellowed will not continue to yellow and fade entirely. There is a finite amount of chemicals in the emulsion.

Hurrell's M-G-M prints from 1931 and 1932 are mostly free of yellowing. And Hurrell was not using that original easel. The custom enlargements from this period were 10x13 double-weight paper with a luster surface, usually ink-stamped "Hurrell" on the reverse or "blind stamped" (embossed) in the lower right border, but rarely both. Hurrell occasionally printed on matte paper; these prints were intended as gifts for (or from) studio employees; the heavy grain of the paper was meant to discourage unauthorized copying or publication.

Between 1932 and 1938, the custom prints Hurrell made at his own studio for private commissions were usually on 11x14 double-weight glossy paper with narrow borders or no borders, although I have seen some on matte paper. The custom prints of his work from this period that were made for M-G-M, the Fox Film Corporation, Goldwyn, and other studios were usually printed by the studio after Hurrell had made the artist's proof for them to match. Because of the quantity of custom prints, there was no time for Hurrell, even with his assistants, to make

them. Yet, with few exceptions, these are the best prints of Hurrell's work, especially the M-G-M prints made between 1933 and 1937. They have clarity, a tonal range, and a consistency of interpretation that make them superior to Hurrell prints of any other period. Hurrell can thank Clarence Bull for the excellence of the lab work, and collectors can also thank him because these seventy-five-year-old prints look like they were printed yesterday.

The 8x10 glossy prints were made by machine. Each studio designed its own, but they all used a roll of paper that was pulled through the machine and flashed by a contact printing device that held the negative. Hundreds, often thousands, of prints were made in this way. Can we consider these 8x10 glossies "collectible" Hurrell prints? They were rarely stamped as Hurrell prints and they were usually printed lighter than his custom prints, so probably not. Are there hard-and-fast rules for this? No. Are there M-G-M single-weight glossy prints stamped "Hurrell"? Yes. Are they collectible? Yes.

What about oversize prints from Paramount in 1937? That studio usually ignored Hurrell's request that they stamp his name on the back of his work. It may be that publicity director John Engstead disliked him, because Eugene Robert Richee's prints from the same period are stamped. A collector has to know that Betty Grable was photographed by Hurrell at Paramount in 1937, even if the studio refused to stamp "Hurrell" on the back of the print. Be careful! There are portraits of Betty Grable by Gene Richee and William Walling that look like Hurrell's work. The only way to be certain is to find one print from the same sitting that is stamped. Or look for Hurrell's toplight.

I am often asked: "What happened to this single-weight photo? It's smaller than 8x10. It has no border. But it's stamped 'Hurrell—Warner Bros.' Is it genuine?" Yes. When Hurrell went to Warner Bros. in mid-1938, he began using single-weight glossy prints and customized his look further by trimming the borders. Are they custom prints? They may be. We can't be sure. But if they are stamped, they probably

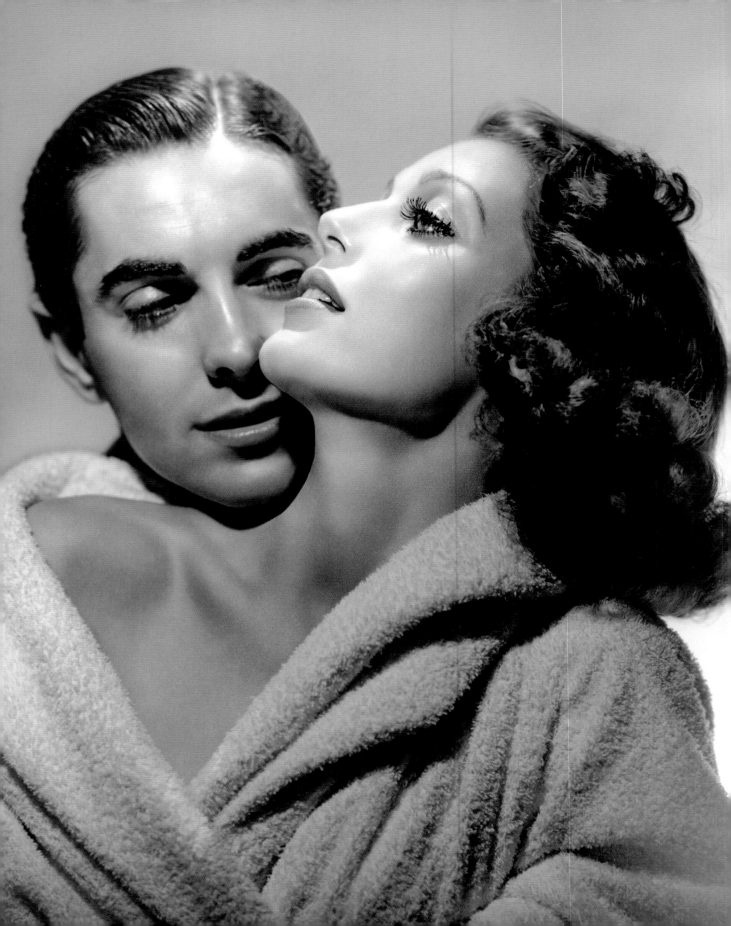

were printed by hand. Warner Bros. had a very large dark-room staff.

Hurrell used stamps of varying sizes and fonts between 1928 and 1943. He occasionally signed prints in pencil, sometimes within the image and sometimes in the border, and usually his full name. He evolved his distinctive single-name signature in the early 1940s. In the late 1970s he began signing prints with paint.

Allan Rich and CAI retained the Hurrell portfolios and a collection of vintage prints until 2002, when the entire group—and the rights therein—were sold to Michael H. Epstein and Scott E. Schwimer. For the next eight years, Mr. Epstein marketed this material under the name hurrellphotos.com. He acquired several hundred additional Hurrell negatives and engaged me to print them, which I did, implementing the guidelines I had learned from mentors who included Edd Hearn, Procopio Calado, Laszlo Willinger, Ted Allan, Clarence Bull, and Hurrell himself. I processed the prints archivally according to Eastman Kodak standards. If stored properly, these prints will last centuries. Like Hurrell, I used Agfa paper. In 2005

the factory closed. I switched to Ilford and was delighted by its quality. My delight was short lived.

By 2016 chemical photography had been all but eliminated by digital photography. Fortunately, a few stores continued to sell photographic supplies; I bought these from B&H, Freestyle, and Samy's. By 2019 there were no more vintage Hollywood negatives available for me to print, even though the technology still existed. I was urged to try digital printing of the high-resolution files I had restored in Photoshop for this book. I was very surprised to see that the Canon Pro Graf 1000 printer, using Cason Platine paper, made superior prints of my favorite Hurrell images. My prior experiences with digital had been unsatisfactory, so it felt almost blasphemous to put a Canon digital print alongside a vintage photograph. I needn't have worried. The two images were almost indistinguishable, except that the digital print had improved both highlight and shadow detail. My archival work continues.

––––––––––

The Hurrell Estate retains rights to George E. Hurrell's name, image, and trademark. It has no connection to any other entity selling Hurrell material or writing about Hurrell. It does grant rights for reproduction and has a library of images available for rental through its website, georgehurrell.com.

The author would like, as much as possible given his resources, to answer questions that relate to Hurrell history and chronology. Vieira would, however, like to clarify certain issues. He does not make appraisals or involve himself in Hurrell business. As the text makes clear, he was never an employee, assistant, or protégée of Hurrell. As an artist in his own right, Vieira interprets Hurrell's work as he believes Hurrell would have wanted.

OPPOSITE: George Hurrell made this portrait of Tyrone Power and Loretta Young in 1937 for the Twentieth Century-Fox film *Love Is News*. "Hurrell did what we call poster art," recalled Loretta Young in 1987. "Tyrone Power and I went to his studio for a full day. Tyrone was the most beautiful thing in the world anyway. He was prettier than I was. But, you know, Hurrell made everybody, male and female, look great. What's the word? *Idealized.* Yes, I like that. I like looking at the beauty in the world—more than the ugliness." To Loretta Young's credit, she was a lifelong Hurrell booster, and her dislike of ugliness did not stop her from going to Skid Row missions to feed the destitute.

BIBLIOGRAPHY

BOOKS

Alpert, Hollis. *The Barrymores*. New York: The Dial Press, 1964.

Baxter, John. *The Films of Josef von Sternberg*. London, TBS, 1971.

Bull, Clarence Sinclair, and Raymond Lee. *Faces of Hollywood*. Cranbury, NJ: A. S. Barnes, 1968.

Crawford, Joan, and Jane Kesner Ardmore. *A Portrait of Joan*. Garden City, NY: Doubleday, 1962.

Dammann, April. *Exhibitionist: Earl Stendahl, Art Dealer as Impresario*. Santa Monica: Angel City Press, 2011.

Dance, Robert. *Ruth Harriet Louise and Hollywood Glamour Photography*. Berkeley: University of California Press, 2002.

Davis, Ronald L. *The Glamour Factory: Inside Hollywood's Big Studio System*. Dallas: Southern Methodist University Press, 1993.

Esquevin, Christian. *Adrian: Silver Screen to Custom Label*. New York: The Monacelli Press, 2008.

Eyman, Scott. *Lion of Hollywood: The Life and Legend of Louis B. Mayer*. New York: Simon and Schuster, 2005.

Fairbanks, Douglas Jr. *The Salad Days: An Autobiography*. New York: Doubleday, 1988.

Flynn, Errol. *My Wicked, Wicked Ways*. New York: G.P. Putnam's Sons, 1959.

Griffith, Richard, and Arthur Mayer. *The Movies*. New York: Simon and Schuster, 1970.

Gutner, Howard. *Gowns by Adrian: The M-G-M Years, 1928–1941*. New York: Harry N. Abrams, Inc., 2001.

Higham, Charles. *Hollywood Cameramen*. Bloomington: Indiana University Press, 1970.

Kobal, John. *People Will Talk*. New York: Alfred A. Knopf, 1985.

———. *The Art of the Great Hollywood Portrait Photographers*. New York: Alfred A. Knopf, 1980.

———. *Hollywood Glamor Portraits*. New York: Dover Books, 1976.

Kobal, John, and Raymond Durgnat. *Greta Garbo*. New York: Dutton, Vista, 1965.

Kotsilibas-Davis, James, and Myrna Loy. *Myrna Loy: Being and Becoming*. New York: Alfred A. Knopf, 1987.

Lambert, Gavin. *Norma Shearer*. New York: Alfred A. Knopf, 1990.

Marx, Samuel. *Mayer and Thalberg: The Make-Believe Saints*. New York: Random House, 1975.

Pepper, Terence, and John Kobal. *The Man Who Shot Garbo*. New York: Simon & Schuster, 1989.

Peters, Margot. *The House of Barrymore*. New York: Alfred A. Knopf, 1991.

Rooney, Darrell, and Mark A. Vieira. *Harlow in Hollywood*. Santa Monica: Angel City Press, 2011.

Russell, Rosalind, and Chris Chase. *Life Is a Banquet*. New York: Ace Books, 1979.

Schatz, Thomas. *The Genius of the System: Hollywood Filmmaking in the Studio Era*. New York: Pantheon Books, 1988.

Schlesinger, Arthur M. *The Coming of the New Deal, 1933–1935*. New York: Houghton Mifflin, 2003.

Shields, Scott, Ph.D., and Patricia Trenton, Ph.D. *Edgar Payne: The Scenic Journey*. San Francisco: Pomegranate Communications, 2012.

Silke, James R. *Here's Looking at You, Kid: Fifty Years of Fighting, Working, and Dreaming at Warner Bros.* New York: Little, Brown, and Company, 1976.

Steichen, Joanna. *Steichen's Legacy: Photographs, 1895-1973*. New York: Alfred A. Knopf, 2000.

Stenn, David. *Bombshell: The Life and Death of Jean Harlow*. New York: Doubleday, 1993.

Stern, Jean. *Enchanted Isle: A History of Plein Air Painting in Santa Catalina Island*. Irvine, California: Society of Plein Air Painters, 2003.

———. *In Nature's Temple: The Life and Art of William Wendt*. Irvine, California: The Irvine Museum of Art, 2008.

Stine, Whitney. *The Hurrell Style*. New York: John Day, 1976.

———, and Bette Davis. *Mother Goddam: The Story of the Career of Bette Davis*. New York: Hawthorn Books, Inc., 1974.

Trent, Paul. *The Image Makers*. New York: McGraw-Hill, 1972.

SIGNED ARTICLES

Albright, Thomas. "The Art of Capturing Stars." *San Francisco Chronicle*, June 27, 1980.

Allen, G. T. "Hurrell Exposes Glamour." *U.S. Camera* 5, no. 1 (January 1942), pp. 23-27.

_____. "Glamour Workshop." *U.S. Camera* 5, no. 1 (January 1942), pp. 74-76.

Apfelbaum, Sharon. "George Hurrell." *Palm Springs Life*, December 1980, pp. 18-20, 64.

Barrett, Sharon. "Shooting Stars." *Chicago Sun-Times*, May 18, 1980.

Birchard, Robert S. "The First Super-Collectors." *Pop Twenty* 1 (January 2012), pp. 64-65.

Borger, Irene. "George Hurrell's Hollywood Glamour." *Architectural Digest* 49, no. 4 (April 1992), pp. 66, 70, 74, 77.

Boz, Napoleon. "Shooting the Stars." *Hollywood Studio Magazine* 4, no. 5 (November 1969), pp. 4-5.

Busby, Marquis. "The Camera Does Lie." *Movie Mirror* 5, no. 1 (December 1933), pp. 46-48, 74.

Carle, Teet. "Backward Look at Glamor." *Hollywood Studio Magazine* 5, no. 9 (January 1971), pp. 8-10.

Carroll, Roger. "He Glamorizes Glamour." *Motion Picture* 63, no. 2 (March 1942), pp. 27-34, 62-64.

Carroll, Sidney. "George Hurrell: Glamour Monger." *Esquire* 13, no. 3 (March 1940), pp. 89, 111-12.

Champlin, Charles. "Tending His Pose Garden." *Los Angeles Times*, December 31, 1976, p. C-1.

Christy, George. "The Good Life." *The Hollywood Reporter*, July 27, 1979, p. 46.

_____. "Too Much of a Good Thing Can Be Wonderful." *Los Angeles Times*, December 21, 1969, p. 25.

Crane, Tricia. "Grand Master of Glamor." *Los Angeles Herald-Examiner*, January 29, 1988.

Fahey, David. "Interview with George Hurrell." G. Ray Hawkins Gallery *Photo Bulletin* 3, no. 3 (June 1980), pp. 1-6.

Haber, Joyce. "Shell Shock on the 'Myra' Set." *Los Angeles Times*, October 19, 1969, p. U-1.

Hayes, Robert. "George Hurrell." *Interview* 11, no. 3 (March 1981), pp. 31-34.

Hicks, Jerry. "A Brush with Art and History at the Laguna Art Museum." *Orange Coast*, June 2007, pp. 214-216.

Hurrell, George. "Glamour." *Esquire* 6, no. 11 (November 1936), pp. 45-46, 73.

_____. "Glamour Portraits with Any Camera." *PIC*, April 30, 1940, pp. 12-13.

_____. "Interview." *International Photographer*, September 1941, p. 3.

Jensen, George. "Movie Mag Pictures." *Rocky Mountain News*, December 1, 1974, p. 25.

Jones, Carlisle. "Studio Portraits." *International Photographer*, March 1941, pp. 13-15.

Kapitanoff, Nancy. "Sixty-three Years of Shooting the Legends." *Los Angeles Times Calendar*, December 15, 1991.

Kendall, Read. "Around and About in Hollywood." *Los Angeles Times*, March 21, 1939, p. 10.

Knight, Christopher. "The Legends Created by Photographer George Hurrell." *Los Angeles Herald-Examiner*, August 25, 1982.

Lacy, Madison. "An Interview with George Hurrell." *International Photographer*, January 1977, pp. 16, 17, 61.

LaSalle, Mick. "Lights Up on Hollywood's Hurrell," *San Francisco Chronicle*, January 16, 1995.

Lane, Virginia T. "Norma Shearer's New Wardrobe." *Modern Screen* 5, no. 4 (March 1933), pp. 40-42, 96-98.

Leider, R. Allen. "George Hurrell." *Celebrity* 3, no. 4 (April 1977), pp. 32-35.

Long, Rod. "The Man Who Made the Stars Shine." *Petersen's PHOTOgraphic* 9, no. 12 (April 1981), pp. 63-64.

Loynd, Ray. "Glamour Gallery of Hollywood." *Los Angeles Herald-Examiner*, January 4, 1977.

Massengill, Reed. "The Unsung Glamour of George Hurrell." *Flatiron News*, September 1995, p. 19.

Morrison, Barry. "Hurrell Has Focused on Stars." *Denver Post*, October 11, 1977, pp. 4, 10.

Morrison, Mark. "The Old Master Today." *Los Angeles* 26, no. 1 (January 1981), pp. 139, 251.

Nelson, Bradford. "Chaney Comes Back." *Screenland* (May 1930): pp. 32-33, 116-117.

Parsons, Harriet. "Norma Talks About Joan!" *Picturegoer* 2, no. 96 (March 25, 1933), pp. 12-13.

Quirk, May Allison. "Fulfillment of a Wink (Ramon Novarro)." *Photoplay* 43, no. 5 (April 1933), pp. 58, 87.

Roman, Robert C. "Boris Karloff." *Films in Review* 15, no. 7 (Aug.-Sept. 1964): pp. 389-412.

Schallert, Edwin. "Film Producers Shaken by Clean-up Campaign." *Los Angeles Times*, June 10, 1934.

_____. "Norma Shearer Reveals Why She Went Wrong." *Los Angeles Times*, July 10, 1932.

Stein, Jerry. "Hurrell's Hollywood Photos Have Glamour." *Cincinnati Post*, February 12, 1987.

Sullivan, Meg. "Hurrell's Magic Camera." *Los Angeles Daily News*, September 18, 1992.

Surmelian, Leon. "Studio Photographer Confesses." *Motion Picture* 56, no. 6 (January 1939), pp. 38-39, 53.

Tallmer, Jerry. "Rembrandt to the Stars." *New York Post*, March 13, 1985.

Taylor, Frank. "Still Photographer's View of Film Queens." *Los Angeles Times*, June 1, 1969.

Thirer, Irene. "Hurrell Waxes on Famed Lens Subjects." *New York Post*, November 13, 1940.

Wayne, Hollis. "Hollywood Hot Shots." *Playboy* 38, no. 12 (December 1991), pp. 118-23.

UNSIGNED ARTICLES

"All in a Day." *International Photographer* 9, no. 3 (April 1937), p. 1.

"Auction Notes." *The ARTnewsletter*, June 9, 1981, p. 8.

"Camera." *International Photographer* 9, no. 3 (October 1937), p. 9.

"The Camera Speaks." *Photoplay* 52, no. 8 (August 1938), pp. 26-27.

"5 by Hurrell." *PM*, March 8, 1942, pp. 16-17.

"George Hurrell." *International Photographer* 13, no. 9 (September 1940), pp. 3-4.

"George Hurrell Leaves to Join Army Air Force." *Hollywood Citizen News*, November 2, 1942.

"He Distracts the Hollywood Stars." *Oakland Tribune*, December 3, 1940.

"He Knows All the Angles." *Charlotte News*, July 26, 1941.

"How Hurrell Shoots." *Motion Picture*, November 1940, pp. 48-49.

"Hurrell." *Playboy* 30, no. 1 (January 1983), pp. 161, 172, 234.

"Hurrell's Magic." *The Coast*, October 1939, pp. 18, 48.

"Legal Tangle After Divorce." *Los Angeles Examiner*, August 29, 1944.

"Movie Glamour to Order." *Look* 4, no. 18 (August 27, 1940), pp. 18-21.

"The Norma Shearer Irving Thalberg Loves." *New Movie* 9, no. 5 (May 1934), pp. 32-33, 70-71.

"Novarro with Impressions." *Los Angeles Sunday Times*, October 20, 1929.

"Portrait Studies." *International Photographer* 12, no. 10 (November 1940), pp. 6-8.

"Shooting Stars." *People and Places*, February 1941.

"Short Takes: Hammered Out." *American Photographer* 7, no. 2 (August 1981).

"Some Newsy Notes on Matters of Art." *Los Angeles Times*, May 31, 1925, p. 34.

"Tradewinds: News of New Products." *International Photographer* 9, no. 11 (December 1937), p. 6.

"Trio of Major Units to Rise." *Los Angeles Times*, October 2, 1927, p. E1.

"TV Ad Pair Divorced." *Los Angeles Examiner*, May 19, 1955.

UNPUBLISHED DOCUMENTS

"Interview on George Hurrell, Photographer, by Robert L. Greene." Oral History Library of the Fashion Institute of Technology, 1987.

"Norma Shearer Arrouge Memoir Notes." Unpublished document, author's collection.

"Norma Shearer Interview by Fred Watkins, 1958." Unpublished document, author's collection.

"Popular Arts Project: Ben Hecht, 1959." Columbia University Oral History Collection.

"Popular Arts Project: Frances Marion, 1958." Columbia University Oral History Collection.

"Popular Arts Project: Jeanette MacDonald, 1959." Columbia University Oral History Collection.

AUDIO RECORDINGS

Crisp, Quentin. *An Evening with Quentin Crisp*. DRG Records, 1979.

Pratt, George C. "Interview with Ramon Novarro." Rochester, New York, April 17, 1968. Unpublished audio tape in the collection of Matias A. Bombal.

Alice Adams, Lux Radio Theatre, January 3, 1938.

DOCUMENTARY FILM

Legends in Light. Produced by Carl Colby and J. Grier Clarke. Directed by J. Grier Clarke, 1993.

WEB SITES

"Biography." Hurrell Estate Web Site, georgehurrell.com

INTERVIEWS

Ted Allan, March 2, 1986

Richard E. Braff, November 21, 1995

Clarence Sinclair Bull, November 2, 1975

Bill Chapman, November 29, 1995

David Chierichetti, December 3, 1995

George Christy, December 27, 1995

J. Grier Clarke, December 20, 1995

Simon Crocker, January 2, 1996

Louis F. D'Elia, M.D., November 28, 2012

David Del Valle, February 1, 1997

Matthew Daniels, May 14, 1987

David Fahey, January 11, 1996

Dore Freeman, December 2, 1975

G. Ray Hawkins, February 12, 1996

George Hurrell, November 1, 1975

George Hurrell Jr., January 27, 1996

John Kobal, March 31, 1976

Mick LaSalle, March 9, 1996

David Leddick, December 10, 1995

Howard Mandelbaum, December 29, 1995

Paul Morrissey, December 21, 1995

Marysa Maslansky, January 16, 1996

Anita Page, February 24, 1996

Allan Rich, January 2, 1996

Joan Rose, November 1, 1995

Jane Russell, August 30, 2010

Richard E. Settle, December 18, 2012

David Stenn, December 2, 1995

Jeremiah Sullivan, June 12, 1988

Jack Vizzard, January 16, 1998

Michael Vollbracht, December 22, 1995

Laszlo Willinger, April 25, 1987

NOTES TO THE TEXT

INTRODUCTION

I'm a somewhat screwy ... Hurrell, "Glamour," p. 44.

As long as I ... "Biography."

I went to the Academy ... Fahey, "Interview with George Hurrell," p. 4.

I got curious ... Carroll, "He Glamorizes Glamour," p. 62.

One day ... "Hurrell's Magic," p. 18.

Because George was entrusted ... Stern, *Enchanted Isle*, p. 86.

stubborn bacterial ... Stine, *The Hurrell Style*, p. 1.

No place ... "Some Newsy Notes on Matters of Art." *Los Angeles Times*, May 31, 1925, p. 34.

LAGUNA BEACH

picturesque cottage ... Hicks, "A Brush with Art and History at the Laguna Art Museum," p. 215.

I had to make ... Kobal, *People Will Talk*, p. 260.

Rembrandt was my ... Stein, "Hurrell's Hollywood Photos Have Glamour."

He made a portrait ... Stern, *In Nature's Temple*, p. 181.

They were all very ... Fahey, "Interview with George Hurrell," p. 3.

Whoever catches the ... "Biography."

William Wendt and His Work ... Dammann, *Exhibitionist*, p. 61.

Laguna Beach was such ... Fahey, "Interview with George Hurrell," p. 3.

Metro-Goldwyn-Mayer was filming ... The M-G-M film of *Romance* was released as *The Road to Romance*.

Pretty soon I was ... Fahey, "Interview with George Hurrell," p. 3

I was bored ... Kobal, *People Will Talk*, p. 260.

THE GRANADA SHOPPES AND STUDIOS

entirely new to ... "Trio of Major Units to Rise."

The Dockweilers were ... Kobal, *People Will Talk*, p. 260.

That slow pace ... Hayes, "George Hurrell," p. 32.

A scientist and a ... Steichen, *Steichen's Legacy*, p. 375.

Steichen was sort of ... Fahey, "Interview with George Hurrell," p. 3.

I apologized for ... Hurrell, "Glamour," p. 45.

this hearty young man ... *Legends in Light* (film).

Everyone takes me for a Spaniard ... Stine, *The Hurrell Style*, p. 5.

Pete had photographically perfect feature ... Ibid.

I'm old-fashioned ... Quirk, "Fulfillment of a Wink," p. 88.

Pete became more ... Stine, *The Hurrell Style*, p. 5.

I was really inspired ... Carle, "Backward Look at Glamor," p. 9.

You have caught my ... Stine, *The Hurrell Style*, p. 6.

Every night we would ... Pratt, "Interview with Ramon Novarro."

My God, George ... Apfelbaum, "George Hurrell," p. 18.

So I went to Murnau ... Pratt, "Interview with Ramon Novarro."

"WHEN MY BABY SMILES AT ME"

Why, Ramon ... Stine, *The Hurrell Style*, p. 7.

She will never forget ... "The Norma Shearer Irving Thalberg Loves," p. 71.

You wanted to be ... Norma Shearer, unpublished interview, 1958; author's collection.

You can't really be ... Ibid.

I knew that M-G-M was considering ... Parsons, "Norma Talks About Joan!," p. 13.

gracious Norma Shearer ... Jack Benny, spoken prologue of the M-G-M film *The Hollywood Revue of 1929*.

Oh, Miss Shearer, ... "The Norma Shearer Irving Thalberg Loves," p. 71.

I was only too ... Kobal, *People Will Talk*, p. 260.

Norma came with ... Lacy, "An Interview with George Hurrell," p. 17.

Welcome to my studio ... Stine, *The Hurrell Style*, p. 8.

Now there is ... Lambert, *Norma Shearer*, p. 130.

a tough little gal ... Kapitanoff, "Sixty-three Years of Shooting the Legends."

The idea was to get ... Kobal, *People Will Talk*, p. 260.

I was pretty nervous ... Hurrell, "Glamour," p. 45.

A great deal depended ... Busby, "The Camera Does Lie," p. 74.

It was my idea ... Kobal, *People Will Talk*, p. 260.

I'm afraid my legs ... Stine, *The Hurrell Style*, p. 8.

And I realized that she'd ... Lambert, *Norma Shearer*, p. 130.

And when my baby smiles ... "When My Baby Smiles at Me," words by Andrew B. Sterling and Ted Lewis, music by Bill Monroe; published by Harry von Tilzer, 1920. The recording played by Hurrell that day was most likely Columbia 922D, recorded in Chicago on November 22, 1926, by Ted Lewis and his band.

She didn't like it ... Ibid.

She laughed ... Lambert, *Norma Shearer*, p. 130.

I'd used more than ... Busby, "The Camera Does Lie," p. 74.

I hung the films ... Hurrell, "Glamour," p. 45.

We started stumbling ... NSA, p. 119.

Norma was like … "The Norma Shearer Irving Thalberg Loves," p. 71.

Why, I believe … Parsons, "Norma Talks About Joan!" p. 13.

It was a tremendous … Ibid.

The gal who had been … Fahey, "Interview with George Hurrell," p. 5.

(caption) *She ribbed me* … Kobal, *People Will Talk*, p. 260.

MORE STARS THAN THERE ARE IN HEAVEN

I didn't care about … Fahey, "Interview with George Hurrell," p. 5.

I didn't care whether … Hayes, "George Hurrell," p. 31.

I went in there … Fahey, "Interview with George Hurrell," p. 5.

Making pictures is not … Schallert, "Film Producers Shaken by Clean-up Campaign," p. 2.

The Culver City plant was … Marx, *Mayer and Thalberg*, p. 131.

Whenever we weren't … Kobal, *People Will Talk*, p. 263.

With George it was … Anita Page to the author, February 24, 1996.

I was always fighting … Kobal, *The Art of the Great Hollywood Portrait Photographers*, p. 211.

Clarence thought that … Fahey, "Interview with George Hurrell," p. 5.

I found that … Carle, "Backward Look at Glamor," p. 10.

Clarence Bull was … Trent, *The Image Makers*, p. 54.

I kept telling her … Fahey, "Interview with George Hurrell," p. 5.

I was the 'posy' type … Trent, *The Image Makers*, p. 54.

I felt a kind of … Stine, *The Hurrell Style*, p. 62.

Please forgive me … George Hurrell to the author, November 1, 1975.

I was the one … Higham, *Hollywood Cameramen*, p. 67.

I took a look … George Hurrell to the author, November 1, 1975.

She could 'feel' light … Clarence Sinclair Bull to the author, November 2, 1975.

There wasn't any problem … Kobal, *People Will Talk*, p. 265.

She wouldn't allow anybody … Ibid.

I hummed and jumped … Stine, *The Hurrell Style*, p. 20.

I had to work … Kapitanoff, "Sixty-three Years of Shooting the Legends."

She was going to do … Kobal, *People Will Talk*, p. 265.

She just sat there … Kapitanoff, "Sixty-three Years of Shooting the Legends."

On each sitting … Hayes, "George Hurrell," p. 32.

She didn't respond … Kobal, *People Will Talk*, p. 265.

But you didn't just tell … Fahey, "Interview with George Hurrell," p. 3.

Finally, I almost fell … Stine, *The Hurrell Style*, p. 20.

There's a crazy man … Pepper, *The Man Who Shot Garbo*, p. 23.

Lon Chaney once told … Roman, "Boris Karloff," p. 396.

I don't want to talk … Nelson, "Chaney Comes Back," p. 33.

Don't worry about … Stine, *The Hurrell Style*, p. 14.

How about some straight … Ibid., p. 15.

(caption) *The first time I ever* … Carroll, "He Glamorizes Glamour," p. 64.

(caption) *The results didn't* … Kobal, *The Art of the Great Hollywood Portrait Photographers*, p. 112.

(caption) *I made more photographs* … Kobal, *People Will Talk*, p. 267.

INVENTING THE GLAMOUR PORTRAIT

The best tunes are … Hamann, *On the Sets in the 30s*, p. 6.

Most of those portrait … Fahey, "Interview with George Hurrell," p. 4.

I did enjoy shooting … Kobal, *The Art of the Great Hollywood Portrait Photographers*, p. 211.

When you get into … Fahey, "Interview with George Hurrell," p. 4.

Ya got the best comedy … Stine, *The Hurrell Style*, p. 29.

Howard, I want that small … George Hurrell to the author, January 21, 1980; Stine, *The Hurrell Style*, p. 21.

I was trying … Kobal, *People Will Talk*, p. 262.

blending stump … George Hurrell to the author, November 1, 1975; terminology clarified by David Chierichetti, December 3, 1995.

I always tried to … Ibid., p. 266.

George Hurrell loved … Trent, *The Image Makers*, p. 54.

You know, George … Stine, *The Hurrell Style*, p. 23.

Shearer was right … Ibid.

I tried to create … Hayes, "George Hurrell," p. 34.

I jumped and hollered … Kapitanoff, "Sixty-three Years of Shooting the Legends."

I used to hate … George Hurrell to the author, November 1, 1975.

That was just the rule … Kobal, *People Will Talk*, p. 264.

The starlets knew the gallery … Ibid., p. 263.

(caption) *The best male* … Carroll, "He Glamorizes Glamour," p. 64.

(caption) *God, I deplore this* … Stine, *The Hurrell Style*, p. 86.

(caption) *Adrian was a loner* … Gutner, *Gowns by Adrian*, p. 131.

THE GILDED CAGE

When you got a … Laszlo Willinger to the author, April 25, 1987.

I always have butterflies … Stine, *The Hurrell Style*, p. 36.

whimsical something … Busby, "The Camera Does Lie," p. 73.

Nice touch … Stine, *The Hurrell Style*, p. 38.

He was almost shy … Ibid., p. 70.

The era of the sophisticated … Ibid.

It was a love … Crawford and Ardmore, *A Portrait of Joan*, p. 97.

When we went into … Ibid., p. 91.

get some sex … Ted Allan to the author, March 2, 1986.

A white dress … Stine, *The Hurrell Style*, p. 41.

We were on the same … Ibid.

When Jean wore … Ibid.

I'm not nervous … Busby, "The Camera Does Lie," p. 73.

The poor guy was fidgeting … George Hurrell to the author, December 1, 1975.

She'd come the long … Eyman, *Lion of Hollywood*, p. 223.

Yes, Howard … Eyman, *Lion of Hollywood*, p. 223.

He'd rather go … Busby, "The Camera Does Lie," p. 73.

If you can put it there … Norma Shearer, unpublished interview, 1958; author's collection.

crazy man … John Kobal to the author, March 31, 1976.

beauteous and fiery … Crawford and Ardmore, *A Portrait of Joan*, p. 94.

His 'presence' was similar … Stine, *The Hurrell Style*, p. 53.

If I couldn't work … Fahey, "Interview with George Hurrell," p. 5.

To hell with the … Ibid.

A fight was brewing … Joan Rose to the author, November 1, 1995.

I told him … George Hurrell to the author, November 1, 1975.

On a weekend … Fahey, "Interview with George Hurrell," p. 4.

And while I had no contract … Kobal, *People Will Talk*, p. 264.

I saw no reason … Ibid.

What do you mean … Stine, *The Hurrell Style*, p. 77.

My God … Fahey, "Interview with George Hurrell," p. 4.

Look! I've had … Stine, *The Hurrell Style*, p. 77.

If you leave Metro … Mayer did, in fact, blackball Harvey White, Stephen McNulty, and Ted Allan … Ted Allan to the author, March 2, 1986.

George has quit … George Hurrell to the author, November 1, 1975.

(caption) *It started with the* … Kobal, *People Will Talk*, p. 258.

(caption) *A top light on Myrna* … Busby, "The Camera Does Lie," p. 73.

(caption) *He was a serious* … Fahey, "Interview with George Hurrell," p. 4.

(caption) *The serious moments* … Fahey, "Interview with George Hurrell," p. 5.

(caption) *the single most important* … Esquevin, *Adrian*, p. 17.

(caption) *He was a really great* … Kobal, *People Will Talk*, p. 267.

"I WISH I LOOKED LIKE THAT"

Allow me to pay … George Hurrell to Norma Shearer, July 16, 1932, Norma Shearer Collection, Cinematic Arts Library, University of Southern California.

There was nothing exactly … NSA, p. 404.

I can't do the Garbo … Schallert, "Norma Shearer Reveals Why She Went Wrong."

They would build up … Fahey, "Interview with George Hurrell," p. 4.

What are you doing … Stine, *The Hurrell Style*, p. 78.

Strick called Norma … Kapitanoff, "Sixty-three Years of Shooting the Legends."

We're sorry, Miss Shearer … Busby, "The Camera Does Lie," p. 73.

She was the Queen … Stine, *The Hurrell Style*, p. 25.

I have to have … "Interview on George Hurrell, Photographer, by Robert L. Greene." Oral History Library of the Fashion Institute of Technology, 1987 (hereinafter "Greene Hurrell Interview"), p. 28.

I want a few snaps … Stine, *The Hurrell Style*, p. 61.

I've spent a lifetime … Carroll, "He Glamorizes Glamour," p. 62.

glaring, gaudy, nightmarish … Peters, *The House of Barrymore*, p. 271.

sprayed stucco … In 1996, the land owner, Francis J. Montgomery, wrote: "About 1892, Victor and Nellie Ponet bought approximately 280 acres, extending from Santa Monica Boulevard to the top of the mountain. Victor Ponet died in 1914 and control of his business passed to his son-in-law Francis S. Montgomery, who in 1924 built four store buildings … along the south side of the two-lane paved road that was Sunset Boulevard.

"About 1931, my father and my mother (Gertrude Ponet Montgomery) formed a corporation, Montgomery Properties, Limited, which was eventually George Hurrell's landlord. In 1951, it became the Montgomery Management. I'm sorry to have no personal recollection of Hurrell; I was in college at the time. I do remember that the entire building burned down twenty-five years later.

"About four years ago, two-thirds of the building was rebuilt for Armani Exchange. The rest of the building is now being rebuilt for Wathne, an outdoor clothing company from Iceland, presently operating in New York City." (Letter to the author, February 26, 1996).

At the end of February … Schlesinger, *The Coming of the New Deal*, p. 69.

I admire and like Joan … Parsons, "Norma Talks About Joan!," p. 12.

erudite, urbane … Stine, *The Hurrell Style*, p. 68.

I wish I looked like that … Busby, "The Camera Does Lie," p. 74.

I passed the door … Griffith, *The Movies*, p. 294.

The first time … Kobal, *People Will Talk*, p. 264.

You could feel an … Borger, "George Hurrell's Hollywood Glamour," p. 74.

George, I want you … Stine, *The Hurrell Style*, p. 179.

So nice to meet … Ibid., p. 101.

Harvey came to M-G-M … David Stenn to the author, December 2, 1995.

When you got her alone ... Stenn, *Bombshell*, p. 171.

She had will ... Ibid., p. 169.

Hollywood's youthful wizard ... Busby, "The Camera Does Lie," p. 46.

(caption) *Norma's New Wardrobe* ... Lane, "Norma Shearer's New Wardrobe," p. 40.

(caption) *I wish I looked* ... Busby, "The Camera Does Lie," p. 74.

(caption) *She was warm, outgoing* ... "Hurrell Has Focused on Stars," p. 10.

(caption) *When illness rendered* ... "The Norma Shearer Irving Thalberg Loves," p. 71.

(caption) *I was trying to* ... "Greene Hurrell Interview," p. 12.

(caption) *Crawford had that kind* ... Fahey, "Interview with George Hurrell," p. 4.

THE HURRELL STYLE

We make Ann a star ... Stine, *The Hurrell Style*, p. 116.

Anoushka's face could ... George Hurrell to the author, July 17, 1976.

I took hundreds of exposures ... Stine, *The Hurrell Style*, p. 117.

Personally I like blue ... Busby, "The Camera Does Lie," p. 74.

If I posed Jean ... Stine, *The Hurrell Style*, p. 41.

We had a run ... George Hurrell to the author, December 1, 1975.

I put him up ... Ibid.

One day I made ... Ibid.

along with a load of evening ... Russell, *Life Is a Banquet*, p. 63.

Those gals were products ... Borger, "George Hurrell's Hollywood Glamour," p. 74.

You'd see them at parties ... Kobal, *People Will Talk*, p. 259.

Loretta Young was one ... Stine, *The Hurrell Style*, p. 134.

I saw some pictures ... Stein, "Hurrell's Hollywood Photos Have Glamour."

She was a disciplined ... Stine, *The Hurrell Style*, p. 134.

Just take a look ... Kobal, *People Will Talk*, p. 385.

What I liked ... Ibid.

Familiarity breeds contempt ... Fahey, "Interview with George Hurrell," p. 6.

Howard looked at one ... Ted Allan to the author, March 2, 1986.

He was an artist ... Fahey, "Interview with George Hurrell," p. 4.

All you had to ... Hayes, "George Hurrell," p. 34.

We would gab ... Stine, *The Hurrell Style*, p. 89.

one of the ace ... "All in a Day."

(caption) *Wallace Beery projected* ... Kobal, *People Will Talk*, p. 270.

(caption) *I admired his work* ... Fahey, "Interview with George Hurrell," p. 4.

(caption) *Bill hated stiff poses* ... Stine, *The Hurrell Style*, p. 89.

(caption) *Bob Taylor wasn't the* ... Stine, *The Hurrell Style*, p. 89.

THE ICONS

The people in these ... Jensen, "Movie Mag Pictures."

There were only a ... NSA, p. 187.

I had never seen ... Stine, *The Hurrell Style*, p. 97.

She never gave me ... Taylor, "Still Photographer's View of Film Queens."

Carole Lombard has a knack ... Surmelian, "Studio Photographer Confesses," p. 53.

She could swear ... Taylor, "Still Photographer's View of Film Queens."

just a big, healthy, happy girl ... Borger, "George Hurrell's Hollywood Glamour," p. 77.

Jean used to come ... "Popular Arts Project: Jeanette MacDonald, 1959." Columbia University Oral History Collection, p. 1564 (hereinafter "MacDonald, CUOHC").

She'd come in with ... Kobal, *People Will Talk*, p. 267.

Harlow would just drop ... Stenn, *Bombshell*, p. 145.

Harlow was not frightened ... Stine, *The Hurrell Style*, p. 97.

The heat is really turned ... Rooney, *Harlow in Hollywood*, p. 143.

I actually began to ... Borger, "George Hurrell's Hollywood Glamour," p. 77.

It was always a joy ... Kapitanoff, "Sixty-three Years of Shooting the Legends."

She was very sensitive ... Stine, *The Hurrell Style*, p. 41.

We were talented ... Kobal, *Hollywood Glamor Portraits*, p. x.

What happened to ... Russell, *Life Is a Banquet*, p. 66.

I could tell she ... Stenn, *Bombshell*, p. 210.

I hardly recognized ... Stine, *The Hurrell Style*, p. 90.

I genuinely liked ... Ibid., p. 41.

The girl was driven ... Joan Rose to the author, November 1, 1995.

(caption) *She's such a spontaneous* ... Surmelian, "Studio Photographer Confesses," p. 53.

(caption) *At her age* ... Kapitanoff, "Sixty-three Years of Shooting the Legends."

(caption) *My style is designing* ... Ibid.

(caption) *Harlow was spirited* ... Stine, *The Hurrell Style*, p. 41.

THE PATRON

the ultra-civilized ... Kobal and Durgnat, *Garbo*, p. 47.

something new ... Mick LaSalle to the author, March 9, 1996.

If I just stayed ... Schallert, "Norma Shearer Reveals Why She Went Wrong."

Each time, she seemed ... Lambert, *Norma Shearer*, p. 214.

Strangely enough ... Busby, "The Camera Does Lie," p. 74.

She knew how to ... Kobal, *People Will Talk*, p. 267

She worked in front ... Ibid.

My experience in silent ... NSA, p. 342.

Norma is a very strong-minded ... Thomas, *Thalberg*, p. 164.

I have a fierce ... NSA, p. 425.

She ribbed me ... Kobal, *People Will Talk*, p. 257.

(caption) *I was always fighting …* Kobal, *The Art of the Great Hollywood Portrait Photographers*, p. 211.

(caption) *You can't fool …* NSA, p. 429.

(caption) *The trace of a …* Ibid.

THE MUSE

They made themselves … Kobal, *People Will Talk*, p. 265.

To walk onto a set … Ibid., p. 286.

Sometimes Crawford would … Joan Rose to the author, November 1, 1995.

The studio didn't make … Kobal, *People Will Talk*, p. 280.

Joan had begun to … NSA, p. 214.

I tried to watch everything … Crawford and Ardmore, *A Portrait of Joan*, p. 13.

She made no bones … Fairbanks, *The Salad Days*, p. 152.

mammoth Thalberg productions that … Kobal, *People Will Talk*, p. 280.

Ramon Novarro discovered George … Crawford and Ardmore, *A Portrait of Joan*, p. 96.

Joan and I ran neck and … NSA, p. 215.

Crawford would work … Kobal, *People Will Talk*, p. 260.

I loved posing … Trent, *The Image Makers*, p. 54.

She was the most serious … Christy, in *The Hollywood Reporter*; Hayes, "George Hurrell," p. 34.

I loved torch songs … Trent, *The Image Makers*, p. 54.

Once when I was … Busby, "The Camera Does Lie," p. 74.

Whenever we went to … George Hurrell to the author, July 17, 1976.

My assistant and I would … Borger, "George Hurrell's Hollywood Glamour," p. 77.

I would start out … Kobal, *People Will Talk*, p. 260.

She would just go … Carroll, "He Glamorizes Glamour," p. 64.

Hurrell would follow … Trent, *The Image Makers*, p. 54.

I used a fifteen-foot … Kobal, *People Will Talk*, p. 259.

Hurrell worked to … Trent, *The Image Makers*, p. 54.

I was always considering … Kobal, *People Will Talk*, p. 261.

Adrian taught me … Trent, *The Image Makers*, p. 54.

Hurrell introduced the … Crawford and Ardmore, *A Portrait of Joan*, p. 96.

A lot of the things … Kobal, *The Art of the Great Hollywood Portrait Photographers*, p. 112.

I used to get questions … Kobal, *People Will Talk*, p. 261.

She'd spend a whole day … Ibid., p. 260.

Joan Crawford is the most … "George Hurrell."

(caption) *I photographed …* Stine, *The Hurrell Style*, p. 62.

(caption) *Crawford was a natural …* Borger, "George Hurrell's Hollywood Glamour," p. 77.

(caption) *Joan Crawford has the …* Carroll, "He Glamorizes Glamour," p. 64.

(caption) *A lot of the things …* Kobal, *The Art of the Great Hollywood Portrait Photographers*, p. 211.

(caption) *Clark Gable is as natural …* Busby, "The Camera Does Lie," p. 74.

(caption) *She had this instinct …* Joan Rose to the author, November 1, 1995.

(caption) *Hurrell worked to …* Trent, *The Image Makers*, p. 54.

(caption) *I was always working …* Fahey, "Interview with George Hurrell," p. 5.

(caption) *Hurrell always played …* Trent, *The Image Makers*, p. 55.

(caption) *We always worked well …* Crawford and Ardmore, *A Portrait of Joan*, p. 93.

(caption) *Joan loved to be …* Stine, *The Hurrell Style*, p. 62.

THE STRAW BOSS

That will be enough … David Chierichetti to the author, December 3, 1995.

Colbert politely looked … Stine, *The Hurrell Style*, p. 110.

She'd never let you … Kobal, *People Will Talk*, p. 266.

Where were you … Richard E. Settle to the author, December 18, 2012.

a big assignment … "All in a Day," p. 1.

My God! I can't … Higham, *Hollywood Cameramen*, p. 40.

There are stars who … Independent photographer John Engstead showed Dietrich how her legs could be lengthened by using the "tilt" function on the view camera's back. Dietrich liked this, but she wondered how she could see this in the mirror. The problem was solved by warping the wood of the mirror to approximate the degree of stretch in the view camera.

I just refused … Kobal, *People Will Talk*, p. 267; Fahey, "Interview with George Hurrell," p. 4.

Shoot, George … "Tending His Pose Garden."

I had to admit … Stine, *The Hurrell Style*, p. 109.

James Montgomery Flagg … George Hurrell to the author, December 1, 1975.

After what happened … Laszlo Willinger to the author, January 21, 1985.

I got tired … Long, "The Man Who Made the Stars Shine," p. 63.

That's not my mouth … George Hurrell to the author, April 1, 1976.

I'm not a good straw boss … Fragmentary clipping from the *Oakland Post-Enquirer*, October 20, 1939.

Just about the time … Ibid.

(caption) *My style was considerably …* Stine, *The Hurrell Style*, p. 121.

(caption) *She didn't want to be …* Fahey, "Interview with George Hurrell," p. 5.

(caption) *Shoot, George. Shoot! …* "Tending His Pose Garden."

(caption) *If you didn't get …* Ibid.

"OOMPH!"

international portrait photographer … Fragmentary clipping, author's collection.

For a while we … Schatz, *The Genius of the System*, p. 214.

Jack L. Warner was tough … Silke, *Here's Looking at You, Kid*, p. 119.

It was not called … Davis, *The Glamour Factory*, p. 167.

jocose penny watcher … Schatz, *The Genius of the System*, p. 217.

The Ford of the Movies … Ibid.

Who wants to look … Silke, *Here's Looking at You, Kid*, p. 123.

Sol Polito just worked … Ibid.

You leave Ernie … Ibid., p. 125.

There was not the … Davis, *The Glamour Factory*, p. 142.

Your figures were … Letter, George Hurrell to Roy Obringer, July 11, 1938, Warner Brothers Collection, Cinematic Arts Library, University of Southern California.

Those fan magazines … Davis, *The Glamour Factory*, p. 250.

Jack Warner even worried … Silke, *Here's Looking at You, Kid*, p. 121.

Hurrell is to a portrait … *Lux Radio Theatre* air check, January 3, 1938.

Boom Lite … "Tradewinds," p. 6.

The power of glamor … Baxter, *The Films of Josef von Sternberg*, p. 53.

You know … Kobal, *People Will Talk*, p. 261.

There is this young … Ibid., p. 420.

Winchell used to … Ibid., p. 420.

They are all sexy … "He Distracts the Hollywood Stars."

I latched on to … John Kobal, *People Will Talk*, p. 261.

Oh, you're so good … "He Knows All the Angles."

One more … Carroll, "George Hurrell, Glamour Monger," p. 89.

Give … "Movie Glamor to Order," p. 18.

Every now and then … "He Distracts the Hollywood Stars."

Well it's chiefly the … Ibid.

Shoot for the sex angle … "Hurrell's Magic," p. 18.

Jack Warner was totally … Silke, *Here's Looking at You, Kid*, p. 121.

There are friends … Carroll, "George Hurrell, Glamour Monger," p. 112.

(caption) *When people asked* … Kobal, *People Will Talk*, p. 421.

(caption) *I'm a mug* … Stine, *The Hurrell Style*, p. 156.

(caption) *Bogart was very* … Ibid., p. 153.

(caption) *I never saw him* … Stine, *The Hurrell Style*, p. 156.

(caption) *I was labeled* … Flynn, *My Wicked, Wicked Ways*, p. 207.

SHINY WAX FRUIT

I was made to … Silke, *Here's Looking at You, Kid*, p. 237.

I dreamed that someday … Ibid., p. 235.

Bette Davis was the queen … Ibid., p. 239.

I don't want some … Taylor, "Still Photographer's View of Film Queens."

You're the most glamorous … "Movie Glamor to Order," p. 18.

You're beautiful, Bette … Stine, *Mother Goddam*, p. 110.

I don't play the music … "He Knows All the Angles."

All I had … Hayes, "George Hurrell," p. 31.

I don't remember … Taylor, "Still Photographer's View of Film Queens."

Hell, these are fine … Ibid.

There was something … Stine, *The Hurrell Style*, p. 144.

She had the ability … Ibid.

If you can keep … Kobal, *People Will Talk*, p. 261; also, George Hurrell to the author, July 17, 1976.

You think about shooting … Hayes, "George Hurrell," p. 32.

I liked shooting … Kobal, *People Will Talk*, p. 264.

A queen doesn't take … Dore Freeman to the author, December 2, 1975.

Well, what are you doing … Stine, *The Hurrell Style*, p. 150.

(caption) *An actress's success* … Hurrell, "Glamour," p. 73.

(caption) *Hurrell's studies of me* … Stine, *The Hurrell Style*, p. 222.

THE PHOTOGRAPHER AS STAR

a triumph … Allen, "Glamour Workshop," p. 76.

Alloo, Mister 'Urell … Stine, *The Hurrell Style*, p. 164.

I found out she … Fahey, "Interview with George Hurrell," p. 2.

She was probably the … Kobal, *The Art of the Great Hollywood Portrait Photographers*, p. 112.

I'm often asked … Fahey, "Interview with George Hurrell," p. 2.

There was a certain kind of fantasy … Kobal, *People Will Talk*, p. 420.

All of us glamorize … Allen, "Hurrell Exposes Glamour," p. 25.

(caption) *I always looked forward* … Stine, *The Hurrell Style*, p. 114.

(caption) *George Hurrell shot magnificent* … Stine, *Mother Goddam*, p. 152.

THE OUTLAW

Bathycolpian … Jack Vizzard (retired PCA censor) to the author, March 20, 1998.

As appointment time nears … Allen, "Hurrell Exposes Glamour," p. 26.

A haystack … Stine, *The Hurrell Style*, p. 165.

We just had a haystack there … Fahey, "Interview with George Hurrell," p. 6.

You could see the seams … Jane Russell to the author, August 30, 2010.

Jane Russell, not yet … "Hedda Hopper's Hollywood," *Los Angeles Times*, June 2, 1942, p. 12.

You don't make a star … Fahey, "Interview with George Hurrell," p. 6.

(caption) *I would be up that* … Kobal, *The Art of the Great Hollywood Portrait Photographers*, p. 121.

COLUMBIA PICTURES

The stills gallery was … Stine, *The Hurrell Style*, p. 175.

If I were you … Ibid., p. 178.

You'd retouch until … George Hurrell to the author, December 1, 1975.

She had a nice … Stine, *The Hurrell Style*, p. 177.

Rita projected … Kobal, *People Will Talk*, p. 266.

Irene Dunne was … Kobal, *People Will Talk*, p. 272.

You can't work with … Fahey, "Interview with George Hurrell," p. 6.

(caption) *Rita Hayworth has a slumbrous* … Carroll, "He Glamorizes Glamour," p. 64.

WAR AND SCANDAL

He's a compact bundle … Carroll, "He Glamorizes Glamour," p. 64.

I would pick a gal … Fahey, "Interview with George Hurrell," p. 5.

I was a real romantic … "Greene Hurrell Interview," p. 19.

Upon my return . . "Hurrell Divorce," *Los Angeles Examiner*, March 3, 1943. (Fragmentary clipping, author's collection.)

I had been drafted … Stine, *The Hurrell Style*, p. 179.

He became infatuated … *Los Angeles Examiner*, December 16, 1942. (Fragmentary clipping, author's collection.)

gallant lady … *Los Angeles Examiner*, March 15, 1944. (Fragmentary clipping, author's collection.)

all charges of impropriety … *Los Angeles Examiner*, January 1, 1943. (Fragmentary clipping, author's collection.)

I shot stills … Stine, *The Hurrell Style*, p. 179.

I was at the Pentagon … Long, "The Man Who Made the Stars Shine," p. 63.

When I was in the army … Hayes, "George Hurrell," p. 33.

It's a physical quality … Kobal, *People Will Talk*, p. 266.

Except for Rita … Ibid., p. 268.

I found her to be … Stine, *The Hurrell Style*, p. 179.

those lovely pictures … The song "I Love an Esquire Girl" was written specifically for the film by Lew Brown, Ralph Freed, and Roger Edens.

As a partner … "Legal Tangle After Divorce."

A new form of photography … Trent, *The Image Makers*, p. 57.

The glamour ended … Loynd, "Glamour Gallery of Hollywood."

I'd get bored … "Hurrell," p. 234.

George, you don't take … "Tending His Pose Garden."

Joan Crawford wanted … "Hurrell," p. 234.

Hurrell couldn't cut … Ted Allan to the author, March 2, 1986.

He's too old … Kobal, *People Will Talk*, p. 266.

He has a violent … "TV Ad Pair Divorced."

I'd get bored with the … "Hurrell," p. 234.

(caption) *I wanted to shoot* … Stine, *The Hurrell Style*, p. 185.

THE LEAN YEARS

The great Hurrell … Letter, George Hurrell to Jerry Wald, April 8, 1960, author's collection.

In 1962 Hurrell came … Ted Allan to the author, March 2, 1986.

There's no way … Morrison, "The Old Master Today," p. 251.

It's beyond me … George Hurrell to the author, February 16, 1976.

Those speedlights … C. S. Bull to the author, August 12, 1978.

Strobe lighting doesn't … Kapitanoff, "Sixty-three Years of Shooting the Legends."

How many rolls … Loynd, "Glamour Gallery of Hollywood."

I've never seen … Haber, "Shell Shock on the 'Myra' Set."

George, this is John … Kobal, *People Will Talk*, p. 256.

John was at … David Chierichetti to the author, December 3, 1995.

John was guarded … David Del Valle to the author, February 1, 1997.

There was a duality … Matthew Daniels to the author, May 14, 1987.

John was a true … Jeremiah Sullivan to the author, June 12, 1988.

After you've looked … Wayne, "Hollywood Hot Shots," p. 119.

Hurrell had now … Kobal, *People Will Talk*, p. 257.

This is getting … Letter, George Hurrell to John Kobal, May 13, 1974.

I understand you have … Paul Morrissey to the author, December 21, 1995.

I've tried to get … Letter, George Hurrell to John Kobal, January 20, 1975.

(caption) *It can't miss* … Christy, "Too Much of a Good Thing."

(caption) *You see, John* … Kobal, *People Will Talk*, p. 420.

THE COLLECTORS

Photography is still in … Carroll, "George Hurrell, Glamour Monger," p. 111.

I saw that photography … Allen, "Hurrell Exposes Glamour," p. 25.

You can throw away … Richard E. Braff to the author, November 21, 1995.

It's like they … David Del Valle to the author, February 1, 1997.

It's very modest … Birchard, "The First Super Collectors," p. 64.

THE NEGATIVES

John never bothered … David Chierichetti to the author, December 3, 1995.

John, you know … Paul Morrissey to the author, December 21, 1995.

With this show … Simon Crocker to the author, January 2, 1996.

My original set … Kobal, *People Will Talk*, p. 267.

the first Hurrell collector … Bill Chapman to the author, November 29, 1995.

Louis D'Elia … Louis F. D'Elia to the author, November 28, 2012.

And the goose … Letter, George Hurrell to John Kobal, June 7, 1976.

The Hurrell Style was poorly … David Fahey to the author, January 11, 1996.

I had absolutely no … Marysa Maslansky to the author, January 16, 1996.

Hurrell finally signed … "Agreement, May 1, 1977," collection of Paul Morrissey.

It was sad indeed … Letter, George Hurrell to John Kobal, May 20, 1977.

(caption) *Hurrell did what we*… Stein, "Hurrell's Hollywood Photos Have Glamour."

(caption) *I've always thought*… Letter, George Hurrell to Joan Crawford, April 16, 1976.

THE BIG HURT

It's supposed to be… David Del Valle to the author, February 1, 1997.

My dad never… George Hurrell Jr. to the author, January 27, 1996.

George was a good… David Chierichetti to the author, December 3, 1995.

I regret that my… George Hurrell to John Kobal, February 16, 1978.

It was pretty… Simon Crocker to the author, January 2, 1996.

I took George's… Marysa Maslansky to the author, January 16, 1996.

Mr. Crosby, I can do… Allan Rich to the author, January 2, 1996.

When Allan Rich approached… G. Ray Hawkins to the author, February 12, 1996.

THE MILESTONE

My wife Betty… Letter, George Hurrell to John Kobal, December 9, 1980.

I am back in harness… Letter, George Hurrell to John Kobal, February 8, 1981.

The most feverish… "Auction Notes."

The Gilman Paper… "Short Takes: Hammered Out."

There is no relation… Ibid.

flirting with postcard… Letter, George Hurrell to John Kobal, July 14, 1981.

THE MACHINE

She's the only star… "Grand Master of Glamour."

Whatever went on… "Hollywood Hot Shots," p. 119.

just sit there like… Hayes, "George Hurrell," p. 32.

Painters are individualists… "Shooting Stars."

The word 'Hurrell' was… Howard Mandelbaum to the author, December 29, 1995.

GENIUS AND MEANNESS

At 84, Hurrell is fiery… "Grand Master of Glamour."

I tried a couple… Kapitanoff, "Sixty-three Years of Shooting the Legends."

very pleasant… David Leddick to the author, December 10, 1995.

REFLECTIONS IN A LENS

any photos from… J. Grier Clarke to the author, December 20, 1995.

Party's over… "Biography."

EPILOGUE

George wasn't… Kobal, *People Will Talk*, p. 269.

I had no formal… Morrison, "The Old Master Today," p. 251.

INDEX

ACKNOWLEDGMENTS

I thank Cindy Sipala, Executive Editor at Running Press, for initiating, guiding, and managing this project. *George Hurrell's Hollywood* dates to the beginning of our ten-year collaboration.

I thank Deborah Warren of East-West Literary for her steadfast, resourceful work on my behalf.

This book was the first to fully convey the work of this artist. It is also the first in which I am a character, and the first in which I challenge assumptions about that work. The need for accuracy has been greater than usual, so there is more to acknowledge.

For research help I thank: Allan R. Ellenberger; Eric Evavold; and Jeff Britting, Archivist, the Ayn Rand Institute. For help with the Hurrell chronology I thank: Garrett Mahoney; Sandy Tanaka; and Richard Settle. For manuscript review, I thank Paloma Rabinov; James Schneeweis; Janet Blake; Cari Beauchamp; and P. R. Tooke.

Writing a Hurrell biography is inspired in some intangible way by working near his first Los Angeles studio. I thank JMF Development, which manages the Granada Buildings, for maintaining the Hurrell legacy: Rodolfo Aguilar; Nicole Gideon; Rachel Windmiller, Portfolio Property Manager; and Jeffrey M. Fish, owner.

I thank the School of Cinematic Arts at the University of Southern California: Stephen Hanson, head of the USC Cinematic Arts Library; Sandra Garcia-Myers, Director, Archives of the Cinematic Arts; and, for many hours of assistance, Ned Comstock, retired Senior Library Assistant. I thank the Oral History Research Office at Columbia University.

I thank David W. Packard and the Packard Humanities Institute.

I thank these institutions and companies for photographs: the Los Angeles Public Library's Photo Collection staff: Terri Garst, Acting Library Assistant; and Christina Rice, Acting Senior Librarian; I thank Janet Blake, Curator of Early California Art, Laguna Art Museum; Jamie Vuignier, the Kobal Collection at Art Resource; the Montgomery Management Co.; Exclusive Artists Management; Marc Wanamaker of Bison Archives; Fathom Galleries; the Pancho Barnes Trust Estate Archive; Clarke Galleries; April Dammann, Stendahl Galleries; Andrew Weiss Galleries; Tom Conroy, Movie Still Archives; Roy Windham, Baby Jane of Hollywood; and Tom Maroudas of hollywoodpinups.com.

I thank these individuals for photographs: John McElwee and Greenbriar Picture Shows; Karie Bible; Martin Brodsky; Kenton Bymaster; Alfred Chico; Robert Cosenza; Damon Devine; Peter Koch; Garrett Mahoney; Matthew Manhard; Rob McKay; Bill Nelson; Connie Parker; Elaine Peschke; J. David Riva; Karl Ruddy; David Stenn; Jack Tillmany; David Wills; and Kim Hill. I thank Lou Valentino for the loan of vintage Kodachrome transparencies.

I thank Chuck Binder of Binder and Associates for graciously arranging the foreword.

I acknowledge the education I received from my teachers at St. Joseph High School: Anthony Aiello; Robert Sickenger, Stanley Murakami; and Patrick McCormick. My undergraduate film education derives from the inestimable filmmaker and educator, Robert L. Hillmann. I thank two photographic mentors: Donald Harris and Michael R. Abbey.

I thank Lou Valentino for forty-seven years of negative loans.

For generous assistance and support, I am deeply grateful to: Rev. Michael Lehman, Senior Associate Minister of First Congregational Church of Los Angeles, and the Deacon's Fund of First Church. I also thank Karie Bible; Mike Chambless; Helen Cohen; Judy G. Drown; Janine Faelz; Janice Findley and Paul Hansen; Keith Hill; Louis Jacinto and Kene Rosa; Eugene La Pietra; Garrett Mahoney; Howard Mandelbaum; Ann Meine; Dom and Sachiko Magwili; Suzanne McCormick; Andrew Montealegre and Marvin Bendana; Gary Morris and Greg Battle; William Nelson; Bruce Paddock; Joe Quintero; Bronni Stein and John Connolly; Deborah Thalberg; Richard Potts and Richard Sommers; Laurie Hendricks and Peter Milio; Vincent Estrada and Victor Gonzalez; Kenton Bymaster; and P. R. Tooke.

I thank John Narmontas, CP, and Active Life; Rev. Scott Colglazier; Ruben Alvarez, MD, Robert E. Brown; and Jann Hoffman.

I thank Cecilia de Mille Presley for her patronage.

Many individuals have contributed to this long-awaited project: Albert Agate, Leonardo Baricala, Darin Barnes, Matias Bombal, Joseph Caro, Anthony Carrillo, Alfred Chico, Francis Coiro, Jon Davison, Rob Easterla, Michael Epstein, Kathleene Labby, James Leggio, Mary Mallory, William Martin, David Noh, Joseph Ornelas, Eddie Muller, Felix Pfeifle, Alan K. Rode, Darrell Rooney, Leonard Stanley, Marguerite Topping, Victor Varela, and Leonel Way.

I wish to acknowledge those family members, mentors, and friends who helped me tell the Hurrell story but who are no longer living: Ted Allan; Barbara Biane; George Bigham; Dick Braff; Nina Del Campo; Procopio Calado, Cal-State Hayward; David Chierichetti; Carole Conroy, Memory Shop West; Sabato Fiorello; Dore Freeman, MGM; Lee Garmes; Kim Goodwin; Edd Hearn; Norman Holmes; Roy Johnson, Limelight Bookstore; Eugene Kenourgios; Arthur Lucia; David Merfalen; Marian Mogel; Jerry Morris, USC Dental; Nell O'Day; Bill Pace; Patrick Pahilga; Randy Pelish; Robert Raiszk, Trojan Camera; Allan Rich; Beverly Ferreira Rivera; Chester Schaeffer; Francisco Sohom; Harvey Stewart; Jeremiah Sullivan; Billie Tooke; Bill Valentine; Jaime Vega; Michael Vera; Michael Vollbracht; Laszlo Willinger; my uncle Jack Costa; my cousin Bernice Dransfield; and my aunt Dorothy Chambless. I remember fifty years of counsel and assistance from my friend, Frank Tingley. I remember thirty years of patronage from Ben Carbonetto. I remember the two decades of support I received from my assistant, Jonathan G. Quiej.

I thank Antonio Marroquin for a smoothly functioning studio and for his care of the pets who sit by me as I write.

For everything else, I thank my family: Jan Callender; Sue Costa; Julie Chambless; Michael and Cindy Chambless; Lenore Griego; Matthew Griffiths; John and Julie Vieira; Guy and Shannon Vieira; and Steve and Janine Faelz.

Lastly, I wish to thank my parents for sending me to the University of Southern California Cinema Department in 1973, a beneficence that launched my life's work.